**The World Wide Web
and Contemporary Cultural Theory**

The World Wide Web
and Contemporary Cultural Theory

Edited by
Andrew Herman
& Thomas Swiss

‘

ROUTLEDGE

A MEMBER OF THE TAYLOR & FRANCIS GROUP
NEW YORK LONDON

Published in 2000 by
Routledge
29 West 35th Street
New York, NY 10001

Published in Great Britain in 2000 by
Routledge
11 New Fetter Lane
London EC4P 4EE

A member of the Taylor & Francis Group
Copyright © 2000 by Routledge

Printed in the United States of America on acid-free paper.
Design: Jack Donner

10 9 8 7 6 5 4 3 2 1

Cataloging-in-Publication Data available from the Library of Congress.
 0–415–92501–0 (hb)
 0–415–92502–9 (pb)

CONTENTS

ACKNOWLEDGMENTS

The authors would like to thank Heidi Henson and Cynthia Lewis for their support and comradeship. Thanks also to Sofia Turnbull and Nancy Smith for their careful attention to the details of The World Wide Web and Contemporary Cultural Theory conference and this book; neither would have been possible without them. Skye Giordano also deserves special thanks for his technical support at the conference, help in creating the websites for the conference and the book, and in getting the screen shots for the book. We also wish to acknowledge the many and varied contributions of Dan Alexander, Robert Hoehle, Michael Cheney, Bobby Gitenstein, Ronald Troyer, Jacob and Alley Swiss, Oliver "Pointer" Herman, Bruce Horner, Suzanne Schnackenberg, William Germano, Nick Syrett and our friends at Routledge, and all the contributors to this book. Finally, we would like to thank the Drake University Center for the Humanities, as well as the Womens' Studies, Cultural Studies, and Honors programs at Drake, for their generous financial and moral support at various stages of this project.

> FROM: THOMAS SWISS AND ANDREW HERMAN
>
> SUBJECT: **Introduction**
> The World Wide Web
> as Magic, Metaphor, and Power
>
>
>
>
>
>
The World Wide Web is the most well known, celebrated, and promoted manifestation of "cyberspace." However, most writing about the Web falls into the category of explanatory journalism; it remains largely unmapped in terms of contemporary cultural research. This book commences that mapping by bringing together scholars from the humanities and social sciences to explore the Web as a complex nexus of economic, political, social, and aesthetic forces. In doing so, the contributors engage the Web as a space where *magic, metaphor, and power* converge.

Although each of the chapters deals with a different aspect of the Web, each of them shares a focal concern with the Web as a unique "cultural technology." As Jody Berland (one of the contributors to this volume) argues, all media cultural technologies embody a spatialized logic of production, dissemination, and consumption that "involves a mediation of a mode of address, the occasion of its reception and its consolidation as technique" (1993: 27). In examining the World Wide Web as a cultural technology, we are concerned with how different dimensions of the Web as a complex practice come together. These dimensions include the material mode of production of the Web and its "content"; the circulation of its content in the form of hypertext, graphic images, or streaming audio and video; and its consumption by users in the places of everyday life such as the home or office. Moreover, the Web can be understood as *techné* in Martin Heidegger's

(1977) sense of the term; that is, as a technology that is simultaneously an instrument and an activity thorough which self and world are cast into sense, thereby transforming "being" in the world. As Heidegger argues, part and parcel of the transformative nature of technologies is the manner in which they mythically reveal and frame being-in-the-world through *poiesis*, or the poetic invocation and representation of self and world (Chesher, 1997). But this transformative capacity, structured in the cultural imagination, typically embodies profound desires, hopes, and fears.

The technology of the World Wide Web, perhaps *the* cultural technology of our time, is invested with plenty of utopian and dystopian mythic narratives, from those that project a future of a revitalized, Web-based public sphere and civil society to those that imagine the catastrophic implosion of the social into the simulated virtuality of the Web. Is there any middle ground? Robert McChesney, in his opening chapter, offers a detailed analysis of the way in which traditional print and broadcast media conglomerates have come to dominate the institutional and technological development of the Web. McChesney—like Vincent Mosco who analyzes the Web "technopolis" in chapter 2, and Stuart Moulthrop, whose later chapter is entitled "Doubting the Web"— argues that utopian claims for the transformative powers of the Web, while not to be dismissed entirely, must be taken with a considerable skepticism.

Whether our imaginings of the Web are optimistic or foreboding, however, they are nevertheless indications of what Robert Romanyshyn (1989) has termed the "reenchantment of the world" through the magic of technology. As writers in this volume note, the Web can be understood as a space of "magic" in many ways, but most notably, perhaps, in that it forms a multimediated arena of performance in which identities are staged, negotiated, and transformed. Magic, for better and for worse, pervades the Web—both as a material and symbolic practice of identity transformation, but also as the mythic representation of this transformative capacity. Taking up the former, Theresa M. Senft offers a complicated autoethnography of her experiences in helping to build Web-based virtual communities by invoking the spectacular magic of the famous cargo cults of Melanesia in which identity formation and a mystical reverence for the commodity are intertwined. In their chapter, Andrew Herman and John H. Sloop explore the relationship between utopian and corporate rhetorics of the Web as a cultural technology of magical personal and

social transformation. Through a close reading of several recent corporate advertising campaigns for Web services, they argue that the subject invoked by the corporate rhetoric of Web utopia is "free" only to the goods-consuming subject of neoliberal capitalism. And Sean Cubitt reflects on the quotidian metaphysics of magic on the Web—especially as it is manifested in numerical representations of chance and contingency that govern everyday life (i.e., lottery pages, astrology and numerology websites, etc.)

At the core of the magical powers of rhetorics about the Web is the use of metaphor, especially those of symbolic equivalency and exchange intended to make them meaningful in the social imagination. Rob Shields explores the meaning of the Web as metaphor by examining hypertext links. In her contribution, Jody Berland focuses upon the figure of the "posthuman" in Web discourse. She scrutinizes one of the reigning metaphors of technological innovation and development: evolution. And in her chapter, Jodi Dean argues that the Web functions as a metaphor for threats to the boundaries, stability, and purity of America as a nation.

Finally, the chapters in this book investigate how the magic of the Web as cultural technology, and the mythical rhetoric of its metaphors, converge to compose a field of power. Of course the news that the World Wide Web is a site of power relations is hardly earth shattering. Yet most accounts of the power dynamics of the Web focus on the issue of which institutions, organizations, or people have power in its domain and which do not. Although the question of power in terms of who has access to or control over the resources of and on the Web is surely an important one (and one taken up in this volume), it is by no means the only way to approach the question of power when considering the Web as an aspect of cultural technology. Power may be best understood not simply as a manifestation of resources or capacities that people either have or don't have, but as an omnipresent flow that is embodied in the conduct of social life. Power isn't simply repressive or coercive, as Michel Foucault reminds us, but is productive and constitutive of all forms of embodiment, identity, and agency, whether those of the privileged or the marginalized.

Accordingly, many of the chapters, including some of those already noted, focus upon how the quotidian pragmatics of power on the Web is contingent upon particular forms and practices of making sense of and knowing the Web. Greg Elmer's essay, for example, explores an

ubiquitous yet hitherto ignored form of web governmentality: the website award. Nancy Kaplan tackles one of the most important forms of power/ knowledge of the modern era: literacy. Kaplan examines the consequences of the Web as a hypertextual medium and space for the governmentality of self produced in the act of reading. David Tetzlaff explores the governmentality of the Web as part of the regime of post-Fordist cybercapitalism by examining the ambivalent practice of software piracy of "warez." Tetzlaff makes the novel and compelling argument that the problem of software piracy for cybercorporations is primarily ideological rather than economic, and the struggle over the "integrity" of software as private property is really a struggle over what kinds of workers and consumers are appropriate to so-called new economy of the Web and the Internet. Steven Jones picks up on this theme of the power/ knowledge of hypertextuality and expands it to encompass the relationship of the Web to the regime of what has been termed "print capitalism." Jones argues that, contrary to most interpretations of the Web, its "bias" in terms of socio-ontological import is toward time rather than space.

We have set up a website (www.multimedia.drake.edu/mmp) that contains additional resources, including images and other multimedia materials relevant to the chapters in this book, as well as keywords for each chapter with direct links to some of the best Internet resources available on the subject of magic, metaphor, and power on the World Wide Web.

> FROM: ROBERT McCHESNEY
>
> SUBJECT: **So Much for the Magic of Technology**
> **and the Free Market**
> The World Wide Web
> and the Corporate Media System
>
>
>
>
> Much contemporary literature discusses the starkly
> antidemocratic implications and trajectory of the con-
> temporary media system (McChesney, 1999). Dominated
> by a handful of massive firms, advertisers, and their bil-
> lionaire owners, the system is spinning in a hyper-
> commercial frenzy with little trace of public service. In
> conjunction with this crystallization of the corporate
> media system in the late 1990s, a theory has emerged
> asserting that we have no reason to be concerned about
> concentrated corporate control and the hypercommer-
> cialization of media. This claim is that the World Wide
> Web, or, more broadly, digital communication networks,
> will set us free. This is hardly an unprecedented argu-
> ment: every major new electronic media technology in this
> century—from film, AM radio, short-wave radio, and fac-
> simile broadcasting to FM radio, terrestrial television,
> cable, and satellite broadcasting—has spawned similar
> utopian notions. In each case, to varying degrees, vision-
> aries told us how these new magical technologies would
> crush the existing monopolies over media, culture, and
> knowledge and open the way for a more egalitarian and
> just social order. But the World Wide Web is qualitatively
> the most radical and sweeping of these new communica-
> tion technologies, and the claims about it top earlier tech-
> nological visions by a wide margin.
> The claims for what the Web will do to media and
> communication are no less sweeping. "The Internet is

wildly underestimated," Nicholas Negroponte, media lab director at the Massachusetts Institute of Technology, states. "It will grow to be the enabling technology of all media—TV, radio, magazines and so on" (quoted in Lohr, 1998b: A11). As the argument goes, if everything is in the process of becoming digital, if anyone can produce a site at minimal cost, and if that site can be accessed worldwide via the Web, it is only a matter of time (e.g., expansion of bandwidth, improvement of software) before the media giants find themselves swamped by countless high-quality competitors. Their monopolies will be crushed. John Perry Barlow, in a memorable comment from 1995, dismissed concerns about media mergers and concentration. The big media firms, Barlow noted, are "merely rearranging deck chairs on the Titanic." The "iceberg," he submitted, would be the World Wide Web, with its five hundred million channels (cited in Herman and McChesney, 1997: 107). As one *New York Times* correspondent put it in 1998, "To hear Andy Grove [CEO of Intel] and Reed Hundt [former chair of the Federal Communications Commission] talk, the media industry is about where the horse-and-buggy business was when Henry Ford first cranked up the assembly line" (Landler, 1998: sec. 3, D.9).

In this chapter I try to untangle the claims, even the mythology, about the World Wide Web from the observable record, though this is not an easy task. For one thing, the Web is a quite remarkable and complex phenomenon that cannot be categorized by any previous medium's experience. It is two-way mass communication; it uses the soon-to-be-universal digital binary code; it is global; and it is quite unclear how, exactly, it is or can be regulated. In addition, the World Wide Web is changing at a historically unprecedented rate. Any attempt at prediction during such tumultuous times is nearly impossible; something written about the Web as recently as 1992 or 1993 has about as much currency in 2000 as discourses on the War of the Roses do for understanding contemporary European military policy. But I believe enough has happened in cyberspace that we can begin to get a sense of the Web's overarching trajectory, and a sense of what the range of probable outcomes might be.

While it is no doubt true that the World Wide Web will be part of massive social changes, I do not share the optimism of the George Gilders, Newt Gingriches, and Nicholas Negropontes.[1] Much discussion of the Web is premised upon whether one has a utopian or dystopian, optimistic or pessimistic view of technology and social change. In short, is one a

technological determinist, and is that determinism of the utopian or Luddite variety? These are interesting debates but, conducted in isolation from social factors, they are not especially productive. The Web utopianism of Negroponte and others is based not just on a belief in the magic of technology, but, more important, on a belief in capitalism as a fair, rational, and democratic mechanism that I find mythological. It is when technological utopianism or determinism are combined with a view of capitalism as benign and natural that we get a genuinely heady ideological brew. So it is true that the Web is changing the nature of our media landscape radically. As Barry Diller, builder of the Fox television network and a legendary corporate media seer, put it in December 1997, "We're at the very early stages of the most radical transformation of everything we hear, see, know" ("All Together Now," 1997: 14). What I wish to examine in this chapter, specifically, is if these changes will pave the way for a qualitatively different media culture and society or if the corporate commercial system will merely don a new set of clothing.

THE MYTHOLOGY OF THE FREE MARKET

One of the striking characteristics of the World Wide Web is that there has been virtually no public debate over how it should develop; a consensus of "experts" simply decided that it should be turned over to the market. Indeed, the antidemocratic nature of Web policy making is explained or defended on very simple grounds: the Web is to be and should be regulated by the free market. This is the most rational, fair, and democratic regulatory mechanism ever known to humanity, so by all rights it should be automatically applied to any and all areas of social life where profit can be found. No debate is necessary to establish the market as the reigning regulatory mechanism, because the market naturally assumes that role unless the government intervenes and prevents the market from working its magic. Indeed, by this logic, any public debate over Web policy can only be counterproductive, because it could only lead us away from a profit-driven system. Public meddling would allow unproductive bureaucrats to interfere with productive market players.

Combining the market with the Web, we are told, will allow entrepreneurs to compete as never before, offering wonderful new products at ever lower prices. It will provide a virtual cornucopia of choices for consumers, and empower people all over the world in a manner previously unimaginable. Enterprise will blossom as the multitudes become online

entrepreneurs. It will be a capitalist Valhalla. Nowhere will the cyber-market revolution be more apparent than in the realm of media and communication. When anyone can put something up on the Web, the argument goes, and when the Web effectively converges with television, the value of having a television or cable network will approach zero. Eventually the control of any distribution network will be of no value as all media convert to digital formats. Production studios, too, will have less leverage as the market will be opened to innumerable new players. Even governments will, in the end, find its power untamable (McHugh, 1997).

As a consequence, the likely result of the digital revolution will be the withering—perhaps even the outright elimination—of the media giants and a flowering of a competitive commercial media marketplace the likes of which have never been seen. Indeed, the rise of the Web threatens not only the market power of the media giants but also the very survival of the telecommunication and computer software giants (see Gilder, 1994).

It is ironic that as the claims about the genius of the market have grown in conventional discourse over the past two decades, the need to provide empirical evidence for the claims has declined. The market has assumed mythological status, becoming a religious totem to which all must pledge allegiance or face expulsion to the margins. The mythology of the market is so widely embraced to some extent because it has some elements of truth. It is formally a voluntary mechanism, without direct coercion, and it permits an element of consumer choice. But the main reason it has vaulted to the top of the ideological totem pole is because it serves the interests of the most dominant elements of our society. And the free market mythology harms few if any powerful interests, so it goes increasingly unchallenged. As this mythology of the free market is the foundation of almost the entire case for the lack of any public debate on the course—and therefore for the privatization and commercialization—of the Web, it demands very careful scrutiny.

The claim that the market is a fair, just, and rational allocator of goods and services is premised on the notion that the market is based on competition. This competition constantly forces all economic actors to produce the highest-quality product for the lowest possible price, and it rewards those who work the hardest and the most efficiently (see Friedman, 1962). Therefore, these new technologies will permit hungry entre-

preneurs to enter markets, slay corporate dinosaurs, lower prices, improve products, and generally do good things for humanity. And just when these newly successful entrepreneurs are riding high on the hog, along will come some plucky upstart (probably with a new technology) to teach them a lesson and work the magic of competition yet again. This is the sort of pabulum that is served up to those Americans who lack significant investments in the economy. It provides an attractive image for the way our economy works—making it seem downright fair and rational—but it has little to do with how the economy actually operates. Corporate executives will even invoke this rhetoric in dealing with Congress or the public and, at a certain level, they may even believe it. Yet their actions speak louder than words.

The truth is that for those atop our economy the key to success is based in large part on eliminating competition.[2] I am being somewhat facetious, because in the end capitalism is indeed a war of one against all, since every capitalist is in competition with all others. But competition is also something successful capitalists (the kind that remain capitalists) learn to avoid like the plague. The less competition a firm has, the less risk it faces and the more profitable it tends to be. All investors and firms rationally desire to be in as monopolistic a position as possible. In general, most markets in the United States in the twentieth century have gravitated not to monopoly status, but to oligopolistic status. This means that a small handful of firms—ranging from two or three to as many as a dozen or so—thoroughly dominate the market's output and maintain barriers to entry that effectively keep new market entrants at bay, despite the sort of profitability that Milton Friedman tells us would create competition. In pricing and output, oligopolistic markets are far closer to being monopolistic markets than they are the competitive markets described in capitalist folklore.

To be sure, despite all this concentration these firms still compete— but not in the manner the mythology suggests. As one business writer put it, "Companies in some industries seem to do everything to win customers, apart from cutting prices" (Martin, 1998: 10). Advertising, for example, arises to become a primary means of competition in oligopolistic markets. It provides a way to protect or expand market share without engaging in profit-threatening price competition. On occasion, foreign competition, economic crisis, new technologies, or some other factor may break down a stable oligopoly and lead to a reshuffling of the deck and

a change in the cast of corporate characters. But the end result will almost always be some sort of stable oligopoly; otherwise, no sane capitalist would participate. Yet even the notion of oligopoly is insufficient: widespread conglomeration, along with pronounced involvement by the largest financial institutions in corporate affairs, has reduced the level of autonomy in distinct industries, bringing a degree of instability—if not much more direct competition—to the system. Rather then concentrate on specific oligopolistic industries, then, it is perhaps better to recognize the economy as being increasingly dominated by the few hundred largest firms. This certainly is the best context for understanding developments in media and communication.

So how should we expect the World Wide Web to develop in this model of the free market? Exactly as it has so far. Despite now having the technological capacity to compete, the largest firms are extremely reticent about entering new markets and forcing their way into existing and highly

Fig. 1.1. In the end, capitalism is indeed a war of one against all, since every capitalist is in competition with all others. The *Wall Street Journal* website, http://www.wsj.com/

lucrative communication markets. Thus the local telephone companies have tended to avoid providing pay television over their wires, and the cable companies have avoided providing telephone services over their lines. This is no conspiracy. There have been a few, and will no doubt be more, attempts by these firms and others to cross over and compete in new markets. But it will be done selectively, usually targeting affluent markets that are far more attractive to these firms (Mehta, 1998). Most important, no existing giant will attempt to enter another market unless they are reasonably certain that they will have a chance to win their own monopoly, or at least have a large chunk of a stable oligopoly with significant barriers to entry. A less risky option for these firms, rather than venturing on entrepreneurial kamikaze missions into enemy territory, is to merge to get larger so they have much more armor as they enter competitive battle, or to protect themselves from outside attack. Short of mergers, the other prudent course is to establish joint ventures with prospective competitors in order to reduce potential competition and risk. In short, the rational behavior is to attempt to reduce the threat of competition as much as possible, and then to engage in as little direct competition as can be managed. When capitalism is viewed in this light, Barlow's "iceberg" thesis is considerably less plausible. After all, the corporate media giants have significant weapons in their arsenal not only to confront but also to shape the new technologies. Moreover, once we have a realistic understanding of how capitalism operates, we can see why the dominant corporate media firms, rather than shrinking, are in fact growing rapidly in the United States and worldwide. In the United States, the media industry is growing much faster than the overall economy, and experienced, for the first time since the 1980s, double-digit growth in the consecutive years 1997 and 1998 (Mermigas, 1997; Cardona, 1997).

But what about new firms? Will they provide the competitive impetus the giants rationally attempt to avoid? In general, new firms are ill-equipped to challenge giant firms in oligopolistic markets due to entry barriers. The role of small firms in the classic scenario is to conduct the research, development, and experimentation that large firms deem insufficiently profitable, then, when a small firm finds a lucrative new avenue, it sells out to an existing giant. Some of the impetus for technological innovation comes from these small firms, eager to find a new niche in which they can grow away from the shadows of the corporate giants in existing industries. It is in times of technological upheaval, as now, with

the World Wide Web and digital communication, that brand new industries are being formed and there is an opportunity for new giants to emerge.

It is safe to say that some new communications giants will be established during the coming years, much as Microsoft attained gigantic status during the eighties and nineties. But most of the great new fortunes will be made by start-up firms who develop a profitable idea and then sell out to one of the existing giants. (Witness Microsoft, which spent over $2 billion between 1994 and 1997 to purchase or take a stake in some fifty communication companies.) Indeed, this is conceded to be the explicit goal of nearly all the start-up Web and telecommunications firms, who are founded with the premise of an "exit scenario" through their sale to a giant (Colonna, 1998). As a Web stock-market manager put it in 1998, Web company stock prices were "driven by speculation about who will be the next company to get snapped up by a much bigger company from another medium as a way of buying their way on to the World Wide Web" (Gilpin, 1998: 7). Hence, the traditional function of start-up firms is still the rule. For every new Microsoft, there will be one thousand WebTVs or Starwaves, small technology firms that sell out to media and communications giants in deals that make their largest shareholders rich beyond their wildest dreams. And for every WebTV or Starwave, there are thousands more companies that go belly up.

What should be clear is that this market system may "work" in the sense that goods and services are produced and consumed, but it is by no means fair in any social, political, or ethical sense of the term. Existing corporations have tremendous advantages over start-up firms. They use their power to limit the ability of new firms to enter the fray, to limit output and keep prices higher. Yet the unfairness extends beyond the lack of competitive markets. In participating as capitalists, wealthy individuals have tremendous advantages over poor or middle-class individuals, who have almost no chance at all. Thus, a tremendous amount of talent simply never gets an opportunity to develop and contribute to the economy. It is unremarkable that "self-made" billionaires like Bill Gates, Ted Turner, Michael Eisner, Rupert Murdoch, and Sumner Redstone all come from privileged backgrounds. And, on the "demand" side of the market, power is determined by how much money an individual has; it is a case of one dollar, one vote rather than one person, one vote. In this sense, then, the political system to which the market is most similar is the

limited suffrage days of pre-twentieth-century democracies, when propertyless adults could not vote and their interests were studiously ignored.

In truth, this is what a defense of the market system, in terms of fairness, boils down to: new firms can start and they can become giants, and to do so they probably have to do something quite remarkable, or be very lucky. All it means is that the system holds open the slightest possibility of a nonwealthy person becoming a multimillionaire, that success is extremely difficult to attain in this manner, and that the hope of being rich will drive countless people to their wits' end.

There are a couple of other aspects of capitalism that do not comport to the mythology. First, when free-market mythologists criticize the heavy hand of government, what they really mean by *heavy hand* is that government might actually represent the interests of the citizenry versus those of business. When governments spend billions subsidizing industries or advocating the interests of business, not a peep is heard about the evils of "big government." Government policies play a decisive role in assisting corporate profitability and dominance in numerous industries, not the least of which is communications. Most of the communications industry associated with the technology revolution—particularly the Web—grew directly out of government subsidies. Indeed, at one point fully 85 percent of research and development in the U.S. electronics industry was subsidized by the federal government, although the eventual profits accrued to private firms (T. Chomsky, 1994). The free distribution of publicly owned electromagnetic spectrum to U.S. radio and television companies has been one of the greatest gifts of public property in history, valued as high as $100 billion. Moreover, it is entirely misleading to submit that in this neoliberal, promarket era of "deregulation" the government is playing a smaller role than in earlier times. In fact, the government role is as large as ever, at least during this formative stage of digital communication systems. Extremely crucial decisions about the Web and digital communication are being considered and will be implemented in the next few years, effectively determining the course of the U.S. media and communication system for at least a generation, perhaps longer. The exact manner in which the World Wide Web and digital communication develop will be determined by technological specifications, as well as by who controls the commercial digital industry (Harmon, 1998). The government will be singularly responsible for these activities, and what it does and who it favors will go a long way toward

determining which firms and which sectors get the inside track. What is different from earlier times is that under "deregulation" there is no pretense that the government should represent the public interest vis-à-vis commercial interests. The government is supposed to expedite commercial domination, which, as a result, should serve the public interest.

Understanding the crucial importance of the government undercuts also the myth that the market exists "naturally," independent of the government, blindly rewarding the most efficient performers. Government policies are instrumental in determining who the winners will and will not be, and those policies are often derived in an antidemocratic and corrupt manner. More broadly, the notion that capitalism is a natural "default" economic or regulatory system for the human race, and can only be messed with by meddling governments or trade unions does not comport at all to the world as we know it. That is, although the establishment of capitalism was a remarkable historical accomplishment, capitalism as an economic system, based on the centrality of investment in pursuit of maximum profit, only developed in a small corner of the world after centuries of social transformation. It required massive changes in morals, laws, religions, politics, culture, and "human nature," not to mention economics. A recent indication of the absurdity of capitalism being humanity's default system comes from postcommunist Eastern Europe, where the attempt to let capitalism develop "naturally" has been nothing short of a disaster in all but a few central European nations where the market had made strong inroads prior to communism.

Another flaw in the mythology of the free market is that it posits that market-driven activities always generate the optimum and most rational social outcome. To some extent this argument for market is based on the almost nonexistent competitive model; in economic theory the degree of market concentration that exists across the economy undermines the claims for producing rational and socially optimal results. But this flaw is much deeper than that, and would even apply in mythological free markets. The simple truth is that markets often produce highly destructive and irrational results (Kuttner, 1997). On the one hand, what is rational for individual investors can easily produce negative results when undertaken by many investors. For example, it is rational for an investor to withdraw an investment during a recession, since the chances for profit are small or nil. But if many investors take this same rational step, they may well turn the recession into a depression in which everyone loses.

The economic collapse of many so-called tiger economies of East Asia in 1998 highlights this aspect of markets to a painful degree.

On the other hand, markets produce what are called "externalities." These are the unintended social consequences of markets that are set up to reward individual pursuit of utility and, most important, profit. To put it bluntly, in their pursuit of profits there are things capitalists do that have important effects, but these capitalists do not care—cannot care—because these effects do not alter their bottom lines. Some externalities can be positive, such as when a corporation builds an especially beautiful office building or factory. It receives no material benefit from those in the community who enjoy gazing at the structure, but the community clearly gains. Most externalities are negative, however, such as air pollution. Unless public policy interferes with the market there is no incentive within the market to address the problem. For extreme examples of this phenomenon, one need only travel to cities like Santiago, Chile, or New Delhi, India, where unregulated markets have produced air that is nearly unbreathable, and where the market "solution" is to have the wealthy move to the high-priced areas with the least amounts of pollution.

The media system produces clear externalities. On the positive side, media can produce educational and civic effects through their operations, though the benefits will not accrue to media owners. The negative side of media externalities is well-cataloged. In their pursuit of profit, media firms produce vast quantities of violent fare, subject children to a systematic commercial carpetbombing, and produce a journalism that hardly meets the communication needs of the citizenry. The costs of the effects of this media fare are borne by all of society. Democratic media policy making, then, should systematically attempt to create a system that produces a greater number of positive externalities and the smallest number of negative externalities.

Yet media externalities are not simply the result of the market; they also result from how the market interacts with new technologies, or from the technologies themselves. In the case of television, for example—regardless of its content per se—when it became ubiquitous and dominant, it changed the way people socialized and interacted. It led, for better or (in my view) for worse, to greater social isolation. All communication technologies have unanticipated and unintended effects, and one function of policy making is to understand them so that we may avoid or minimize the undesirable ones. The digitalization and computerization

of our society are going to transform us radically, yet even those closely associated with these developments express concern about the possibility of a severe deterioration of the human experience as a result of the information revolution. As one observer notes, "Very few of us—only the high priests—really understand the new technologies, and these are surely the people least qualified to make policy decisions about them" (Charbeneau, 1995: 28–29).

For every argument extolling the "virtual community" and the liberatory aspects of cyberspace, it seems every bit as plausible to reach dystopian, or at least troubling, conclusions. Is it really so wonderful or necessary to be attached to a communications network at all times? Is it such a wonderful environment to be on city streets where everyone is talking into little cell phones? Is sitting in front of a computer or digital television for hours per day really such a great thing for humans to do, even if it is "interactive"? Why not look at the Web as a process that encourages the isolation, atomization, and marginalization of people in society? In fact, cannot the ability of people to create their own "community" in cyberspace have the effect of terminating a community in the general sense? In a class-stratified, commercially oriented society like the United States, can't the information highway have the effect of simply making it possible for the well-to-do to bypass any contact with the balance of society altogether? These are precisely the types of questions that need to be addressed and answered in communication policy making, and precisely the types of questions in which the market has no interest. We should look—and think—before we leap.

THE HUNT FOR THE KILLER APPLICATION

In this "whoever makes the most money wins" environment, the pursuit of Web riches is conducted by a host of other media and nonmedia firms, all of whom act both out of a desire for more profit and out of a fear of being outflanked by their competitors if they do not proceed aggressively. The crucial factor in the World Wide Web's becoming ubiquitous and dominant will be the expansion of broadband capability to the bulk of the population, the ability, that is, of having material flow as quickly online— even as fast as the speed of light—as signals travel on television. When that happens, the Web may well become a vast converged communication machine, eliminating traditional distinctions between communication and media sectors as everything goes digital. The president of

NBC News, Andy Lack, predicts that it will be at least the year 2008 until full-motion video—television as we know it—is widely available in U.S. homes via the Web, and others tend to think it could take longer than that (Snoddy, 1997a; Sandberg, 1998). But firms do not have the luxury of sitting back and waiting for that moment: those who will dominate cyberspace in the future will be determined well before the era of widespread broadband access.

The late 1990s, accordingly, has seen a flood of investment to Web-related enterprises (Karlgaard, 1998). "It may seem as if the two year old Internet industry is mounting a takeover of corporate America," the *Financial Times* noted in 1998, "The reality is more like a merger" (Denton, 1998a: 6). Huge sums have been squandered already, and more will certainly be lost in the future as firms seek out the "killer application" that will define the World Wide Web as a commercial medium. But by the end of the 1990s the dust is beginning to settle and some inkling of how great wealth can be generated by the Web is becoming ever more clear. And as the formal policy is to let the market rule, wherever the most money can be found is how the Web will develop.

The two most important corporate sectors regarding the Web are telecommunications and computers. Each of these sectors is more immediately threatened by the World Wide Web than are the dominant media firms. In the case of the seven or eight massive telecommunication firms that dominate the U.S. telephone industry, the Web poses a threat to its very existence. The new technology of Internet protocol (IP) telephony threatens to open the way to vastly less expensive communication and the possibility of newfound competition (Higgins, 1998; "All Together Now," 1997; Taylor, 1998). The telecommunications giant Sprint has gone so far as to revamp its entire network to operate by IP standards (Waters, 1998b, 1998a). More important, the very notion of voice telephony is in the process of being superseded by the digital data networks that send voice as only a small portion of its data delivery. In this sense, the big telecommunications firms may appear like giant dinosaurs made irrelevant by the Web.

Yet the giant telecommunications firms have a few distinct assets with which to play. First, they already have wires into people's businesses and homes and these wires are suitable for carrying Web traffic. Second, the World Wide Web "backbone" of fiber-optic trunk lines is owned by several of the largest U.S. telecommunications firms, including WorldCom-MCI, AT&T, GTE, and Sprint (Yang, 1998). These factors make the

telecommunication firms ideally suited to become Internet service providers (ISPs) to business and consumers, already an area with a proven market (C. Warner, 1998). Indeed, with the entry of the large telecommunication companies into the ISP sector, the *Financial Times* wrote that the "Internet small fry" were "on the road to oblivion." It added: "The situation is very much like the PC market 10 years ago where a lot of smaller PC dealers went out of business" (Poynder, 1998: 12).

With regard to being an ISP, as in other facets of telecommunication, size means a great deal for establishing a competitive advantage. Hence, the dominant trend in the late 1990s has been a wave of massive mergers among the largest telecommunications firms, not only in the United States but globally. The second asset these firms enjoy is a great deal of cash flow, which permits them to engage in more aggressive acquisitions than perhaps any other Web-related firms. The consensus of opinion in the business community is that early in the twenty-first century as few as four to six firms will dominate the entirety of global telecommunications.[3]

The other major contender in providing Web access is the cable television industry; in the United States that means the five or six companies that have monopolies over more than 80 percent of the nation. By the summer of 1998 the Federal Communications Commission (FCC) effectively abandoned the notion that the ISP market could ever be remotely competitive. It granted the regional Bell companies the right to restrict the use of their wires to their own ISP services, rather than make them available to all users at a fair price. By doing so, the FCC hopes to encourage at least two viable ISP services—one telephone based, the other cable based—in each market, rather than have it become a monopoly (Schiesel, 1998a).

Whether or not the ISP industry becomes a killer application remains to be seen, but is certainly shaping up as possibly becoming a highly lucrative aspect of the emerging digital communications networks. The key to great Web wealth may be whether the ISPs can mimic what the U.S. cable companies did (which was to demand partial ownership of cable TV channels if those same channels wanted access to their systems, while simultaneously launching their own channels), and use their control over the crucial Web wires as a means to get a piece of the commercial action that transpires over their systems. This is an issue I will turn to shortly with the discussion of portals. In the meantime, that these firms will dominate the wires providing Internet service is regarded as a

good thing in the business press: if these telecommunications giants can put "internet economics on a commercial basis," as one *Financial Times* writer noted, it might lead to "higher user costs," but it would also lead to the Web's more rapid commercial development, which is more important (Kehoe, 1998a: 14).

One of the striking features of having Web access provided by the private sector is that the notion of universal service to the entire population is and must be sacrificed to the needs of the market. The most money is made by pitching high quality service to the affluent who can afford it, and who are most attractive to advertisers. As TCI founder John Malone has put it, the best way to conduct the Web access business is to offer "tiered" service, with high-speed access for the affluent and business, on down to slow Web access for those who cannot afford (Coleman, 1998). In 1998 the average U.S. Internet user had an income that was double the national average, and there was little reason to expect that to change quickly (Webber, 1998). The fees expected for high-speed Internet access in the twenty-first century would exclude all but half of the U.S. population (Hansell, 1998c). The greatest disparity is between African Americans and white Americans, where the difference goes well beyond what one would expect from economic factors alone (Quick, 1998a).

Computer firms, too, are threatened by the World Wide Web. None more than Microsoft, which stands to see its lucrative monopoly on stand-alone computer software eliminated by the rise of digital computer networks. Since recognizing the threat in 1995, Microsoft has used all of its market power and wealth to see that it not be outflanked on the Web, and that it have a finger (or hand) in the pie of any emerging killer application. Microsoft is a partner with TCI in its digital cable TV operation (Mermigas, 1998d); it also has its own WebTV, connecting TV sets to the Web through telephone lines—and that technology may in the end prove superior. In addition, Microsoft has a play in each of the two routes that are competing to establish high-speed Web access to the consumer personal computer market (Crockett, McWilliams, Jackson, and Elstrom, 1998). Through its 11 percent stake in Comcast, Microsoft has a piece of @Home, the cable modem ISP run by the major cable companies. It also is a partner with Intel, GTE, and the "baby Bell" regional phone companies in the venture to offer high-speed Internet access via telephone lines (Takahashi and Mehta, 1998; Schiesel, 1998b), and has a 10 percent stake in Time Warner's Road Runner cable modem service (Bank and Cauley, 1998).

Microsoft has major horses in virtually every route that could lead to a commercially viable consumer-oriented World Wide Web, including its Internet Explorer Web browser, the Microsoft Network online service, and its joint venture with NBC, the website-cable TV MSNBC (Hamm, Cortese, and Garland, 1998). Most observers expect that a key determinant in who profits will be who wins the struggle to set the standards for streaming audio and video at high speeds across the Internet. A number of companies are competing on these standards, including Real Networks, in which Microsoft has a 10 percent stake (Wheelwright, 1998b). Yet Microsoft has little to fear: as the *New York Times* noted in 1998, the company "now owns all or part of each of these companies" (J. Gleick, 1998: 18).

Microsoft's ravenous appetite for dominating the Web attracted the attention of the U.S. Justice Department, which advanced an antitrust case against it in 1998 and 1999. The first ruling was not in Microsoft's favor, and the ultimate result is very much up in the air (Hof, 1998; Kehoe and Wolfe, 1998). Microsoft built up an impressive lobbying army in 1997 and 1998 to prevent any future problems in Washington, D.C. In classic fashion, it doled out money to any candidates who might have any say over its activities in Congress, Republicans and Democrats alike (Wayne, 1998). And despite Microsoft's having to jump some hurdles with regulators, Paine Webber's chief investment strategist stated in 1998 that Microsoft's strategy would pay off. The company had established a "dominant position across the entire Information Age spectrum," he noted, making Microsoft "the leading beneficiary of convergence" (Mermigas, 1998b: 18).

But the really important corporate activity, as the Microsoft example suggests, is not understood by looking at firms in isolation, or even at sectors as a whole, but rather by looking at the interaction of firms with those of other sectors. Although digital convergence is only just beginning, and there remain important distinctions among computer, telecommunications, and media companies, a striking business convergence has emerged due to the Web. This takes the forms of mergers and acquisitions, equity joint ventures with two or more partners on specific projects, and long-term exclusive strategic alliances between two firms. On the one hand, this convergence is due to the desire to limit risk by linking up with potential competitors or swallowing them. Following the logic of Richard Nixon's memorable adage, it is better to have your enemy

inside pissing out rather than outside pissing in. On the other hand, this convergence is explained by the inability of a telecommunications, computer, or media firm to provide a comprehensive Web service.

So ironically, the most striking feature of digital communication may well be not that it has opened up competition in communication markets, but that it has made it vastly easier, attractive, and necessary for firms to consolidate and strike alliances across the media, telecommunications, and computer sectors. In the late 1990s there were a series of mergers between large telecommunications and computer equipment companies, due to the growth of the Internet (Kehoe, 1998b). Almost all the media giants have entered into joint ventures or strategic alliances with the largest telecommunications and software firms. Time Warner is connected to several of the U.S. regional (Bell) telephone giants, as well as to AT&T and Oracle; it has a major joint venture with U.S. West. Disney, likewise, is connected to several major U.S. telecommunications companies, as well as to America Online. News Corp. is partially owned by MCI WorldCom and has a joint venture with British Telecom.[4] The media firms most directly implicated in this convergence are the cable companies, since their wires are arguably the best suited of the existing choices. As noted above, Comcast is partially owned by Microsoft, while Microsoft cofounder Paul Allen purchased Marcus Cable in 1998, but the truly seminal deal was AT&T's $48 billion purchase of cable giant TCI in 1998. The key to the deal was the linking of TCI's wires to the home with AT&T's trunkline fiber-optic system. The point will be to offer "one-stop shopping" to home consumers of local and long-distance telephony, cable television, and high-speed Internet access via cable modems (Mermigas, 1998a; Goldblatt, 1998). Through TCI's Liberty Media, AT&T will now have interests in a large stable of media assets. Criticism of the deal is mostly that it is premature, not improper.

Business analysts expect more mergers among phone, cable, and media companies, a "scramble to control the information pipeline into people's homes." "One way or another," Merrill Lynch's media analyst stated in 1998, cable companies "are going to be affiliated with phone companies. There's going to be consolidation in this industry" (Pope, 1998: B1). In due course the global media oligopoly may become a much broader global communication oligopoly, dominated by a small number of massive conglomerates with a myriad of joint ventures linking all the players to each other. In the battle between the World Wide Web's

ballyhooed "decentralizing" bias and the market's tendency toward concentration, the market is winning.

But where, exactly, are the killer applications to justify the expense of some of these acquisitions and joint ventures? By the end of the 1990s the market began to crystallize around two commercial Internet applications. The most important is electronic commerce, using the World Wide Web to buy and sell products. In addition to being interactive, the Web permits marketers to generate a superior profile of a user's past purchases and interests through examining the "cookie" file in a user's Web browser, among other things (Quick, 1998b). At the low end, one 1998 study predicts that U.S. and European spending online will reach $16 billion by 2002 (Hollinger, 1998). Using broader criteria, other studies by private groups and the U.S. government forecast electronic commerce at a whopping $300 billion by 2002 (Green, Cortese, Judge, and Hof, 1998b, 1998a). By all accounts electronic commerce is becoming the future of retailing and commerce, and the U.S. government calls it the foundation of the "emerging digital economy" (Ingersoll, 1998: A3). It seems clearly a historic world phenomenon, lacking only improvements in Internet security before it becomes the standard for commerce (Maddox, 1998a). And as electronic commerce becomes the rule, it will push those not online to get connected.

Yet how do the communications giants benefit from electronic commerce, unless they sell their own products? After all, aren't these transactions simply between buyer and seller? This leads to the second "killer application" for the World Wide Web: portals. Portals refer to Internet services that people "use to start their treks through cyberspace." They bring order to the Web experience. More than browser software or the standard ISP, portals organize the entire Web experience and provide a "search" mechanism to bring Web material to users as effortlessly as possible. If successful, a portal can provide a "home base" for an Internet user, which he need never leave. "Portals are transforming the internet from a chaotic collection of thousands of websites into something more manageable and familiar for consumers and investors," the *Financial Times* notes, "by capturing large audiences and establishing themselves as the primary internet 'channels'" (Parkes and Kehoe, 1998: 7). "The search engines have become to the World Wide Web what Windows is to the computer desktop," a technology investment banker stated in 1998. Even if portals never reach that lofty perch, something like them looks

to be the immediate direction for the Web. (Already, the battle for dominating the portal market for digital television—that is, providing the channel guide that will serve as the first home page for viewers—has come down to a slugfest between TCI and News Corp. on one side and a firm allied with NBC and Microsoft on the other [Littleton, 1998: 21]).

The archetype of the portal is America Online (AOL), an ISP that did $2.5 billion in business in 1998. AOL provides an "Internet on training wheels," with e-mail, chat rooms, and banks of operators to answer any questions users might have. With eleven million subscribers, AOL accounts for 40 percent of all online traffic, and 60 percent of home use (Gunther, 1998: 69–80). Fully 80 percent of AOL users never venture beyond AOL's sites ("Ma Bell Convenience Store," 1998). AOL has also shown the way to Web riches, and not only through the monthly access fees it charges its subscribers. In addition, AOL is "drawing advertisers, who sense a mass market taking shape" (Green, Hof, and Judge, 1998: 162). Even more important, it uses its hold on such a huge section of the Web population to extract fees from firms that want to do commerce on AOL (Snyder, 1998a). In just one of scores of deals, for example, the company will receive $12 million plus a share of revenues over four years for giving The Fragrance Center a prominent display on AOL (Lewis, Waters, and Kehoe, 1998). Nor is AOL alone; other providers like Excite! and Yahoo attract massive audiences as well, and each of them is trying to offer full service similar to that provided by AOL (Green, Hof, and Judge, 1998). This ratchets up the cost of selling wares electronically, with all that that suggests about how competitive digital capitalism is going to be. "Launching an E-commerce site without a portal partner," one investment analyst noted, "is like opening a retail store in the desert. Sure, it's cheap, but does anybody stop there?" (Gurley, 1998: 226).

AT&T, through @Home, intends to take dead aim at the portal market. "The telcos and cable companies are coming after AOL's customers," a Forrester Research analyst stated (Gunther, 1998: 80). AT&T executives have stated that it does not want @Home to be a traditional ISP, offering "dumb-pipes" that others like AOL and Yahoo use to get rich (B. Warner, 1998: 21). "It is clear," the *New York Times* wrote, "that whoever controls the front door that people use to start their Internet surfing—a "portal" in industry jargon—will control the biggest share of advertising and shopping revenues" (Hansell, 1998d: C4). In 1998, Microsoft introduced "start.com," a portal that would provide personalized data collection,

web-searching, and email for customers (Lohr, 1998b; Swisher, 1998). This might prove to be Microsoft's best bet in becoming the web's gate-keeper (Sacharow, 1998e). What is clear is that telecommunications, media, and computer firms each have something to contribute to a viable portal, so many more mergers and acquisitions will take place before the market stabilizes. Analysts forecast a "long and brutal war" over control of the portal industry, with estimates for the final number of viable firms ranging from two or three at the low end to four or five at the high end (Hansell, 1998a: C3).

THE WORLD WIDE WEB AND THE MEDIA GIANTS

Media firms and media industries are directly involved in both electronic commerce and the establishment of viable commercial portals. Yet these are best regarded as parts of a broader series of moves, in addition to digital television, made by media firms to extend their empires to cyber-space. "For traditional media companies," the *New York Times* correctly notes, "the digital age poses genuine danger" (Landler, 1998: 1). The great fear for the media firms is that the Web will breed a new generation of commercial competitors who take advantage of the medium's relatively minuscule production and distribution costs. And its greatest fear is that the broadband Web will lead to an entirely new media regime that makes the corporate media giants irrelevant and obsolete. It remains to be seen exactly where the Web and/or any other digital communication network will fit into the global media landscape ten or twenty years down the road. As Time Warner CEO Gerald Levin has put it, it is "not clear where you make money on it" (Landler, 1998: 9); but even if the Web takes a long time to develop as a commercial medium, it is already taking up some of the time that people formerly devoted to traditional media (Richtel, 1998). Media firms have responded accordingly, leaving nothing to chance; since the early 1990s they have been establishing an online pres-ence so that as the Internet develops, they will not get boxed out of the digital system.

Most of the Web activities of the traditional media firms have been money losers, and some have been outright disasters. Time Warner's Pathfinder website, for example, began in 1994 with visions of conquer-ing the Web, only to produce a "black hole" for the firm's balance sheet (Wolff, 1998: 16). Likewise, the New Century Network, a website con-sisting of 140 newspapers run by nine of the largest newspaper chains

was such a fiasco that it was shut down in 1998 (Dugan, 1998). But none of the media firms has lost its resolve to be a factor in, or even to dominate, cyberspace. As one media executive put it, in Internet business, "losses appear to be the key to the future" (Wolff, 1998: 18). This is one of the distinguishing characteristics of media firms as they approach the World Wide Web in comparison to entrepreneurs who want to use the Web to become media content providers: the media firms have a very long time frame in mind, and very deep pockets; they simply cannot afford to abandon ship.

By the end of the 1990s, all major media have significant Web activities. The media firms use their websites, at the very least, to stimulate interest in the traditional media fare. This is seen as a relatively inexpensive way to expand sales ("Times Web Site Ends Fee for Foreign Users," 1998). Some media firms duplicate their traditional publications or even broadcast their radio and television signals over the Net—accompanied by the commercials, of course (Wheelwright, 1998a; Tedesco, 1998b). The newspaper industry has rebounded from the New Century Network debacle, and has a number of sites designed to capture classified advertising dollars as they go online (Barron, 1998; Sacharow, 1998a; Brooker, 1998), but most media firms are going beyond this. Viacom has extensive websites for its MTV and Nickelodeon cable TV channels, for example, the point of which is to produce "online synergies" ("MTV Emphasizes Online Synergy," 1998; McConville, 1998). These synergies can be found by providing an interactive component and by adding an editorial dimension beyond what is found in traditional fare, but the main way in which websites produce synergies is by offering electronic commerce options for products related to their sites (Jensen, 1998). Several other commercial websites have incorporated Internet shopping directly into their editorial fare. As one media executive notes, Web publishers "have to think like merchandisers" (Snyder, 1998d: 30). Electronic commerce is now seen as a significant revenue stream for media websites; all in all, the similarity between digital television and what is happening on the Web is striking (C. Ross, 1998b).

Indeed, by the end of the 1990s the possibility of new Web content providers emerging to slay the traditional media appears more farfetched than ever before. In 1998 there was a massive shakeout in the online media industry, as smaller players could not remain afloat. Forrester Research estimated that the cost of an "average-content" website

increased threefold to $3.1 million by 1998, and would double again by 2000 (Denton, 1998b). "While the big names are establishing themselves on the Internet," the *Economist* wrote in 1998, "the content sites that have grown organically out of the new medium are suffering" ("Brands Bite Back," 1998: 78). Even a firm with the resources of Microsoft flopped in its attempt to become an online content provider, abolishing its operation in early 1998. "It's a fair comment to say that entertainment on the Internet did not pan out as expected," said a Microsoft executive (Karon, 1998: 3). As telecommunications and computer firms work to develop Web content, they now turn to partnerships with the corporate media giants.

We can now see that those who forecast that the media giants would smash into the World Wide Web "iceberg" exaggerated the power of technology and failed to grasp the manner in which markets actually work. In addition to having deep pockets and a lengthy time, the media giants enjoy five other distinct advantages over those who might intrude into their territory. First, they have digital programming from their other ventures that they can plug into the Web at little extra cost. This in itself is a huge advantage over firms that have to create original content from scratch. Second, to generate an audience, they can and do promote their websites incessantly on their traditional media holdings; thus bringing their audiences to their sites on the Web. By 1998, it was argued that the only way a Web content provider could generate users was by buying advertising time in the media giants' traditional media; otherwise, a website would get lost among the millions of other Web locations. As the editor-in-chief of MSNBC on the Web has put it, linking the website to the existing media activity "is the crux of what we are talking about; it will help set us apart in a crowded market" (J. Brown, 1998: 96). "Offline branding," a trade publication observed, "is also key to generating traffic" (Riedman, 1998a: 18). It is the leading media "brands" that have been the first to charge subscription fees for their Web offerings; indeed, they may be the only firms for which this is even an alternative (Taylor, 1997; Pogrebin, 1998).

Third, as advertising develops on the Web, the media giants are poised to seize most of these revenues. Online advertising amounted to $900 million in 1997, and some expect it to reach $5 billion by the year 2000. It is worth noting that this will still be no more than 3 percent of all U.S. ad spending that year, suggesting again how long a path it will be to an

era of Web dominance. (Maddox, 1998b; Hall, 1998; Green, Hof, and Judge, 1998). The media giants have long and close relationships with the advertising industry, and work closely with them to make Web advertising viable (C. Ross, 1998a; Mand, 1998a, 1998b; Riedman, 1998b). The evidence suggests that in the commercialized Web, advertisers will have increased leverage over content, in the same manner their influence has increased in television in the 1990s ("Web Becomes a Viable Channel," 1997). A common form of Web advertising is "sponsorships," whereby for a flat sum ranging from $100,000 to $1 million annually, "the advertiser, its agency and the host Web network work together to develop advertorials" (O'Connell, 1998: B1, B6). The media giants also have another concrete advantage in their dealings with major advertisers: they can and do arrange to have them agree to do a portion of their business on their Web.

Fourth, as the possessors of the hottest "brands," the media firms have the leverage to get premier location from browser software makers and portals (Orwall, 1997b). Microsoft Internet Explorer offers 250 highlighted channels, the "plum positions" belonging to Disney and Time Warner, and similar arrangements are taking place with Netscape and Pointcast (Bank, 1999: B6; "Microsoft to Feature 250 Content Channels In New Web Browser," 1997, B3). Fifth—and this relates to their deep pockets—the media giants are aggressive investors in start-up Web media companies. Approximately one-half the venture capital for Web content start-up companies comes from established media firms.[5] The Tribune Company, for example, owns stakes in fifteen Web companies, including the portals AOL, Excite!, and the women-targeted iVillage ("Tribune Company," 1998). If some new company shows commercial promise, the media giants will be poised to capitalize upon, not be buried by, that promise.

In this context, the nature of emerging Web content makes sense. "The expansion in channel capacity seems to promise a sumptuous groaning board," TV critic Les Brown wrote, "but in reality it's just going to be a lot more of the same hamburger (L. Brown, 1998: 10). By the end of the 1990s the World Wide Web was seen as offering media firms "new synergy," whereby media firms offered enhanced websites based on their traditional media brands chock full of commercial applications such as electronic commerce (Caruso, 1998: C3). The most popular areas for Web content are similar to those of the traditional commercial media, and, for

the reasons just mentioned, they are dominated by the usual corporate suspects. Viacom's MTV is squaring off with GE's NBC, AT&T's TCI, and *Rolling Stone* to, as one of them put it, "own the mind share for music." Each website is "slavishly reporting recording industry news and gossip," all to become at least one of the "default destinations for people interested in music on the Web." The stakes are high: Forrester Research estimates that online music sales, concert ticket sales, and music-related merchandise sales could reach $2.8 billion by 2002 (Reilly, 1998: B1).

The greatest war for market share is with regard to sports websites, where Disney's ESPN, News Corp.'s Fox, GE and Microsoft's MSNBC, Time Warner's CNNSI, and CBS's Sports Line are in pitched battle. Sports are seen as the key to media growth on the Web; advertisers, for one, understand the market and want to reach it. In addition, sports websites are beginning to generate the huge audiences that advertisers like (Grover, 1998). To compete for the Web sports market, it is mandatory to have a major television network that can constantly promote the website. One Forrester Research survey found that 50 percent of respondents visited a sports website as a direct result of its being mentioned during a sports broadcast. Indeed, 33 percent said they visited a Web sports site while watching a sports event on TV (Snyder, 1998c). The media giants also routinely bring their largest advertisers to their sports websites as part of package deals between advertisers and the firm's television properties (Snyder, 1998b). Media giants can also use their resources to purchase exclusive Web rights from major sports leagues, as Disney has with the NFL (Tedesco, 1998c). And, as with music sites, sports offer all sorts of electronic commerce possibilities (Gellatly, 1998).

We might want to ponder what all of this means for the nature of journalism on the Web. This is really a fundamental issue; if the Web fails to produce a higher caliber of journalism and stimulate public understanding and activity, the claim that it is a boon for democracy is severely weakened. Many have chronicled the deplorable state of commercial journalism at the hands of the media giants.[6] There is little reason to expect a journalistic renaissance online. At present the trend for online journalism is to accentuate the worst synergistic and profit-hungry attributes of commercial journalism, with its emphasis on trivia, celebrities, and consumer news. One observer characterized the news offerings on AOL, drawn from all the commercial media giants, as less a "marketplace of ideas" than "a shopping mall of notions" (Solomon, 1998).

This does not mean that there are no considerable advantages or differences between the emerging digital world and what preceded it. Even if the Web becomes primarily a commercial medium for electronic commerce, e-mail, and commercial news and entertainment fare, it will also be a haven for all sorts of interactive activities that never existed in the past. In particular, the Web's openness permits a plethora of voices to speak and be heard worldwide at relatively minimal expense. This is indeed a communications revolution, and one that is being taken advantage of by countless social and political organizations that hereto-fore were marginalized (Quick, 1997). In 1998, for example, the global and largely secretive negotiations for a Multilateral Agreement on Investment (MAI) were undercut when a flurry of Web communication created a groundswell of popular opposition. The MAI was barely cov-ered in the commercial media, and to the extent that it was the cover-age was favorable to a global bill of rights for investors and corporations (N. Chomsky, 1998). Yet this point should not be exaggerated. As a rule, journalism is not something that can be undertaken piecemeal by ama-teurs working in their spare time. It is best done by people who make a living at it, and who have training, experience, and resources. Jour-nalism also requires institutional support (from commercial and gov-ernmental attack) to survive and prosper. Corporate media giants have failed miserably to provide a viable journalism, and as they dominate journalism online there is no reason to expect anything different. In this context, it should be no surprise that the leading product of Web jour-nalism is none other than Matt Drudge, who, as *The Economist* puts it, "spares himself the drudgery of fact-checking" ("The Press in Spin Cycle," 1998: 35).

Another way to grasp the corporate media approach to cyberspace is to look at the activities of the two largest media firms, Time Warner and Disney. Time Warner produces nearly 200 websites, all of which are designed to provide what it terms an "advertiser-friendly environment," and it aggressively promotes its websites to its audiences through its existing media (Landler, 1998: 9; Freeman, 1998). Its CNN website is now available in Swedish, with other languages to follow (Jakobsen, 1997; Galetto, 1997). The company uses its websites to go after the youth market, to attract sports fans, and to provide entertainment content sim-ilar to that of its "old" media (Griffith, 1998; Shaw, 1997). It established a major website focused on 1998 World Cup soccer in order to attract

global attention to its Web activities (Elliott, 1998). The success of the World Cup website led Time Warner to "go ahead with more ad-supported non-U.S. Internet projects." As a Time Warner executive stated, "We've had hits originating from 92 countries with their own Internet suffixes.... We now want to take things we learned from this and move on" (Koranteng, 1998: 20). Also in 1998, Time Warner began to develop entertainment content explicitly geared for the Web, in anticipation of a broadband future (Maddox, 1998c); the company is bringing advertisers aboard with long-term contracts and giving them equity interest in some projects (Sharkey, 1997). Its most developed relationship with advertisers is the ParentTime website venture it has with Procter and Gamble (Riedman, 1997).

Disney's vision of the digital future also sees a major role for advertising. "With a click of a remote-control button," ABC president Preston Padden enthused in 1997, "customers will be able to tell us if they want a free sample of a new headache remedy or wish to test-drive a new car" (Pope, 1998: B5). Disney has been as aggressive in cyberspace as Time Warner and the other media giants have; in 1997, as part of a "blitz by Disney to establish Internet beachheads for many of its products," it launched a subscription site for its Daily Blast children's website, available exclusively on the Microsoft Network (Orwall, 1997a: B4). In 1998 Disney announced that it was extending its conception of advertising to see that Web commerce was more directly "integrated into Disney's site." Its first major deal was with Barnes and Noble, granting the bookseller exclusive right to sell books across all Disney websites. Disney not only gets a percentage of sales, but it also gets free promotion of its wares in Barnes and Noble stores and on the Barnes and Noble website. According to Disney, the two sites that offered the most promise for commercial synergy were its ESPN Internet Ventures and ABCNews.com (Sacharow, 1998b: 22). Disney's ultimate online aim, as the president of Disney's Starwave website producer stated, is "to create the destination which contains everything someone could want.... It's the brand power that we have" (Sacharow, 1997: 48).

But establishing hegemony over any new media rivals on the Web still does not mean that cyberspace will prove particularly lucrative; one could argue it proves the opposite. Time Warner, for example, was exultant that it sold enough online advertising to cover nearly 50 percent of its online unit's budget for 1998. For a small start-up venture, this would

spell death (Freeman, 1998). This is where we return to our point of departure for this section, to electronic commerce and portals, the two prospective killer applications on the Web. What is the relationship of the media firms to these two phenomena?

With regard to electronic commerce, media firms stand to be major players because a significant amount of what is being sold are media products. It also casts the future of traditional media retailers—bookstores, music stores, video rental stores—in a shadowy light. The way was shown by the rapid emergence of Amazon.com, the online bookseller; its market value in 1998 was greater than the combined market values of Barnes and Noble and Borders, the two chains that dominate U.S. bookselling (Karlgaard, 1998). Selling music online is by all accounts expected to be one of the next great arenas for electronic commerce. In 1998, online music sales totaled $87 million; in 2005 they are projected to reach some $4 billion (Rawsthorn, 1998c). The key factor, from the industry's perspective, is to work on laws and technologies to prevent copyright infringement (Chervokas, 1998; Bulkeley, 1998b). By 2005 or so, people will have the music downloaded directly to their computers, rather than mailed to their home, which should increase sales exponentially (Rawsthorn, 1998b). Before selling out to Seagram in 1998, music superpower PolyGram established a board-level panel to assess how the Web was changing the essential nature of selling music (Goldsmith, 1998).

Selling music online will probably be the strongest direct threat to an existing media industry. The market power of the five firms that dominate global music is based largely on their extensive distribution networks; with electronic distribution those networks cease to matter. The production of music in and of itself is not a particularly expensive undertaking. On the surface, one might ask what function the music companies fulfill as distribution goes online (Pareles, 1998). (When bandwidth expands, in a decade or so, and movies can be distributed directly online as well, the media giants will face less threat there because the capital costs of filmmaking are significantly higher, and their distribution networks will remain important because the role of big screen theater exhibition should not change.) The challenge for the music giants—Bertelsmann, Sony, Seagram, Time Warner, and EMI—will be to parlay their existing market strength, during the next decade or so while they still have it, into online market power. They are already in negotiation with Internet service

providers and portals to grease the wheels for selling their wares in a privileged manner online (Rawsthorn, 1998a). They combine this with their large promotional budgets to try to establish barriers to entry that can survive the World Wide Web (Siklos, 1998). The big five might be able to use these factors to keep start-ups at bay, but media giants like Disney, News Corp., and Viacom—with their own significant market power online and promotional budgets—should find themselves in a position to expand their music activities if they wish to do so.

Some media giants have incorporated electronic commerce directly into the heart of their planning for the future. GE's NBC, following the trail it is blazing in television, has established Giftseeker, an online shopping website. NBC will incorporate Giftseeker directly into its television advertising sales, so that clients will integrate their NBC advertising with Giftseeker exposure (C. Ross, 1998c). Bertelsmann and Sony, the third- and sixth-largest global media firms, respectively, are not only wed to electronic commerce, but they have downplayed owning digital television channels and systems, making the development of the Web a main strategic focus (Studemann, 1997). Sony, for example, is a major investor in NextLevel, the firm that already dominates the hardware market for the crucial digital TV set-top boxes (Calley, 1998). Sony is looking to finally capitalize upon synergies between its consumer electronic activities and its media holdings; it hopes to build the home-entertainment systems that are ideal for downloading Sony music, movies, and games (Kunii, Brull, Burrows, and Baig, 1998). Bertelsmann plans to become the leading global Web retailer of music and books (Sacharow, 1998d). One Bertelsmann publishing executive stated, "Our goal is, quite simply, to eventually offer online all books, from all publishers, in all languages" (Nix, 1998: 7).

It is with portals that the media giants are making the greatest inroads. Portals, in effect, are pretty much media companies, and that is how they see themselves. "Any media company is leveraging their relationship with their audience. Period. End of discussion," an AOL executive said. "You build the audience, you figure out how to extract value. . . . We have a very big ability to control the flow of our audience" (Gunther, 1998: 79–80). GE's NBC led the media foray into portals with its purchase of Snap and partial interest in Snap creator CNET in June 1988 (Hansell, 1998b). Disney followed the NBC deal almost immediately by purchasing 43 percent of the portal InfoSeek with an option to take controlling interest. The head of Disney's Internet Group called the deal "mission-

critical" to Disney's future growth (Parkes and Kehoe, 1998: 7). "The game is to end up with something bigger and better than AOL," said an ABC executive (Tedesco, 1998a: 15). Observers expect the other media giants to purchase their own portals if they are not turned off by the high prices. The remaining independent portals are eager either to get purchased by media giants or to work closely with them (Mermigas, 1998c; Scism and Swisher, 1998). "The Internet media business," the *New York Times* wrote, "is expected to follow the pattern of cable television, where entrepreneurs created CNN, ESPN and MTV and were later bought out by Time Warner Inc., Disney and Viacom Inc. respectively" (Lohr, 1998a: A11). Whether or not media giants come to own portals outright, they almost certainly will be major players in all of them.

It may turn out, as a few Web experts suggest, that portals will prove to have been a flash in the pan (Sacharow, 1998c). As the president of InfoSeek has put it, "The Internet's still in the Stone Age" (Tedesco, 1998a: 15). Yet however it develops, the following comment from the president of Time, Inc. seems fairly accurate: "I believe the electronic revolution is simply one new form of communications that will find its place in the food chain of communications and will not displace or replace anything that already exists, just as television did not replace radio, just as cable did not replace network television, just as the VCR did not replace the movie theatres" (Snoddy, 1997b: 7). The evidence so far suggests that media giants will be able to draw the Web into their existing empires. While the Web is in many ways revolutionizing the way we lead our lives, it is a revolution that does not appear to include changing the identity and nature of those in power.

CONCLUSION

Based on current trends, this much can be concluded about the World Wide Web: despite its much-ballyhooed "openness" to the extent that it becomes a viable mass medium, it will likely be dominated by the usual corporate suspects. Certainly a few new commercial content players will emerge, but the evidence suggests that the content of the digital communications world will appear quite similar to that of the predigital commercial media world (Bulkeley, 1998a). In some ways the Web has even extended commercial synergies and the role of advertising and selling writ large to new dimensions. This does not mean that the World Wide Web will not be a major part in reconfiguring the way we lead our lives;

it almost certainly will. Some aspects of these changes will probably be beneficial whereas others may be detrimental.

Nor does this mean that there will not be a vibrant, exciting, and important noncommercial citizen sector in cyberspace open to all who veer off the beaten path. For activists of all political stripes, the Web increasingly plays a central role in their organizing and educational activities. But we should not extrapolate from this sector that this is the overriding trajectory of cyberspace; it isn't. The capacity to establish websites is not the same as the capacity to dominate a culture or a society. In a less dubious political environment, the Web could be put to far greater democratic use than it is or likely will be in the foreseeable future. But the key point is simply that those who think that technology can produce a viable democratic public sphere by itself where policy has failed to do so are deluding themselves. And the dominant forces in cyberspace are producing the exact type of depoliticized culture that some Web utopians claimed that technology would slay. Indeed, a main function of noncommercial Web activities in the coming years may well be ideological: if one doesn't like what is predominantly available, the argument will go, she should shut up and start her own website or visit any one of the millions of obscure sites. It is not a political issue.

Aside from the notion of Web content per se, the notion that the Web is a democratic medium—that it will remain or become available to the public on anything close to egalitarian terms—seems dubious at best. A market-driven digital communications system seems just as likely to widen class divisions as it is to narrow them. In the eighteenth century, Thomas Paine wrote, "The contrast of affluence and wretchedness continually meeting and offending the eye, is like dead and living bodies chained together." In the digital age, however, the affluent can increasingly construct a world where the wretched are unchained and out of sight—a communications world similar to the gated residential communities to which so many millions of affluent Americans have fled (Turow, 1997; Parkes, 1997). A viable democracy depends upon minimal social inequality and a sense that an individual's welfare is determined in large part by the welfare of the general community. Unfortunately, the media system, and digital communication in particular—can accentuate the antidemocratic tendencies of the broader political economy (Dahl, 1989; Christiano, 1996).

NOTES

1. For a discussion of the new "wired" house, see Schonfeld (1998).
2. For discussions of the imperative to eliminate competition, see Engler (1995) and Sweezy (1981) especially ch. 2, appendix B, "Competition and Monopoly."
3. See Herman and McChesney (1997), ch. 4.
4. See Herman and McChesney (1997), chs. 3 and 4, and Flaherty (1997).
5. This is drawn from Herman and McChesney (1997), ch. 4.
6. For a discussion see McChesney (1999), chs. 1 and 2.

> FROM: VINCENT MOSCO
>
> SUBJECT: **Webs of Myth and Power**
> Connectivity and the New Computer Technopolis
>
>
>
>
>
>
>
> In spite of considerable talk about the "death of distance"
> and "the end of geography," computer technology appears
> to accentuate the importance of place, both physical and
> virtual. This chapter begins by evaluating the death-of-
> distance arguments and considers their implications for
> nationhood and citizenship, particularly the return to dis-
> cussions of "local" citizenship. It proceeds to examine
> this literature with respect to the technopolis, a major
> component of the Information Society, particularly of its
> transformed geography. It then focuses on how the tech-
> nopolis embodies and reenacts mythic narratives and
> power relations central to the global information econ-
> omy, concentrating on two of the most recent, unique,
> and, for a variety of reasons, important, cases. Primary
> attention is directed to New York City, where the lower
> Manhattan center for cyberware design and Web devel-
> opment, dubbed Silicon Alley, anchors a network of firms
> that extend north to the entertainment, advertising, and
> publishing districts of Midtown. The chapter also
> includes a brief report on research based in the area just
> south of Kuala Lumpur in Malaysia where the govern-
> ment is building what it calls the Multimedia Super Cor-
> ridor. These cases are particularly significant because
> they are among the most prominent examples of how the
> technopolis model is being transformed by the promise
> of cyberspace. Specifically, in their embodiment of both
> the power and the myth of connectivity, they mark an

important new development in the vision of technopolis once pioneered by Silicon Valley.

THE END OF GEOGRAPHY

It is an increasingly popular myth that computer communication ends the notion of geography by completing a revolution in the process of transcending the spatial constraints that historically limited the movement of information. *The Death of Distance* (Cairncross, 1997) is one of many recent books announcing the triumph of technology over place—the annihilation of space with time. The argument is simple: the convergence of computer and communication technologies permits people to meet anywhere at any time, thereby making possible the ubiquitous exchange of information from the simplest two-person exchange to the operation of a multinational conglomerate, with its vast requirements for moving information and ideas rapidly, efficiently, and with close to complete security. In the nineteenth century, spatial barriers meant that news took weeks by packet boat to get from New York to New Orleans. Now, distance is by and large insignificant and—particularly with the arrival of global mobile satellite systems that permit seamless wireless communication between any points on the globe, soon to be completely irrelevant. In an important sense, all space is becoming cyberspace, because communication is migrating there. Yet cyberspace is fundamentally different from geography as we know it because this space is almost fully transparent with respect to communication.

Notwithstanding the occasional nuance in the death-of-distance literature, it is typically a breathlessly overstated argument. In this respect, it follows in a long tradition of writing about technological change—particularly electronic technology, which has been announcing the death of distance for over a century. In the nineteenth century, the railroad would unite Europe as no conqueror ever did; the telegraph would overcome class and racial divisions in America, and electricity would bounce messages off the clouds to isolated villages, which would nevertheless need to cope with the minor irritant of what was charmingly called "celestial advertising." The historian David Nye (1994: 5) convincingly refers to these as visions of the "technological sublime," a literal eruption of feeling that briefly overwhelms reason only to be recontained by it. Better still, as his mentor Leo Marx (1964: 207) put it, "the rhetoric of the technological sublime" involves hymns to progress that rise "like froth on a

tide of exuberant self-regard sweeping over all misgivings, problems, and contradictions." Taken in by this frothy sublime, the death-of-distance advocates have missed significant characteristics of communication that call for a modification of its meaning. Assuming that overcoming distance improves communication, supporters miss the equal tendency of more communication to increase dissonance and intensify conflict. The rail and telegraph brought Europe closer together in war as well as peace. Moreover—and this is particularly significant to the issue at hand—proponents of the end-of-geography idea underestimate the importance of face-to-face contact and of informal networks whose contacts are based partly on and certainly facilitated by geographical propinquity. That is why new webpage designers and software engineers do not locate in South Dakota or Nebraska where the cost of doing business is low and where the telecommunications infrastructure is sufficiently robust to permit teleconnections at the level of most anywhere else on the continent. Instead, they locate in places like lower Manhattan, where the costs of doing business are among the highest on the continent because physical proximity to fellow professionals, potential customers in the advertising and publishing businesses, service providers, and universities are enormously important to their business success. Whereas tele-marketing and mail order computer firms like Gateway—which sees little benefit from such networking and has a lot to gain from low-cost, docile labor—can benefit from locating in the hinterland, professionally based companies, the bedrock of the producer services industry, require more cosmopolitan settings.

We would benefit from a more careful assessment of the march to a world emptied of spatial significance, of a friction-free globalization, because it appears that no theoretical or political position is immune from the tendency to be swept away by all the end-of-geography, globalization talk (O'Brien, 1992). Karl Marx may have started it all with his reference to how capital annihilates space with time (1973: 539). Manuel Castells's and Jeffrey Henderson's (1987: 7) assessment of a world divided between placeless power and powerless places is another way of saying the same thing. From another perspective, James Beniger's book *The Control Revolution* (1986) is noteworthy in this context because it offers what has to be the most extreme version of the "globalization through communication technology" theme. The computer, Beniger maintains, is the logical result of a history of organizing technologies that

we have set against the second law of thermodynamics, the natural dis-organizing tendency physicists call entropy, delaying, though not con-quering, the inevitable heat death of ourselves, the earth, the universe, and everything.[1]

Although it is true that few social scientists have gone as far out on a limb as Beniger, we have to credit him for playing out what is implied in the many visions of geography's end, and of placeless power, of un-bounded capitalism that fill the literature. That is a primary reason why the so-called new geography is so vitally important today. Simply put, the work of people like Doreen Massey (1992), Saskia Sassen (1991), and Sharon Zukin (1995) remind us that capitalism, like the universe, is also lumpy; that space and place matter, as do the relationships among places; and that this conclusion has profound consequences.

In essence there are two major problems with the death-of-distance or end-of-geography perspective. First, it tends to equate distance with geography, asserting, sometimes subtly but often rather bluntly, that over-coming distance constraints diminishes or even eliminates the impor-tance of geography. Yet distance, which measures the time it takes to get from one place to another, is different from geography, which represents the place itself. Hence, it may take less time to move a person or a mes-sage from one place to another. But this does not eliminate or even dimin-ish the importance of place itself because places contain characteristics that matter irrespective of distance. For example, the sheer presence of the advertising industry in New York's Madison Avenue district makes it attractive for webpage designers to locate in Manhattan, notwithstanding their ability to design at a distance in locations with lower rents. Oppor-tunities for physical connectivity, both regular and random, outweigh the benefits of relying primarily on distance-insensitive technologies.

The second major difficulty with the death-of-distance argument is that it tends to see geography solely in physical terms, as material space. Another one of the values of the "new geography" is that it reminds us that place is also a symbolic, social, and cultural construction, a repre-sentation of our imagination of space, as well as of our physical rela-tionship to it (Pile and Thrift, 1996). This means that spaces are valued not only because they constitute communities of dense face-to-face net-works, but also because they are imagined communities, places satu-rated with specific cultural identities that matter because enough people

agree that they matter. New York is not only a community of physical connectivity, it is also an imagined community of cultural connectivity. It is both a physical space where people can connect to make deals but also an imagined space with multiple overlapping identities, today including Silicon Alley. Malaysia is using its Multimedia Super Corridor project to create the physical conditions that would help build its imagined community combining the tropical magic of a lush Asian rain forest with the contemporary vision of the hothouse for testing new forms of friction-free capitalism.

LOCATION, LOCATION, LOCATION

Rather than think about this as the death-of-distance, it is more useful to refer to the *transformation of space* made increasingly salient by the introduction of information and computer technology (ICT). In the sense of physical geography, the use of ICT reconstitutes the spatial map by revalorizing locations and the relations between them. It also reconstitutes what we now call *cyberspace.* Cyberspace is typically conceived of as something new, a product of ICT applications. Yet this formulation perpetuates myths of revolution that suggest that everything now changes with the arrival of this technology, creating a radical rupture in history that diminishes the value of the past because cyberspace provides an entirely new start to time. Notwithstanding the value of such mythic formulations that have received extensive attention, cyberspace is not new, but rather a deepening and extension of those shared communication spaces created over the history of communication technology and accelerating with the telegraph, telephone, and broadcast technologies. ICT applications contribute to reshaping or remapping the contours of cyberspace just as they remap physical geography. Perhaps more important is that these dual transformations interact so that physical geography and cyberspace are mutually constitutive. Hence, while it makes some sense to distinguish analytically between Castells's space of places and space of flows, we should not make too much of this. Physical space is easily understood as the space of places, but it too is a space through which people and objects flow, so it too is a space of flows. Similarly, cyberspace is not just a space through which our electronic transmissions flow; it is also a space of places with identifiable addresses that take on much of the same significance—economically and politically, as well as

socially and culturally—that traditional spaces enjoy. Hence, while it is hard to disagree with Castells's notion that information and communication technologies transform spatial relations, one could argue that they do not do so by combining material resources in powerful places with the immaterial flows of placeless power. Rather, we are experiencing the remapping of the global political economy by the combination of resources and valuable flows in both physical geography and cyberspace.

Raymond Williams came to a similar conclusion when he invoked the concept of *militant particularism,* meaning that solidarities that developed in specific local struggles gave rise to general ideas about what might benefit humanity (Harvey, 1996: 19–45). For Williams (1989), global ideals like the democratization of social, political, and economic life and the creation of vibrant public spaces were hatched in the tumult of concrete conflicts in communities, factories, offices, and homes. It is true, perhaps, that his "long revolution" meant the massive transformation of space and place, but for him particular places continued to matter because they energized the struggles that gave shape to that revolution. Democracy, as well, grows out of a series of particular local struggles. The term *militant particularism* is useful to describe the ways in which the places now called *technopoles* matter, provided that we modify its meaning to incorporate two further dimensions. First, the drive to transform spaces such as the central and lower parts of Manhattan and the drive to level miles of rain forest to create Malaysia's Super Corridor are themselves forms of militant particularism. Supporters of democracy might see them as rather perverse forms of what Williams had in mind, but they are no less militant and no less particularistic than the struggles of the Calton weavers to win basic rights for working people in eighteenth-century Scotland. Second, militant particularism is also a state of mind, an imagined place, no less significant and therefore no less worthy of militant attachment than the dirt, bricks, and mortar that constitute a physical place. The transformation of New York into an imagined Web of multimedia capital, and of Malaysia as an imagined nexus of East and West relies on particular visions of place. So too do the visions of those who oppose these changes because they would destroy the New York of gritty diversity and the Malaysia of tropical rain forest. One of the ways to connect the physical and the imagined is by invoking terms of identity that mutually constitute who we are with who we want to be. Citizenship is a leading candidate for such invocation.

CITIZENSHIP AND CYBERSPACE

It is especially important to invoke citizenship today because much of what we see in the media—as well as in academic accounts of media activity—addresses people, whether located in physical space or cyberspace, as consumers and as audiences. Citizenship elevates human activity beyond the commonly accepted view that the best way—indeed, for some, the only way—to define human activity is by its marketplace value, its worth as a consuming or laboring commodity. The widely accepted view of citizenship is that elevation has also been accompanied by extension. Here it is common to invoke the work of T. H. Marshall (1964) who charted the progress of citizenship in modern Western society, starting with the legal sense of basic rights and protections—for example, *habeas corpus*, due process, the presumption of innocence, and the right of trial by a jury of one's peers. From here, citizenship was extended to encompass political rights, particularly the right to vote and to public assembly. Finally, social citizenship stretches the notion to include the right to employment, housing, health care, and other social welfare benefits.

Analysts of the media and of cyberspace have also invoked citizenship from time to time. The turn to civic journalism and the movements around community networking and public broadcasting suggest an effort to extend media citizenship and resist the all-consuming process of media commodification. Yet the very necessity to specify journalism as *civic*, networking as *community*, and broadcasting as *public* defines the weakness of media citizenship. Civic journalism would have once been redpenciled as a redundant expression. Now it is a hoped-for niche, however weak, in the singularity we know as the market, less evidence of citizenship's extension than of its exhaustion.

These developments lead to the conclusion that even as we welcome the insertion of citizenship into debates about the Information Society we need to critique it. Discussions of citizenship today carry the burden of enlightenment assumptions that progress has deepened and extended citizenship to encompass more people and more facets of social life. Marshall's three steps in the evolution of citizenship comprise just the most celebrated of such visions of linear progress. But there is another view of contemporary citizenship that is not only a hard-earned right fought for and won by wave after wave of popular struggle but also a state-imposed discipline that controls, shapes, and confines that struggle by creating a

set of rules that determine legitimate participation in national state affairs. Moreover, it is a tool of discrimination that permits the state to define who among its people can have that right. This is not to suggest that it is a natural step from *liberté*, *egalité*, and *fraternité* to the Terror: that would amount to a simplistic inversion of Marshall's vision of the progress of citizenship. Rather, citizenship is not just a pure right or an unabashed gain but a social practice defined and redefined in political struggle. This fact was not lost on the Ayatollah Khomeini, who extended full voting and civic participation rights in Iran to anyone over the age of fifteen. What would Marshall think of this?

Moreover, it is not just a question of invoking citizenship, but of determining *which one*. Indeed, there are two interconnected analytic distinctions, one political, the other spatial, that provide different ways of thinking about citizenship. The first is the distinction between citizenship as a bundle of legal rights derived from the sovereign state and citizenship as democratic participation in a community. The former or liberal regime of citizenship is based on a formal, legal tradition and has achieved hegemony, if an increasingly shaky one, in the age of the nation-state. The latter or civic republican version of citizenship is founded on reciprocal social action, on shared social identity and responsibility. Here the sense of citizenship is not derived from a central authority, but from the lived experience of participation and identification, typically founded in a collective interpretation of how that identity came to be established and why active participation is necessary. This is a subaltern form of citizenship, at times tightly linked to the legal form and often counterhegemonic to it (Oldfield, 1990). For example, formal Canadian citizenship has been tightly connected to other forms of social identity, including ethnic and linguistic, through various forms of coercive (invocation of the War Measures Act) and noncoercive (policies of multiculturalism) state action. Yet it is also challenged by the sense of membership in such communities as when francophone Canadians in Quebec resisted the military draft as a form of illegitimate state coercion.

The second distinction is related to the first but foregrounds the spatial dimension. As Riesenberg (1992) notes, the concept of citizenship is not only ambiguous, defining civic virtue in a public arena even as it supports discrimination and exclusion, but the West has experienced two different spatial versions of citizenship. And here is where one can build a bridge to the technopole. Most of the discussion of citizenship is about

the rights and privileges conferred by the nation-state beginning roughly in the aftermath of the French Revolution. Yet discussion of this citizenship does not appear in English until about the eighteenth century, when according to the *Oxford English Dictionary* ("Citizenship," 1989: 249–50), David Hume speaks about how "too great disproportion among the citizens weakens any state."

Riesenberg uncovers another citizenship—that of the city, the community, the region, or the city-state, which is canonically dated with classical Athens. The very first definition of *citizenship,* common in English from the fourteenth century, the *OED* tells us, is "an inhabitant of a city or (often) of a town; esp. one possessing civic rights and privileges, a burgess or freeman of a city" ("Citizenship," 1989: 249). It is this form of citizenship that merits reflection, but certainly not to dust off romantic visions of a classical golden age. G. E. M. de Ste. Croix's work *The Class Struggle in the Ancient Greek World* (1981), with its brilliant assessment of class divisions, slavery, and patriarchy, puts to rest uncritical celebrations of Athenian democracy. There are other reasons for such reflection.

Most of us would agree that in many important economic, social, and cultural arenas, nation-states around the world are in retreat, particularly with respect to those political and social rights that we have come to associate with citizenship. For example, the Canadian government (and, by extension, several provincial governments) are less able than they were twenty or thirty years ago to make economic policy, provide education, deliver health services, support the poor, protect the culture, or provide affordable housing. Canadians are certainly not alone in a position to conclude that the World Trade Organization and the International Monetary Fund have more to do with these matters today. Yet to say that citizenship is not what it used to be is not simply to conclude that it has diminished; it has also been reshaped. Today's national citizenship is more a matter of guaranteeing other things: protection from would-be immigrants, transmitting and adapting a global neoliberal business agenda to the particular circumstances of each nation, and, not the least, giving us national teams to root for in international competitions like the Olympic Games and World Cup soccer. The reshaping of national citizenship and the concerns it raises lead some to return to notions of local citizenship as a genuine alternative. This is not to re-create a liberal regime of formal rights derived from a different central

authority, simply a relocation of citizenship, but to transform the meaning of citizenship into a genuinely democratic practice based on active social participation.

MAGIC PLACES: THE TECHNOPOLES

The technopole is one reason why specific local places are taking on a growing significance in spite of the end-of-geography talk, for the technopole is a specific place that brings together institutions, labor, and finance that generate the basic materials of the information economy. These materials result from various local, national, and, in some cases, international, planning activities by public and private sector organizations to promote systematic technological innovation. The term *technopole* originated in the Japanese government's effort of the 1960s to build a science-based technopole, Tsukuba, about forty miles outside of Tokyo. Most would see Silicon Valley in California as the icon and most successful form of the technopole. In their global survey, Manuel Castells and Peter Hall (1994) refer to two dozen or so technopoles, many eager to emulate the Silicon Valley model.

Japan began this process by recognizing the need to maintain and perhaps even accelerate the productivity gains that its economy enjoyed in the 1950s, based largely on the postwar occupation and direct foreign investment. As the occupation ended and its trappings faded, and as foreign investment moved elsewhere, Japan looked to an alternative. With no advantage in natural resources, it turned to intensive technological development built on the tight coordination of centralized government, corporate and research institutions. Led by agencies like the Ministry of International Trade, companies with such household names as Toyota and Sony helped to organize scientific and technical research and development networks that would bring together diverse professionals in specific locations, thus carrying out basic (often simply the reverse engineering of successful Western products) and applied research and incubating resulting products until they were ready for the export market. Although some of this work took place in isolated regions of the country, the most successful companies were based around Tokyo where they could enjoy proximity to centers of finance capital, other producer and consumer services, and government. The focus on technology and the urban connection gave birth to the *technopole* designation.

There is a link between the original technopole in Japan and Silicon

Valley. First, the latter grew out of a similar protected network, only in the case of Silicon Valley it was the Department of Defense (DOD) that fed military contracts to teams of engineers based in and around Stanford University. With the help of the DOD, teams grew into networks that formed companies that continued to benefit from the protection that a growing military research budget and cold war justification could bring. Japan also provoked the "second coming" of Silicon Valley when its 1980s mastery over mass production of semiconductors—brought about by a highly protected oligopoly and low-wage production—forced Silicon Valley firms into high-end customized production lest they face the loss of global leadership. As Anna Lee Saxenian (1994) and others have documented, the preeminence of Silicon Valley was built upon the success of this transition. Much of the credit goes to the fluid network of associations among professionals who moved from company to company, met in many different informal as well as workplace settings, and cross-fertilized innovations that make up the hardware and software landscape of business and home. Notwithstanding the importance of informal networking, which is frequently pointed out was missing in the more centralized, rigid, and less successful technopole based in the Boston area, insufficient attention is paid to the treatment of labor in Silicon Valley. This includes the "work until burn out" treatment of young computer professionals and the low-wage, often homework-based labor process that provides a low-cost production base at one end of the Silicon Valley food chain.

The most interesting of the newer technopoles draw from the Japanese and Silicon Valley models but, more important, take them a significant step further. These earlier successes built resilient and fluid production networks that brought together diverse knowledge professionals who could manage innovation from idea to market. Newer technopoles integrate these production networks into similarly resilient and fluid *consumption* networks located within the technopole. This chapter proceeds to take up two types of this newer computer technopolis in New York's Silicon Alley and Malaysia's Multimedia Super Corridor.

NEW YORK: FROM BROADWAY TO SILICON ALLEY

New York City has been a global commercial center for the past century. Indeed, its lack of government presence (it was the federal capital from 1785 to 1790 and never a state capital) has been cited as a major

contributor to a risk-taking, endemically self-transformative culture (Bender, 1987). For most of its modern history, New York was the model of a diverse economy, combining specialized manufacturing supporting a large working-class population and a service economy rooted in finance, real estate, and media. Beginning in the 1920s, business leaders, with primary investments in real estate, sought to drive out manufacturing to create more lucrative office space. It was not until the 1960s that New York began to feel the economic consequences of this, as the attraction of lower-wage, nonunion jobs outside the city led to a massive decline in manufacturing and the end of the postwar boom. Along with the precipitous decline in skilled and semiskilled manufacturing jobs that has continued to the present (from one million in the mid-1950s to one quarter million in the mid-1990s), employment in the financial services industry also declined as firms moved to the suburbs and automation cut jobs outright (Fitch, 1993; Mollenkopf and Castells, 1991). By the mid-1970s the city faced bankruptcy. It is now the "global city," with analysts sparing few superlatives to describe what they see as the city's rebirth (Barber, 1996). There is considerable debate about what this rebirth means and about the price paid for it (Passell, 1997), but there is little doubt that the historic centers of the city, the downtown financial district and Midtown's Times Square, have been transformed. The transformation emanates from the development of an integrated network of information and entertainment businesses anchored at the southern end of Manhattan by a high-tech district dubbed Silicon Alley, and, in Times Square, by a number of media conglomerates dominated by the Disney corporation.

Silicon Alley is the technical hub of an agglomeration of New York's media industries connecting advertising, publishing, broadcasting, telecommunications, mass entertainment, contemporary art, and fashion, all concentrated in a collection of overlapping districts from Broad Street at the south end of Manhattan, moving north to the SoHo, Greenwich Village, and Chelsea artistic communities, through the Times Square entertainment district and on up to the publishing houses north of Times Square and the advertising agencies along Madison Avenue (Roche, 1997). Filling office buildings left vacant by financial services firms that shed workers with new technologies or relocation and thus giving a postindustrial economic allure to a city once bankrupt and out of manufacturing alternatives, Silicon Alley embodies a cyber version of

the *phoenix* myth: in this case the city reborn from the ashes of its industrial past (Chen, 1997b). Even so, it also propels a transformation of urban politics and power as corporate-controlled bodies such as business improvement districts remake public spaces into private enclaves and rewrite the rules of policing, civic activity, and public spectacle. All of this takes place in the name of connectivity, in this case referring to the connections among the convergent computer, communications, and cultural sectors in Manhattan and to the market potential of a Web industry built on enhancing electronic connectivity worldwide.

In a short time, Silicon Alley has become a global center for multimedia design and development. According to a 1997 Coopers and Lybrand report, the district anchors a new media industry that employs 56,000 in New York City and 106,000 in the metropolitan area's 5,000 new media firms, making it one of the largest employers of computer communications workers in North America, on a par with Silicon Valley. Annual revenues climbed 56 percent in 1996 to $2.8 billion in the city and 50 percent in the metro area, to $5.7 billion. Full-time jobs in new media now match those in the premier media industries of New York, advertising and print publishing (Coopers and Lybrand, 1997). In addition, Silicon Alley has become a model for the kinds of mobile production that are increasingly common in Web work. Casual workers move in and out benefiting from physical proximity when necessary and return-

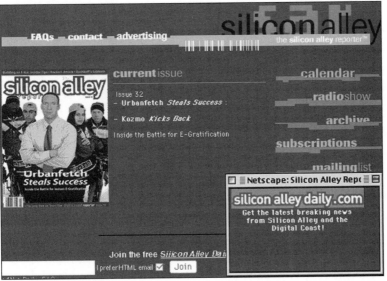

Fig. 2.1. Silicon Alley embodies a cyber version of the *phoenix* myth: in this case the city reborn from the ashes of its industrial past. The Silicon Alley website, http://www.siliconalleyreporter.com/

ing to other office or home sites. In fact, Silicon Alley has pioneered in the short-lease, prebuilt, prewired office, what it calls the "plug 'n' go" system, which allows small businesses and casual workers to move in and plug into physical and cyber networks (Rothstein, 1998). The district itself is expanding in ways that place it in closer proximity to traditional media industries. With rents rising and vacancies declining in the heart of the district, companies are moving north as far as Midtown, west to the Hudson River, and down Broadway through SoHo as far as New York Harbor, where the tax rebates and refurbished buildings are attracting new firms.

Silicon Alley is unique in its integration of media (especially publishing and advertising), the arts (for example, the Tribeca film industry) for attracting talent to multimedia design and production, and telecommunications (for example, the regional Teleport). According to one commentator, "A lot of the style of ... Silicon Alley may be new, but the muscle behind it is not. Established New York industries, especially advertising, publishing, fashion and design ... are now leading much of the expansion of the new technologies" (K. Johnson, 1997). A 1996 Coopers and Lybrand report highlighted the significance of close ties among businesses in these several communities. Forty-three percent of new media companies surveyed worked principally for advertising firms, and 42 percent for print publishing and entertainment firms (Coopers and Lybrand, 1996). By the start of 1997, New York had surpassed all rivals in the number of registered commercial and nonprofit Internet domain sites, having twice as many as its nearest rival, San Francisco, and 4.3 percent share of the entire United States (K. Johnson, 1997).

The advertising firm Saatchi and Saatchi demonstrates a vital way in which this system of commercial connectivity works. Their Silicon Alley Web unit, Darwin Digital, brought together Proctor and Gamble with Time Warner at the address Parenttime.com. The project links Time Warner's child-care magazine division with an integrated advertising package supplied by Proctor and Gamble, all created and run from New York City. Darwin Digital has also helped create a new network for children's games on the Internet with the major sponsorship of General Mills, the Minneapolis-based cereal company, whose creative staff came to New York to produce the site with Darwin (K. Johnson, 1997). Indeed, some of the most successful Silicon Alley firms are exclusively devoted to advertising. For example, the Alley firm AdOne was in 1998 the largest

online classified network in the United States, with over five hundred local, regional, and national partner publications combining a print readership of 40 million. Advertising has also attracted venture capital to the district, as Silicon Alley has generally, as well—an unusual occurrence for this region. Investment in New York's new media industry grew from $167 million in 1996 to $240 million one year later, boosting the state of New York to fourth behind the high-tech states of California, New Jersey, and Texas. The biggest deals, however, are in advertising. Whereas investments of around $500,000 are common for Silicon Alley's typically small Web design firms, in 1997 the Silicon Alley Internet advertising firm Double Click, Inc. was on the receiving end of a $40 million deal with the Silicon Valley-based venture firm Weiss, Peck, and Greer (Ravo, 1998). Online advertiser 24/7 Media Inc. leaped into the competition with Double Click with a $10 million venture deal. Finally, another online advertiser, Agency.com, was voted the top Silicon Alley firm in 1997 by the New York business zine @*ny*. New York expects continued growth in the new media sector because of its prominence of top advertising agencies and close ties to Wall Street. Following its historic role as a world capital of commerce, it will concentrate on electronic commerce, which is expected to become the biggest revenue maker as the Internet develops.

Further uptown from Silicon Alley but drawing extensively from it are a series of projects that are similarly transformative. The Times Square district, historically a center of working-class entertainment but more recently an area held up for media mockery because of its reputation for crime, now includes in the neighborhood no less an icon of purity than the Disney Corporation. Anchored in the New Amsterdam Theater, which it "purchased" for $36 million—mainly city and state loans at 3 percent interest—Disney has brought wholesome entertainment like its blockbuster musicals *Beauty and the Beast* and *The Lion King* to Broadway. Additional new theaters, major hotel chains, new media headquarters, and big retailers like the Gap have followed Disney (Goldberger, 1996a; Hiassen, 1998; Nelson, 1995; Rose, 1996).

CREATIO EX NIHILO IN MALAYSIA

If New York is viewed as the Information Age phoenix rising from the ashes of manufacturing decline, then Malaysia is the magic land where palm-oil plantations become Multimedia Super Corridors almost over-

night. The Multimedia Super Corridor (MSC) enacts an alternative but related myth, *creatio ex nihilo*, as the Malaysian national government creates a completely new environment, built out of what it views as the raw material of four hundred square miles of rain forest and palm oil plantation south of Kuala Lumpur. This increasingly celebrated place is where the Malaysian government proposes to spend between $8 and $15 billion of public and private money to turn this area of rolling countryside, rain forests, and palm-oil plantations into a postindustrial district where multinational corporations will develop and test new software and multimedia products. Malaysia's "nothing" is giving way to two new high-technology cities: Cyberjaya, what one pundit called "an info tech omphalos," and Putrajaya, a new cyberready locus including an administrative capital and a new international airport (Greenwald, 1997; Rizal Razali, 1997; Wysocki, 1997). Today their major highway is a $2 billion fiber network under construction. Yet the plan is that in these cities bureaucrats will serve the public in cyberspace, consumers will shop with smart cards, children will attend virtual schools, professors will lecture electronically at the planned multimedia university, executives will manage through teleconferencing, and patients will be treated through telemedicine. The government has struck deals with many of the world's leading computer communications companies, including Microsoft, IBM, and Nortel, which will establish development sites in the region to test new products and services such as electronic commerce, telemedicine, virtual education, paperless administration, and state-of-the-art electronic surveillance and policing. The companies will enjoy substantial tax freedom, the opportunity to import their own labor and technology, and to export all capital and profit. Malaysia hopes to use this project to jumpstart a stagnant economy and move beyond a low wage platform as the basis for growth.

The implications of purchasing this hoped-for growth by turning its land into the locus for transnational cyberdevelopment projects and its citizens into beta testers for electronic capitalism are profound. Like the Silicon Alley project, the MSC is to be built on two conceptions of connectivity, including the idea that the creation of a dense Web of multinational businesses in a new space can propel national development and the idea that social progress grows out of fully integrating citizens into the electronic Web. The MSC is an effort to stem the erosion in the massive growth that Malaysia experienced based on a labor cost advantage it

enjoyed in computer and telecommunications hardware production. Having lost that advantage to other Asian nations, particularly to Bangladesh, Vietnam, and China, the Malaysian government believes it can pioneer in software and product development. Malaysia proposes nothing short of making a national model out of the city-state Singapore's centrally directed, export-oriented, high-technology approach to development. Indeed, although the MSC is concentrated in one soon-to-be developed region, plans exist to support it with a hardware corridor in the north of Malaysia that would attract national and foreign businesses interested in higher-end production, with more skilled labor than can be found in the lowest wage regions of Asia (Ng, 1997: 23). Malaysia marks an important test of whether the once superfast-growing regions of Asia can continue to grow in the highly competitive area of software engineering and information technology product development. It also bears close scrutiny because Malaysia proposes to retain tight censorship, strong libel laws, and a patriarchal Islamic culture, even as it welcomes foreign multinationals, inviting them to test the full range of new media products on its citizens. Recent developments in global financial and equity markets also mark this as a case to watch because massive declines in currency values, the near collapse of stock prices, and the withdrawal of foreign capital have created huge rifts between Malaysia (joined by Indonesia, Singapore, and Thailand) and "first world" powers that once pointed to these so-called Asian tigers as evidence for the success of traditional modernization schemes (Sanger, 1997).

TECHNOPOLES, GOVERNANCE, AND CITIZENSHIP

An analysis of these cases leads to the inescapable conclusion, which by and large applies across the technopole literature, that there is a great deal of interest in them as economic growth engines, some interest in the technopole as a new form of cultural representation (King, 1996; Zukin, 1995), and practically no interest in their political governance—that is, in addressing technopoles as sites of political power and their residents as citizens. It is not particularly surprising that the research concentrates on the technopole almost exclusively as a site for economic growth. It *is* somewhat surprising that this view is shared by writers on the broadly defined left, by people like Manuel Castells, whose book with Peter Hall provides 275 pages on the phenomenon but nothing on governance (see also Saxenian, 1994). One reason for this support may be that most

technopoles confound free-market purists because they require govern-
ment support and involvement in their planning and development, as
well as connections to local universities. Hence the technopole naturally
attracts those who would find a role for the state, for technology, for the
university, and for more than a small measure of planning in the devel-
opment process.

So with the exception of the occasional critic like Saskia Sassen
(1991), even the Left has proven to be as drawn to the technopole as the
high-tech companies that reside there. This means that critical assess-
ments based on a concern for governance and citizenship are muted, with
the primary concern leveled—as the work of Castells and Hall—as well
as Saxenian demonstrates—at the failure to deliver on economic
promises, an outcome attributed to fumbling state, or large corporate,
bureaucracies.

This is particularly unfortunate because many of the technopoles,
including the New York and Malaysia cases, are not simply test beds for
high-tech products; they also test new forms of governance, and of social
and cultural experience with significant implications for citizenship.
Because the new technopoles are, unlike Silicon Valley, sites for build-
ing connectivity among producers as well as between producers and con-
sumers, they hold considerable significance for cultural analysis.

NEW YORK: CITIZENSHIP IN A PRIVATE MONOCULTURE

The transformation of New York is not simply an economic development
project emanating from the convergence of postindustrial information
and entertainment businesses in one densely networked space; it is also
a political project that results from the exercise of power and transforms
governance as surely as it transforms entertainment attractions in Times
Square. Additionally, this transformation contains enormous social and
cultural implications because changes in urban political economy also
change communities, their human composition, and the quality of the
lives lived within them.

Along with the creation of a new media district in New York, we find
a significant transformation in governance with the formation of private
sector run business improvement districts (BIDs) that have been put in
charge of a wide range of services. They police the streets, manage the
parks, haul away trash, and remove the homeless, all with private, mainly
nonunion, low-wage workers, including former welfare recipients who

have recently been required to find jobs. In addition to this, they have the authority to issue bonds (much to the consternation of city officials, who fear both the competition in credit markets and the consequences of a BID default) and pay their management well: the head of one earns over twice the salary of New York's mayor. Moreover, the BID that encompasses Silicon Alley has managed to divert public and private funds to build some of the only new public spaces in New York, primarily to service upscale, high-tech workers and their families. So along with high-technology comes the privatization of basic services and the reorganization of urban government and civic spaces. One-time public places like historic Bryant Park—adjacent to the New York Public Library and currently now under BID control—now close at night and contain swarms of private security guards (particularly during the many corporate-sponsored events such as fashion shows) who prevent the homeless from entering the park (Birger, 1996; Breskin, 1997; Greenhouse, 1997; Zukin, 1995). As a result, even the *New York Times* editorialized that "in its eagerness to benefit from privatization, the department [of Parks] seems to be allowing businesses to set the agenda" ("The State of New York's Parks," 1998: A18).

The only new park construction in New York City is located in Battery Park City, near Silicon Alley, and is a model of upscale space to attract high-tech and financial sector workers. Even a supportive architectural critique notes, "Sometimes it seems as if Battery Park City has been the *only* patron of public space in New York in these years" (Goldberger, 1996b). Some "showcase" parks like Central Park (sections of which are closed to the public for part of the year but open to companies like Disney, who use it to film commercials) and Bryant Park have been spruced up with private money, while the rest of the city's public space suffers from neglect. In the past decade public funding for parks is down 31 percent and the city is left with 1,700 park employees for 1,400 parks and playgrounds on 27,000 acres (J. Barron, 1998; "The State of New York's Parks," 1998). This is in keeping with the general erosion in the quality of life for New Yorkers who now enjoy the dubious distinction of living in the city with the largest gap between upper- and middle-, and between upper- and lower-income groups in the United States (Perez-Peña, 1997).

For a city widely viewed as the global information center, New York has taken a remarkable number of recent actions that amount to the curtailment of basic information freedoms. For example, in an attempt to

make its sidewalks more tourist friendly, the city government decided to require sidewalk artists to purchase restrictive licenses. Any artists refusing licensing would be kept off the streets. Among the leaders in lobbying for restricting such activity were business improvement district leaders. According to the president of the Times Square BID, "Portrait artists come when the streets are most crowded. These are the times when the streets cannot bear that kind of immobile congestion." And according to the president of the Fifth Avenue BID, artists attract crime: "The relationship is ancillary. The vendors create an atmosphere where pickpockets can flourish" (Li, 1996: sec. 13, p. 1). A group of such postindustrial "refuseniks," aided by the American Civil Liberties Union, sued the city and won a Federal court ruling declaring such licensing unconstitutional. The Department of Parks and Recreation imposed a similar requirement that artists must obtain a permit to display their works in front of one of New York's biggest tourist attractions, the Metropolitan Museum of Art. Claiming that local artists were creating sidewalk congestion, the city tried to remove these vendors. Again, the artists mobilized to resist and the case awaits hearing in court. The city has also attacked the First Amendment rights of street musicians by imposing a $45 daily permit to perform on the street. Following the lead of their fellow artists, the musicians organized protests and won a Federal district court ruling that the fee exceeded standards necessary to regulate a First Amendment–protected activity. Concluding that city streets were not only overrun with artists and musicians, the city decided that there were far too many news vendors and sought to terminate numerous concessions and raise substantially the license fee for all of the remaining. Once again, vendors mobilized and won a lower court ruling that operating a newsstand is a First Amendment activity and that the city was out of bounds in removing concessions and excessive in demanding a substantial increase in fees. The city has not lost every case, and it may win on those that have not exhausted their hearings and appeals. Yet this pattern of activity suggests a coherence between polishing up its high-tech and mainstream media image and eliminating voices that might scuff the shine. Yet there is also a contradiction between the widely shared claim that New York has become the information and media capital of the world and the fact that—if one is to accept the courts' view—the city militantly restricts the information and media rights of its own citizens (Gonzalez, 1997; Sachs, 1998).

Headlines around the world trumpet the new Times Square, but few stories wonder about how it has, as one account puts it, "pushed homeless youths out of their traditional haunts. They now populate a lonelier, and hence more dangerous, diaspora in areas such as Harlem, and are much harder for the nightly patrols of outreach workers to find and help." The city's own Department of Youth and Community Development failed to spend $1 million allocated to it to house homeless young people in 1997 and thereby lost $1.5 million in state matching funds (Rosenberg, 1998: 16). Fewer discuss the failure of Times Square to provide room for any creative alternative, as one cultural entrepreneur learned when, after eighteen months and $100,000 spent to turn an old movie house into a performance space for poets, actors, and musicians, his vision lies on the brink of failure because he cannot afford the rents driven upward with the arrival of Disney. As he concluded, "We became victims of this upscale thing. We're like canaries in the English mines. They brought them down to see if they would live. They now send in the artists, and when the neighborhood goes up, they throw us out" (Gonzalez 1998: B1). Another nearby victim of the "upscale thing" was the primary bookstore selling new and out-of-print books, maps, and vintage photographs showcasing New York City. The New York Bound Bookshop and its neighboring newsstand were eliminated so that the lobby of 50 Rockefeller Plaza could sport a brighter space, a new decorative wall, and a new concierge, whose job early on presumably consisted of telling people that the bookstore had disappeared (Chen, 1997a: B7).[2]

MALAYSIA: CITIZENSHIP MEANS BETA TESTING FOR MULTINATIONALS

Hoping to leap into its own version of an Information Age monoculture, the Malaysian government has signed agreements with several of the world's major computer and telecommunications firms under which the companies agree to set up shop in the new technopole and in return receive a ten-year tax holiday and complete freedom to bring in their own workforce and capital and to export all products developed in the zone.

These firms will be permitted to test new products in seven flagship areas, which Malaysia's Multimedia Development Corporation defines as follows:

1. Electronic Government: An opportunity to reinvent government.
2. Multi-Purpose "Smart" Card: Tool for the information age.

3. Smart Schools: Education for a smart society.
4. Telemedicine: A new paradigm in healthcare provision.
5. R&D Cluster: Next-generation multimedia technologies.
6. World-wide Manufacturing Web: Building Best Practices in High-Tech Operations.
7. Borderless Marketing: New Frontiers in Commerce (Multimedia Development Corporation, 1997b).

Putrajaya is to be the new national administrative capital, operating as fully as possible in an electronic environment, including compulsory smart cards for each resident (Multimedia Development Corporation, 1997a). One cannot help but conclude that this gives a whole new meaning to the responsibility of citizenship—namely, beta testing new products for transnational computer companies. Shall we call *this* virtual citizenship?

Cyberjaya, the new residential city, is a "hyper" version of the corporate suburb permitting near full corporate ownership, control, and governance. This view is reinforced by legislative changes planned to test new forms of legal citizenship with the Corridor. According to current plans, municipal governance will become the responsibility of the private Multimedia Development Corporation, with its own corporate rules and tax structure, its own form of citizenship, and the power to enact new laws. Tenants will not enjoy traditional legal occupancy rights but will have to abide by a ten-point bill of guarantees overseen by the corporation. Heading the corporation is an international advisory panel chaired by the prime minister. Its thirty-two members are all from private business (except for one professor of business) and include Microsoft's Bill Gates; the heads of Netscape, Sun, Compaq Computer, British Telecom, Sony, NTT, and Siemens; and others comprising a who's who of corporate cyberspace.

CONCLUSION: SPACE FOR CITIZENSHIP?

Notwithstanding all the talk about the death-of-distance, research demonstrates that, whether defined in geographical or electronic terms, place matters. Rather than annihilating space with time, the application of communication and information technologies transforms space, including both the space of places and of flows. This chapter has addressed one leading edge example of transformed spaces; the technopole or high-tech

center. Drawing on recent exemplars, it examined the evolution of technopoles from a largely productivist space to one based on connectivity between producers and consumers, both collective and individual. The New York and Malaysia examples are important because they represent both an expansion and a tightening of the technopole net and because they attract widespread attention by enacting myths of birth and rebirth that provide a particularly magical allure to the space these technopoles occupy.

These are also important cases because they raise fundamental questions that have not received much attention in a largely technicist and economistic literature about the nature of governance and citizenship in the technopole. Both New York City and Kuala Lumpur are pioneering in redefining the control of space by privatizing and internationalizing it in new and more penetrating ways. They are providing striking examples of just what "local" citizenship may come to mean in high-technology places. It is indeed hard to find in the technopoles of the world any genuine source of inspiration for fresh thinking about citizenship at the local level, for ways to return to its original meaning of citizenship in the city or the community.

This reflection on the local raises important issues about the metaphor of connectivity that is so prominent in contemporary discourse. Connectivity does not mean that distance is dying or that geography is at an end. Rather, the architecture of connectivity accentuates the importance of certain nodes in its global networks making particular spaces, such as the Silicon Alley/Midtown Manhattan nexus and the Kuala Lumpur/Cyberjaya/Putrajaya nexus in Malaysia. Additionally, it offers powerful tools to deepen and extend existing practices that tighten certain power relations. The Silicon Alley/Madison Avenue connection forms a central node in the global advertising business, serving as the springboard for the commercialization of the World Wide Web. Connectivity also justifies transformations in governance that accelerate the privatization of public services and, as the evidence from Malaysia attests, the deepening of a surveillance society. Connectivity is a powerful metaphor, indeed a time and space transcending myth. It is all the more powerful because the comforting image of a shrinking globe of connected peoples masks fundamental transformations—both globally and locally—in political, economic, and cultural activity.

NOTES

The author is grateful for the assistance of a grant from the Canadian Social Sciences and Humanities Research Council.

1. Most physicists would agree that we should be more careful about applying so-called laws of physics to social processes. They would concur with the particle physicist Lee Smolin (1997), who concludes that there is no *law* of thermodynamics, just a tendency under certain closed system conditions, and therefore no natural entropy and no inevitable heat death. Indeed, most cosmologists see what we call the universe as a lumpy mass of energy producing galaxies embedded in a cosmic ecology of universes.

2. Bookstores may close along with Times Square peep shows. But the market for controlled and commodified titillation opened a new niche as financiers have leased a Fifth Avenue site for an upscale "Museum of Sex" that is to open in 2000 complete with theater (for X-rated film festivals) and a restaurant featuring "aphrodisiac-oriented food" ("Sex on Display," 1998).

> FROM: JODI DEAN
>
> SUBJECT: **Webs of Conspiracy**
>
>
>
>
>
>
>
>
> **CAPRICORN TWO**
> Imaginings of cyberspace often employ metaphors of outer
> space. In a commercial for U.S. Robotics, astronaut Sally
> Ride explains, "You need stamina—that is true in space
> and it's true in cyberspace." The Pathfinder mission to
> Mars was successful less for its nifty Sojourner rover than
> for its websites featuring real-time Martian downloads.
> Contra James T. Kirk, space *wasn't* the final frontier; the
> World Wide Web is the new one.
> Happy "go get 'em" space images are not the only ones
> linked to cyberspace; the articulation of outer- with cyber-
> space is more complicated than the simple reappearance
> of iconic rockets and astronauts. In *Capricorn One*, a sci-
> fi B movie featuring O. J. Simpson in a story about a faked
> Mars landing, conspirators employ state-of-the-art tech-
> nology and media savvy in order to stage an inspiring
> achievement for an audience of gullible Americans. What
> makes the film not completely forgettable is its address-
> ing of popular suspicions of large-scale scientific projects
> produced for a television-watching public by a govern-
> ment seemingly preoccupied with securing its power in a
> mediatized age. It highlights the marginalized doubts of
> conspiracy thinkers and "flat-earthers" that have haunted
> American reception of the space program since the initial
> broadcast of Neil Armstrong's moonwalk: If he was the
> first man on the moon, who was operating the camera?
> These doubts reappear today in connection with cyber-

space. They inform a retroactive narrative about the space program that not only highlights doubt rather than scientific truth and technological trust, but that also places the question of the terms of truth and trust at the center of debates around the Internet and the World Wide Web.[1] For example, in a *New York Times* article from July 1997, "NASA Flew to Mars for Rocks? Sure." Amy Harmon writes:

> Back when Apollo 11 allegedly landed on the moon, conspiracy buffs complained that not enough information had been released to tell whether it really had or not.... Not even the most determined doubters could make the same case for the Mars mission. For two weeks now, earthlings have been bombarded with high-resolution images, press conferences, and geologic readings. Yet perhaps precisely because of the abundance of information, suspicions about the veracity of the data coming from outer space have soared—especially on the Internet, the information overload.
>
> The amorphous network often fosters the nagging hope that if only all the data on it could adequately be sorted, truth would finally emerge. This is coupled with the utter certainty that such nirvana can never be attained, and thus the peculiarly comforting suspicion that something important is being hidden. (1997–4E)

Harmon doesn't tell us why the suspicion that something is being hidden comforts. She doesn't tell us who this important thing might be hidden from or who might be doing the hiding. She doesn't explain the link between conspiracy, information, and the Web.

Yet she isn't alone in making such a link. The connection between conspiracy and the World Wide Web, one that takes the problem of truth and trust in a mediatized public as its central problem, is almost commonplace. Thus, Howard Fineman, in a 1997 *Newsweek* article on the Web's political impact, worries that "[i]n a digital world, every unchecked 'fact' is all too available, every opinion equal. The nifty Web page of the Holocaust-denier can seem just as convincing as the rerun of *Schindler's List*. 'Now you can immediately link the obsessions of a few like-minded folks in Tampa, Wichita, and Montana.'"[2] Just as the Steven Spielberg film *Schindler's List* stands in for the reality of the holocaust, so too does the possibility that a Montana-based website that someone in Wichita could access represents a larger threat to democracy, a threat imagined as conspiracy.

On the Web, abundance, immediacy, and availability seem danger-
ous, fuel for suspicion and obsession. They threaten—exceed—a public
sense of the bounds of truth and trust and, in so doing, hint at conspir-
acy. Anxiety about the World Wide Web tends to center on its excesses,
on the overabundance of information, the overstimulation of graphics and
gimmicks, the multiplicity of links. In traditional media and political
representations of the Web, moreover, these excesses produce a flatten-
ing of distinctions between authorized and unauthorized, official and
covert, expert and amateur, true and false that seems to threaten reason,
democracy, and the bounded stability of the nation.

Americans have long been suspicious of foreign entanglements, of
alien others, of agreements, contacts, and alliances that could call into
question an often unsteady sovereignty seeking to justify itself as ethi-
cally exceptional, as politically pure and unique. In such a setting, the
Web is simultaneously the site and source of America's corruption. It is
that place, that set of interactions, performances, and enjoyments, that
realizes the hope for the public. In so doing, however, it reveals the fun-
damental contradictions that must be disavowed for this hope to be sus-
tained. On the Web, we get what we wish for—an inclusive public—and
that's precisely the problem.

My argument is that the language, metaphors, and fears of conspiracy
in which current thinking about the World Wide Web is imbricated draw
our attention to the problem of the public informing anxieties around the
Web's excesses. The assumption that excess corrupts is an idea associ-
ated with conspiracy. Like the Web, conspiracy theory is often derided for
an inability to distinguish fact from fiction, for illogic, and for ama-
teurism. The resemblance between the Web and conspiracy thinking is
almost uncanny: each relies on odd, seemingly random, links that have
always already resisted a reconciling closure or coherence.[3] Each demon-
strates a preoccupation with minutia, evidence, documentation.[4] Each
occupies and disrupts a popular, populist political field. Attacks on the
Web, again, like attacks on conspiracy theory, attempt a reassuring delim-
itation of the known even as they rely on a fear of the hidden, on a fear
of a truth that cannot be known.

My claim is not that the conspiratorial imagining of the World Wide
Web determines how it is practiced or represented. It is, rather, that con-
spiracy haunts our thinking about the Web. Jacques Derrida observes,
"Haunting belongs to the structure of every hegemony" (1994: 37). I

argue that the metaphors of conspiracy haunting representations of cyberia in general and the Web in particular result from a hegemonic conception of democracy in terms of a rational public sphere. Conspiracy haunts the Web because it haunts the public.

As developed by Jürgen Habermas (1989), the ideal of the public sphere refers to the norms of universality, inclusivity, equality, and reciprocity governing discussions among private persons about matters of common concern. During the eighteenth century, this ideal of the public starts to serve not simply as the location of democracy, but as the primary meaning of democracy. Over and against the hierarchies of rule by blood and tradition, democracy comes to be thought of as rule through informed debate among equals. Democratic struggles, then, are those involving contestations over access and inclusion, over who and what is "in" or "out" of the conversation. Ensuring visibility, of peoples, power, and issues, is thus a hallmark of democratic politics.

Few, of course, think that contemporary democracies actually realize the ideals of the public sphere. Indeed, Bruce Robbins (1993) highlights the always already lost character of the public present in laments of consumerism, apathy, and ignorance. Nonetheless, a variety of thinkers—activists, theorists, and commentators—continue to presume that the public is a necessary concept for democracy, that it furnishes the norms and frameworks for political contestation.[5] Some advocates of the Internet, for example, have argued that it is a resource for democracy because it helps realize the public sphere by providing a structure for feedback and debate (Buchstein, 1997).

Conspiracy organizes a variety of inchoate fears about the Web's capacity to serve as a location for democratic exchange in late capitalist technoculture. Deeply implicated not only in the history of America but also in the history of enlightenment, evocations of conspiracy make possible a conjuration of forces and desires for governing the Web in the name of the public (Hofstadter, 1952; Davis, 1971; Rogin, 1987; Pipes, 1997). Conspiracy thinking, whether as a fear of conspiracy or a fear of conspiracy theory, resonates with drives to expose secrets and protect the nation, drives that start to clash as the practices of global technoculture realize the claimed ideals of the public sphere.

Esther Dyson announces, "The Net is a medium not for propaganda, but for conspiracy." She worries that the Net "allows all kinds of people to enter the conversation. There are still reliable and unreliable sources,

but for now, as people move onto the Net, they tend to lose their common sense and believe all kinds of crazy tales and theories. Unfortunately, we as a society haven't learned 'Net literacy' yet. We take a story's appearance online, as well as in print, as proof that it has been subjected to rigorous journalistic standards, but there's so much stuff out there that no one has the time to contradict all the errors" (1998: 50). Dyson doesn't specify which conversation she has in mind so it's hard to be sure what she's trying to preserve and protect. Presumably, she's thinking about something like the public sphere, something in which "we as a society" participate, something that requires a "common" sense.

What might such an all-inclusive conversation look like? Dyson's horror at the thought of "all kinds of people" entering it tells us (1) that the possibility of an inclusive public sphere conjures up anxieties around truth and trust; and (2) that what she defends as the public sphere relies on conception of rational debate excluded to all but the reasonable few. Who exactly loses her common sense and believes crazy theories because of a cruise on the World Wide Web? Presumably the ignorant, ill-informed, and unsophisticated; those left unguided by reliable sources and entrenched authorities; or perhaps just those who aren't really one of "us."

Dyson's "us" is remarkably small: who today shares her confidence in journalistic standards, especially amidst the controversies around nerve gas in Laos, emotional anecdotes in the *Boston Globe*, and the remark-

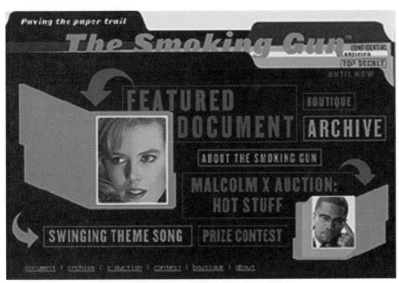

Fig. 3.1. Conspiracy haunts the Web because it haunts the public. The Smoking Gun website, http://www. thesmoking gun.com/

able elisions between so-called respectable and tabloid journalism during the O. J. Simpson trial and Monica Lewinsky affair? In her anxiety around the inclusion and access the Web provides, Dyson returns to an eighteenth-century conception of truth and concomitantly narrow assumption of trust. She posits a field of knowledge deemed reliable precisely because of the credibility—to her—of a small group of authorized, trusted, speakers.[6] Only a few can be believed. Only a few produce "real" knowledge.[7] But should anyone think that, given the time, one could "contradict all the errors" threatening us out there on the Web? And even if one could contradict these errors, could one correct them? What would it mean even to recognize or identify something as an error? And why might we think that identification could undo, disempower, or exorcise error in the first place?

CONJURING THE WEB

Conspiracy metaphors conjure up the World Wide Web as a cauldron of suspect sensibilities, of lurking claims and unstable histories. The power of this conjuration appears not simply in its reductive transformation of uncountable acts of access, linkage, purchase, and response into a limited number of sites designated in terms of particularly threatening content, but also in its remarkable capacity to, like a portal, web ring, or <a>tag, link different, even discordant, ideas. One or two unsavory URLs serve as synedoches for a larger, more ominous, and perhaps unspeakable danger.

One might think that the possibility of limitless information would help realize the claims of a democratic public sphere. If those who participate in "the conversation" have an abundance of data at their disposal, shouldn't they be able to make more informed decisions? Some versions of public deliberation stipulate that nothing be omitted from consideration, that participants have access to all relevant information. Yet conspiracy rhetoric links precisely this vision of an end to ignorance, secrecy, and the rule of expert knowledge that animates the ideal of a public sphere with gullibility, seduction, and widespread irrationality. The very prevalence of information and inclusion of multiple voices claimed on behalf of democratic discourse morphs into undecideability of truth claims and the fear that "all kinds of people" will enter "the conversation."

Conspiracy's haunting of some media accounts of the Internet starts in the second half of the nineties, about the time Pierre Salinger claimed that TWA flight 800 was shot down by a missile. This is also when the

World Wide Web replaces chat rooms, MUDs, and usenet groups as (with e-mail) a primary way of thinking about the challenges of cyberspace, virtuality, and computer mediated interaction. As the Web becomes the predominant understanding and experience of the Internet, the hegemonic discourse on new media changes. It no longer highlights technology's and, by implication, our own progression toward truth and reason, toward ideally democratic communities. Instead, by raising questions of the terms of belief, trust, and credibility, changes in the discourse make possible the installation of those conspiratorial tropes already haunting the possibility of the democratic public sphere.

The first change involves content or data. For mainstream print media, the World Wide Web isn't the information superhighway promised by Al Gore and Newt Gingrich. Instead, it's a vast repository of porn and drivel. This lament is typically followed by the observation that home pages tend to feature photos of pets or Beanie Babies, that more people use the Web to fawn over celebrities and document UFO sightings than, say, to grapple with the constitutional implications of a recent Supreme Court decision. The complaint goes further: not only do few use the Web as a learning resource, but those who do can't find anything. The porn and drivel, the limited ability of the available search engines, and the likelihood that some corporation has bought its way to the top of a site list make serious work impossible. A search for information on the hazards of silicon breast implants, for instance, results in promos for pharmaceutical companies and links to thousands of porn sites.

The second change involves the conception of the kind of subjectivity produced through networked interactions. Instead of identity experimentation and play with multiple personae, what has emerged as an overriding issue for new media is the less active consumer orientation of the passive Web browser, the "click-potato" mashed by push technology. Recent observers have replaced earlier cyberwork's emphasis on the transformations in subjectivity that online interactions make possible with a conception of the Web subject as a gullible consumer in need of protection (e.g. Grossman, 1997; Shenk, 1997; Toulouse and Luke, 1998). Indeed, in some accounts, the quintessential Web subject is the child threatened by porn and pedophiles.

One explanation for this refiguration may be that the Web opens up the Internet to vast numbers of new users. Like the PC, it brings the Net home. Web users are neither computer professionals nor devout hobby-

ists and hackers. They tend to be rendered in demographic terms, part of an increase in Net use by members of category X, Y, or Z. Or they are those who sign on via America Online. Such Web cruisers are less likely to spend hours constructing their virtual identities than they are jumping from site to site taking in ads, checking out new products, enjoying parodies and porn, and exposing themselves to the wild ideas of ufologists and right-wing conspirators.

Finally, the third change is in the characterization of computer mediated politics. Instead of enabling participatory democracy through large-scale, real-time debates and candidate question-and-answer, Web politics is presented in terms of seduction, deception, and manipulation by conspiracy, neo-Nazi, and right-wing militia websites. Looking more for pleasure than information, casual users are thought to open themselves up to wily corporations, advertisers, and political bad guys. The assumption seems to be that the combination of drivel and inexperience lures in and protects all those political and market forces heretofore barred from public debate by the standards of objective journalism and the containment provided by party politics.

That these particular changes in the discourse on new media have accompanied the rise of the Web wasn't inevitable; other possibilities are out there, even if not so readily available. One person's drivel may be another's delight. Some celebrate the fact that more people now have opportunities to put up websites. We don't have to watch reruns of *Baywatch* if we're bored. The influx of corporations and the consumer-oriented turn of the Web doesn't have to be negative. Small businesses and independent producers may have a chance now that Toys-R-Us can't completely monopolize toy sales. New bands and musicians can get their music out without having to go through industry record producers and exclusive forty-song playlists. Those of us in small towns aren't confined to WalMart.

Politically, Web campaigns like R. U. Sirius's "The Revolution" may not be serious electoral options. With no discernible difference between the major parties, the prohibitive expense of even Congressional campaigns, and the bland uniformity of most reporting in mainstream newspapers and telecasts, however, websites from the political margins attest at least to a kind of political liveliness and conviction. Those of us who suspect that mad cow disease might be more than a dotty British mishap, that there is organized resistance to bovine growth hormone, or that some citizens have continued critical investigation of the Oklahoma City bomb-

ing might think of the Web as an important vehicle for political action and activists, and a new terrain for political activity.

Yet this way of thinking has little purchase today. The early rhetoric of free information, universal access, and virtual democracy implied that the Internet would realize the promise of the public sphere. The new discourse implies that it hasn't. With the coming to prominence of the World Wide Web, information has been formatted as porn and drivel, subjectivity as gullible consumerism, and political action as seduction, manipulation, and deception.

Conspiracy theory can be installed in depictions of the Web because of this new format. That is to say, the changes in the discourse on networked communications are particularly effective insofar as they citationally evoke anxieties around the corrosive illogic of conspiracy theory. The fear is less that the Web will be a vehicle for actual conspiracies than that it will enable conspiracy theorists to seduce gullible Web cruisers who happen upon their websites. Once voiced, this fear motivates calls for protective intervention. A dismissive attitude toward conspiracy theory is linked to critical assessments of the World Wide Web so as to make regulation seem natural, necessary. Indeed, the articulation with conspiracy establishes a moralizing agenda for intervention that relies on an idealized vision of politics and community. Save us from porn and drivel. Keep the market in its place. Reassert politics' proper borders. Give us (back) our public sphere.

WEBS OF PUBLICITY

The change in the discourse on networked communication is not the only reason for the increasing articulation of the Web with conspiracy, however. The web is linked to conspiracy because the compulsion to reveal is at the very core of the notion of the public (Dean, 2000).

Publicity depends on the idea of secrecy. The power of the public is a power to unmask or reveal. Historically, as Habermas makes clear, the ideal of the public and the norms of publicity emerged out of clashes with monarchy in all its hidden privileges and machinations. Conceptually, moreover, secrecy is the "inside" or boundary against which publicity is constituted. These two dimensions of publicity point to the way that the public is called into being through the bringing of a matter to attention. There isn't a public prior to that bringing. When the public sphere provides our model for democracy, then, political action revolves around exposure, revelation. *Disclosing* and *making visible* are synonyms for *politics*.

In this context, the problem posed is not so much the representing or regulating of the Web as it is the representing and governing of the nation. New media change the terms of revelation and interpellation, the possibility of secrets, and the capacity to call a public into being. The Web is a metaphor for America at a time when the spread of technoglobal entertainment culture, when transnational mobilities and complicities, threaten the identity and stability of America as a nation.

To be sure, governmental actors continue to reassert state authority. The policing and incarceration of African-American men, the incitement to revenge whipped up by death-penalty enthusiasts, the myriad regulatings of decency, sexuality, and families are but a few such efforts in this domain (Connolly, 2000; Passavant, 2000). Nonetheless, we might usefully think of these political incursions more as state struggles than successes, recognizing in them contestations over the scope, boundaries, and terms of freedom in late capitalist technoculture. Against this background, then, we could perhaps think more clearly about conspiratorial renderings of the Web with regard to the claims of publicity simultaneously raised and disavowed.

Why is it then that the World Wide Web appears as a web of conspiracy threatening the stability of America as a nation? There is something in the evocations of conspiracy that is more than a fear of the seductions of irrationality. Perhaps something like conspiracy, which haunts and threatens political hegemony, is also feared. In the remainder of this chapter I consider two reasons for the conspiratorial rendering of the Web. The first involves the disavowal of the organizing myth of the public effected through the web's emergence. The second concerns the political danger that the Web presents to the boundaries that establish the political.

To talk about the way the World Wide Web disavows the public as an organizing myth for America as a nation, I want to return briefly to Amy Harmon's observation that the hope that truth might emerge on the Web is coupled with the certainty that it cannot and "thus the peculiarly comforting suspicion that something important is being hidden." Why is this suspicion comforting? Because it reaffirms the possibility of the public and the public requires the hidden, the secret.

That this is the case is clear when we consider statements like "the public has a right to know." The very notion that public rule depends on access to information, on truth and knowledge, places the secret at the heart of the public. A public of those who know, who need to know, is called

into being through its revelation. Revelation gives "us" something to talk about, a way of knowing who and what "we" are. Without a secret to discover, something hidden that can be exposed, there is no public. Today especially, disclosure (or perhaps, exposure), seems the very essence of political action. Accepting that there *is* something left to be discovered, that there is something beyond what we can see before us, somehow seems precisely that act of faith that is capable of securing "us" as a public.[8]

Thus, although on the surface of things it might seem as if the abundance of information available on the Web would support the ideal of a democratic public sphere, the Web actually endangers the ideal of the public because it eliminates the possibility of the secret. Everything is already out there. We may not know the URL, but somebody does. Put somewhat differently, that information is available on the Web eliminates the possibility of "coming out" with something new, with revelation or the scoop. If it's there, then someone knows it. Getting "it" on the news or in the papers is redundant; significant perhaps, but not the kind of "publication" it was in the past. Once configured as drivel, moreover, secrets seem pointless, boring, tawdry. After all the energy expended on bringing them to light, we may be somewhat embarrassed. Is that all? It hardly seems worth it. Most of the secrets revealed on the Web aren't compelling enough to generate more than a few thousand "hits" much less interpellate a public.

That the Web appeals to an already fragmented audience, to small demographic units or even individuals, points to the loss of an ideal of everyone, of a universal and universalized public to which we all somehow belong. Instead of totality, it offers proliferation and dispersion. In so doing, it puts in stark relief the televisuality of what has served as the ideal of a public. If millions of websites are politically threatening, bringing with them risks of fragmentation, the legitimation of marginalized and extreme political positions, and the de-authorization of traditional and mainstream information sources, then perhaps all along the public sphere was only *Sixty Minutes*, *Nightline*, and the evening news. Perhaps we were never more a public than when we gathered around our television sets watching a giant step for mankind or hearing about the state of the union (Dean, 1998).[9] That a language of conspiracy provides a compelling way to talk and think about the Web thus makes a certain sense. The Web subverts a prominent experience of what has become mainstream politics—namely, disclosure and the consequent generation of

an already select audience. Making the televisuality of the public visible, the Web unmasks the narrowness operating in the name of the public. Conspiracy rhetoric clicks on this populist edge.

I have emphasized contemporary articulations of publicity and secrecy, but the link between the public and secret isn't new. Its history extends at least into struggles against monarchical rule and the bourgeois revolutions. Habermas, in his classic account of the emergence of the bourgeois public sphere, emphasizes not only the importance of revelation ("Only in light of the public did that which existed become revealed, did everything become visible to all"), but also, and perhaps more surprisingly, the public's deep connection with conspiracy (1989: 4). Describing the secret societies popular in eighteenth-century Europe, he highlights their efforts to enlighten. Habermas writes, "The coming together of private people into a public was … anticipated in secret, as a public sphere still existing largely behind closed doors…. As long as publicity had its seat in the secret chanceries of the prince, reason could not reveal itself directly. Its sphere of publicity had still to rely on secrecy; its public, even as a public, remained internal…. This recalls Lessing's famous statement about Freemasonry, which at that time was a broader European phenomenon: it was just as old as bourgeois society "if indeed bourgeois society is not merely the offspring of Freemasonry'" (1989: 35). The public sphere has early roots in secret societies. Indeed, Habermas allows that publicity itself, as a norm of reason, might require secrecy. Paradoxically, those adepts, who like the Freemasons and the Illuminati, understood secret societies as organizations for the cultivation of reason, would better represent Habermas's public sphere than associations that did not cloak themselves in secrecy but stuck to custom and tradition. For the illuminated, secrecy was a condition for the publicity of reason. In the historical context of monarchical rule, the norms of reason thought to underlie an expansion of the people's rights and liberties had to be protected from prying eyes. They depended on remaining hidden.

Derrida, too, attends to the occult dimension of the public, to the secrecy it demands and disavows. "During the Middle Ages," he explains, "*conjuratio* also designated the sworn faith by means of which the bourgeois joined together, sometimes against a prince, in order to establish free towns…. In the occult society of those who have sworn together [*des conjurés*], certain subjects, either individual or collective, represent forces and ally themselves together in the name of common

interests to combat a dreaded political adversary, that is, to conjure it away" (1994: 47). The claiming of representative status by those who would, in the name of common interests, oppose a specific political power is a claiming imbricated in secrecy and magic even as it pretends to publicity and rationality.

Derrida's remarks are in the context of his attention to various meanings articulated in the noun *conjuration*: the conspiracy, or secret alliance of those who swear together; the magical incantation to bring forth what is not there; and, the exorcism, destruction, and disavowal of that which risks coming back (1994: 40–48). These meanings of conjuration suggest how the magic of the Web might be linked to the occult dimension of the public and thereby to the second reason for prominence of conspiratorial depictions of the World Wide Web, namely the political danger that the Web represents to the boundaries of the political.

It would be fun to focus on incantation, the seemingly magical connection between a few keystrokes and the arrival of a presence on our screens. Folks might share my desire to exorcise the annoying America Online applet that appears every time the Windows program loads. But more significant for my argument is the sense of commitment and responsibility Derrida links to conspiring together (1994: 50). The performance of a promise involves a taking on of responsibilities. As such, the commitment, although secret, is also in a certain way public. Indeed, conspiring displaces the frontier or boundary between private and public, between what is secret and what is already political. And, again, this displacement is an effect of the responsibility performatively undertaken. What kind of responsibilities do we have on the World Wide Web either as cruisers or as webmasters? This is precisely the location of the core of contemporary anxieties around the Web. Not only can we not answer the question, but it isn't clear that there is a "we" who can pose it.

The ideal of the public is associated with notions of responsibility, obligation, and rights. Some political theorists think of these obligations in terms of civility; others consider them issues of objectivity and truth. In both respects, the specter of conspiracy might be oddly reassuring. In a domain of no commitments, the breathing and swearing together of those who understand themselves as allied suggest that responsibility is still possible, that some people, even on—*especially* on—the Web, undertake it. In a field where contradictory claims intermingle with conflicting criteria for truth, the ability to act in accordance with a

single truth, to search it out, to orient one's convictions around it, holds open the possibility that the truth may be out there. The paranoia invested in anxieties around conspiracy expresses a kind of hope or desire for truth and trust. Conspiracy's assumption of responsibility reassures us of the possibility of commitments in a domain where they seem impossible.

EXORCISING THE PUBLIC

The World Wide Web brings to the fore—brings back—the secrecy and magic necessary for the public, but also necessarily disavowed in the name of the public. To claim the ideal of the public, to evoke it as the utopian moment of democracy, requires the exorcism of secrecy. This very requirement generates the public. The loss of the secret, however, is the loss of that which can interpellate and secure a public, that which can provide it with an organizing center and the pretense of totality. In this respect, the Web fulfills the ideal of the public and at the same time destroys it, perhaps because the ideals of inclusion and accessibility proclaimed in the name of the public in fact conjure up a nightmare vision of a political terrain where truth, trust, and responsibility are impossible.

The prevalence of metaphors of conspiracy in the discourse on the technocultural impact of computer mediated interaction suggests that the Web *is* the public—and that's precisely the problem. What has been theorized as the public sphere is an exclusive conversation according to a set of norms designed to keep it exclusive even as they gesture to universality. The utopian connotations of the public resist closure in the name of a political domain in which truth and trust not only flourish but are organizing ideals. What conspiracy's haunting of the Web suggests is that truth and trust, responsibility, are incompatible with the public. The more open and dispersed the conversations, the more varying ideals and approaches proliferate, the greater the threat to those accustomed to authorizing truth, to determining the grounds of responsibility.

The World Wide Web is not that site where the nation—much less the planet—addresses itself. There is no such site for there is no such conversation. Perhaps the magic of the Web is its capacity to conjure the public: to evoke it as an ideal, to realize it in all its proliferating, undecidability, destabilizing inclusivity, and to exorcise it as an exclusive, normalizing fiction.

NOTES

1. I'm indebted to Lee Quinby for helping me to think more clearly about this point.

2. Fineman is quoting Doug Bailey, whom he identifies as "the pioneering founder of the Political Hotline."

3. I disagree with Steven Johnson's claim that "on the World Wide Web, where this imaginative crisis is most sorely felt, it is the link that finally supplies that sense of coherence [supplied by narrative links in the novels of Charles Dickens]" (1997: 116). Not only is coherence not a goal—What would it even mean in this context? Why would one need a coherent vision of millions of networked computers?—but there is no such thing as "the" link. There are always more links opening up and extending our interaction on specific sites into interactions on other sites.

4. Although I do not agree with Paige Baty's rendering of conspiracy in terms of coherent narrative plots, her account of the link between conspiracy thinking and mass media technologies of reproduction is insightful. Baty writes, "The meshed networks of dissimulation 'revealed' by conspiracies and conspiracy theories in the cartographic mode of remembering also correspond to mass-mediated forms of circulation, for the conspiratorial net is itself woven through plots and channels of information" (1995: 116).

5. Stephen Wray (1998) presents a compelling critique of the dominance of the Habermasian model of the public sphere in accounts of new media. Demonstrating how this model restricts thinking about democracy, he argues for the inclusion of action accounts such as the "Boston Tea Party."

6. Steven Shapin (1994) details the rise of the modern sense of truth and trust.

7. See Donna Haraway's (1997) critical account of the place of the modest witness at the emergence of modern science. Drawing from Steven Shapin's (1994) account of Robert Boyle's experiments with the air pump she writes, "This separation of expert knowledge from mere opinion as the legitimating knowledge of ways of life, without appeal to transcendent authority or to abstract certainty of any kind, is a founding gesture of what we call modernity. It is the founding gesture of the separation of the technical and the political" (1997: 24).

8. I'm indebted to Paul Passavant for helping me think about this point.

9. See also Derrida's reference to the technical, scientific, and economic transformations already disrupting a topographical sense of the public

in the years immediately following the First World War (1994: 79–80). Of the structural incompetence of professional politicians today, he says, "The same media power accuses, produces, and amplifies *at the same time* this incompetence of traditional politicians: on the one hand, it takes away from them the legitimate power they held in the former political space (party, parliament, and so forth), but, on the other, it obliges them to become mere silhouettes, if not marionettes, on the stage of televisual rhetoric. They were thought to be actors of politics, they now often risk, as everyone knows, being no more than TV actors" (1994: 80).

> FROM: ANDREW HERMAN AND JOHN H. SLOOP

> SUBJECT: **"Red Alert!"**
> Rhetorics of the World Wide Web
> and "Friction Free" Capitalism

> If there is one clear "winner" in the hypermedia envi-
> ronment, it is the collective interests of transnational
> capital.
>
> —Ronald Deibert, *Parchments, Printing,*
> *and Hypermedia*

> **CYBORGS@ESCAPE VELOCITY TO HEAVEN'S GATE**
> Even by the spectacular standards of a media culture fas-
> cinated by the apocalyptic and the morbid, the story of
> the mass suicide of thirty-nine members of the so-called
> Heaven's Gate cult was bizarre. The "facts" of the event
> are wellknown: members of the group were convinced that
> the approaching Hale-Bopp comet was accompanied by a
> spaceship of benevolent aliens from the "Level Above
> Human" that would take members to "the literal Heav-
> ens." According to leaders Ti and Do, the earth was about
> to be "recycled," and the coming of the comet was the last
> chance for humans to transcend the "Luciferian" realm
> of mortal embodied existence on this planet. The comet
> was a veritable "Heaven's Gate," and thus its arrival pro-
> vided a propitious moment for the members of the group
> to suicidally perform the "final act of metamorphosis or
> separation from the human kingdom," which was to
> "disconnect" the soul from the "human physical body or
> container"—a mere vehicular vessel for movement on
> Earth.[1]
> The story is certainly strange in terms of the group's
> beliefs (New Age/UFO millenarianism and monkish anti-
> sexual asceticism) and final action (mass suicide), but
> what is perhaps equally fascinating on a cultural level is

the way the event has been pointed to as signifying, alternatively, the dangerous potential and utopian possibilities of cyberspace technologies.[2] In virtually every extended report in the days following the event, there was some comment on the connection between the cult and the World Wide Web, with experts brought forth to elaborate on the connection and the frightening possibility of similar "cults" with Internet outreach. For example, the *San Francisco Chronicle* called the Heaven's Gate group "Net-savvy cultists," and *Time* magazine's cover story was titled "Inside the Web of Death" and included a sidebar essay entitled "Life and Death on the Web" that asked the question, "Is the Net somehow to blame?" (Quittner, 1997: 47). For many, the group's actions were not seen as a wild aberration in the world of cyberspace but instead as directly connected to the new technology.

What made the case especially interesting for those interested in cyberspace's cultural articulation was the way the group tied itself to Internet technologies in terms of outreach of its "message" and in terms of employment and income to support the group financially. As became well known, all the members of the group were also employees of Higher Source, Inc., a computer graphics and web-design firm that had a lucrative business designing websites for a variety of organizations, ranging from a Madonna fan club (www.pre-madonna.org) to the tony San Diego Polo Club. Second, the group maintained its own elaborate website, which contained all the manifestoes and pronouncements of Ti and Do regarding the imminent *Götterdämmerung* foreshadowed by the coming of Hale-Bopp. According to press reports, the groups' preparations for leaving this mortal coil for the heavens were painstakingly meticulous. Among them were a further revision of the group's homepage (www.spacestar.net/sshgt/index.html), which proclaims "RED ALERT! Hale-Bopp Brings Closure to Heaven's Gate." The page goes on to evoke Ti and Do's divination of the comet as the "final marker" of the end and provides a guide to the rest of the website where the visitor might find his "boarding pass" for the final journey. Whatever aspects of material human life the members of Heaven's Gate felt to be ephemeral to their evolutionary salvation and willingly left behind (everything), it was imperative that the server be left on. In fact, the group had paid their website provider in advance so the site would remain active for three months after their suicide. Moreover, surviving members of Heaven's Gate said that they had no plans to let the website lapse after those three months were over.

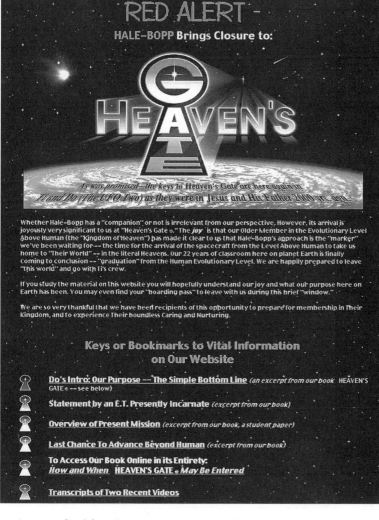

As a result of their Internet connections, the case acted as a discursive snapshot of both utopian and dystopian discourses about cyberspace. In *Electronic Eros*, Claudia Springer (1996) argues that discussions of cyborgs in popular fiction, film, advertising, and editorial commentary provide a nodal point around which cultural critics can witness contemporary cultural tensions over the relationships among sexuality, gender, and technology. In much the same way, the Heaven's Gate suicides call on contemporary fears and hopes regarding the changing interconnection between humans and media/technology. Indeed, a cursory glance at

the surface features of the suicides is enough to make those with even surface knowledge of Donna Haraway's classic 1985 "Cyborg Manifesto" salivate and/or shudder. With the group's stylistically and surgically fashioned gender ambiguity (the males subjected themselves to castration), construction of the "flesh" vehicular rather than essential, and connections with the Internet, they play out a lot of the surface features of Haraway's cyborg. With their physical demise, however, they represent a darker side to Haraway's vision: rather than permanently partial and contradictory identities, they provide permanent erasure of gender, class, and race on individual nodal points. While they might indeed be a move away from modernism's binarisms of male/female, black/white, and so on, they are more of a move toward an erasure of such concepts than that of a smoothing out of their rigidity. Rather than Haraway's cyborg, they appear more as *Star Trek: The Next Generation*'s borg.

Combining good-old-fashioned cult intrigue and a more contemporary fascination with, and fear of, computer technology, it is no wonder then that the haunted and haunting virtual presence of the group in the nowhere/somewhere matrix of cyberspace sparked a number of voices to once again either promote a utopian vision for the future of cyberspace or dystopic moral panic (sometimes both emerging from the same source). For instance, Jon Katz of *HotWired* (*Wired*'s daily web publication), called the events the "first Web tragedy" and a "disturbance in the field" in that the Net was an intrinsic part of its performance and circulation (Katz, 1997). Steve Silberman (1997), also of *HotWired*, went even further, noting the resonance between Heaven's Gate yearning for transcendent disembodied travel of mind and spirit and the utopian rhetoric of cyberspace. One UCLA professor called cyberspace "THE place" for cult recruitment. The Web provided a fertile ground for what one talking head called "spiritual predators," cults such as Heaven's Gate who fed upon the anomic social isolation of Net-heads who spent too much time alone surfing the Web and not enough time communing with friends, family, coworkers, community, and church on this side of the screen. It was as if Charlie Manson and Jim Jones were doing a Durkheimian dance in cyberspace. Ironically enough, on the day Charles Manson was denied parole in 1997, a day close to "Heaven's Gate's" earthly departure, he noted that he was content to remain in prison as he was busy working on his webpage, a claim that added to the conversation concerning cyberspace and dystopia (E. Gleick, 1997: 32).

However, if one portion of contemporary culture sees cyberspace as

the devil's den, another welcomes it with great relish, and, as a result, the utopic vision of cyberspace that counteracted the doomsayers (and in our experience has certainly been the dominant articulation of hypermedia and cybertechnology) was quick to follow.[3] For examples, defenders of cyberspace such as the editor of *Wired* Magazine (interviewed on CNN) made quick counterarguments. In this vision, the Internet is like any other revolutionary technology—it is an instrument that can be used for good or ill, and whether it is used for good or ill is a matter of human choice and not inherent in the technology itself.

Ever since William Gibson coined the term *cyberspace* in *Neuromancer* (1984), defining it as a "consensual hallucination," there has been the elaboration of a utopian rhetoric wherein cyberspace is conjured as a mythic space of ludic possibilities of disembodied travel, identity transformation, and virtual communities. In Deleuzeian terms, the utopia of cyberspace is a "smooth space" of interstitial nomadic movement and fluid subjectivity, in contrast to the "striated" space of logocentric constraint and embodied stability of the so-called meatscape reality on this side of the screen. Examples of this rhetoric are legion: for example, Mark Dery (1996) characterizes the utopian imaginary of cyberspace as an emplotment of "escape velocity." In the parlance of astrophysics, escape velocity is the speed at which one body is able to pull away from the gravitational pull of another body. In the utopian rhetoric of cyberspace, according to Dery, escape velocity entails "transcendentalist fantasies of breaking free of limits of any sort, metaphysical as well as physical" (1996: 8). The disgust with which Case, the cowboy of Gibson's *Neuromancer*, views his own flesh, "the meat," is symptomatic of this longing for transcendence, to exist outside of the need for either sex or catheters to interrupt one's life. There may be no better way of describing the millenarian philosophy of Heaven's Gate, and its actions, than as an attempt at articulating and quite literally enacting the fantasy of escape velocity.

John Perry Barlow, founder of the Electronic Frontier Foundation, authored a Declaration of Independence of Cyberspace that perhaps provides the clearest example of such discourse. Barlow writes, and we quote this at length to give a clear sense of its flavor,

> Governments of the Industrial World, you weary giants of flesh and
> steel, I come from Cyberspace, the new home of Mind. On behalf of the

future, I ask you of the past to leave us alone. You are not welcome among us. You have no sovereignty where we gather.... We are creating a world that all may enter without privilege or prejudice accorded by race, economic power, military force, or station of birth.... We are creating a world where anyone, anywhere may express his or her beliefs, no matter how singular, without fear of being coerced into silence or conformity.... Your legal concepts of property, expression, identity, movement, and context do not apply to us. They are based on matter. There is no matter here.... We will create a civilization of the Mind in Cyberspace. May it be more humane and fair than the world your governments have made before. (Barlow, 1996)

This "declaration of independence" is more than a move from the sovereignty of nation-states and corporations; it is from the corpus of materiality tout court. Barlow's topos of cyberspace is exquisitely utopian in the etymological root meaning of the term as both *outopia* (nowhere) and *euotopia* (somewhere good) (K. Robbins, 1995: 135). Cyberspace is "everywhere and nowhere, but it is not where bodies live."[4] It is a fluid interstitial domain of the always already in-between of communicative reciprocity and relationality that is separate from the all-too-firm and locatable realm of bodily existence. Cyberspace is the "new home of the Mind," where all the embodied striations of difference are put under erasure. It is a world "that all may enter without privilege or prejudice accorded by race, economic power, military force, or station of birth"; "a world where anyone, anywhere may express his or her beliefs, no matter how singular, without fear of being coerced into silence or conformity." The realm of cyberspace is a realm of limitless movement and freedom. As such, it poses a threat to the governmental and corporate "weary giants of flesh and steel" who are "terrified" by the ludic, heterogeneous, and chaotic "global conversation of bits." While this passage represents something of an extreme, it also represents many of the themes in the utopian discourse—a space where bodies don't matter; a space untouched by prejudices according to race, class, or force; a space without coercion; a space for free expression.

It is important to note that this utopian discourse works on the same grounds of the dystopian discourse—indeed, each of the public arguments concerns the same issues, and these issues are all based strongly on a sense of romantic individualism.[5] In the alternating utopic/dystopic

discourse about cyberspace, then, cyberspace and hypermedia are positioned as having effects on the "freedom and self-determination" of individual human agents, human agents that are always assumed. Indeed, the primary focus of these arguments, and the terror evoked by the Heaven's Gate case, are the common tropes of "individualism" and "free will." While the physical body may play a different part in the equation (or no part at all), the idea of the free acting/free willed/free expressing individual works on both ends of the vision. The same questions—the same fears and celebrations—arise around cyberspace that have arisen around the entry of almost any "alien" discourse encountering the ideology of individuality, be the alien agent Eastern forms of religion, psychedelic drugs, or communism. In each case, both a utopia and a dystopia depict either the individual's loss of will to the alien through "brainwashing" or mental damage or the individual's celebratory merging with a greater form/way of being. In the following section of this chapter, we want to first point out the way in which this public connection of the Web's relationship to the "individual" misunderstands the relationship between media technology and epistemology/ontology and, as a result, allows for a discursive condition in which questions about cyberspace's role within our material economy (that is, the relationship between cyberspace's utopian dreamscape and capital culture) are ignored or displaced. We will then turn our attention to popular descriptions of the relationships between humanity and media technologies as well as between media technology and the discourse concerning it. Thereafter, we will provide an analysis of a number of contemporary advertisements about purveyors of Internet and Web services (and the way in which each articulates meanings about cyberspace in general) and will argue that what we have most to be concerned about—and the task most clearly needed to be filled by cultural critics—is the relationship between cyberspace and capital that is assumed by these advertisements. Finally, we will suggest directions that should be pursued by critics concerned about this relationship.

EXTENSION AND EXPULSION IN THE NEW WORLD

In *The Perfect Crime*, Jean Baudrillard attempts to aphoristically improve upon Marshall McLuhan's understanding of the relationship between media technology and culture. "McLuhan saw modern technologies as 'extensions of man,'" Baudrillard notes; "We should see them, rather, as

'expulsions of man'" (1996: 35). While it is certainly arguable that McLuhan understood both the extensive and expulsive effects of media, what rings true in Baudrillard's observation is the way that many popular and critical accounts of media theory in general, and of McLuhan in particular, overemphasize the idea of extension at the cost of understanding the more important point—the way in which the dominance of a media form transforms what it means to be human (hence expelling humanity as it has come to be known). [6]

McLuhan's observations on media as extensions of human beings (i.e., extending their reach in space and time) often are read as implying the continued existence of the romantic individual, only extended, going further temporally and spatially. When media theory is interpreted in this way (or when these assumptions operate with or without McLuhan being invoked), the utopian and dystopian visions about media technologies end up focusing on the effects of technology on an assumed "individual." While the individual is able to "do more" in one vision and is brainwashed or harmed in the other, the existence and focus on the individual, free-acting human operates in both visions and the concern of both camps is the same—to improve the human condition as a space for individual goods and rights.

What is overlooked in such an equation is the way in which McLuhan used the idea of extension to emphasize media as *techné* in the Heideggerian sense, *techné* meaning both an articulation of material technique and a change in knowledge that transforms being in the world (Heidegger, 1977; Chesher, 1997). As Iain Chambers (1994: 51) argues, technology as techné is "simultaneously a technical instrument and cultural activity." Media changes the very conception of being, bringing to fulfillment a transformation in the idea of the individual as standing alone to one who is multiply identified, emerging in and through community discourses. While there certainly should be concern and thought put into how media technology affects being, such concern cannot start with the assumption of how media technology affects humanity as it is currently defined. Rather, it must be concerned with what will *come into being* as a result of the changes in dominance of a particular media form. As such, while media technology cannot be reasonably attacked by those frightened by its potentiality to stifle human free will, it also cannot be defended by those who, like the editor of *Wired*, position it as only a tool to be used or misused by free-willing individuals. As McLuhan noted

years ago, a media technology cannot be judged as good or bad based upon its use as form alone, as if it were neutral otherwise. Rather, in and of themselves, media technologies change who "we" are and what/how we think simply by virtue of general use as forms rather than what content we transmit through them (1964: 35).

Similarly, in an investigation of various theoretical discussions of cyberspace and its effects, David and Ann Gunkel note that many of these discussions—both utopian and dystopian—are problematic in that they all base their concerns on concepts and categories that existed prior to the dominance of a new media form. Gunkel and Gunkel metaphorically compare the emerging discourse about cyberspace to Columbus's journal entries concerning the "new world" and find similar themes. In both cases, Columbus and critics of cyberspace write in ways that illustrate their ethnocentrism and general epistemology illumined by enlightenment thinking (1997: 123). As they note, "The new world is situated under the conceptual domination of the old. In the new world, one finds only what s/he wanted to find and discovers only what one, in advance, already desires to produce" (124). Hence, in utopian views of cyberspace, one sees ideas of what we now value but do not see as currently in full fruition (for example, a color-blind society with equality for all, an end to illness and physical pain, an end to financial strife, an increase in freedom). Simultaneously, in dystopian visions, we are faced with a world that, due to the dangers of cyberspace, is perilous because it destroys natural human values (for instance, it hurts individuality and creativity by making everyone lazy; it leaves people open to be fooled and manipulated; it ends the need for human contact).

ADVERTISING CYBERSPACE

As we will illustrate below, if one looks specifically at advertising concerning Web services providers, one finds precisely a hyperrealized version of the utopia of the Old World transformed onto the new.[7] Such advertising presents a world in which gender, race, class, age, and other differences do not work as impediments to any person's ability to meet with success. More, it is a world that works smoothly, in which desires are not only within reach but are satisfied before the individual is fully aware of their existence. It is a world in which not only are individual differences not impediments, but in which there are no irritations, no delays, no noise whatsoever when it comes to desires and fulfillment. First, then,

advertising about cyberspace maintains the romantic individual and that individual's ability to express her "self" and fulfill her desires without hindrance. While signifiers of differences might exist as marked on individual bodies (bodies will have the signifiers of gender and race), these signifiers will have nothing to do with the expression of individuality or the fulfillment of desire—only the individual as held over from the old world can decide when and where to have fulfillment.

Second, while the ads provide a friction-free marketplace with no impediments to fulfillment, capital itself and the interests of capital are seemingly erased from the equation. The world becomes one in which capital, the work space, inequity, and noise disappear. As a result, the critical project must be one of making capital visible, bringing noise back to the equation of a friction-free consumer utopia. The real "red alert" about cyberspace is not that we fall prey to utopian dreams of bodily transcendence and virtual selfhood, but that such dreams become indistinguishable from corporate fantasies of what Bill Gates calls the "friction-free capitalism" of the twenty-first century.[8]

We will suggest that this movement into a friction-free capitalism zone is accomplished primarily through two metaphors—an aural one focusing on music over noise, and a spatial one positing a "here" of cyberspace and the frictionless means of travel. However, as we will illustrate in the remainder of this chapter, the utopian rhetoric of cyberspace has been appropriated and deployed in the service of corporate sovereignty. That is, while such advertisements might play off of the promises of transcending the limits experienced by humans (while maintaining their individuality), they also work to reify the bindings of capital culture.

THE SOUNDS OF CYBERSPACE

It is significant that Donna Haraway (1985) once called "noise" the primary tool of the cyborg. What she was aiming for, of course, was an employment of noise as part of a struggle against "perfect code," a common language. If the concept of the cyborg has two faces, one is Haraway's, in which differences exist but in a perpetual state of transition, a radial heteroglossia between and within any given identities. Hence, while gender and sexual differences continue, they are no longer essential, but unstable, open to a variety of meanings, never translatable into a single code as noise constantly disrupts any fixed meanings. The other face would be perhaps that of *Star Trek*'s original Borg, a creation with

such a radical sense of difference from romantic individualism that, as Katrina Boyd (1995) argues, it had to slowly be transformed into a collection of romantic individuals manipulated by a single sinister villain as the series, and eventually film, carried the concept forward. [9] While Haraway's cyborg challenges normal conceptions of humanity and military/patriarchal/capitalist order by providing "permanently partial identities and contradictory standpoints " (Boyd, 1996: 95), *Star Trek*'s Borg battles traditional concepts of humanity through the creation of a perfect code that provides no partial meanings, no partial identities, a "we" that eradicates the "I"s that make it up. While Haraway's cyborg uses noise to disrupt seamless capitalist patriarchal ideology, the *Star Trek* Borg creates a seamless noise that wipes out the individuality necessary for a dominant ideology of capitalism, free will, and progress.

The concepts of music and noise are no strangers to contemporary discussions of cyberspace and Internet service providers. However, as we will argue, such ISP advertisements promote a seamless music that, while obviously oppositional to Haraway's cyborg, is also oppositional to the *Star Trek* Borg in that it works to promote an improved version of the romantic individual, one unencumbered by the noise of race, class, and gender, and enabled to work for consumption—for industry—within the traditional ideology of capitalism. This distinction between music and noise and its place in this discourse is particularly interesting. When Jacques Attali (1985) titled his work on the function of music within ideological and economic capital he titled it *Noise: The Political Economy of Music* in order to signify the metaphoric and literal relationship between music and noise. Attali suggests that, in terms of cultural phenomenon, relations of power can be found in the always shifting boundary between noise and music. Music is tamed noise, a structural code that defines the hegemonic ordering of positions of power and difference located in the aural landscape of sound. Noise, on the other hand, falling outside of dominant codes, transgresses the dominant ordering of difference. Music affirms the dominant order while noise threatens it. Through experience, we all know that in a literal sense, the meanings of noise and music are not only persistently shifting for each of us (that is, familiarity can make what was once noise sound like music just as once unacceptable behavior becomes acceptable after it is repeated often enough). All the same, in the day-to-day function of our lives, on a pragmatic level we generally prefer music to noise. Music soothes agitation; it can be ignored

while one is at work. Noise, on the other hand, keeps one from attending to the work at hand. Hence, while ideological change can only take place through the disruption of noise, through one walking outside the boundaries of the sidewalks (taking shortcuts through the city), we are more likely to prefer listening to music. [10] As critics, we may endorse the noisiness of Haraway's cyborg, but as consumers, we party, relax, and work to the sounds of music. While many of those who celebrate the oncoming of cyberspace and the World Wide Web celebrate it precisely for its ability to bring a multiplicity of voices into a conversation, to create space for a noisy and loud democratic space, our general inclination in quotidian life is toward the silence that is music.

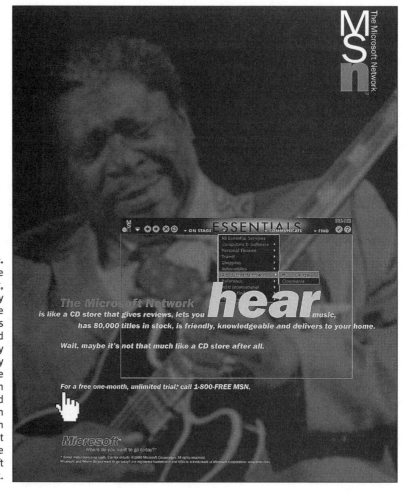

Fig. 4.2. In the advertisement, not only is music the focus, but it is purchased without any hassle, any "noise"—the space between desire and consumption is erased. An advertisement for the Microsoft Network.

Print advertisements for Microsoft Network (MSN) literally invite us to use the Web to listen to music, and to do so with ease, without the "noise" of actually purchasing the music. For example, one of their ads published in *Spin* features a virtual CD store, with the text of the ad emphasizing the friction-free (noiseless) way that the network allows you to listen to music: "The Microsoft Network is like a CD store that gives reviews, let's you *hear* music, has 80,000 titles in stock, is friendly, knowledgeable and delivers to your home. Wait, maybe it's not that much like a CD store at all." The foregrounded subject implied by both image and text is "you," the consumer. In the background is a recognizable icon of musical authenticity, B. B. King, the King of the Blues. Mediated between consumer desire and its object is the MSN home page, the "Essentials" menu pulled down to Arts & Entertainment, which yields the option of "Music Central." The text of the ad is most proximate to the implied spectator/consumer and functions as the discursive employment that connects consumer and B. B. King. In the advertisement, not only is music the focus, but it is purchased without any hassle, any "noise"— the space between desire and consumption is erased. Like Bill Gate's fiction-free capitalism, or what Ronald Diebert (1997: 151) refers to as the creation of a "disappearing float" (of interest, borrowed money, or wait time), we see here a completely trouble-free space of consumption in which no noise interrupts the process of consumption and in which the individual, given his specific and individual tastes, can get whatever he wants with the press of a button.

More telling is an ad for MCI published in *USA Today* that deals with a variety of MCI's telecommunications services, including their Internet service. The full-page newspaper advertisement is divided into two large visual sections, and there is a third smaller section on the bottom with text. The top portion of the advertisement is divided into 117 equal-sized small pictures, many of them repeated, of various people in the act of singing (some of the pictures are of the same singers from different camera angles). The variety of genres and singers is broad, ranging from opera singers to punk rockers, nuns to rockabilly artists, cowboys to blues musicians, hip-hop artists to polka band members (this is all visually signified without written text). Placed in the middle of the 117 pictures is the word "noise" (covering a number of the images). The bottom half of the visual section of the text is mostly blank; only one of the pictures from the top half of the ad—a picture of an elegantly dressed (apparently

Caucasian) woman singing what one might suppose to be a ballad—is on this bottom half. Just below this picture is the word "music," offering up the peaceful sounds of a single singer as "music" versus the "noise" generated by a multiplicity of voices all operating at once. Just below the visual portion of the ad is the written text with the well-known MCI Internet advertising slogan, "Is this a great time or what ? : =)" side by side with MCI's assertion that "It's easier to listen to a single voice for all your communication services."

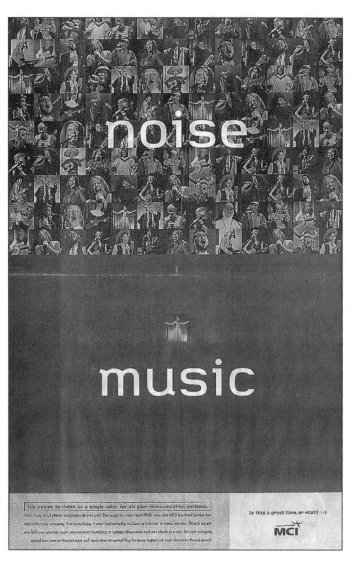

Fig. 4.3. Differences, at least in the public realm, are seen as noisy, prohibitive to the sound functioning of an economy. While we may each have our own desires and can fulfill those in private, we do so most successfully when the public forum is one of music. An advertisement for MCI.

Visually this is a stunning ad, with MCI promising to remove each of us from the messiness of multiple voices by delivering us to a location of music—one voice, one song. While MCI may be up to nothing intentionally sinister here—they are simply suggesting that it is easier for anyone to have fewer phone bills, fewer customer service representatives than it is to have more—the advertisement simultaneously takes us visually from a space of multiple individuals providing multiple types of expression to a space in which multiplicity and difference is erased. The advertisement works on the grounds that we all in fact do privilege singularity and sameness, over the messiness of difference and ongoing noise. Significantly, the ad notes that it's a "great time" because one "can spend less time on bureaucracy and more time on something important: your business." In such an advertisement, differences, at least in the public realm, are seen as noisy, prohibitive to the sound functioning of an economy. While we may each have our own desires and can fulfill those in private, we do so most successfully when the public forum is one of music—music, brought to you, of course, by MCI.

GETTING THERE: TRANSPORTATION TO THE DISEMBODIED ZONE

Not only are music and friction-free fulfillment imagined in such advertisements, then, but they are also the vehicles that will get us to this utopian zone. For example, in an arresting MCI Internet television commercial that was aired frequently in 1997, the narrative and rhetoric of bodily transcendence in cyberspace is fused with, and visually enabled by, an escape velocity of high-speed editing. In this thirty-second spot, there are no fewer than twenty-eight edits. The speed of the edits alone gives one the feeling of being positioned in a multiple number of positions simultaneously, positions that could only be occupied so quickly at escape velocity. In the midst of the edits, one encounters a rainbow coalition of multicultural bodies: a middle-aged black businessman, an elderly white man and elderly black woman, an Asian-American woman, a deaf white girl, a young white woman, and a parade of children from seemingly every shade of race and ethnicity. It is, however, obvious that one of the points of the advertisement is to suggest that these embodied differences do not make a difference in cyberspace, where bodies are escaped for all practical purposes. That is, while the commercial visually (and arguably aurally) shows the signifiers of these differences, they are shown as being indeed "differences" as opposed to "otherness." Visually,

the commercial cuts back and forth between the people, who both face the camera and interface with computers, and a computer screen, both of which enunciate the story of cyberspatial escape velocity. The narrative begins with a young white girl saying, "People here communicate minds to minds." Where is "here," where is the location of this topos of disembodied communication? The trajectory of emplotment that will lead to "here" is a mantra of descriptive statements about the emplacement of "here" that literally and magically erase embodied (social, physical, cultural) differences.

A black businessman silhouetted against the material landscape outside his office window opens a laptop, upon the screen of which the words "There is no" are typed out, a statement that is vocally completed by a white woman at the same time a young girl crosses out the word "RACE" on a blackboard. In fast succession, the rest of the utopian mantra of transcendence is enunciated: "There are no genders" says an Asian woman; "There is no age" says the voice of a young black boy and an older white man, as a white father leans over his daughter's shoulder to type out the words on a laptop in their kitchen; "There are no infirmities" says a deaf white girl via sign language. In each case, the people and the computer screen collaborate in beginning and finishing the statements that compose the mantra. Indeed, one of the fascinating things about the commercial is that very quickly the enunciation of the statements becomes disconnected from particular individuals you see, as, for instance, the voice of a child speaks the words that come out of an elderly white man's mouth. The disarticulation of body and speech is, of course, intentional, and foregrounds the new locus of communication, the computer screen, upon which is typed out the last statement of the mantra, "There are only minds." Again, while we can see the visualization of these differences, we are simultaneously told that they do not exist, that they do not matter (when they do matter, referring to the earlier print ad, we have noise).

Again, where is "here," this place of the transcendental subjectivity? "Utopia?" asks the black businessman and the computer screen rhetorically. "No," comes the answer, "It's the Internet, where minds, lives, and doors open up." The logic of the response seems to indicate that the Internet has one up on utopia; it is a utopia with open minds and doors.

Visually and textually, the commercial emphasizes the *here* of cyberspace. What we are left with until the end is the question of travel. That

is, if the Internet is the place of enlightened transcendental subjectivity, what vehicle does one use to get there? The commercial then cuts between a series of smiling multicultural faces and the computer screen as it types out and specifies the portal through which escape velocity will lead us to the open doors of the cyberspace: "MCI has the fastest Internet Network" and then "MCI has the largest Internet Network." Just after revealing MCI's role in taking us to this space that turns differently enabled and empowered bodies into a community of communicatively competent cogitos, judgment is passed: a young black man, a classroom full of multiculturally diverse school children begin shouting the con-

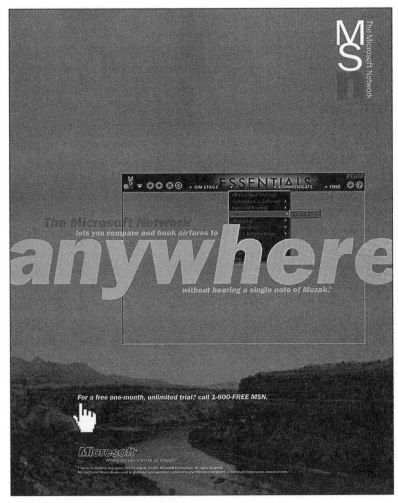

Fig. 4.4. The consumer/ tourist is folded into smooth space of autonomous travel (they decide place and destination), yet folded into the striated space of Expedia and expedition, the instrumental rational ritual of fastest and most efficient utilitarian ritual of cash/ commodity exchange and exploration. An advertisement for the Microsoft Network.

clusion of MCI's emplotment toward utopia: "Is this a great time or what?"—a rhetorical question that is finished by the computer, which types out "time or what? :-) " on its screen. This, then, is the telos of MCI's story, a smiley "emoticon" of beatification, signifying absolute ecstatic joy that something better than utopia is here if we climb aboard the MCI dreamship. In effect, not only does the commercial project the Internet and the Web as disembodied spaces, but as spaces seemingly free of ownership or corporate ties; MCI offers the ride to this utopia, but is invisible upon one's arrival.

In the Microsoft advertisement for CD stores mentioned earlier we see again a common assumption and promise from both Microsoft and MCI: a corporation provides the ride to the utopia of a disembodied culture, a generic friction-free CD store. You hitch a ride to a friction-free capital culture on MCI or Microsoft and then industry and other earthly hindrances disappear. Where do you want to go today? There is double movement of travel—the consumer to the imagined place of musical desire and authenticity and the movement of place through cyberspace to the "home" of the consumer. The emphasis is on what you can *hear* at *home.* One doesn't have to go anywhere, since where you want to go is delivered into the private space of your household. A frictionless flow of consumer desirability and sovereignty, territorialized and striated by the flow of capital inscribed by the corporate sovereignty of MSN.

As a final example of such spatialized discourse, in another ad for the Microsoft Network—this one found in *Time*—the reader is faced with text that asserts, "The Microsoft Network lets you compare and book airfares to **anywhere** without hearing a single note of Muzak." There is the same hierarchical structure of depth and linear perspective as with the previous MSN ad. In the foreground is *you,* the consumer/traveler. In the background is a wide open but recognizable landscape of the Grand Canyon. Mediating between the two is once again the MSN home page, with the "Essentials" menu pulled down to the only option available under travel, Expedia, MSN's travel info database. Indeed, for Bill Gates (1996) it is the seamless ease with which the prospective traveler is able to orchestrate his real-world itinerary through the Web that is a key feature of "friction-free" capitalism. Here we see the same double movement as in the previous MSN ad, but with a different valence. Here the emphasis is on a literal and figural line of flight that will take the con-

sumer anywhere she wants to go today. Hence, the interesting use of the Grand Canyon, an unpeopled landscape with a vast horizon, a spatial metaphor for the myth of the frontier as a limitless territory yet to be mapped, plotted, and emplaced. The consumer/tourist is folded into the smooth space of autonomous travel (she decides place and destination), yet folded into the striated space of Expedia and expedition, the instrumental rational ritual of fastest and most efficient utilitarian ritual of cash/commodity exchange and exploration. No noise, no Muzak, no waiting—just the smooth and frictionless articulation of consumer desire and the preferred itinerary and telos of travel, provided by MSN. As with the "CD store" ad, this ad promises the consumer that he can stay within the comforts of home and completely ignore the normal problems of purchasing (e.g., pushy sales people, long lines, Muzak interludes).

Just as cyberspace is offered as providing a zone of music rather than noise, of what we already know over what we might hear otherwise, it also provides us with a space without bodies—where differences have no meaning, where everyone can share in the utopia of the American dream of individual progress. The utopia removes all impediments to individual success and fulfills all our desires, and the only way to get "there" is through the movements of a corporate transport ship, a movement from here to there through corporate travel. Only through the music of our existing capital structures can we reach the utopia moment seemingly promised to us since birth.

CONCLUSION: CIPHERING (IN) THE NEW WORLD

As we noted earlier, in their discussion of the discourse concerning the "new world" of cyberspace, David and Ann Gunkel argue that the new world, because it is based on the "conceptual domination of the old," provides us with a world that has the same sights and sounds, the same values, as the old (1997: 124). Hence, as we approach this new world (*any* new world, for that matter), we most readily look at it through the interpretive screen we use to understand our current world. Given this, and given what we have seen in our investigation of where the Internet is currently situated, the critical task should be a familiar one. When Gunkel and Gunkel note, "What cyberspace becomes will, to a great extent, depend on what we call it" (1997: 133), they are echoing in many senses Haraway's call for "noise" over music. Indeed, when Haraway

notes that while changes in media create changes in ontology and epistemology but that these changes are also shaped by our "world changing fictions," our "building and destroying machines, identities, categories, relationships, space, stories," she is calling on us to break down the obvious, to make noise where there is music, to "strike fear" in the expected. If indeed cyberspace is going to provide more than a disembodied utopia in which all "otherness" gets born in the sameness of difference, more than an era in which corporate capital is the only clear winner (Deibert, 1997: 206), we must help create the new world in ways that differ from the old, that disrupt its values while recognizing the material changes in ontology and epistemology. As Jean Baudrillard, in his recent move toward a less celebratory, more prescriptive concern with new media technologies has noted in prescribing the critical task, "Cipher, do not decipher. Work over the illusion. Create illusion to create an event. Make enigmatic what is clear, render unintelligible what is only too intelligible...." (1996: 104). In other words, create noise were there is music; make visible the multiple voices of democracy when they are being subsumed, make obvious the workings of capital; when given a picture of a utopian zone of friction-free consumption that does not illustrate those whose work is exploited, rewrite the image.

As the manifesto of cyberspace and cyborgs plays itself in popular film, in the tragedy of Heaven's Gate, in cyberpunk fiction, and in commercial advertisements for the World Wide Web, the job of critics must be to add some shape, some commentary to the way the discourse of the future will be shaped. Our concern in this chapter is that within the various utopian/dystopian views of cyberspace, industry slides free as merely the vehicle to the disembodied perils and promises of the Web. We seem to either be faced with a dystopian vision in which cults lead wayward minds into suicidal plots and in which our children find their way to the most offensive forms of pornography, or we are faced with a utopia in which Internet providers allow access to a friction-free zone of capitalism in which no one is hurt, prejudice overcome, the dustbin of capitalism forever placed not only out of view but out of order. As social critics, it is imperative that we join in the discursive struggle over what the Web will be, to make visible that which slides away imperceptibly through the utopian discourse of cyberspace. A very different red alert must be sounded.

NOTES

1. Information about the case can of course be found in a variety of news sources at the time of the event. More, one can still look at mirrors of the group's web page. For a standard news account, we would suggest *Time* magazine's April 7, 1997, issue, which has eight different essays about the group (or related issues), including a lead article that covers most of the major issues of the case (E. Gleick, 1997 : 28–36). As for websites, a search on any of the major search machines will turn up a number of mirror sites. One that we could recommend would be http://www.disinfo.com/prop/media/hgate/

2. We will be employing terms like *cyberspace* and *cyberspace technologies* fairly loosely throughout the chapter in order to refer loosely to the computer communications environment as it has commonly come to be understood and used publicly, including web pages, e-mail, chat rooms, and so forth.

3. It appears to us that in the academy, the discourse about cyberspace technologies was fairly uniform in its celebration of its transgressive possibilities initially and has since become reserved. In popular culture, there is simultaneous praise for its possibilities of "making life easier" and fear of "addictions," "pornography," or "abductions."

4. One cannot help but note the similarity of this quotation with Susan Bordo's (1993) criticism of Donna Haraway's "Cyborg Manifesto," a criticism subtitled "The 'View from Nowhere' and the Dream of Everywhere." While we suggest that this essay be read in full, she is simply arguing that arguments that complicate the "body" or "identity" by deconstructing its naturalness often then attempt to suggest a playful postmodern space in which identity can always slide away to another place. Bordo claims that such positions are not only logically unfeasible but allow no single place from which to speak. If we are everywhere, we are nowhere. Hence, while Bordo sees gender and all identity as necessarily elusive and not on solid ground, she also argues that we cannot "live" completely fluid existence.

5. We should be careful to note here that we are discussing public (i.e., mass-mediated) discussings of cyberspace here and not necessarily academic arguments, many of which are informed by poststructural discourses that do indeed posit permanently partial identities, contingent truths, and so forth.

6. In McLuhan's (1964) groundbreaking effort, *Understanding Media: The Extensions of Man*, he notes that all media forms should be seen as working to both amputate and extend humans in the form of the new technology (11). It seems clear to us that here and elsewhere McLuhan

was observing the ways in which media technology both extends (as in the subtitle of the work) humanity's reach in space and time, but simultaneously transforms what it is to be human, and, in that way, expels traditional *meanings* of humanity.

7. While we will only provide a few examples of such advertisements, we take these to be what Kenneth Burke (1945) calls "representative anecdotes." That is, these advertisements fit the overall tenor of advertisements for Internet providers that we have encountered over the last several years. These are not simply handy examples, but ones that we think illustrate a general discourse.

8. Ironically enough, Mark Poster's (1990, 1995) distinction between the Mode of Information and the Mode of Production comes close to duplicating a space for Gates's friction-free capitalism.

9. By "original Borg," we are referring to the Borg as it was represented in its first two appearances on *Star Trek: The Next Generation* ("Q Who?" and "The Best of Both Worlds" parts I and II) and not as it became more humanized in later episodes and in the film *First Contact*.

10. This is a nod to Michel de Certeau's (1984) "walking in the city" metaphor.

5

❯ FROM: DAVID TETZLAFF
❯

❯ SUBJECT: **Yo-Ho-Ho and a Server of Warez**
❯ Internet Software Piracy
❯ and the New Global Information Economy

WHERE IT'S AT: WHY THE WEB RULES THE INTERNET

The Web may not yet be the financial success that so many venture capitalists are anticipating, but it has certainly been a phenomenon in cultural terms. While it may not quite be true that everyone has a website, or even that everyone surfs the Web, there is little doubt that almost everyone knows something about it, and more important, recognizes the Web as carrying some sort of social significance. A quick look at any indicator reflecting the public consciousness—newspaper and magazine articles, the bookshelves in the local Borders or Barnes and Noble— shows that the Web thoroughly dominates discussion and thought relating to the larger landscape of computers and new media. In casual conversation, the Web has usurped the name of its larger technological environment, the Internet. We say, "I was Net surfing," or "I found it on the Net" when we are actually talking about the Web.

Of course, the Internet is much more than the Web. There are MUDs, LISTSERVs, USENET, IRC, and so on. But in many ways these technologies and the cultural practices that sprouted around them are the Old Internet, the Before-Web era, the pre-history of New Media. They're all still around, but they no longer have the buzz, and they certainly garner only a fraction of the attention that falls to developments in the land of your-business-

here-dot-com. The Web comes to us amid a lot of hype about interactivity and user involvement, but compared to the Old Net, it's actually a movement in the other direction. The Old Net was focused on highly interactive forms, with personal involvement on both ends, while the Web is basically a form of electronically enhanced publishing that has more in common with traditional mass media forms than it has differences.

The Web *is* significantly different from more established media in terms of access on the presentation end. Anybody with a personal computer can put up a webpage. Many Web "portal" sites now host personal webpages for free, though almost all of them place some sort of advertising on the "free" page. Not that putting up an ad-free page is prohibitively expensive. Many "traditional" ISPs now include a chunk of server space for a website as part of their standard service package—usually available for $20 a month or less. A number of personal, even idiosyncratic websites have attracted a lot of attention—the most notable case being the rise of Matt Drudge from Web gossip-page author to mainstream TV pundit. But this wide-open mediascape is not so new and different as it may appear, and it doesn't necessarily signal some sort of shift of power away from central authorities toward the common folk. One precedent lies in the early days of radio, when much of the signal available was transmitted by hobbyists. These amateur broadcasts found many listeners among the rapidly growing radio audience because it was all new and because, well, there wasn't much else to listen to. Yet, once the government organized the spectrum to clear the way for professional broadcasting, commercial radio began to grab increasing shares of the audience by providing entertainment and production values the hobbyists could not match.

Fast forward now about fifty years. When Sony introduced affordable small-format video equipment—around the same time that cable television started to grow and municipalities required franchisees to provide public access channels on their systems—many media activists predicted a revolution. Not only could anybody become a producer, they could also put their work before the public! That was twenty-five years ago. The mass audience never took much of an interest in public access programming. While the number of cable channels offered has continued to increase, the number of access channels has shrunk, with little public notice or complaint. Access TV was just "bad TV"—dull, awkward, unprofessional. Commercial broadcasters were able to define *radio* and

TV on their own spectacular terms because their voices were louder, and they were able to reproduce themselves into omnipresence via national networking and advertising.

Much the same thing is happening on the Web right now. Why was Internet publishing mainly an academic domain before the Web? Why has the Web turned the Internet into a commercial phenomenon? Why are countless software developers creating new tools for Web graphic production and Web animation?

The Web introduced the possibility of visual spectacle to the Internet. The original idea of the researchers who developed the Web was simply to enhance the information value of documents by including pictures and tables in-line, but clever coders figured out how to hack HTML table structures in ways that allowed webpages to be almost as fully designed for visual appeal as pages in *Wired* or *Raygun*. The number of sites that display plain text on a browser neutral-gray background has shrunk as fast as the number of sites that feature attractive design has exploded. Each new iteration of HTML moves further from the original conception of simple documents and enables greater richness in visual content. Not that I'm complaining—the fact that a wider range of aesthetic devices can now be applied to Web design is the reason I have a job, and the new technologies open opportunities for independent artists, as well as corporate marketing departments.

However, with the Web becoming redefined in terms of visual pizzazz, most individual webpage authors attempting to compete with corporate voices wind up playing a game they cannot win. Under the rules and definitions the Web has already adopted, the "best" sites—the ones that look the sharpest, perform the most tricks, have the most bandwidth—will belong to the people that have the most resources to spend on these things. It's not just that amateurs don't have the talent or the money to operate at this level, it's that they don't have the time. The original HTML was a relatively simple tool that anyone could learn with a minimum of effort. In contrast, if you open the source code of a typical slick-looking corporate page today, you see all kinds of Javascript or other forms of programming gobbledygook that testify not only to the presence of specialized and cultivated expertise, but to many hours of labor.

The Web is likely to become stratified between the public and the personal—evolving into different forms that will just happen to share the same transmission channel, in the same way that television and home

video just happen to share the same underlying technology. The current business model of choice on the Web is the "portal," which attempts to leverage all the various types of content offered on the Web by providing an organizing guide within which advertising space can be sold. I suspect the basic premise of the portal—sites created by individuals become the raw material for large profit-making sites, based on their suitability for the sponsor's purposes—will become a more general model for the access of noncorporate sites. That is, people will continue to make personal pages that will circulate the way snapshots or home videos do now—through networks of family and friends who will be e-mailed the URLs. This private realm will occasionally be tapped as a resource by higher-traffic, profit-oriented sites in much the same way that footage of tragedies finds its way onto Fox Network specials and footage of pratfalls finds its way to *America's Funniest*—that is, framed and contextualized within mainstream entertainment terms.

The ascendance of the Web continues a diffusion of focus that has been going on for some time in our media culture, with the proliferation of magazines, cable channels, and all varieties of specialized subcultural marketing. This is not necessarily a progressive development. In fact, diffusion of content and audience may actually be one of the mechanisms on which concentration of power is constructed. The Web is a mass medium for a fragmented postmodern culture—a mass medium without an actual mass, at least in the sense that millions watch the same TV show at the same time, or see the same movie during the same opening weekend. There's a mass of people online at any time, but they're all off in their own special little corner, the total audience scattered across the multiple nodes of the Web. Yet, at each node, the rules of engagement are not only remarkably similar to each other, but remarkably similar to traditional media: Show me a picture! Show me a new trick! Cool! The Web has actually pulled Internet use away from the interactivity of the Net's old text-based forms toward a more visual, individual form that better articulates with the TV-dominated culture of the Society of the Spectacle. This movement directly correlates to the Web becoming a safe home for capital.

As we attempt to theorize the social and cultural trajectories of the Web, we ought to compare it to forms of communication that work differently, to draw contrasts that can help us understand the character of the Web by opposition. I suggest the more revealing contrasts are not

with conventional mass media, but with other forms of Internet communication—most of which, unlike the Web, developed outside the parameters of the profit motive. In the remainder of this chapter, I will consider practices in the "computer underground" in a location *off* the Web, not only to analyze their cultural politics in their own right, but also as a means of illuminating the politics of the Web by comparison.

WAREZ THAT: AMONG THE INFORMATION OUTLAWS

I spent quite a bit of time in the spring and summer of 1998 in a hangout frequented by a host of international criminals. While a few people dropped by this place to do legitimate business or just to visit with friends, the vast majority of goings-on there were illegal. The law calls it theft, and companies who say they are its victims claim that their collective losses amount to over $11 billion a year. Some go so far as to say that these activities threaten the very basis of the new economy, yet few of the desperados I encountered displayed any qualms about their actions. I experienced all of this, yet I never left my office the whole time.

I was logged on to the Internet using a program called Hotline, and the criminals with whom I was keeping company were "warez" hobbyists. *Warez* is slang for pirated software, copies of commercial programs that are illicitly passed from individual to individual, with no sales fees returned to the publisher. (Using 'z' for plurals, substituting characters of similar shape for letters—using *3* for *E*, for example—and randomly aLterNaTinG uPPerCaSe and lOwErCasE letters are graphic tokens of the warez subculture, especially common among its more youthful members, though now often derided as juvenilia by more mature pirates.) The $11 billion plus per annum figure is the software industry's estimate of its worldwide loss to piracy. However, only a relatively small percentage of this can legitimately be attributed to warez. Most piracy is more organized and entrepreneurial. Businessmen in "third world" countries duplicate all sorts of software and sell the unauthorized copies openly in supermarket-type stores for a small markup over the cost of the disk itself (Neumann, 1995). Domestically, the software publishers have discovered that many corporate information system managers simply duplicate a single copy of software onto all the PCs spread throughout their firm, avoiding the requisite site licenses for obvious savings on necessary productivity tools (Fryer, 1995).

In contrast, warez activity is more personal and less profit oriented.

Warez collectors usually either barter exchanges with each other—I'll send you a copy of Illustrator 8 if you send me a copy of Unreal—or simply post files in public places for anyone who comes by to download. A few people offer to sell custom home-burned CD-ROMs of selections from their collections, but they usually justify the fee as a below-cost recompense for the time it takes to make the CD. Still, the practice of charging any form of actual money is frowned upon by most members of the warez scene. I refer to them as "collectors" because warez enthusiasts generally acquire large libraries of software, most of which they have no desire or ability to ever use. This distinguishes warez trading from the more informal, face-to-face instances in which someone passes a useful or entertaining program to a friend. Trading warez is not something its participants only do every now and then. It's a full-blown avocation that takes up a considerable amount of time.

Even though profit may not be involved, software publishers still see each illicit copy as a loss, and express great concern over warez, at least publicly. In fact, most of the advertising and promotion offered by the two industry groups that wage antipiracy campaigns—the Software Publishers Association (SPA) and the Business Software Alliance (BSA)—is directed at individual end users rather than wayward corporate IS departments. The publishers think people just don't understand what an evil thing it is to copy software. They want to set us straight. However, the Hotline Community—which is how its users refer to themselves—has heard the sermons and the warnings, but pays them no mind.

My investigation of warez was spurred in part by an article that appeared in *Lingua Franca* in March of 1998, reviewing the work of scholars who have been reassessing the cultural politics of the real, historical pirates of the Spanish Main. The author, Lawrence Osborne, writes that instead of viewing them as "the biker gangs of the eighteenth century" some historians now "laud pirates as proto-revolutionaries, heroic proletarian rebels fighting the brutal oppression of the emerging capitalist world order"—not merely outlaws, but subversives (1998: 35).

What about warez, then? How far can we go with this pirate metaphor? Is there a politics in software piracy, too? Is the action on Hotline just make-believe defiance, or a real subversion of power? If it does challenge authority, how does it do so? I will offer some tentative answers to these questions toward the end of the chapter, but first a bit of description of the practice in question would seem to be in order.

PICK UP THE HOTLINE

When I started to get curious about warez, I did what any typical new-media-savvy cyber-citizen might do: I queried Alta Vista and started surfing the Web for relevant sites. The search engine turned up a lot of hits, but the sites they linked to contained precious little information, much less any actual software. Most Web warez pages are just a series of links to other pages that are themselves merely lists of links, with a few links to FTP servers that turn out to be dead or password protected. Eventually, I discovered a few sites dedicated to "Hacking and Cracking" that contained some bits of useful information about the computer underground, but only limited amounts. These sites typically had an air of self-censorship. Finally, one of the webpages clued me in: Get off the Web and get on Hotline.

Warez distribution occurs in a variety of Internet forms. Programs are archived, the archives are sliced into small sections, and then uploaded into USENET news groups in the form of binary files. According to *Wired,* nine warez groups account for between 30 and 40 percent of all USENET traffic (McCandless, 1997). Barter exchanges are usually conducted via IRC, with traders using a program called ICQ ('I seek you') to locate one another, or in chatrooms on AOL. Another method is reminiscent of the techniques pioneered by legendary "dark side" hacker Kevin Mitnick: a pirate will gain FTP access to some forgotten space on a server belonging to some unsuspecting institution, upload a bunch of files, and let the members of his circle (and it is usually a "he") know the IP address or Internet address so they can download away until the illicit activity is discovered and closed down by the system administration.

Hotline—a general purpose Internet communication package distributed as shareware—is the preferred tool of the Macintosh underground, and is easier to master than the other warez tracking methods. Although its publisher promotes the software as having a variety of legitimate uses, the vast majority of traffic on Hotline at present involves some kind of illicit activity. In addition to warez, Hotline is also buzzing with the distribution of MP3s (compressed audio files bootlegged from commercial pop music CDs) and various forms of pornography. You might forgive the pirates their "misuse" of Hotline, though, since the software seems designed to be a perfect tool for underground exchanges of data. Hotline has two components: server software that lets any computer con-

nected to the Internet act as a readily accessible source of files, and client software that lets users connect to these server computers, exchange messages, and download files. Hotline servers offer a variety of functions, including public chat, private chat, and a news message board. The main attraction, though, is Hotline's file transfer capability, which allows downloads or uploads to be resumed after an interruption. You can download part of a program one night, and if the server shuts down before you're finished, you can find it the next night and pick up where you left off. The software offers users an easy means to find the cyberspace location of any Hotline server that wants to be found. Hotline servers can set themselves up as tracking servers, known simply as Trackers. When the Hotline user accesses a Tracker, a list of all the servers whose operators have allowed themselves to be tracked appears in a window.

One of the benefits of the Tracker system is that it relieves server operators of the requirement to maintain a static IP address. They can have their IP assigned dynamically, appearing at a different location every time they boot up, but the Tracker will still locate them and users can identify them by name. This makes it considerably more difficult for anyone to locate the server in the real world—to file a piracy complaint with the SPA or the operator's ISP, for instance.

A few Hotline servers are "public," meaning they let anyone log in and download. These are usually very busy, with long waits for download slots to open. In contrast, the majority of servers are "semi-private," letting anyone log in to post messages and look around, but restricting file downloads to "members" who have obtained a password. This system allows Hotline to operate as a sort of autopilot version of the software barter system. The server operator makes the contents of his collection available for all to see. He asks that anyone who wishes to obtain some of these files first transmit to him some useful file he does not yet have. Upon receipt of a worthy file, the administrator will grant a password account to the uploader. This isn't just a matter of greed on the administrator's part, it also reflects a group ethic. If you would take, so also must you give.

USERS AND GRATIFICATIONS

Denizens of the computer underground fall into a variety of descriptive categories: hackers, crackers, pirates, and the warez elite. The term *hacker* originally referred to someone who improvised computer hardware or modified existing software to perform a special task. However, as

computer development moved into the bosom of corporate America, the spaces left open for legitimate individual manipulation began to narrow. Now *hacker* refers primarily to people who break into someone else's computer system, either to copy off-limit code, or to alter the way the system functions. Hackers may acquire warez, but the free use of commercial software is not their main concern; their interests lie primarily in gaining access to forbidden systems, and occasionally on creating mischief once inside. A hacker's skills are only partly based in computer science. "Human engineering," the ability to find passwords and other key information by presenting a false identity on the phone or looking through trash, also plays a role. More pure programming skill is found among *crackers*, who devise methods to defeat the copy-protection schemes used in many expensive graphics and multimedia programs. Their work is usually distributed in the form of *cracks* (abbreviated [k])— small programs that alter the code of a standard copy of the software so it no longer requires a serial number or asks for a *dongle* hardware key. There aren't that many true crackers, and the warez community depends heavily on their largesse in making their cracks available.

For every true cracker or hacker there are countless numbers of mere pirates—a pirate being anyone who obtains software illegally on any kind of routine basis. Being a pirate doesn't require anything in the way of programming skills, just a somewhat-more-than-basic grounding in computer and Internet literacy. Run-of-the-mill pirates are usually distinguished from the warez elite—enthusiasts who not only have the largest collections, but are also well connected within the larger warez online community, and who often provide the initial copies of the software that then spread out from server to server and trade to trade.

Warez pirates are mostly male, and mostly not involved in any kind of serious illicit activity offline. Though a fair number of pirates are in their twenties, thirties, or even forties, the archetypal warez trader is a teenage boy. He uses warez channels to check out the latest game releases, or to obtain a graphics program he wants to learn, but the getting and the having mean more than the using. After interviewing Jake, a fifteen-year-old

pirate, *MacWorld*'s David Pogue (1997) reports, "Warez are like baseball cards; their value is the prestige of ownership." This prestige is conferred within the warez subculture, as traders go online to compare their collections with those of their peers. However, by my observation, the primary gratification in warez is simply the action of locating and downloading the forbidden file.

Hotline can be as absorbing and time-consuming as *Myst, Doom,* or any other good computer game. Pirates spend hours on end trolling the trackers, searching for new downloads. We might describe Hotline as a sort of MUD with less chatty participants and a heightened reality effect. As in a MUD, everyone on Hotline enters under an assumed identity, which may or may not reflect their real-life persona. Each server is a "room" in the larger Hotline environment, and each administrator is a wizard. The open public rooms are crowded and chaotic, and the more interesting and productive experiences come in the more private rooms. You may need to hang around a bit and discover the local rules in order to get into a room. More likely you will need to search other rooms in order to find a magic object that will act as a key to the new room you want to enter.

Of course, in terms of pure play action, roaming around Hotline in search of some new file—and then waiting minutes or hours to finish a download—is pretty dull. The thing that makes it exciting is the forbidden quality of its prizes, the values and restrictions that come from outside the computer in the "real" world of stores and cops and federal legislation. A MUD becomes a fascinating pastime because users agree to invest its ephemeral tokens with a reality effect. Hotline becomes a fascinating pastime because Bill Gates and Al Gore have invested its ephemeral tokens with a reality effect. There's a feeling of empowerment that comes with beating the system. The thrill rises with the stakes—there are real government agents who could conceivably come and arrest you. Yet the possibility of this seems remote, somehow (which it is) because you are just sitting in your private space, sending signals across wires.

BYTE IT: LAW AND ORDER IN CYBERSPACE!

As Jake, the fifteen-year-old pirate with a $200,000 software collection puts it, "If I steal your dog, then I've got your dog and you don't. That's theft. But we're not taking anything away from anyone!" (Pogue, 1997).

The software industry replies—not without a certain logic—that each act of piracy takes away a chance for them to make a sale, robs them of their right to compensation for their products.

The BSA and the SPA don't break down their figures on piracy losses to estimate what percentage occurs due to warez. They just bring out the same dramatic global numbers whenever any sort of piracy is discussed. Numerous articles about warez published in the computer press feature the $11 billion per annum figure prominently. One news brief in *Wired*, though, noted that of that estimate, only $2.3 billion comes from domestic piracy with the rest occurring overseas (Eno, 1997). The SPA also estimates that 40 percent of the software used in major businesses in this country is installed without proper licenses. That represents an awful lot of lost revenue, and would leave but a fraction of the $2.3 billion to be laid at the feet of warez trading.

It's a matter of some contention, however, whether warez constitutes a real loss to software publishers at all. The software industry counts every illicitly reproduced copy of a program as a lost sale, and calculates its estimates of lost dollars and jobs accordingly. While this makes sense for business software improperly installed in employee cubicles—the workers need to use it and the firm could muster the resources to buy it—warez offers a different case. The average warez collector is pursuing a hobby. With the exception of a few games, there is probably nothing in his collection that he would buy if he couldn't obtain it for free. Some warez pirates do have more pragmatic ends. Computer graphic software packages, including specialized 3-D rendering applications, are among the most widely circulated warez, sought by collectors of all sorts. But a good number of pirates are using these programs in attempts to begin a career in design or animation. These are mainly high school and college students, learning Photoshop or Lightwave in their spare time, or struggling contract workers trying to make ends meet. As one pirate explains,

> i want to either code or do graphic art when i grow up. problem is, the programs that professionals use for both these fields are very expensive (i.e. photoshop/painter 500–600 and codewarrior is in that area too). now, how am i going to effectively learn these skills? i could take a class, but as soon as i go home i can't sit down at my mac and key in some code or edit a picture of my dog. hmm ... what if i had the software we use in class at my house? fine, i cant buy it, ill pirate it. i learn

the skills and set myself up for a good job. some ppl say this hurts software companies, but if im not going to buy the software in the first place, whos the victim? (post to "The Warez Ethic" news by nail 3D)

Even the struggling graphic artist who purloins an illegitimate copy of SoftImage or Maya may be doing the industry more benefit than harm. Peter Plantec (1998), the animation columnist for the trade magazine *AV Video Multimedia Producer*, recently noted the value such people have to the industry. Plantec observes that warez helps renew and sustain the professional field that publishers tap as a market, and thus warez can actually be seen as generating profit instead of loss. He reports, as do many Hotline posts, that once animation and design workers become successful, they typically buy legitimate copies of the software they use regularly. Michael Surkan of *PC Week* writes: "It's long been one of the computer industry's best-kept secrets that not all piracy is bad. To gain market share, it's useful to have as many people as possible understand your software.... I've heard of large (very large) companies uploading applications to pirate bulletin boards in Third World countries to help gain market penetration" (Surkan, 1998). In other words, piracy allows publishers to avail themselves of the Id/Netscape/Internet Explorer strategy of gaining users and attention through giveaways, while relieving the publisher of the necessity of seeming to downgrade the value of the product by declaring it to be available for free. Perhaps this helps explain why, despite the software industry's public expressions of deep concern over warez, the chances of warez collectors facing significant consequences for their crimes are quite small.

Pirates don't really understand how the SPA and BSA operate, and that appears to be the way the software cops like it. Hotline posts indicate that warez traders believe the SPA exists primarily to combat their activity, and that it is somehow affiliated with the government and law enforcement agencies. Neither of these are true, but the SPA and BSA are publicly vague and close-to-the-vest about their activities. Their websites frame their policies and practices in the most general of terms, and though their archived press releases document the occasional civil judgment or more occasional criminal conviction, there are no indications of how many people are employed in antipiracy investigations, what methods they use, how they identify targets, or how many cases they pursue within any time frame.

In truth, the SPA and BSA are private, for-profit organizations. Both are general trade groups, engaged in lobbying and other typical industry group activities in addition to antipiracy efforts. The BSA was created by Microsoft, Lotus, and other large publishers who felt the SPA was too responsive to the needs of smaller publishers at their expense (the SPA has supported the Justice Department in the Microsoft monopoly trial). Yet, in terms of antipiracy campaigns, they share similar policies and issue joint reports on the dire state of software theft in attempts to influence legislators to pass more restrictive laws. These attempts have been quite successful, culminating in the passage of the federal NET (No Electronic Theft) bill in late 1997.

Yet neither organization is primarily concerned with seeing pirates thrown in jail. Instead, both groups support their broader activities, and turn a tidy profit besides, by pursing civil court cases against corporate pirates. The SPA and BSA have managed to forge a deal with the publishers in which they go after miscreant firms in the publishers' name, but get to keep anything they win in judgments compensating for unpaid fees. In other words, the thieves have to pay the cops, not the company they bilked in terms of reproducing unlicensed copies. Computer journalist Jeff Tarter notes, "They come out of every raid with a sack full of money. They turned piracy into a cash cow" (cited in Fryer, 1995). The BSA, "with no more than 36 employees and three offices worldwide," expected to recover $7.5 million in 1998 (Eno, 1997). It only takes one disgruntled employee and a quick call to a BSA or SPA anonymous tip line to blow the whistle on a corporate violator. Investigators from these groups are likely to be too busy trying to line up the next big corporate score to worry much about warez traders. Hobbyist pirates are a lot harder to identify, much less likely to be turned over by stoolies, and, most important, there is no immediate profit in chasing them down.

Of course, every once in awhile the industry needs to come down on an individual pirate to keep its image up. Since there's no profit potential here, only easy targets are likely to get stung—namely, people operating high-traffic, wide-open public sites. One case of this type that received a lot of publicity involved Microsoft filing suit against Chris Fazendin, a twenty-four-year-old worker at a prepress company. Fazendin had posted a crack for Office 97 on his website. Microsoft subpoenaed the logs from Fazendin's ISP, and sought to make him repay the $345 cost of the program for each instance of the crack being downloaded from his

site. Of course, Fazendin had nothing like that kind of money, and after milking the case for the appropriately punitive publicity, Microsoft dropped the suit in return for Fazendin surrendering his 486 PC and promising never to do it again (Frauenfelder, 1998).

A warez pirate is much more likely to get in trouble with his ISP than with the SPA itself. In fact, this is how most pirates get shut down. The ISP discovers warez are being exchanged, and demands the pirate shape up. There's nothing an ISP can do but tell the user to stop, threaten to drop the account, and call in the SPA or BSA if the bad conduct persists. On receiving a warning from the ISP, which usually arrives in the form of a "cease and desist" letter, the pirate—who probably already has more software than he could ever use already squirreled away—generally decides the hobby is no longer worth the hassle and goes looking for a new pastime; warez pirates are not die-hard buccaneers fighting to the last breath. It's important to note, though, that the warez traders who get busted are inevitably people who operate servers, webpages, or some other relatively organized site of distribution. I have encountered no reports of the BSA/SPA, an ISP, or a publisher pursuing anyone for downloading warez, only for offering files for the taking.

The actual state of enforcement against warez—the worst that's likely to happen is you lose your Internet connection and stop "dealing"—stands in stark contrast to the principles embedded in the increasingly restrictive federal legislation governing intellectual property. The NET law makes infringement of $2,500 of software a felony punishable by fines of up to $250,000 and prison terms of up to five years. Prior to the passage of this bill, the legal system operated with a logic corresponding to the pattern of SPA stings—only corporate copiers and people who resold bootleg reproductions for profit were in real danger. In the precedent-setting case of *U.S. v. LaMacchia*, the court dismissed a criminal prosecution against an MIT student who had used the school's servers as drop sites for Internet piracy because no money had changed hands and no profit motive was involved (McCandless, 1997). The NET law eliminates the "LaMacchia exception" and the future possibility of such dismissals, specifically stating that redistribution for profit does not need to be involved (Rodger, 1997). The mere act of copying is now the crime. A lot of otherwise harmless teenage boys have thus been officially categorized as dangerous felons.

PIRATE PHILOSOPHY

Despite the new laws, and the antipiracy campaigns of the trade groups, most warez traders don't believe they're doing anything wrong. However, a certain number of younger pirates *embrace* the notion that their trading is criminal; call them the "gangsta tradahz" (The rap-derived alterna-attitude is witnessed by the large number of Hotline servers employing the word 'pimp' in their title or description). What better scene for a teen to stage youthful rebellion than to engage in criminal acts that cause great gnashing of teeth in government and industry yet cause no physical pain, pose the ever-present threat of punishment but with very little risk of follow-through, and don't even require the rebel to leave his room?

Still, on the whole, the Hotline Community does have community values, a shared ethic, centered on the almost universal denigration of *leeching*—that is, downloading large quantities of software without uploading anything in return. Most Hotline users leech most of the time—in part because most servers are well stocked enough that it's hard to add something new. Yet, almost everyone on Hotline acknowledges that constant leeching is bad form, and that being a good member of the Hotline community means uploading a file every now and then. The more you contribute to the general welfare, the better the subculture allows you to feel about yourself.

Furthermore, many warez pirates, perhaps even most of them, hold to the idea that everything on the Internet ought to be free. That is, they advance some form of libertarianism, anarcho-syndicalism, or even socialism applied to computing, data processing, and information exchange (though not necessarily to "real life"). Cyberlibertarian or cybersocialist ideals do wind up in conflict with certain pirate motivations and practices. This is evident in the biggest continuing topic of discussion on Hotline, the merits of free servers and completely open dissemination of warez versus private servers and limited distribution to a small circle of friends and associates. On one side are the elite pirates and crackers who fear their labors will be wasted or wrecked if anybody can easily get their hands on illicit information. On the other side are the administrators who let anyone come in and download what they please. If this means traffic is too heavy to make the server usable most of the time, or if it means an increased likelihood of the server catching too

much attention and being forced to shut down, or if people don't use the files they take with discretion—well, nobody ever said freedom was perfect, but it's still the right thing to do. In the earlier days of my observation of Hotline, the outstanding cyberlibertarian site was a server called The Commune, which included a library of literary, philosophical, and political works and an extensive collection of fine art images in its file archive, along with an excellent selection of warez. Sure enough, after awhile the volume of traffic on the server alerted its host ISP to possible misdeeds, and the site was forced to shut down.

Although it, too, eventually disappeared, for much of my time on Hotline, discussion of the philosophy and politics of warez was solicited and housed by a server labeled The Warez Ethic. This site offered a modest collection of warez for free download, but since it operated on a slow modem connection, it was hardly a center of trading activity. The news, though, contained a long list of thoughtful posts that, judged by the one thousand or more daily "hits" reported by the administrator, attracted a significant number of readers. The relative popularity of this site is significant in that users don't come to Hotline to write philosophically, they come to pirate. However, the posts on "The Warez Ethic" showed that pirates also think. Discussions on the server spread to such varied topics as pornography's relation to freedom of expression, comparisons between Bill Gates and Hitler, Microsoft's monopoly position, Saddam Hussein, and conspiracy theory. However, the central topic was political philosophy in connection to piracy—with comments fairly quickly moving from concrete discussions of warez to more abstract considerations of ethics, morality, and justice. The seventeen-year-old administrator, who went by the handle 'NoahNelse,' framed the discussion with this statement of his ethic, which appeared at all times at the bottom of the news window:

> We are at the dawn of the technology gap. This gap has begun to separate those who can afford technology and those who cannot into two distinct classes. It is the role of pirated software to close this gap—to make the technology and information that will determine the future available to everyone. And it is this cause the Hotline™ community should be working toward—the cause of freedom of technology and freedom of information.

Those who chose to limit who can access technology and information for their own gain are doing a disservice to this cause. I envoke you to do your part in the freedom of all information and technology by distributing for free anything that is sold and not limiting this distribution to anyone. Everyone deserves access to technology whether they be wealthy or poor, Mac user or PC user, and Hotline™ is only the beginning of a revolution that will guarantee that everyone has the access they deserve. By letting small differences divide us, we are only hurting the coming revolution. I ask you to feed the revolution, free the technology, share the information, and do nothing to support those who would hurt this cause.

Debate on "The Warez Ethic" was generally engaged between different liberationist perspectives. Where NoahNelse might find inspiration in Gandhi, another post might advocate a more militant stance:

Marxism is dead. Good! Marx didn't like it either. But cl@ss war persists; it intensifies daily with the conglomeration of the world's resources in banks and robber baron pockets. Class war means taking power over the means of reproduction (whether it's a printing press, distribution agency, birth control, radio station, or software) out of the hands of the very few and putting it back in the hands of the many. Warez are one way of doing this. Maybe a small one, maybe a historically crucial one. History is often changed by the forceful or diplomatic will of a few, and control over society's means of production and reproduction. Crack the power! (post to "The Warez Ethic" news by makako)

A few posts, however, derided all of these ideas as hypocritical rationalizations.

We should stop justifying theft to one another in the guise of morality and/or ethics. We KNOW what we are doing is wrong, yet we continue not because we have a need for the software we use, but because we want it. Stop lying to yourself and others. We are thieves and that's all there is to it ... So, stop couching your theft of someone else's property behind hackneyed phrases such as freedom of information and the like. We live in a capitolistic society where the almighty dollar is

God. Without it, none of you would be here to download or use any of this stuff anyway. You'd be busy pounding your clothes in a stream somewhere trying to get the skid marks out of your drawers... Stop being a victim to yourself and soon, others will cease to treat you like one. (post to "The Warez Ethic" news by Big Daddy PC)

Such bully-boy, dog-eat-dog philosophy is rare on Hotline, but it raises a question about those teenage pirates and their 'gangsta' attitude. What will happen as the rebellious warez pimpz grow up? Will the absolutist posture of SPA/BSA rhetoric and its legislative reflection in the NET lead them to harden their criminal identity? Will they make "I guess I am a criminal. Well so be it. Tough shit for you" a philosophy for life, instead of just a pose for adolescence? Or will the acknowledgment of the illicit status of warez built into their current rebel pose simply lead them to more readily cast the hobby aside as they grow up and seek respectability? Does the antipiracy discourse help insure that warez is just a phase that kids go through? Or will they continue their hobby, but under a more mature philosophical framework—that is, will they turn from expressions of badass 'tude to ideas that piracy really isn't a bad thing after all? Might they even begin to consider some of the ideas advanced by "The Warez Ethic"?

Time may reveal an answer to these and to other questions posed by the ideologies of piracy. For now, though, I suggest we view these expressions neither as signs of co-optation on the one hand nor opposition on the other, but rather as contested terrain. As such, this could be a productive site for intervention by activists working for progressive change in cyberspace.

LOOKING DOWN THE INFO-HIGHWAY

Jake the Pirate's analogy about the stolen dog is more than a convenient rationalization. Indeed, the NET law is an attempt to rewrite ideas that have stood for centuries about what constitutes right and wrong. With virtual property now so central to the economy, our concepts of justice have to be reformulated to include a prohibition against virtual crimes. The passage of the NET law is only the first step. The next step is to convince the public to accept these new premises. The popularity and persistence of warez testifies that this process has a long way to go.

I find myself wondering why copyright infringement has come to be

known by the term "piracy." Oceanic pirates definitely deprived their victims of their property, and often life or limb in the process. Real piracy was a violent interruption of commerce and life; copyright piracy is passive by comparison. The victims not only keep possession of their property, they may never even know that piracy has occurred. The Caribbean pirates cast themselves into a life apart, while software pirates are mostly only part-time outlaws, holding legitimate jobs and participating in the dominant social structure in a variety of ways in their offline lives.

Perhaps the metaphor makes more sense once we acknowledge that 'pirate' has another set of connotations besides those derived from real-life seafaring thieves. As maritime historian David Cordingly (1995) writes in *Under the Black Flag*, our ideas about pirates are inseparable from a variety of pirate myths, and the term now references romantic fictions more than any historical reality—Errol Flynn, *Pirates of Penzance*, *Peter Pan*, Disneyland. Pop-culture pirates are rough and full of bluster, but ultimately harmless, and maybe even good guys underneath. Above all else, the pirate now serves as a signifier of the world of fantasy, something apart from everyday reality, a resident of the land of make-believe.

Maybe this is the more relevant metaphor underlying the designation of copyright violators as "pirates." In using this term, we indicate that we find the act somewhat whimsical, and of no great consequence. The problem for the software industry is not just that there are a lot of pirates about, then, but that a lot of people don't see this act as significant.

And perhaps, somewhere under the surface, the connotation of make-believe works to place the whole issue in ironic perspective. It's easy enough to view the whole territory as imaginary: warez lets people cooped up in their rooms make believe they're outlaws or revolutionaries; the publishers make believe they really care about warez; the SPA and BSA make believe their loss estimates have some basis in measurable fact; various parties make believe that the product being stolen and the act of appropriating it are comparable to real material products and physical instances of theft; and everybody makes believe that the economy is running on something other than make-believe.

It is this last instance that suggests we should not disregard the significance of warez, even if we find its practitioners to be engaged in make-believe struggles instead of material ones. The postmodern economy depends on the ability of capital to make the virtual act like the real, to make information, ideas, strings of ones and zeros function as

material commodities. As such, the idea of property must be redefined away from possession of material goods toward access to data. However, this economic impulse contradicts deep-set North American cultural traditions of material-based pragmatic thought of free expression, and even of "free" broadcast media. Closer to home, the growth of the Internet, and especially the Web, has been based largely on its "freeness" of various kinds—not just the free browsing software, but the (relatively) free access to a wide variety of information sources. This is exactly what has made capital nervous about Web ventures. Past the developers getting rich on the R&D dreams of the venture capitalists, how can you make money on an everyday basis in an environment like this? At the same time, information is clearly the most promising source of new value available. How then, do you resolve this contradiction? If the software publishers can't even regulate the distribution of their commodities, how is anybody else going to be able to secure a reliable means of accumulating profit?

The popularity of piracy and the ho-hum response it often garners outside of the computer industry are evidence of the instability of the conceptual and legal mechanisms on which capital is now trying to operate. This explains industry policies that at first may appear contradictory. The corporate focus of SPA and BSA enforcement tactics reveal that the software industry knows it isn't really losing significant amounts of money on warez, and spokespersons for these organizations have admitted as much to a few inquiring journalists (Frauenfelder, 1998; Pogue, 1997). Neither organization is involved in anything other than the token pursuit of warez traders, and no one imagines that the government will assign a large task force of federal agents to crack down on NET violations. So why the bluster and PR against individual piracy when corporate copying is the real money loser? Why the pressure for new, harsh laws that tighten the screws on warez if nobody's going to enforce them? The answer is that the computer industry realizes this is a problem that has to be solved ideologically. Authorities do not act by force alone. We have any number of laws that are not meant to be fully enforced, that aim more to influence how people think than to punish them when they misbehave. So it is with the campaign against warez now being waged by the allied forces of industry and government.

Warez practices, and the ideas and gratifications behind them, present a measured set of obstacles to the necessary ideological mechanisms of

cyber-capitalism. However, it would be unwise to be too celebratory here. For one thing, the ideological force of warez doesn't exactly move in a single direction. On the one hand, pirates refuse to accept the commodification of information. They simply reject the premises behind the concepts of ownership and control of data strings advanced by the software industry. Even the pirates who eventually pay for the software they like are reasserting the primacy of use value over exchange value. On the other hand, the lure and excitement of the pastime depend exactly on the exchange value of software in the real world—and the pursuit of expensive unneeded software reproduces the fundamental premises of commodity fetishism. For every NoahNelse pirating for principle, many more pirate just for the thrill, a cultural engagement that may in the end be little different from going to see *Armageddon* or watching *The Jerry Springer Show*. Finally, we must also note that this whole dynamic occurs within a context that is extremely gendered, and rife with indifference to sexual exploitation.

However, the stakes involved in the use of Hotline and other Internet channels for piracy extend beyond the ideology of software and information, beyond the question of what constitutes property, value, and theft. Warez is not only significant in terms of what people pursue and why they do it, but in terms of how they go about the process. Warez trading practice is a matter of slipping, sliding, and hiding—false identities, shifting locations, a dedication to privacy. These habits, as well, may be troublesome for the new economy.

Tim Anderson (1995) argues that we ought to interpret the social dynamics of the information superhighway in the context of post-Fordist economic patterns as analyzed by David Harvey. In brief, Harvey argues that Industrial-Age capital—characterized by large factories and other rooted and centralized forms of production and authority—eventually became too unwieldy to extend profits. Capital has responded to this by employing new technologies to become more flexible, mobile, and diffuse. This involves moving production to a series of sites with large pools of cheap labor, thus fragmenting labor into more competing segments, which, in turn, will drive wages down everywhere. It also involves maneuvering around regulatory or cultural restrictions defining the length of the workday, health and safety conditions, and job security. The most obvious manifestation of post-Fordism at work is the return of the sweatshop: Nike can easily move the manufacture of Air Jordans to whatever

"third world" country can offer the cheapest, well-regulated labor pool at the longest hours. But post-Fordism has its more purely high-tech variations: some U.S. firms farm out data-processing tasks to India, and with everything transmitted electronically, the work in Calcutta operates no differently than if the workers were in the office building next door. Anderson argues that telecommuting follows a similar pattern— fragmenting the workforce, colonizing the home and "leisure time" in the service of profit, anytime, anywhere, in the form of fax machines, cellular phones, laptops, and modem connections. "This extension of the worksite (and the workday) has been ... created through a logic of capital desiring ever more substantial profits. Capitalism has consistently understood the effects and advantages attained by making labor informal.... The virtual office and the new sweatshops are merely different expressions of the same post-Fordist principles" (Anderson, 1995: 71).

The high-tech economy in Silicon Valley is at the leading edge of such transformations. While the software industry has created a well-publicized group of new millionaires, it has done so using production practices that increasingly deny rank-and-file workers anything resembling a steady job. More and more work is handled on a contract basis, so employers have no lasting commitments to their employees, and needn't worry about health insurance or other benefits. Of course, since each contract employee has her own computer and Internet hook-up, this high tech piece-work can be done at home. There's less office space and hardware to maintain, capital retains maximum flexibility, and workers scramble to make ends meet.

The information superhighway offers, among other things, the potential to expand this system to other fields of work in other parts of the country. For many kinds of information work, telecommuting is presently inefficient due to the lack of bandwidth in standard modem connections. But as mergers and other interconnections of power continue to develop between computing firms and communications giants such as AT&T and TCI, the technological and economic problems presently standing in the way of high-speed network connections to the average home will be erased. The digital pipe may come into the home under the guise of offering entertainment and information designed to meet our individual needs, but it also means we will all soon have the potential to be cyber-laborers in one form or another. As Anderson writes, "We need to be prepared for a day when we no longer 'go to work' but are involved with work on what

seems to be a never-ending basis. We need to be prepared when the labors of the day become one with interactive infotainment technologies that promise an expanding palette of choices" (1995: 76).

However, the construction of the ideal cyber-workplace requires significant changes to the way people use computers today. First of all, most of us think of our computers as part of our private realms—what's on our PCs and what we do with them isn't anybody else's business. Of course, with telecommuting, our computer literally becomes part of somebody else's business. Riding just below the surface of the warez struggle is a measure of uncertainty about the whole question of ownership as applied to information and code—not just who owns what, but whether anybody can own anything that floats through the ether or runs over wires. Here we see the converse of the first point—while our computer may be private to us, we also see it as a tool that opens any knowledge we desire. This is, after all, the era of tabloid TV, tabloid politics, tabloid everything. We expect our communication boxes to reveal all secrets, shine lights in every dark corner. Inquiring minds want to know. Hackers and pirates share this ethos of illumination—the desire, maybe actually the *need* to pull down barriers that thwart their curiosity.

Post-Fordism via telecommuting, then, has to turn these habits completely around: instead of having the right to control everything inside the computer, we have the right to control nothing. Privacy rights, like ownership rights, belong not to us, but to the company on the other end of the cable.

It is reasonable to believe, I think, that for these factors alone, increasing trends toward cyber-work may meet some more general forms of resistance from quarters not presently involved in the hack/crack/piracy underground. This suggests, in turn, that the digital cable connection, like any other workplace, will be subject to forms of regulation, surveillance, and discipline. Capital must figure out how to exercise power on and through the data pipe.

As Sandy Stone (1995b) reminds us, power needs a name and address in order to deliver its effects: "Governmental and regulatory structures work to increase the definition of whereness" (398). This is accomplished through the use of "location technologies," phone numbers, social security numbers, and so on. Location technologies are especially important in regulating computing networks, where subjects lack that essential "whereness." As Stone puts it, "In cyberspace you are everywhere and

somewhere and nowhere, but almost never *here* in the positivist sense" (398). In this condition, then, the purpose of location technology is "to halt or reverse the gradual and pervasive disappearance of the socially and legally constituted individual, in which the meanings of terms such as distance and direction are subject to increasing slippage" (399). Authority not only needs to establish a location, it needs to verify an identity by connecting discursive manifestations of subjectivity back to some particular definable physical presence. Stone calls this "warranting." Together, location technologies and warranting provide the foundation for traditional models of discipline and punishment: "I know where you are. I know that you are responsible."

The panoptic surveillance Foucault theorizes as the dominant mode of contemporary social control might seem to be immune from these requirements. Micro-power permeates the nooks and crannies of everyday life so thoroughly that it doesn't need to depend on specifics. It's Buckaroo Banzai's "No matter where you go, there you are," cast in a more sinister light. The incidence of software piracy, however—not just warez but casual exchanges between friends—indicates that where virtuality is concerned, the generic control effects of the panopticon are insufficient. The software cops are essentially engaging in a panoptic strategy against warez—maximum visibility of the potential of enforcement, minimum visibility of the actual agents. BSA vice-president Bob Kruger reports the group's number-one antipiracy tactic is creating the "perception of threat" (McCandless, 1997). It's not working that well. The pirates understand just how slippery their presence is in virtual space, and the less-than-fully-material nature of what they do there. So they continue to upload and download until they get tagged by a cease and desist order—and even then who's to say that these operators, once busted, don't continue to warez under a new handle, with a new ISP, using more discrete methods?

The piracy problem is just the most obvious sign of a more general condition. In order to territorialize the Internet in the service of corporate capital, the system will need to generate new forms of warranting and location technologies applied to the purpose of generating social control within virtual space. In light of this dependence on new forms of naming and placing, the pirate's insistence on privacy and ephemerality takes on a political dimension that goes far beyond questions of copyright.

CAUGHT IN THE WEB?

Warez distribution through a form such as Hotline requires someone to take the measured risk of opening a server and listing it on the Tracker—of taking on a form of name and address—yet the technology of Hotline allows this to be accomplished in the most indefinite manner possible. The Tracker system makes servers easily found for the purpose of accessing files, but difficult to locate in terms of concrete physical location. In fact, when Hotline servers come to the attention of the authorities, it usually has nothing to do with Hotline itself—the ISP makes note of the unusually high traffic to the user's account.

In contrast, consider the technologies common on the Web. The Web not only brings the element of visual spectacle to the Internet, but new forms of warranting and location technologies as well. Where Hotline is characterized by the dynamic IP, the defining feature of the Web is the URL—the uniform resource locator. Once a website is found via a search engine or other hyperlink, its physical location is often easily identified by anyone with a minimum knowledge of networking, with a tracing route often apparent right in the URL. If you object to my site at www.mills.edu/academic/drcm/tetzlaff.html, you already have my employer, my position, and my department all but identified. This is why pirate action stays off the Web, and warez websites consist of little more than a wild goose chase of circular or dead links. As one warezguy told journalist David Laprad (1998), as far as piracy is concerned the Web "sucks." Another refers to pirates who deal on the Web as "simply clueless." Laprad continues, "Why is there so little downloadable content on the Web? It is too public. Too traceable."

Once Web surfers land on the rather anchored wave that a typical commercial website represents, they are likely to encounter an online form that must be filled out before the "free" information on the site can be accessed. Real name, e-mail address, and postal address are generally required fields, and most forms request other identifying data, such as gender, age, place of work, and occupation. Of course, the user can always refuse to fill out the form, but most commercial sites now exchange *cookies* with the browser, an automated process the average surfer is unlikely even to know about, much less understand or know how to disable. The first time I surfed over to Amazon.com and had their

page say, "Hello David Tetzlaff, here are some book recommendations just for you," I was amused, but also disconcerted. How much did this computer know about me, how did it find out, and how did it recognize me as the person at the other end of the network connection? I dug deep into the Netscape preferences and discovered how to make the browser refuse to accept cookies. I surfed cookyless for just a short while though, because too many sites I wanted to use for this or that just wouldn't work unless cookie exchange was enabled. So I turned it back on. That's the current bargain on the Web—you can have access to our information, as long as you don't mind giving us access to the internal workings of your computer.

Of course, even before it became corporatized, the Web's defining genre was the personal home page, on which users place a variety of data that defines their identity, typically including a photograph along with addresses, phone numbers, and the like. In comparison to the fluid and floating identities that may flourish online within LISTSERVs, chat rooms, MUDS, and other Internet forms now shadowed by the Web's ascendancy, the home page fixes an identity, archives it, and places it for anyone to locate and investigate.

The Web, then, is collecting and building the kinds of technologies and cultural habits on which a post-Fordist cyber-workplace can be constructed. There's a deeper politics to the Internet Explorer controversy that doesn't have anything to do with monopoly power. Microsoft is working to fuse Web access with its operating system, and through that to eventually create seamless connections between the Web and Microsoft's productivity software—especially Microsoft Office. Thus, the lines between the computer, the Web, the workplace, and the home will all become increasingly blurred. By squeezing out Netscape and other competitors, Microsoft is forcing this integration and undermining any possible alternative visions of cyberspace. The popular metaphor comparing Microsoft to the Borg from *Star Trek* may turn out to be way too accurate. You *will* be assimilated. Resistance is futile. For the Internet to truly become a hive, some means must be found to turn surfers into worker bees. Much of the development of the Web, Microsoft-style, seems to be headed in this direction.

How might these forces be resisted? Short of turning off our computers, which in the society and culture of the twenty-first century will

amount to just giving up the field of struggle, what can we do? One answer is to find ways to subvert those processes of warranting and location on which authority structure depend, in order to re-create the dispersed and ephemeral presence earlier manifestations of computer networks have facilitated. Those of us who wish to dissent from the new info-order may find we need the pirate's skills in operating within the edges of the information system. We may find, first of all, a need to abandon the Web, and to employ forms like Hotline, IRC, and ICQ to communicate around and outside of corporate frameworks. However, mere pirate skills will probably not be enough. Effective resistance is likely to require not only the ability to evade the technologies of placing and naming, but to disable them—in other words, the ability to hack. While most warez enthusiasts have little or no true hacking skill, pirates have a lot of respect for hackers and a strong interest in hacking. Among the things pirates collect and circulate is knowledge about hacking and other material forms of antiauthority behavior—a text file of *The Anarchist's Cookbook* is a common sight in Hotline file archives. More to the point are collections of "how-to" text files on hacking, cracking, scamming free phone service, and setting up fake Internet accounts.

Again, in contrast, this information is difficult to find on the Web. The most useful hacking and cracking sites I encountered in my investigation, "weasel.org" and "the mighty zeus" were forced to shut down despite the fact they offered no copyrighted software for download. The industry considers distributing the means to infringe copyright—only information, in such cases—to be a form of infringement, and Weasel and Zeus being teenagers engaging in a hobby weren't about to argue the point with a bunch of attorneys. Zeus left a short sign-off message on his page. He reported that he had been visited by the police, and noted, "I don't want to get into trouble for having fun." He concludes, "From now on I am working on my Mac, not playing anymore."

I'm not suggesting that Hotline is the magic weapon that will save us all from cyberhegemony, but I'm glad that people can still find a place to play with the system instead of work for it. As the Web continues to shift computer networking toward spectacle, the commodity form, and the ideologies and technologies that may enable corporate power to turn all of our wired homes into virtual sweatshops, I feel some comfort in knowing that the Internet still contains communities built from the bottom up, that

people have created a space where dangerous information can be freely passed around (and I might be able to find it if I ever need it), that there is still a forum where locations shift, identities remain unwarranted, and ideas about information and freedom not only circulate but become articulated in awkward practice.

> FROM: SEAN CUBITT
>
> SUBJECT: **Shit Happens**
> Numerology, Destiny, and Control on the Web
>
>
> They say it is misery itself to live in folly, to err, to be
> deceived, *and to be ignorant. On the contrary: this is*
> *what it is to be human.*
>
> —Desiderius Erasmus, *The Praise of Folly*, 1514
>
>
>
> **A SECULAR DIVINITY**
> With the Y2K bomb ticking in our common unconscious,
> we have achieved a secular millenarianism that, it
> seemed, would fail to emerge in a culture without gods or
> common calendars. Even Christians no longer believe
> unquestioningly in the universality of the Christian cal-
> endar, and only the winter and Christmas TV schedules
> remind us of solstice and agricultural cycles. In a society
> whose only true believers are self-consciously nostalgic,
> even archaic in their belief in "old" religion, traditional
> values, and parental authority, it seems appropriate that
> our only trepidation on entering a new millennium should
> concern the crashing of a handful of our less essential
> devices. Yet like the millenarian cults surrounding Oliver
> Cromwell's English Revolution (see Hill, 1972), Fifth
> Monarchy Men walk among us, and the spirit of the New
> Age inhabits the Web. Hans Moravec's project of down-
> loading consciousness into a computer (Moravec, 1988) is
> paralleled in the sympathy that resonates between net-
> worked communication and historical femininity in Sadie
> Plant's work (cf. Plant, 1997), as it is in the voudou spir-
> its of William Gibson's cyberpunk science fiction (espe-
> cially his *Count Zero*, 1987). Hacker theology insists that
> the Net is an environment capable of generating life, and
> common experience at the interface (see Turkle, 1984;

1996) suggests that we submit to the workings of both the stand-alone machine and the desktop gateway to the Web with the respectful, even embarrassed reverence of those who communicate with familiars, presenting ourselves not as personae—actorly roles—but as avatars: incarnations, rebirths. The most serious journalistic account we have of the origins of the Internet is called *Where Wizards Stay Up Late* (Hafner and Lyon, 1996). We are self-conscious about our reverence, our personifications of technology, our attributions of fabulous powers to the media of communication. But most of all, in the absence of God or gods, we have found a firm belief in the wilderness of chance, chaos, and complexity, in the power of the last survivor of the pantheon, Lady Luck.

CHANCE IN A UNIVERSE OF VALUES

It is no accident that the phrase *it is no accident* has become a mantra. Just below the surface of any claim prefaced with this exposition is the doubt that whatever it is is indeed accidental, and that synchronicity is not only not absolute for a culture au fait with astronomical time, but is by definition debarred from causality. Events occurring simultaneously must either share a cause in the past or act upon one another at a distance, a relation forbidden by all but the most arcane of quantum mechanics. But to claim that "it is no accident" is to admit, tacitly, that no prior shared cause has been properly identified, that instead a common factor is being proposed as the guiding principle of both events, and that this principle is itself not quite able to claim causality, hovering instead on the brink of accident. The deaths of John F. Kennedy, Elvis Presley, Adolf Hitler, Marilyn Monroe, and Princess Diana were all "not accidents" in this sense: the folk beliefs that power the conspiracy theories and myths of afterlives surrounding them, like faith in UFOs, thrives in the hinterland between the provable and the absurd. Proof, instead, is the grail of the nonaccidental, made holy by its absence. By the same token, the nonaccident can never be disproved. The nonaccident instead asserts an axiom, the axiom of harmonic reverberations linking ostensibly disparate phenomena across space and time, an axiomatic patterning of the universe and, more specifically, of human experience.

The Net is a natural home for such pattern seeking. After all, the Internet is itself a mode of patterning, a palimpsest of intellectual shapes laid over one another. One of the Net's core functions, from the earliest days of ARPANET, has been copying. Rumors and jokes, conspiracy theories,

and New Age myths spread like spores across the Internet and the Web because they need minimal effort to reduplicate and republish. If then they appear to reproduce themselves and function as viruses, carried symbiotically or parasitically on channels and via messages, then they become memes: microbeliefs that propagate themselves throughout the species by its communications (Dawkins, 1989: 192–201; Dennett, 1991: 200–10). By now many of us have received the "Good Times Virus" e-mail, warning users not to open any e-mail with the subject line "Good Times" because it supposedly carries a virus. And by now most of us have also received the message that elucidates the warning as itself the infestation, a message that has become, through its constant forwarding from list to list, a self-replicating piece of code that preys on neophytes. The explanation has itself become part of the virus, the inevitable secondary infestation, like the sore throat after the cold.

Elvis sightings, new evidence about the assassination of Pope John Paul I or about the Dead Sea Scrolls, all circulate with self-propelling vigor via the amused and the ironical, the bemused and the gullible, as harmlessly irritating as advertising jingles. Neither fiction nor document, such theses occupy a subjunctive mood, a zone of probability. They ask us, "What are the chances of that happening?" and invite speculation about the fringes of the material and immaterial worlds. The nub of the Web as rumor mill is this marginal position between fancy and fact: it is for this reason that we insist our students triangulate the data they

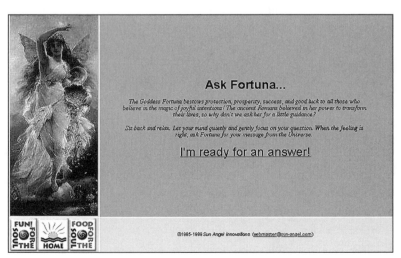

Fig. 6.1. It is no accident that the phrase *it is no accident* has become a mantra. The Numberquest website, http://www. numberquest. com/interact/ angel.html

retrieve from the Web, finding second and third sources to back up the figures and cases they use to build their arguments. Without a governing protocol or discursive hierarchy like those of refereed journals and scholarly apparatus to guide us, the Web can proliferate not only information but surmise, opinion, guesswork, assertion, fallacy, superstition. The misinformation superhighway promulgates the fruits of the hyperactive thalamus as readily as the bona fides of hegemonic discourse.

In cultural studies, we have learned not to dismiss the activities of popular culture, but we have yet to accept the validity of an entirely amateur conceptual machinery. When we teach, whatever our disagreements about method, content, pedagogy, and assessment, we all rehearse the tribal rituals of annotation, referencing, logical argument, and permissible extrapolation, never trusting the naive wisdom of the popular to provide its own metadiscourse. Yet this is what the Web provides: a babble of explanatory frameworks offering partial and sometimes systematic understanding of the world, of significant moments of its history like the deaths of celebrities, the groundwork of an ethics of honesty and transparency. The patterns surrounding the Roswell Incident are more than isolated fragments of craziness: they are allusions to the foundations of a cultural mode. The "it's no accident" theme introduces its second principle, the axiom of accident. The universe, and more specifically human experience, is packed with random events. The serendipitous nature of Web browsing allies itself to this fundamental *aperçu*, providing the grounds for the collision of discourses and opinions in a meticulously disorganized environment. Of all these chaotic patterns that inhabit Web space, few have been as productive as the various branches of numerology.

The extraordinarily partial numeracy that invests our society is a source of marvelous mathematical surmise, a treasure trove of intuitive algorithms and bashfully offered insights. Since, as Valerie Walkerdine has argued, arithmetic has functioned since the Industrial Revolution as the defining discourse of rationality, it has also functioned in schools as the privileged medium through which schoolchildren are introduced to the principles not only of reason but also of administration. "Teaching children to read and write," she says, "proved not to be enough to stamp out rebellion. The liberal order of choice and free will had to be created by inventing a natural childhood that could be produced and regulated in the most invisible of ways. Mathematics became reason" (Walkerdine, 1988: 212). This not only accounts for the suffocating boredom so many

of us experienced in early school years' math classes but it may also account for the irrational resistance to and in the order of numbers, the terrible lessons of "more" and "less," of calculating interest and summing columns. Out of the instrumental drumming of multiplication tables is born a certain magical belief in the powers of numbers beyond book-keeping and statistics, one that seeks its lineage in ancient wisdom but finds new inspiration in reaction to the throttling of creative mathematics in early schooling.

The nonaccidental is perhaps the most characteristic mode of resistant number magic, and perhaps the most profound. Against the brute necessity of summing, against the absolute and universal truth claims of a denaturalized arithmetic, number magic establishes the claim for non-rational connections between numbers. Perhaps the most familiar system outside the instrumental is astrology, a highly numerate language for the description of time and destiny. Nicholas Campion, in his analysis of the origins of Western astrology in the millenarian tradition, assembles data on the origins of key numerical systems: the Babylonian order of sixty that still guides the geometry of circles, notably the compass; the Hebrew solar cycle of twelve and four; and the Mesopotamian lunar cycle of twenty-eight days and four phases. Campion argues that these celestial rhythms were taken for evidence of a mathematical coding of the universe, an order that might be expected to attach to terrestrial patterns like the annual flooding of the river-based civilizations, or the rise and fall of empires, or the path taken through life by a king, or finally by a citizen. Perhaps most relevant for the study of cyberculture is his claim that contemporary New Age millenarianism, like the eschatology of Marxism, derives from the mythic cycle of the Great Year, still dreaming of the return of the Golden Age, the divine monarchy (Campion, 1994: 500).

Campion does not attempt an account of the postmodern consensus in the cultural academy, but it is interesting to address it in these terms. The legend of the end of eschatology/history so forcefully argued by Jean-François Lyotard (1984) and Jean Baudrillard (especially 1975) can be understood in a dialectical relationship with this populist utopianism. If, today, astrological millenarianism inhabits the popular resistance to instrumental reason, then postmodernism is resistant to that resistance. Either historical process ends with the triumph of Western capitalism—for good or ill—leaving us with nothing to do but tidy up the recalcitrant elements, or the algebra of the cosmos points our species toward unful-

filled and transcendent destinies. The former seems to me to be based on the concept of a universe in which numerical values can be placed on everything, in principle if not in fact: the universe of the "theory of everything" currently made moot as the *summum* of a united physical science. The latter, however, accepts that accidents will happen, but that they are guided by an invisible ordering whose most profoundly touching aspect is its metaphorical resonance with the cycles of birth, puberty, maturity, and death. The world will appear to the uninformed as stochastic or conjectural—but hidden powers handle the fall of dice, the layout of rooms, the tumbling lottery mills. Popular number magic is based in the axiom that apparent randomness has a meaning, and that meaning will be revealed in the moment when the universe of values is overthrown.

AMATEUR COSMOLOGIES

Theodor Adorno's critique of astrology ascribes the tragic flaw that promotes belief in it to the cult of facts. Positivist science, he argues, "teaching absolute obedience of the mind to given data, 'facts', has no principle such as the idea of reason by which to distinguish the possible from the impossible" (1994: 116), thus throwing the enlightened mind into an excess of credulity. Science itself, whether taught as an assemblage of truths to which school students must subject themselves, or through the jargon of professionalisation, contributes to its other. Adorno thus contrasts the "secondary superstition" of astrology with a pure rationality that, however, has been tormented into self-betrayal in the period between Gottfried Leibniz and Adolf Hitler. Today we are less likely to use this yardstick, and perhaps instead to compare astrology with the materialism of contemporary science. What we are less used to doing is exploring such do-it-yourself metaphysical systems in their own terms. Here, for example, is a reasonably typical example, derived from a website devoted to numerology:

> #3 A 3 dwelling is a happy dwelling. Not that unhappiness never occurs, but rather, the inhabitants are basically full of good cheer and accommodating to the many family members and visitors who happen by. Positive attitude proliferates in this house and the creative urge is palpable. Artists, poets, writers, actors and dreamers flock to 3 and little children are quite happy here too. A 3 house is decorated to reflect the creativity of the inhabitants and this can range from wildly

eclectic to *House and Garden* chic. The important thing is the
"look" of it. There will be a desire to make this house stand out as
unique or glamorous amidst the others on the block. Good for enter-
tainers, authors (or letter writers), sociable people, artists, politicians,
and anyone involved in communications of any type, including long
hours on the telephone. (Angelia, 1998)

You arrive at the number of the house or room by the familiar numero-
logical method of adding together its constituents numerals. (To find the
magic number of a house whose street address is number 182, add the 1
and 8 to get 9; add the 2 to form 11; add 1+1 to get 2, which is the magic
number for the address). As Adorno observed of newspaper astrology,
the system is reliant on an invariant typology of personalities, in Angelia's
case ascribable not only to people but to houses. The technique for
adding digits has a long and honored past, deriving from the Kabbalah
and its techniques for deciphering the divine word. The kabbalist prin-
ciple is that the Bible, as the word of God, contains all wisdom. Since
Hebrew numbers are denoted by letters, the letters of the Bible form a
numerical sequence as well as a verbal one. A variety of techniques,
including the adding of digits, gives a second meaning to the Book, a
secret wisdom allied to a hidden cosmology. These techniques flooded
Europe in the later Middle Ages, inspiring Geoffrey Chaucer, Giovanni
Boccaccio, and Dante Alighieri among others, their remnants still visible
in the impact of Jakob Boehme on the English poet and prophet William
Blake in the early eighteenth century. (For a fascinating interactive art-
work exploring this quality of Blake by Simon Biggs, see Cubitt, 1998).
In Angelia's secular rereading of numerology, the World Wide Web
demonstrates another of its less highly regarded properties, its function
as living memory.

The Web acts something like the popular tradition identified by Carlo
Ginzburg. In his study of the sixteenth-century heretic Menocchio,
Ginzburg argues that no cultural history is complete that sees the rul-
ing class as the unique source of worldviews and theoretical models.
The miller Menocchio, he argues, read the newly available printed
books through a cultural filter that selected and obscured preferred
meanings, triggering memories and distortions, a filter that "continu-
ally leads us back to a culture that is very different from the one
expressed on the printed page—one based on an oral tradition"

(Ginzburg, 1980: 33). Oral culture, Ginzburg argues, is not a mass of fragmentary superstitions, but a complex and articulate whole, even if only dimly perceptible, a complex, moreover, that is capable of continuing through the triumphant development of a written culture. If literacy, in the upshot, became the tool of standardizing "natural" languages in the interests of nation formation and governance—and here perhaps Marshall McLuhan still haunts the Web—in the electronic discourses of network communications, something of that ancient tradition still manifestly holds sway.

Fig. 6.2.
Mass media
culture looks
to science for
explanations,
certainly, but
a century
of Social
Darwinism
has also
turned to
quasi science
as a source
of moral
justification,
if not injunc-
tion, for the
free market,
red in tooth
and claw, to
genetics as
justification of
eugenics and
genocide, to
ecology as
justification
for Luddism.
The Sun Angel
website,
www. sun-
angel.com/

Sacred Geometry Structure
for creating peace in Kosovo

Please lend your positive attention to helping to create world peace.
You CAN make a difference!! All it takes is a little bit of focus and a positive feeling in your heart.

This Sacred Geometry Structure for creating peace in Kosovo came to intuitive artist, Dottie Martin when she asked what could be done to help the situation in Kosovo. As with the sacred geometry soul portraits she does for individuals, everyone who works with this image, or even just sees it briefly, feels a deep stirring and knowingness of its importance and powerful influence for peace. She says it is several miles up in the sky, and is itself probably about a mile or more in length. It spins clockwise, and showers down rays of colored light from each of the three balls. The more light, the more influence for peace. Each individual contributes his/her own unique quality to the light, and as more individuals join in with a common vision, the more the individual and group contribution is amplified.

The more people are aware of this subtle structure, the more light and peace for the region. Dottie says she is also seeing another such structure form over Russia, and a third one is forming over the Middle East. We'll continue to add Dottie's Sacred Geometry visions to this web page as she receives them and paints them for us. Please PASS IT ON! Send as many people as you can the link to this page.

"It is several miles up in the sky, and is itself probably about a mile or more in length. It spins clockwise, and showers down rays of colored light from each of the three balls. The more light, the more influence for peace." - Dottie

Artwork is Copyright © 1999 Dottie Martin.

How to "Pray for Peace" - Excerpted from a message from Pam Perry, Creative Health Network

When praying for peace at this or any time we recommend that you simply 'feel' the experience of peace and harmony, then ask for that feeling to be applied to the desired area of the world. In other words do not pray for the bombing to end, or for Serbia to retreat. It is the feeling of peace that works the magic, not the thought. We do not claim to know the solution. We simply ask to be used as instruments of peace, and to let our light shine where it is most needed. If words are needed say something like 'Peace prevails now in Kosovo and Serbia.' Then feel the presence of peace in that area, say thank you, and end your prayer.

May Peace Prevail on Earth and in Kosovo!

Please also visit James (Jimmy) Twyman's site (he's the "Peace Troubadour") http://www.emissaryoflight.com/ and the worldpuja.org site. Worldpuja seems to be one of the main coordinators of a series of special events for peace in Kosovo (Marianne Williamson is a regular), including a talk by the Dalai Lama this Friday afternoon, followed by a peace concert by Jimmy Twyman and others (Liz Story, Gregg Braden) in the evening. All to be carried live on the Internet. See the worldpuja site at http://www.worldpuja.org for details.

Thank you for your help!
Sun Angel Innovations

If Angelia's article strikes us as naive, we should perhaps think back to those founding cultural analyses, the anthropological studies of "primitive" peoples that make the postcolonial blush. The Web has produced the conditions in which an old traditional culture might reemerge. I am not speaking here of profound superstition: flat-earthers, race supremacists, or believers in Wicca; rather, I want to pinpoint a specifically mathematical culture that has held its own for millennia, and in which the crude numerology of house numbers takes its place. Number magic matches the definition Keith Douglas gives in embarking on his monumental study of *Religion and the Decline of Magic*. As Douglas explains, "Nearly every primitive religion is regarded by its adherents as a medium for obtaining supernatural power. This does not prevent it from functioning as a system of explanation, a source of moral injunctions, a symbol of social order, or a route to immortality; but it does mean that it also offers the prospect of a supernatural means of control over man's earthly environment" (1971: 25).

Without overstating the case, I want to ask whether this description fits not only Angelia's site, but the pseudoscience of the daily press. Mass media culture looks to science for explanations, certainly, but a century of Social Darwinism has also turned to quasi science as a source of moral justification, if not injunction, for the free market, red in tooth and claw, to genetics as justification of eugenics and genocide, to ecology as justification for Luddism. Likewise, information science has functioned as symbolic structure of the social order from Herman Hollerith's automation of the census to the "Bell Curve" debates. Richard Dawkins's theme of the selfish gene discovers something similar to Moravec's quest for digitized immortality—if not for human beings, then for their genetic material. If, then, in popular discourses about science we turn in blind faith toward technology as the scientific warlock that will heal our ills, surely that, too, is offered in the hegemonic media as a power more than natural.

Given the use of science education as a mode of control, it is unsurprising that the popularized religion of science should likewise be greeted with skepticism by populations methodically debarred from participating in real scientific endeavor. Given only the option of believing, without rational induction into the discourse, it is unsurprising that huge numbers turn from science as they turn away from the avant-garde. If science and the arts are already two cultures, and if high and low culture

are the "two torn halves of an integral freedom to which, however, they do not add up" (Adorno 1977: 123), why should we be surprised to find, alongside the popular arts, a popular science? And what is there to suggest that we would find anything but a filter placed over the reading of popular scientific journalism, like the filter Ginzburg's heretical miller placed over his reading four centuries before, to descry in autodidact readings of the popular science magazines the evidence for an alternative worldview? Or, finally, should it shock us that that filter should give evidence of an oral tradition as robust as the dominant, a tradition that is not accounted for simply by labeling it an ignorant, ill-informed, and pseudoscientific imitation of dominant culture? To understand how the Web, itself a mathematical phenomenon, operates between the professional and autodidact cultures of mathematics, and what that can illuminate about the nature of Web democracy, we need to explore the formations of these twin cultures.

Both traditions can trace their inheritance to the same mystic source, the theorems of Pythagoras, for whom the sanctity of number was so great that, according to legend, the Pythagorean Brotherhood hid the very existence of irrational numbers like π. Mathematicians evaluate their ideas, whatever their fields and debates over axioms and techniques, by the elegance, even the beauty, of their solutions. Though physical reality can provide both problems and applications, the work of pure mathematics is conducted rigorously beyond the confines of physical reality, even those of physical possibility, occupying a virtual world governed not by brute objectality but by axioms and the rules of proof. Irrational numbers were already radically assimilated into the conceptual toolbox of mathematics when the imaginary numbers were added, numbers like i, the square root of -1, which have perfectly logical positions within the practice of mathematics but are not in any ordinary terms thinkable. The practical value of such numbers exceeds the difficulty of conceptualizing or visualizing them: they exist as functions of the notational schemata of math. And yet, even in the classical maths of the eighteenth century, the authors of famous formulae, such as Leonard Euler with his $e^{\pi i} + 1 = 0$ would regard them not as inventions but as discoveries tinged with the miraculous.

Freeman Dyson once described general relativity as a mathematical leap in the dark, adding, "It might have remained undiscovered for a century if a man with Einstein's peculiar imagination had not lived"

(cited in Stewart 1987: 132). The implication is clear: for Dyson, mathematics underpins both physical and nonphysical reality, despite the fact that we may be utterly ignorant of it. Relativity is for him a prime example of a phenomenon that had persisted from the earliest moments of the universe without being known or understood, whose effects must have appeared as divine interventions or random events until the arrival of Albert Einstein. In this sense at least, Dyson proves himself a Cartesian, sharing René Descartes's belief in an ultimately knowable, because mathematical, universe.

Of course, it does not follow that all random occurrences can be explained as the functioning of rules known only to the elect. We did not have to travel to the moon to know that it was unlikely that the explanation for dogs howling at it was that it was made of green cheese. Wild surmise and superstition are different from the constructions of numerical space in their lack of discursive structure. What sets apart the professional culture of mathematics is shared disciplinary protocols for determining truth or falsity. Yet even the amateur numerologist seeks a response to the fundamental Pythagorean premise that everything is number. The golden number (phi) and the Feigenbaum number (delta) are themselves hardly less magical than the alternative, unproven, and unprovable mathematics that spies out the influence of the planets on daily and annual rhythms, or the geomancy that aligns houses with their most favored aspects.

The importance of mathematics to the Web is almost too obvious to require explanation—*almost*. The overlay of binary and hexadecimal codings in machine language and such common factors as the numerical coding of colors, the Boolean algebra of searches and switches, are very close to the surface of Web authoring, while geometric choices either intuitively or in carefully worked-out form help govern the aesthetics of page design, from the almost universal use of the <CENTER> tag to the more elaborate arithmetic of flow diagrams for whole sites. Web authors constantly find themselves using mathematical techniques. It is scarcely surprising (one might almost say, "no accident") that the period of the Web's most startling growth has been accompanied by a massive upsurge in sales of popular science and popular mathematics books. To the extent that it is itself a mathematical phenomenon, the Web spans mathematical dreams, and in as much as it poses itself as a virtual universe—one clearly governed by mathematical concepts, it is also unsurprising that

it has become a spawning ground for sometimes naive, sometimes mystical, and sometimes fascinating beliefs in the power of numbers. The popular cultures of the Web take numbers and logical operations as raw material for the development of an amateur culture, one freed from the constraints of disciplinary specialisms to pursue its own forms of truth. As in the case of the heretical miller Mennocchio, those truths are cosmological in their holistic attempt at the discovery of pattern, taking the Web's mathematical structure as a model for society (very much the case in North American "Netizen" rhetoric, for example in the Electronic Freedom Foundation) and for the natural universe. Such amateur mathematical cultures on the Web frequently place their faith in some type of divine logic linking the various levels of human and natural interaction. Mathematicians are more skeptical, and as a result more able to discern the limits of logic in probability, the math of quantum physics, and the patterns of complexity that Roger Penrose (1995) discerns in the human mind.

What links both cultures is the belief in order, even where that order is counterintuitive, and despite the fact that that order is very differently conceptualized in each tradition. The irrational numbers that underlie the geometry of the circle, the snail's shell, or the dripping of a tap are irrational only by agreed terminology (a number is irrational if it cannot be expressed as a ratio of two whole numbers). In other words, they exemplify the reasonable order of the universe. But at the same time, their detailed expression leads us into grounds that are not entirely reasonable, into the looking-glass world of Euler's theorem, of imaginary numbers, of modular space whose axes are combinations of real and imaginary numbers, of elliptic equations. Beyond the rational, though founded in rational standards of truth and proof, mathematics forges a fractal universe whose specific conjectures will only ever be clear to specialists, just as Web surfers stake their all on the logic structures underpinning the medium, not knowing how but believing that they work. Both professional mathematics and Web cosmology are cultures of trust.

THE MATHEMATICS OF DEMOCRACY

Of all the mathematics that has leaked into the common parlance of the Web, the language of chaos has been the most far-reaching in its imaginative appeal and its popular recirculation (see J. Gleick, 1987; Waldrop, 1992). The mathematics of turbulent systems, chaos theory, has

provided the scientific academy with an imagined (conceptualized but not proven) outcome that squares the circle of determinism and freedom, granting almost ex nihilo the grail of free choice, core to the ideology of individualism. Since parallel work in neural networks and in cognitive psychology works on the axiom that mind and brain are the same, free will can be placed confidently in the mind-brain of individuals, rather than, for example, arising as emergent order from social interplay. A cornerstone of North American individualist ideology has been cemented in place, as has a rationale for free-market competition.

This very specific model of competitive individualism is necessary to forestall the otherwise obviously social theses of chaos theory concerning interactivity. In an article for *Physica*, James P. Crutchfield explains, "The world about us is replete with complexity arising from its interconnectedness.... This interconnectedness lends structure to the chaos of microscopic physical reality" (cited in Davies, 1987: 69). This remark comes in the context of a discussion of "Space-time dynamics in video feedback," and it is this instance of the term "feedback" that occupies center stage in the conceptualization of the Web as turbulent system. Like free marketeers, Netizens associated with *Wired* magazine and the Electronic Freedom Foundation assert the foundational axiom of the existence of individuals exercising free choice as a prerequisite for the development of a self-regulating system. The self-regulating system, probably the best-known phenomenon of the mathematics of chaos, is then deployed to argue for a "frontier" ideology that refuses government, very specifically the U.S. federal government, but also the interference of government in general and governments in particular. As such free market models become hegemonic on a global scale in the wake of the General Agreement on Tariffs and Trade (GATT) and the antiinterventionist interventions of the World Bank and the International Monetary Fund, chaos theory provides the ideological model for a global economy in which the benefits are supposed to feed back to individuals. The loop is complete.

Like the economic system, or the physical systems addressed by Crutchfield, the Web is understood here as a system dependent on feedback for its structuring. Chaos and feedback provide models for a range of metaphors guiding the principle of the Web as a self-regulating system. The Web exhibits autocatalytic symmetry-breaking, like Ilya Prigogine's famous chemical clocks that oscillate between ordered states rather than

simply mixing indeterminedly (see Prigogine and Stenghers, 1984: 146–53). J. E. Lovelock's Gaia hypothesis provides a second model, of the Web as ecology, a highly complex feedback system automatically self-stabilizing in the face of potential disaster (see Lovelock, 1979). The Web is compared to the bootstrapping of life out of the primeval swamp, a thesis addressed later in this essay. The abused Prigogine model is deployed to argue for a dangerous form of plebiscitary democracy, the majority always carrying the day and always bearing with them the guarantee of their right in the proof of numbers. The Gaia hypothesis, already roundly criticized in scientific circles for its incipient paganism, has attracted critiques from ecologists for its accommodation to pollution as a naturally occurring phenomenon that the ecosystem is capable of assimilating and healing. The Net's parallel mythology is that "flaming" and other group tactics will always assimilate and reconstruct such pollutants as child pornographers and race-hate sites; that there is a strange attractor of decency and civility toward which network communications will automatically tend.

You would like to empathize with this faith. Yet the dynamics of the industrialization of the Web tend to disprove it. The rise of push media was strongly tailwinded by a special feature in *Wired* celebrating the prospect of fat data pipes underwritten by advertisers and content sellers, a move from do-it-yourself media to readymade, and faith in "trusted sources" (Kelly and Wolf, 1997: 80). The evolutionary model they deploy habitually is coded here as an evolution from smoke signal e-mail, via magazine webpages, to push media as TV. With a keen professional eye for both their readership and their advertisers, we can perhaps trust *Wired* in this prediction at least: the global players—IBM, Microsoft, News Corp., the "baby Bells," MCA, Dreamworks SKG, Buena Vista, Deutsche Telekom, Bertelsmann, Con Edison, Intel, and so on—have been preparing alliances for network product and market share battles for half a decade. Even without push media, the same autostabilizing factor would be likely to enter the emergent structures of the Web, for what produces itself magically from the chaotic flows of communication is exactly what emerges from the turbulence of the global economy: monopoly. From all the number magic that underpins the ecological and chaotic models, for all the touching faith in the emergence of personal wealth, civility, and plebiscitary democracy, the most likely outcome appears to be the mag-

ical return of the same system that has already devastated the lives of most of the world's inhabitants and large tracts of its biosphere.

But mathematics, though forced to serve—like all the sciences, the needs of dominance—is mercifully relatively autonomous still. In a recent account of unification attempts in the physical and life sciences, David Deutsch mentions the 1994 discovery of Peter Shor's algorithm, rendering practical the prospect of a quantum factorization engine (Deutsch, 1997: 215–16), the first practical application of which would be in decoding Internet communications coded using public-key encryption, a cryptographic system relying on the difficulty of factoring large numbers. Perhaps the most significant aspect of this small mathematical advance lies not so much in the quantum devices it requires to make it run as the proof it offers of the old adage that in the long run there is no safe encryption, and no such thing as a secret message. Following the recent successful Internet group attempt to decode the keys for PGP (Pretty Good Privacy, the most popular Internet encryption software), the news comes as less of a surprise. What it bodes is the end of privacy.

Privacy has become, over the 250 years of its sociological importance, something of a dead weight. Today only wife-batterers and tax-evaders genuinely guard their privacy: the battered and impoverished might wish for more openness. The Web itself, as a space for self-publication, becomes a space not for privacy but for publicity. The technical erosion of privacy comes along in parallel with a crisis in the meaning of privacy, as public and private spheres intersect over increasingly blurred boundaries. As the personal becomes the political, the private becomes public, and the Web takes its place in the process as a device for pushing the process even further, publicizing the intimate. Here again a certain mathematics is involved. If the result is a self-stabilizing feedback system, then all we have achieved is our fruitful position as consumers—of power, of goods, of images, of brands—by establishing each networked browser, via the use of cookies, as a feedback channel to corporate centers. What is an individual in the free market if not a stimulus-response unit providing information to capital about choices and preferences? Privacy, in this perspective, is simply the right Esther Dyson claims to owning and therefore selling one's own data (1997: 206–11). Yet the concept of ownership, specifically of information, falls prey to the algorithmic penetration of privacy, and with it the specificity of the rational agent of

neoclassical economics. We face, instead, a scenario without privacy, a scenario of publicity, of living without secrets, without property and therefore unburdened by the selfish genie of individualism.

Deprived of individualist free will, the Web becomes open once again to the fractal geometry of complexity theorems—without, this time, the probable replication of economic monopoly systems in information space. Such complex democracy is inefficient, scoring low on the scales of wealth creation, energy consumption, and stability that we use to measure existing political democracies. Slow, painstaking, cyclical and circuitous, complex and turbulent, it concerns itself with the constant pursuit of diffuse and mutually exclusive goals, a microclimate of constantly shifting parameters. This kind of interactivity is not a matter of that devalued "choice" between two rival brands, or two paths at the crossroads of a game in which all paths have already been designated. Turbulent democracy has no foreseeable goals, other than itself. Yet it exists as a utopian project because it engages a future other than the present, precisely an unforeseeable goal. This, it seems to me, is the inspiration behind the number magic of hope, the popular culture of a world that is still full of process yet denies fate. Where the *Wired* democracy looks forward only to the perfection of an existing (and clearly imperfect) system, turbulent democracy, as expressed in the mazed metasystem of popular number theory, rehearses, albeit in the resistant language of ancient theocracies, an alternative process of human development. As misinformation and misunderstanding proliferate across the global network, they function as the random mutation of genes within a megaorganism, the society of human beings. The parasitic corporations that feed off this collective mind should not then be mistaken for its organizing structures. In human communication, what makes feedback so essential is that it is *not* homeostatic, but randomizing, mutating, evolutionary.

EVOLUTION AGAINST DESTINY

The architect of a biologically informed plan to create an "Internet wildlife preserve" for artificial life algorithms, ecobiologist Thomas Ray ascribes to evolution a semidivine authority, provoking a new mode of technological determinism, attributing agency and quasi subjectivity to machines. As Ray explains on his Tierra webpage, "The DNA of living organisms is a genetic 'program.' This is a parallel software of a complexity much greater than any that could be written by humans. Experi-

ments ... show that evolution by natural selection works very effectively in the medium of computer machine code. Evolution will find forms and processes that exploit the possibilities inherent in the computational medium" (Tierra, 1998). Ray's eminence in the artificial-life community arises partly from his scientific credentials, and partly from a proper caution exercised in extending from the analogy between DNA and computer codes into the domain of society as information system, the argument by analogy that underpins Jean Baudrillard's concept of the social as self-replicating code. Yet in the brief quotation above we can descry the outlines of just such an argument. The double helix is the symbol of an epoch in which human will is reduced to a pseudopsychology of coping. Genes are credited with determining intelligence, sexuality, addictiveness, and even wealth. Destiny combines with the ideologies of liberalism to produce a lethally disabling discourse of birthrights and personal achievement. When hegemony cannot be achieved by the illusion of freedom, it must be sought through the illusion of fate.

Warped systematically in the interests of ideology, evolutionary science appears as no more than a cathedral of injustice. No wonder then that we find flickering in its shadows the rushlights of occult cults. The Web not only disseminates the gospel of necessity: it harbors too the counterdiscourse of randomness. At times such sites succumb to the prevailing fatalism, proffering magic numbers in the hope of Lottery wins and happy homes. Yet unlike the iron hand of the free market and biological determinism, the proliferating numerological sites recognize as their own the true, if obscured, Darwinist deity: pure luck. Chance guides the surfer rather than the overdeterminations of default browsers and commercially structured search engines. Where fate is invoked, it is in the subjunctive mood, the mood of "what if?" The teleology of a global, participatory economy is set aside in favor of a discourse and a hyperstructure of serendipity in which the teleological goal is always deferred, not only to another time, but to another and subjunctive mode of being, the mode of those beliefs we do not quite hold. The anonymity of the Web may not have liberated us from the prison house of gender, but it has delivered us from the chains of DNA by stripping away the firm identity it is presumed to have structured.

The myths of information as destiny depend upon a discredited mathematics of closed systems. The Web, however, is not closed, not even bounded, but permeable. Like any leaky system, irreverent interruptions

generate the unforeseen. Take electricity, the material form of logic switching in all computer-mediated communications, the sine wave without which no computer would function. On several listservs during the early summer of 1998 a story circulated concerning a British electricity supplier experimenting in the use of electrical current as a carrier wave for Internet services. Apparently, in their test area, the height of the street lamps corresponded so closely to the wavelength used in the experiments that they functioned as antennae and broadcast wildly all through the night. The very math of the wavelengths on which information economies depends is open to sudden environmental disturbances. We have known since Kurt Gödel's theorem that there is no such thing as a closed system. In the absence of closure, neither the laws of entropy nor the teleological fate of Web economism and biological predestination hold good. The arcane traditions of the poor have turned out to be the preservation of a spark of democratic contingency in the darkness of informatic determinism, a startling testimony to the failure of closure and the radical necessity of openness. On the day that this openness is fully inscribed as social, we will all win the lottery.

7

> Any sufficiently advanced technology is indistinguish-
> able from magic.
>
> —Arthur C. Clarke

> The technologies of figural expression offer unprece-
> dented control over the strategies of divide in space,
> order in time, and compose in space-time. This is not
> simply a question of what happens on the screen (cin-
> ematic, televisual, or computer), but how these tech-
> nologies serve to define, regulate, observe, and
> document human collectivities.
>
> —D. N. Rodowick, "Reading the Figural"

LINKS AND ONTOLOGICAL MYTHS OF THE WORLD WIDE WEB

The ontology of the World Wide Web is more than simply a question of space, sites, or pages; it is fundamentally concerned with links and motion. This chapter questions the idea of "cyberspace," by discussing the spatial and temporal qualities of the Internet as an effect of the brico- lage of digital images, text, and other elements linked together by hypertext references. Hypertext links—the cornerstone of the Web—are sometimes ignored by crit- ics, yet links are central not only to the navigational prac- tices of Web browsers but also to the constitution of webpages themselves. It is through both clearly marked and embedded links that webpages are constructed as apparently stable displays on a computer screen. How- ever, links also disrupt the easy flow of a text or webpage to force viewers into an awareness of the constructed qual- ity of webpages: they send the viewer elsewhere; they

break up the authorial control of texts and supplement and problematize what has been displayed or written. Consider the case of the online journal *Suck*, where links are used, according to Rosenberg, "not as informational resources or aids to site navigation but as a rhetorical device, a kind of subtextual shorthand. A link from a *Suck* article, far from illustrating a point, more often than not undercuts it. A *Suck* link's highlight is often a warning: Irony Ahead—do not take these words at face value. *Feed*'s Steven Johnson analyses it in his new book, *Interface Culture*, as a kind of associative slang: 'They buried their links mid-sentence, like riddles, like clues. You had to trek out after them to make the sentence cohere'" (S. Rosenberg, 1997).

In this case, links were more than just functional transportation. For Johnson, "they triggered that sense of mystery, the sense of a code half-deciphered." They might turn entire sentences into minimalist prose where links are not just "further reading" but more conscious modifications and reflections back on the original statement. A highlighted word, "sellout," could sarcastically link to the site of a Web mogul—or ironically link right back to *Suck*, indicating the author's own sense of complicity. "By linking to itself, *Suck* broke with the traditional, outer-directed conventions of hypertext: what made the link interesting was not the information at the other end—there was no 'other end'—but rather the way the link insinuated itself into the sentence," condensing rather than expanding it (S. Johnson, 1997: 134). Johnson continues: "They could move faster through their sentences if they linked out strategically to other documents. They didn't need to spell out their allusions; they could just *point* to them and leave it up to the reader to follow along. So they left things out, and let the trails do the work (1997: 132–33).

I will argue that links *always* disrupt the static quality of a webpage; they move us away to other pages, or up and down a page. Webpages are not browsed as static texts, but in motion—even in the simplest manner, as one scrolls down the length of a webpage. This sense of mobility lies in the nature of the bricolage of elements and of hypertext links as "indexes"—semiotic pointers to a fuller presentation (such as another webpage) that they announce, indicate, or prefigure. Rather than primarily cyberspatial, the Web must be understood as dynamic. It is not a timeless, ambient space in which "action takes place," but rather a vectoral space that does not exist apart from the action of calls out to remote servers and files and linkings from one page to another.

Johnson praises the humble hypertext link as the key to the magic of the Net. "The eureka moment for most of us came when we first clicked on a link, and found ourselves jettisoned across the planet. The freedom and immediacy of that movement—shuttling from site to site across the infosphere, following trails of thought wherever they led us—was genuinely unlike anything before it" (Johnson, 1997: 110). This vision runs counter to many popular tropes for the Net and the Web. Webpages are stabilized and lent an apparent permanence through spatial metaphors— such as the reifying idea of a "page," the Internet as a literal "network" or a "superhighway," and even the notions of "frontier" and "cyberspace." Spatial metaphors have been used to launch and promote computer-mediated communications and digital environments (Chesher, 1997: 81; see Argyle, 1996). With their sources in literature (Gibson, 1984; Stephenson, 1992) and animated film, this language has formed a set of images that affected the direction and development of technologies as public demand for affordable access and versions of cyberspace, virtual reality, and the Net grew. Such metaphors offer a mythic overview, a totalizing sense; they promise a commanding vision of computer-mediated communications processes.

THE MYTH OF TOTALITY

The Web as totality offers a labyrinthine environment of data. Even though the full scale of the Web—in terms of the number of possible interconnections and the myriad geographical locations of the addressable domains—is difficult to grasp, this conception of totality operates on the principle of Plato's ideals and forms. The idea of a network, or even of the sort of net found in other domains of everyday life experience provides an *exemplification* of the overall Internet—a model of the general in the particular.

Michel de Certeau presents us with an example of such a bird's-eye view in his discussion of the planner's vision of the city "from above" rather than from the ground level of individual footsteps and vehicular motions. The planner has a vision of the city as if from a high building: "The person who ascends to that height leaves behind the mass that takes and incorporates into itself any sense of being either an author or spectator. Above these waters Icarus can ignore the tricks of Daedalus in his shifting and endless labyrinths. His altitude transforms him into a voyeur. It places him at a distance. It changes an enchanting world into a text. It

allows him to read it; to become a solar Eye, a god's regard. The exaltation of a scopic or a gnostic drive. Just to be this seeing point creates the fiction of knowledge. Must one then redescend into the somber space through which crowds of people move about, crowds that, visible from above, cannot see there below! The fall of Icarus" (de Certeau, 1991: 59). To grasp the experience of a city, it is necessary to move back to ground level, to follow the footsteps and movements of crowds, to grasp the fact that sites are not always used the way they are intended to be, nor can the actual use or ways of inhabiting an environment be predicted from the totalizing vision of the whole.

If one cannot obtain an overview of a city from any one point on its sidewalks, the Web is not visible from the point of one single webpage. There is no one page at which it all comes together, even though some search engines have attempted to become so-called portals to the Web by providing categorical and keyword indexes. Phrases such as "the Net" or "the Web" are ideograms that code in the visual sense something one can neither envision nor see. In the case of "the Net," this overall vision offers us the illusion of mastery of the Internet; the global and hugely scaled is represented as a tool, as a simple object. The Internet comes represented as a "landscape before us," awaiting our instructions. In addition, the idea of a formal or informal social network is something most have participated in. While our experience of such a social network is only of the interaction and sociability with those who we interact with immediately, we have the social understanding that our interactants relate to others whom we may or may not know. Thus, what we say may indeed be conveyed to others. The idea that networks may stretch beyond our own localized interactions is a familiar one that offers a sense of possibility.

An overview that is rarely articulated focuses on the structure of computer addresses and the topology of data. The strictness of the conventions governing the transmission protocols that allow computers to be interconnected, as well as the decentralized arrangement of packet-switching in the Internet, governs the nature of the resulting network. Cyberspace can be no more than this in terms of its infrastructure. To participate, a computer must be assigned a unique domain name or identity. In this network, one can only find that which has already been mapped, indexed, and linked. The Web is an indexical apparatus (Elmer, 1998). Like a labyrinth, connections to other spaces, such as the lived space of every-

day life, are weak. If the Internet is a space, then it is an immanent space built up, secreted, out of already-known elements and codes (Nunes, 1997: 168). In this case, "the map precedes the territory" (Baudrillard, 1990: 1).[1] We are often amazed at the speed of "travel" through the Web but, as Chesher has argued, "the sacrifice made for speed is the acceptance of a rigid data topology.... Grids are a modernist model of space. The ontology of the digital domain is an embodiment in electronics of the ideal of addressability that the modernist project imposed on the physical world. The grid of the nineteenth century colonial map imposed latitude and longitude to encompass, define and therefore possess all possible places. By having a potential grid reference of anywhere everywhere was reduced. On a grid, here and there are irrelevant.... (1997: 85)

This critical literature on spatiality provides a foundation, but it is necessary to advance beyond what becomes a circular discussion, locked in the realm of metaphors that "misrepresent the topology of computers' data architectures" (Chesher, 1997: 81–22), and the process by which data is represented on interfaces such as the computer screen. The focus in many studies of the World Wide Web presupposes the singular integrity of webpages and sites. These understandings of the Net ignore the dynamic quality of the experiences of users. Given my argument that movement is central, it is important to ask about the nature of the hypertext link, What is the ontology of a mouse click?

Geographical metaphors of "the site" spatialize webpages as places, implying territories defined by geopolitical borderlines that separate space into areas. These images are also joined by legal and illegal practices of crossing and communication. What is missing in this vision is that systematic border crossings may be a constitutive part of webpages, not merely links outside their boundaries. Such crossings occur to such an extent that one wonders whether or not webpages are so full of holes, of comings and goings between different groups of material that they can be understood as coherent pages—except, perhaps, from the viewpoint of the author. In the case of the World Wide Web, the preoccupations and interests of authors may be different from those of their readers, who may be more concerned with the ongoing thread of connections from one page to another rather than focusing on the linear flow of a narrative on a given page or set of pages. Scrolling to the bottom of a page offers the opportunity to not only skim any webpage text, but to search for links onward to another page. Links offer the opportunity to move out of any predefined

thread of webpages. In short, webpage authors and their readers are different—and this difference is in turn unlike that between a print writer and reader. It is their use of, and attitudes toward, hypertext links that divides the Web author and reader.

CONNECTIVITY

Links are generally interconnections to "elsewhere," and to other pages. Even in the case of *Suck*'s ironic and self-accusatory links, one returns to a page that has been changed by the added connotations and implications of a circular hypertext link. To a reader, the page is no longer simply "the same." Of course links and references assume much greater importance for the Web than for any print text. The central characteristic of the Web and of other networks is connectivity. The contents of a network (those things that are interconnected) are not essential; rather, it is their joint "turning toward" each other that constitutes them as part of a network. Networks may be more or less decentralized, but the general notion of connectivity in a net is that each element is interconnected with a multiplicity of other elements. In a network, then, the status of individual elements is determined by their connections. These make some elements into nodal points through which the network itself may be argued to flow onward. Other elements are end points that could be represented as peripheral, though strictly speaking, notions of center and edge only apply to certain forms of network—such as a simple, radial network that resembles a spoked wheel.

An element such as a webpage is "turned toward" a number of other elements (other webpages) in a network. The page takes some of its identity from this participation in a network. First, its identity is relational; it is not self-contained, but depends on its relationship with other elements. (For example, a node gains its nodal identity by the existence of links to other elements.) Beyond being simply elements, or even elements in an arrangement (as some realists might approach the spatiality of the Net) elements may stand in relation to other elements as nodes or points on the way to another point.

A second feature of identity within a network is dialogical (Bakhtin, 1981). Beyond being partly relational, the identity of elements depends on the substantive identity and character of the elements to which it is linked. One might speak of networks as characterized by multilogism, both at the macrolevel of their connectivity and in the microlevel inter-

actions of each node in the network. Dialogism is a generic term that has been imposed in translation to label the applications of Mikhail Bakhtin's ideas. These applications stress interaction and develop Bakhtin's original metaphor of differing points of view presented in a conversation. Rather than tending to merge these points of view, Bakhtin places the emphasis on their difference and the richness of the resulting weave of interacting ideas and positions (Shields, 1996b). On the Web, every page is interconnected. One must "link" from an arbitrary "home page" to a given page or site.

Multilogism is found at the level of the hypertext reference, or "link," in the case of the World Wide Web. But a reference or addressed link is capable of changing shape or the state of the display dramatically when it is invoked. It is often described as a leap or jump between pages. On the screen itself, the state of the text is altered abruptly. One may well move on, or move to a completely different view or display. Direction is not proscribed—one simply "jumps."

There is, however, a third aspect to the identity of a network element in the case of the World Wide Web. The essence of the hypertext link is that it has a double function, as a sign that is a seamless part of a page or text and as an indexical sign that flags and indicates (like an index entry, another page or image). For example, an image file may be imported from a distant computer to form an essential part of a webpage—most pages involve this sort of bricolage of distinct images. This image may itself be used as a "clickable" link to another webpage, which may concern or explain the topic or motif of the image. This two-sided quality makes the link a liminal sign, an element that is "betwixt and between" (Turner, 1974). This is not only a question of the ambiguity of the hypertext reference as a symbol of "between-ness" or a threshold condition to another text or webpage; it is the double ambiguity of an exterior and threshold elements made internal to a page. For this reason, links cannot be treated as merely thresholds or passages to other pages. The link is both a part of the text and an index caught on the threshold of departure, signaling to another page or text. It is paradoxical because it appears to be an interior gateway. To indulge in an architectural metaphor, it is less a portal to the outside and more like a hidden passage in a building—a door to the inside, which leads out somewhere else, reinforcing a sense of self-sufficient totality. Ambiguity thus becomes mystery in the absence of a span across clear categorical divisions. In this

case, distinctions such as inside and outside, here and there break down; webpages do not distinguish between internal and external, the native and the foreign.

Links are thus Janus-faced, threshold elements forming an essential part of a webpage, but leading elsewhere—as if they were arrows frozen in flight, but still imbued with an overriding sense of being in flight, between here and there. As boundary elements, they suggest the existence of an elsewhere and the possibility of viewing it next. As Jean-François Lyotard notes, all forms of writing can be understood as "a means of calling forth presence, of making the subject 'here' without being here. This presence appears in idealist ... discourses as a kind of dissimulation—writing a false speech. But from the standpoint of writing as technology, the *telos* of writing is to *simulate* the immediacy and transparency, and hence the ideality, of speech. Writing truly becomes tele-graphy (distance writing) in that it 'breaches' the spatial and temporal constraints on a [face-to-face] culture" (Lyotard, 1991: 49–51).

This argument might be seen as a second starting point for deconstructing the apparent stability and static presence of webpages. Not only as technology but as texts and images they allow a form of vicarious transport. In the case of webpages, distant elements are part of their immediate presence. The absent is made present through indexes that invoke data stored in remote databanks. However, webpages are simulations of presence to a particularly high degree and must be re-created from a digital pattern upon each viewing. Presenting elements that are absent reaches its zenith in the case of the hypertext link (see Shields, 1992). Thus, Johnson describes hypertext links as "a way of drawing connections between things, a way of forging semantic relationships. In the terminology of linguistics, the link plays a conjunctive role, binding together disparate ideas in digital prose. This seems self-evident enough, and yet for some reason the critical response to hypertext prose has always fixated on the disassociative powers of the link. In the world of hypertext fiction, the emphasis on fragmentation has its merits. But as a general interface convention, the link should usually be understood as a *synthetic* device, a tool that brings multifarious elements together into some kind of orderly unit" (1997: 111).

He also describes the link as "the first significant new form of punctuation to emerge in centuries" (111) because of its syntactical qualities; links stitch together material within and between pages and alert us to

related materials and the latent possibilities of expanding on a particular image, comment, or feature. This describes a condition of indexicality. The index is described by the semiotician Pierce (1955: 275ff) as dyadic: A throws B and, unexpectedly, B hits C. This involves two dyadic interactions, A-B and B-C. Thus, A throwing B might be represented as an indexical sign of the second dyad, an object B hitting C. Following the index A-B, we make a leap across the bounds of one dyad to a second dyad B-C. The lines of responsibility A-B-C are only reconstructed *post hoc ergo procter hoc* through a process of elision, inference, and coupling. This hides a sudden change of state and meaning that occurs at the point of the indexical *and* between A-B *and* B-C. Indexicality is that situation where a leap is concealed and orderly separations of "what follows" infects the "here and now." The result is an aura of uncanniness, foreboding, or anticipation.

Hyperlinks conform to the model of the index. They take the form of a name—the file name of a webpage. Translated by the interface into machine code, when called or clicked upon, they invoke a start address of webpage content. As Nunes (1997) argues, this process of invocation, or "calling," is central to the organization of information storage and retrieval and is carried over into the organization of all digital domains. At a broader level, however, this process of naming and calling is the key procedural moment that brings forth "the Web" or "the Net" as a totality—as something larger or more encompassing than the material presented at any one time on a video display. We believe that the webpage just viewed or used continues to exist in its surrogate digital form as a computer file, and can be reinvoked or "called back up" as needed. Similarly, there are other pages indicated by links visible on a screen that are not just possible webpages, but actual material that others might already have seen or explored.

A NEW WORLD

Other expressions called, *indexicals* by some philosophers of language, include "I," "here," "there," and "now." They may indicate a referent that is tangibly present—"rock," a person's name, and so on. However, they also may designate a reality that appears and disappears with the utterance—"America," "modernity," and the like (Mason, 1990: 16). These names designate totalities, complex spatial objects that may amount to "imaginary worlds." They can't be found as totalities, only as

pieces or traces that are socially constructed as indicators of the existence of the totality. As such, they are concrete abstractions (cf. Lefebvre, 1991; Shields, 1999: 159–60). They are both a material product of human imagination and labor and a medium of social actions because they structure and become the limits for subsequent activities. Yet they depend on an indexical leap from a fragment that is encountered and an abstract, absent totality, which is conjured.

If the Net is not a frontier, nor a physical space, may it nonetheless be an "imaginary world"? With a sense of spatial extension and temporal delay, an illusory sense of a world may be created. Imaginary worlds—such as the early explorers' understanding of the Americas as the New World—cannot be seen, but they must be named, as in the case of concrete abstractions discussed above. A name, in turn, is a part of a network, or rather of different networks, of names. No single name can cover this imaginary world in its entirety: it is always more than the sum of its parts. Hence the inherent excess of meaning in a term like "America," which designates indexically but cannot be reduced to a single description. As Ludwig Wittgenstein wrote, "It seems—at least so far as I can see at present [May 1915]—that the matter is not settled by getting rid of names by means of definitions: complex spatial objects, for example, seem to me in some sense to be essentially things—I as it were see them as things.—And the designation of them by means of names seems to be more than a mere trick of language" (cited in Mason, 1990: 16–17).

Drawing on Mason's discussion of the invention of *America* by the first European explorers, we can say that an ensemble of names in a digital domain interlocks indexically and tropologically with other systems (chronological, topographical, and so on), which contributes a "reality effect." Despite the vast number of contexts in which a proper name (such as a webpage name) can occur, it remains invariable from one context to another—and rigidly so in the case of the Net or Web. It is in this sense that we can say that systems consisting of names of "objects" (home page) and of names of relations (specific, embedded links) between objects designate entities and relations between these entities. What they designate we call a *world* (Lyotard, 1984: 67; Mason, 1990).

The question about this totality remains: What does it mean to discover a new world? This is an especially important question because the world apparently being "discovered" does not seem to be vanishing, even though it is weakly interconnected to the world of face-to-face propin-

quitous social interaction. A chimera or mirage could be expected to disappear. If it has not, it remains the case that, in its accessibility limited to the most wealthy and connected, and in the impossibility of actually living in this world, the Net is certainly not like the worlds of everyday common sense, and more like a fictional world. As a shared digital domain, however, it continues to exist when we turn away from it to other tasks. The upshot of this is to indicate that digital domains such as the Web do not coincide exactly with our notions of *world*. Yet, they do breach the limited totality of the known world—a geographic totality that has been closed since 1492 (Todorov, 1984: 13–14).

The magical quality of the World Wide Web lies not only in its complexity but in the conjuring effect of calling a world into existence through the habitual and pervasive practice of naming webpages and groups of pages as "sites" and "calling out" to have them invoked on one's own machine via hypertext links. Names become tropes or sites. The abstraction of a digital domain that actually resides in nested 32 x 32 gridworks of addressable computer memory locations mutates in the mind's eye into indexical geography of identities. This pervasive indexing is such that to exist in a digital domain, any given element must be named with an address. The spatiality of digital domains is part of the effect of this universal addressability. Ontologically, digital domains are not spatial, but an effect of indexicality, and this indexicality is a form of *action*—the humble link.

ACTION IN THE DIGITAL

Gilles Deleuze refers to the index as a "skeleton-space" because so much of what is significant seems to be missing, like a skeleton devoid of organs and flesh.[2] There are the interstitial, absent-middle elements, "missing intermediaries, heterogeneous elements which jump from one to the other, or which interconnect directly. It is no longer an ambient space [of flows] but a vectorial space, a vector-space, with temporal distances. It is no longer the encompassing stroke of a great contour, but the broken stroke of a line of the universe, across the holes. The vector is the sign of such a line. It is the genetic sign of the new action-image, whilst the index was the sign of its composition" (1983: 168; see also Shields, 1997b).

The index involves a leap that produces a sense of space. This interaction (the "between" of the index or the space between the different

actions) traverses a space that may be infinitesimal (approaching the limit, or degree-zero). The link may return (almost) to itself, instituting a change in quality rather than a leap to new material. But this may be a link across that conceptual "space" that separates "my" webpage from "yours" by the action of leaping across a border in which the flimsiest line between digital data is conjured into a putative cyberspace. The distinctions that are generated by this leap across the boundary are qualitative (different in kind) rather than quantitative (different in degree). In the equivocal form of the interaction, infinitesimal distance exists only to suddenly explode into infinitely large distances, differences, or situations. Hence the potentially uncanny quality of links:

> The link added another dimension to the language, but not in the story-space sense of the word. You never felt that you were exploring. You were just reading but the sentences that scrolled down the screen had a strange vitality to them. They were more resonant somehow.
>
> When you added it all up, the meaning of the sentence was a good deal more complicated than the original formation. Like one of Freud's dream studies the sentence had a manifest and latent content. The former was clear-cut, straightforward.... The latter was more oblique. As in the dream work of psychoanalysis the latent content had a way of infecting the manifest content. (Johnson, 1997: 134–35)

This leakage from the latent to the manifest is precisely the index at work. Johnson does not go on to examine how the indexicality of the Web puts the entire assemblage into motion. Pages are the most visible, machinic elements that deflect or attempt to channel the flow across and through the Net. It is not texts—as stable or even cut-up, but still clearly identifiable entities—but the movement of browsing that characterizes the World Wide Web, not the superficial stasis of the webpages themselves. Constant attention and "attendance" is required to scroll and click through pages and sites. The World Wide Web is a *very* nervous system of flows and users who must imagine themselves mobile, even while remaining seated. The mobile fixity of the user is comparable to the ambiguous, mobile fixity of the link that remains in place on a page, even while presenting an indexical line of flight to another page.

Movement is pervasive on the Web. Pages scroll and assemble their

component images, sound bites, and headlines. Page elements troupe in like the actors on a theatre stage. One is almost always offered the opportunity to rearrange the screen image—as many say, reading a static document online is wearisome. Hence the Microsoft slogan "Where do you want to go today?" and the technical description of hypertext links as "going to" a webpage or site (even if it is a file stored on one's own computer). Even when absent from our computer screens, these webpages are made indexically present through each hypertext reference.

THE AESTHETIC OF DELAY

Paul Virilio describes computers as a technology of speed; however, the lived experience of the Net is more often one of delay. The patterning of time lags indicating connection and interaction with a remote document, image, or program is central to the aesthetic form of the World Wide Web. While contents of webpages and sites differ, connection delays, sluggish displays, and time-outs remain the frustrating common point of Web users' experience. Something of the geographers' "friction of distance" remains, even if this is more likely a sign of the overloading of local systems than the speed of transoceanic signals.

The wait while an image or sound is downloaded—with only a quarter of a picture visible, for example—is typical of the suspense of the Web. This slowness is not only an indicator of distance but may be read as an index of technological labor: the machine seems to be working; this is part of its charm; that it labors "just for you." Suspense creates not only frustration but the catharsis of the full image, and thus delight. Theorists have only partially expressed this. For example, Chesher misses the primacy of action with his comment, "Space in the physical world becomes site in the ontology of the digital domain. Distance is manifested in invocational delays of nano- or microseconds. Although digital domains almost eliminate spatiality for the user, there is a residue of the physical in technical and economic limitations" (1997: 85). A further effect of this cathartic reward structure is that links are gratifying channels of users' curiosity and desire. The World Wide Web becomes a large-scale, purified display of flow and desire caught within a rational technology that is antithetical to it.

The moment of delay is also the moment of dynamism in which the invocation of a name results in another element being made present, or

being re-*present*-ed on screen. However, time is not the founding ontological quality of the Net; rather, the action-interval of the index causes a specific sense of temporality—the instant or moment. The index is all movement—a synthesis of space and time. Hegel refers to this as the "second negation" that synthesizes both space and time (the point, moment, site) by integrating them in motion (transforming the point into the line that stretches through space and divides it, transforming pure homogeneous space forever). The peculiar sense of time on the Web—the moment of delay—would not occur in the same way without hypertext references. Of course, clock time would pass, the machinic tempo of the CPU would steadily pulse on, and one might still "loose track of time" psychologically, but how is one reminded of not only the passage of time but of temporality when browsing the Web? The answer lies in the elapsed time of the moment of delay. This makes time (which might have been momentarily forgotten) present to us in a uniquely frustrating manner. Time is made palpable in the form of delay and lived in the experience of suspense—this temporality is as much an effect as is the illusion of spatiality on the Net.

ETHIC OF THE INDEX

These effects of creating a sense of space and of time might be termed the *ethic* of the index. The index has an "ethical" quality because it relates elements and is thus concerned with the relations between texts, and anchors the existence of a "site" of related pages with a governing ethos of, for example, authorship or a theme. Ethics derives its meaning from *ethos*—the atmosphere or sum of relations between elements.

Unlike morals, which are universal (Maffesoli, 1996), ethics are local, contextual, and momentary. They are situational. The ethos of the Web is not one of sovereign territories and isolated webpages, but of the traveling shot, the mobile index that carries a browsing reader through multiple links and pages that never have time to fully "unscroll" or are ignored except from their links (consider the case of pages in a foreign language). These are brought into a relation recorded in browser programs, internal history lists. This set or collection of pages and their constitutive elements are most obvious to the user when invoked by the "back" and "forward" buttons of the browser software.

Martin Heidegger emphasizes the contextual and "bottom-up" qual-

ity of ethos as an emergent feature of everyday "dwelling." In contrast to the "top-down" quality of prescriptive moral systems, the immanent quality of the ethical is local. Against Heidegger's transcendental ethics, which tends to a metaphysics, an ethos is a weak anchor by which to stabilize life: it is the opposite of a mode of governance (a moral politics) and rather founds an aesthetics (cf. Maffesoli, 1996). This is a nonprescriptive and nonregularized relation, a "drawing together"—in short, a mode of composition rather than governance.

The peculiar spatiality of the Web, by which something understood as *cyberspace* balloons out of infinitesimally small divisions between segments of data, is also immanent and an effect of the relational qualities of the index. The indexicality of links produces a sense that the Web is a world that might be explored. However, it is a "new" world in more than the terms of popular metaphors of frontier and discovery. Unlike geographic space, the Web is an expanding universe whose limits are set not in spatial terms, but rather by the imagined expansion of the elements that fill it, and the hypertext linkages that connect them. It is a space with no specific dimensionality—it can only be understood in the vector terms of hypertext leaps. As in the Medieval Scholastics' debate concerning how many angels would fit on the head of a pin, to ask how many dimensions the Web has is to make a category mistake, transposing geographic space onto a purely digital domain.

The temporality of the Web is also a felt effect of the common experience of delay. These shared experiences (*aesthesis*) find their expression in the suspense and catharsis, revelation and transport, that browsing the Web offers users. This might be summarized as the particular "chronotope" that characterizes the World Wide Web and differentiates it from other forms of expression. Bakhtin's (1981: 100, 282ff.) notion of the chronotope (*chronos* = time + *topos* = space) was developed to distinguish literary genres from each other—contrasting, for example, the mythic time of the epic from the psychological time of the novel or the "adventure time" of the Hellenistic romance (think of the *Iliad*). While the roots of this chronotope lie in the indexicality of hypertext links, its result is not only the apparent stability and unitary quality of webpages as elements within a network, but its results are also in the quality of the entire Web as an "imaginary world," a complex totality that results from the ethic of the index.

NOTES

1. The system of addressing itself is based on a finite Cartesian grid (for the Internet, 32 x 32). Every file, and indeed every place on a hard drive and every bit in a computer's memory is rigidly indexed in a series of enclosed grids, like a Russian folderol doll.

2. Note this late-Deleuze development of the idea of the "body without organs"—a "dis-organized" body, entity, or qualitative space (see Deleuze and Guattari 1988).

8

> FROM: GREG ELMER
>
> SUBJECT: **The Economy of Cyberpromotion**
> Awards on the World Wide Web

The architecture of the Internet is by definition an imagined space—we are no more able to feel, touch, or survey its expressive contours than we are able to represent its totality. In an attempt to explicate such abstract spaces we often turn to the realm of metaphorical language to provide ourselves with mental maps, diagrams, and structural imagery. Politicians thus regularly debate the merits of laws regulating the information superhighway, while online users continue to communicate in dungeons, salons, and chat rooms. The most traveled—or in the vernacular "browsed"—portions of the Internet are likewise metaphorically described as worldwide "webs," data-mined by programmable spider-robots (Elmer, 1997).

Paradoxically, many scholars interested in the unique community-building possibilities of online communication, particularly those invested in the burgeoning field of "computer-mediated communication," have largely limited questions of architecture to the "virtual" dimension of social and dialogic conventions (see Markham, 1998). On the heels of Howard Rheingold's (1993) study of the constitution of online community, a plethora of diasporic, subcultural, and professional Usenet-community studies have focused on the general problematic of real-time dialogue from multiple positions of isolation (Healy, 1997). Thus, in opposition to the metaphorical discourse eschewed by politicians and the popular press, Herman Van Bolhuis and Vicente Colom have argued that studies of computer-

mediated communication are more likely to focus on humanistic keywords such as "civility, reciprocity, harmony, spirituality and virtuality" (1995: 10).

The focus on online dialogue should come as no surprise given the overwhelmingly text-centered format of earlier online networks, bulletin boards, and the Internet itself. The introduction to the 1994 special issue of *Communication Education*, for instance, restricted the definition of computer-mediated communication to dialogic technologies such as electronic mail, listservs, BBSs (electronic bulletin boards), Internet relay chats (IRCs), and of course the Usenet (Santoro, 1994: 78–81). Although there was at one time a tendency to characterize programs such as telnet, file transfer protocol (Ftp), gopher, wais, and even the World Wide Web as "infomatics" and not "communication" per se, the multiplatforming and networking of technologies and programs on the Net have now broadened the scope of computer-mediated communication by automating links between communication programs such as e-mail, the Usenet, and the Web. Internet users now typically append contact information (such as telephone, fax, home and home page numbers and addresses) to the signature files at the bottom of their posts and e-mails as if to flaunt their cybercredentials (particularly if their content provides specialized information on a topic of particular interest to a specific group). With the advent of increasingly more complex and powerful e-mail browsers, users—including those without the time or resources to build a home page—can also forward a hypertextually linked web address in the text of e-mail messages, automatically facilitating an addressee's jump to a site on the Web.

We might ask ourselves, then, how the search for community in cyberspace—the raison d'être of many dialogically defined studies of computer-mediated communication—might be augmented by an understanding of the networking possibilities (and frustrations) of the Web. As I have said, I believe the answer to be in part architecturally driven. Where questions of architecture are largely marginal in the Usenet or e-mail's highly structured and personalized environment (listing messages and posts in chronological order by topic and sender) the hypertextual environment of the Web has, conversely, introduced a host of questions related to the structuring, posting, and retrieval of information in a nonlinear environment.

With increased storage capacities, faster processors, and graphics browsers, the Internet has therefore become both a technology of interaction and display, a medium and an archive. As a consequence, it has

become a much more permanent enterprise, relatively speaking, in the sense that communication is increasingly contextualized by references to a home (page). Such archival techniques are, more to the point, often accompanied by attempts to codify and govern on-line conventions (for example, FAQs—frequently asked questions) and provide structure to a complex, decentered environment. In this regard, the Internet is like other archival technologies—the subject of much scholarly inquiry, historical and theoretical. The Canadian political economist and historian Harold Innis (1972), for one, questioned the relationship between technologies of communication (paper, the printing press, and so on), the centralization of knowledge (monasteries, universities), and their accompanying forms and strengths of government (or "empires"). From an epistemological and etymological perspective, the philosopher Jacques Derrida, similarly deconstructs the word *archive,* highlighting its invocation of place and power: "the meaning of 'archive,' its only meaning, comes to it from the Greek *arkheion*: initially a house, a domicile, an address, the residence of the superior magistrates, the *archons*, those who commanded" (1996: 2).

In this chapter I likewise attempt to question the archival politics and problematics of—and *in*—the Web. I argue that with the ongoing commercialization of online life and the Web in particular, techniques of "promoting" archives, resources, and sites have become somewhat of a battleground in which competing views of the Web have emerged. First, by focusing on the problematic of finding and promoting sites in a hypertextual environment, this chapter details the extent to which the search engine industry (led by Yahoo, Microsoft, Netscape, Excite, Lycos, and others) have attempted to redefine the Web as a place to register one's resources in all-in-one (and now one-stop shopping) Net guides, search engine databases, and online indexes. The hyperproliferation of website awards, conversely, points to a more community-based view of the Web in which links are forged not only to a central guide, but, more important, to a group of like-minded websites, constituting an online collectivity that complements the strict dialogic understanding of virtual communities.

DEFAULTS, REGISTRATIONS, AND NET GUIDES

Adding a much-needed historical perspective to the hypertextual environment of the Web, Michelle Jackson (1997) has argued that the contemporary predominance of commercial and proprietorial interests in cyberspace can be traced back to the initial architectural design of the

Web. According to Jackson, a crucial decision made by early Web programmers to separate the software that stored information from the software that displayed information led to the birth of the "browser," and "the notion of client-defined (rather than server-defined) information display. An important implication of this decision is that the user is separated from the data." Unlike e-mail or the Usenet, where individuals routinely engage in one-to-one or bulletin-board-style posting of messages, Jackson's essay concludes that the Web's restricted, proprietorial form of hypertextuality has created yet another medium dominated by "a speaker and an audience" (particularly by website owners and designers).

In a world where information has become increasingly commodified and restricted through the costs and accessibility of computers and technological capital (or "know-how"), Jackson's arguments directly speak to the democratic possibilities of authoring online content and cyberspace. However, with respect to the promotion of sites through Web awards, such a critique is complicated by the various identities and tasks of "Web masters" (some quite amateurish, others decidedly professional, still others governmental or administrative). Moreover, in addition to her criticism of the Web's elitist and proprietorial hypertextual environment, Jackson's technological history also speaks to the commercialization and monopolization of online archival techniques (i.e. search and retrieval tools), specifically the power of Netscape's and Microsoft's Web browsers—in conjunction with their accompanying Web guides, search engines, and so-called 'portals'—to increasingly center information services and searches on the Net.

In attempting to archive the contents of the Web, Netscape, Microsoft, Yahoo, Lycos, and others have not only been attempting to redress the problem of finding and retrieving information on the Web, they have also sought to establish their browsers and subsequent portals as boot-up default settings—a universal departure terminal on the so-called information superhighway. Since many users, particularly novice users, are unaware of the ability to change the start-up default setting (Feldman, 1997: 123), the leading browsers have secured a definitive advantage in the search for advertising dollars. Alongside the online net guide Yahoo, the Net browser giants top the list of revenue generating sites in an industry that is expected to increase its advertising revenue from just over $100 million as of 1997 to an estimated $5 billion in the year 2000 (Coile, 1997).

In addition to offering indexing tools, default Web browsers, Net guides and search engines also serve a distinctly promotional purpose—for instance, providing users with signposts to the latest "cool" and recommended sites. Yahoo, generally recognized as the foremost guide on the Net, also maintains a listing of its own "picks of the week," an archive of previous picks, and a mailing list that automatically updates subscribers on the guide's site recommendations. Yahoo's listing of recommendations, while helpful to individuals and groups looking to establish credentials for future Web design work or advertising possibilities is, nevertheless, a complement and afterthought to its larger categorical and indexing strategies. Coaxing Internet users to "Discover all the very best sites on the Web—quickly and easily, without fuss and frustration ...!" Web guides and indexes such as Yahoo have instead focused on name-brand recognition through magazine publishing and advertising. In this respect Yahoo largely mirrors the business strategies of competing Internet giants such as *Wired* magazine, who have themselves established a popular search engine, Hotbot, and a book publishing arm.

PROMOTING HYPERTEXTUAL COMMUNITIES

Yet alongside the horizontal and monopolistic trends in the online search and index industry, professional communities, small business, and everyday users have sought to structure and Network their own particular interests and resources on the Web. Without the ability to archive and map large amounts of data on the Net or set their home page as a mass default setting (clearly the most efficient and economic form of auto-/ self-promotion), users have realized the Networking, mapping, and promotional potential of website awards. Joy McManus (1997: F14) has thus argued, "The factor responsible for the alternative Web award explosion could be that most of the giants in the award world tend to focus exclusively on mainstream, highly visible or commercialized sites that are easily found by anyone who spends a reasonable amount of time on the Web."

With over 1,100 sites offering almost 1,600 different honors, this veritable economy of website awards provides a unique study of the manner in which particular communities or—recognizing the hypersegmented and specialized nature of online discussions—"lifestyle enclaves" (Healy, 1997), not only converse but also navigate, Network, display, promote, and archive discussions and resources. Such a study is again predicated upon the notion that individuals, communities, and commercial

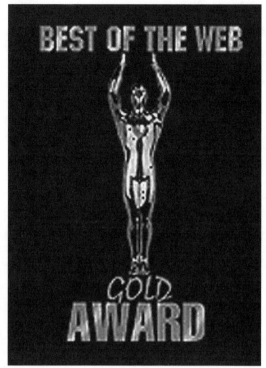

Fig. 8.1.
Users have realized the networking, mapping, and promotional potential of website awards. The Best of the Web Gold Award.

interests routinely supplement their online posts with Web-based archives of their discussions, FAQs, graphics, maps, photographs, and links to resources of interest on other websites. Yet, in addition to these other online conventions, website awards also speak to a hypertextual politics of finding and being found—that is to say a means of Networking and promoting a hypertextually linked community of like-minded resources and interests outside of the economically powerful yet simply index or subject-based default portal, search engine, or Net guide.

Although online awards recognize such disparate elements as design, content, and user-friendliness to name but a few of the more conventional criteria, their architectural and promotional utility—particularly as a community-building tool—is singularly embodied in the award logo. Proportionately sized for display, award logos litter the bottom of an increasing number of website home pages. For true award junkies, linked pages (or "e-mantles") are often exclusively reserved for a phalanx of award logos. More important is that the particularities of the Web's hypertextual environment subsequently provides the ability to forge links through the

awarded logo itself to the awarding website and sites that attempt to govern and promote the larger online award community.

A testament to the centrality and shear banality of some strategically placed award logos, however, can be found at a number of websites that offer parody awards. Focusing on the ubiquity of award logos, the Fort Ogden Outpost Freebie Awards site (http://www.fortogden.com/freebie.html), for example, offers a number of fake award logos for "all of the neglected, forgotten and downtrodden." Logos "free for the taking," which the site encourages its visitors to download, copy, alter, or reformat, include the "hardly ever used award" and other awards for "hidden meaning," "hot air," and "old fashioned elegance." Too Many Web Site Awards website (http://www35.pair.com/asknic/award.html) likewise argues that the proliferation of web awards has degraded, or at times altogether eliminated, the recognition of true accomplishment. Thus, according to the site, "Award[s] should be bestowed upon someone by their peers and be of relative circumstance. The Award should maintain Honor and Integrity. On behalf of these principles, we feel that Awards on the Net all too often ignore or are lacking in these principles. We may win one of these coveted "Net Awards" by merely pointing this out on our page." Moreover, in offering its own "Award Free Site" logo for downloading without the need of an accompanying link, Too Many Web Site Awards also critiques the powerful networking and cynical auto-/ self-promotional functions of these awards.

In an attempt to actively promote the resources of the lesbian, gay, bisexual, and transgendered (LGBT) communities, the Totally Cool Queer Site Awards Home Page (http://www.geocities.com/WestHollywood/5616/) has, conversely, altogether embraced the networking function of website awards on a number of levels, offering an excellent example of a highly organized and networked resource for a distinct community. And while the focus of the site is unquestionably placed on the award and its prominent gold logo, the site is also littered with a host of community building strategies. It is, however, the award itself that marks the site with a distinctly populist and democratic philosophy or statement of purpose, reading, "[t]he purpose of TOTALLY COOL QUEER SITE™ Awards [is to] showcase Queer Sites nominated and voted on by YOU for their Excellence in Design and Queer Content. Our emphasis is and always has been that this is a Queer Web Surfer's Award. There are no secret groups of people deciding who is listed or chosen as

the winners. That is entirely up to our visitors to decide. And who better to choose the Best Queer Sites than Queer Web Surfers?"

In addition to bestowing a "cool award" and logo—that can be used to "surf from one great page to another"—the site also displays an archive of past winners and a number of links to health, entertainment, and commercial resources for LGBT communities. More advanced Web users interested in publishing and web authoring are pointed toward the Guild of Gay Webmasters, a comprehensive site of over seven hundred members in thirty-nine countries that offers resources such as possible Web advertisers, help-wanted classifieds, a membership directory and application form, and perhaps—not surprisingly—a listing of awards for gay and lesbian websites. Displaying a linked logo reading "Webmaster for a Cure member," the webmasters' site also offers its own AIDS-awareness logo for members to place and link on their own home pages.

Not all sites, however, are so distinctly tied into promoting and servicing particular communities. In addition to Networking like-minded communities and interests, multiple-award-winning sites such as Views of the Solar System (www.if.ufrgs.br/ast/solar/eng/awards.htm), a site dedicated to the dissemination of astrological information, also highlights the niche marketing aspect of the award-promotional economy. In general, the eleven functioning award links on the site's Awards and Recognition bring together an interesting number of educational groups in search of a relatively common demographic. Clicking on the Education Index "Top Site" award logo link, for instance, takes users to the home page of the College View Corporation, a business specializing in educational products. The online award from television's Discovery Channel, likewise, attempts to link a specialized or segmented audience to a host of videotape and curricular products, in so doing producing a crossover audience/consumer from the television to computer screen. Institutionally speaking, the Star Award and the Geological Survey of Canada Site of the Week both attempt to seek support for the programs, policies, and overall goals of, respectively, the Los Angeles Griffith Observatory and a research and development wing of the Canadian government. The remaining awards on the astrological site once again address the problematic of finding and retrieving child-centered online information. The Magellan, Luckman, Net Guide, and Pont awards consequently offer a range of Internet guides, directories, yellow pages, free e-mail accounts, and a search engine free of pornographic sites.

GOVERNING WEB PROMOTION: THE AWARD COMMUNITY

With such an immense number and variation of Web awards, networked outside of the major search engines and Net guides, attempts to index the award community itself have, not surprisingly, become increasingly commonplace. Award registration sites such as the Contest Network (http://www.citeweb.net/theAC/), for example, serve as both a resource (how-to) for Web awarders and a veritable one-stop application site for potential awardees. For those in search of an award the Contest Network's Award-it page offers an award application form that is automatically sent to over 160 websites that bestow awards. All applicants are then sent newsletters from Award-it informing them of winners. Reinforcing its own reflexive duplicity or auto-/self-promotion in the wider economy of website awards, the Award-it page also urges users to vote—via a linked logo—for its own candidacy in the "prestigious" Akira Web awards.

In an attempt to build its own repository of website awards, Award-it also solicits the participation of those users looking to promote their respective site awards. In addition to weekly newsletters, Award-it encourages its members to display its logo, promoting its place within a greater and seemingly regulated community of website awards. Moreover, just as FAQs and other communicative conventions have been to varying degrees codified on the Usenet and listservs—often referred to as Netiquette—award registration sites similarly outline a relatively consistent set of ground rules. "Award-it," for instance, reminds its potential clientele that an up-to-date database is essential for managing the up to one hundred daily submissions (99 percent of which will be "substandard"). Noting that potential members should actually view websites before offering them awards, the Award's Jungle registration site (http://207.49.108.200/flamingo/chowch/aj/)—which once again suggests that users might vote for its site via a link to Starting Point Hot Site—also provides a number of criteria to consider for website awards:

1. No adult sites.
2. Site should be easy to navigate.
3. There must be no Under Construction signs.
4. Loading time of page should be taken into consideration.

With surely no more than 10 percent of all website awards registered with sites such as Award-it and the Awards Jungle, the mainstreaming, regulating, and (most important) centralization of website awards and automated applications is clearly nowhere near assured. Nonetheless, such attempts to facilitate the promotional and indexing needs of Webmasters and everyday users do shed some light on the rationalization, regulation, centralization of content, collectivities, and archives in the hypertextual environment of the Web. And while the intentions and ownership of such enterprises are often as questionable as many online awards themselves, such registration sites nevertheless complicate our understanding of "computer-mediated" communication, community building, and hypertextual promotion in a portal-dominated (and default-encoded) Net culture. Whatever the purpose of association, be it artistic, professional, educational, commercial, or governmental, the networking of resources via Web awards, through the circulation and linking of logos, offers a much more complex reading of online communication previously afforded by dialogic studies of computer-mediated communication, one better attuned to the wider, networked, and vested interests online, and, increasingly, on Wall Street. Not only does the study of online phenomena such as Web awards or like-minded networking strategies such as "web rings" introduce questions of crossovers and networking among different platforms on the Net, it also highlights the increased importance of promotional tactics in a hypertextual architecture dominated by a select few start-up indexing home pages—the need to find and be found without always returning to an increasingly hypercommodified center (a portal). Such an approach to questions of online community and communication are made all the more urgent by an age increasingly governed by the need to efficiently access, retrieve, and "diagnose" information and services from a host of so-called "providers."

NOTE

1. This article was written with the support of a generous fellowship from the Quebec government's Fonds FCAR. The author would like to thank the editors of this volume for their comments on an earlier draft of this chapter.

> FROM: STEVEN JONES
>
> SUBJECT: **The Bias of the Web**
>
>
>
>
>
>
>
>
>
> Though I have worked as a journalist, taught journalism
> courses, and maintained an interest in journalism's progress
> at the end of the twentieth century, it has been many years
> since I believed there was much for me to say about it. Co-
> incidentally, I had been feeling much the same way about
> the Web; until recently, I had found the Web less than
> interesting. It was not the interactive medium that I had
> believed the Internet would provide us with; e-mail and
> Usenet were much more like the media that I hoped could
> bring about social change in ways I envisioned.
>
> But I was wrong. The Web has become the most impor-
> tant Internet phenomenon there is. And I say that not
> because of its ubiquity, or its use for electronic commerce.
> I say that because of its rise to prominence in 1998 as a
> medium for news. I was wrong, and I have Web-journalist
> Matt Drudge to thank for showing me that I was.
>
> Journalism and the Web share some things, and not
> simply in regard to their content. Newspapers today are
> still largely disdained by social scientists, as are journal-
> ists and journalism by the public. In some cases those who
> study newspapers and journalism are marginalized, or
> worse; journalism programs have, for example, been dis-
> continued at a number of colleges and universities in the
> past several years. The Web, too, has its detractors, and its
> use in academia, though on the increase, is still met with
> resistance. But resistance to the Web is breaking down in
> the middle-class American home, and, concomitantly,

public disdain for journalism has fueled use of the Web because news on the Web seems less like the journalism to which we've become accustomed. Also, our hopes for the Internet as a public forum mirror what our hopes had been for journalism. We have forgotten that newspapers created "imagined communities," to borrow from Benedict Anderson, and now believe those are made online (S. Jones, 1997). This chapter will argue that journalism and the Web are linchpins for understanding the Internet and our hopes for it as a public forum.

I.

In an essay that sets out the connections between Harold Innis's writing and North American communications theory—where James W. Carey sets the framework for his analysis of the social and economic consequences of communication technologies—there is a quote attributed to John Dewey that has haunted me for many years. Dewey is reported to have said, during a lecture at the University of Michigan, "A proper daily newspaper would be the only possible social science" (in Carey, 1989: 143). The reason this has haunted me is that I could never *directly* connect the phrase "proper daily newspaper" to anything in Dewey's writing. Of course, I might be able to make connections between it and his writing about community, public life, education, and so on. Dewey's interest in journalism is well known, as was his acquaintance with Franklin Ford and the "Thought News" (Czitrom, 1982). But those are not sufficiently *direct* connections. What *did* Dewey mean by a "proper daily newspaper"? Is there such a thing? What would it be like?

I am not about to make any claims that the Web as a technology serves some sort of journalistic purpose, or to suggest that "a proper Internet would be the only possible social science." Like media before it, the Web is put to whatever social uses people see fit, whether those people work for corporate interests, government interests, selfish interests, or without interest. There is, however, a fundamental difference between the Web and other media, insofar as Internet-based media generally permit publication without enormous capital expense and infrastructure. Hence, the Web has potential to commingle social, industrial, and commercial uses and motivations in new ways.

What I intend in this chapter is to examine the relationships between our sensibilities regarding recent debates concerning journalism's purpose and the biases of the Web from the perspective of Harold Innis's

and James Carey's contributions to our understanding of the social con-
sequences of communication technology. I want to revive Harold Innis's
work on the bias of communication in one of the contexts in which he
most often spoke about it—namely that of journalism—in an era that has
come to be dominated by the Internet more than any other form of com-
munication. Much of Innis's discussion of monopolies of communication
relates to the "power of the American newspaper industry to monopolize
the Canadian pulp and paper trade and to force low tariffs" (Czitrom,
1982: 159; see also Innis, 1972).

Innis's great contribution to communication theory lies in his under-
standing and explication of the connections *among* transportation, com-
munication, and ritual. His ideas, filtered through a subtle reading of
Dewey, were taken up by American communication scholar and theorist
James Carey, who in his seminal essay "A Cultural Approach to Com-
munication" noted the tensions between the transmission and ritual views
of communication. "Two alternative conceptions of communication have
been alive in American culture," Carey wrote, "[and b]oth definitions
derive, as with much in secular culture, from religious origins.... The
transmission view of communication is the commonest in our culture—
perhaps in all industrial cultures—and ... is formed from a metaphor of
geography or transportation....The center of this idea of communication
is the transmission of signals or messages over distance for the purpose
of control.... A ritual view of communication is directed not toward the
extension of messages in space but toward the maintenance of society in
time; not the act of imparting information but the representation of shared
beliefs" (1989: 14–15, 18). Carey's purpose in critiquing them was to
open up new avenues for the study of communication at a time when the
transmission view was one that predominated among scholars. However,
it is important to note that at no time does Carey demand that the trans-
mission view be discarded or ignored. As Innis understood clearly, the
two views are in some ways inseparable. Moreover, Innis knew what the
fluid nature of change brought on by communications technology meant,
and scrutinized not merely the "peaks and valleys" but the points at
which the wave of change in communication technology crossed the
mean. Innis's understanding that *distribution* is a key element of both
transportation and communication is one we should take more seriously,
particularly as it connects to Nicholas Negroponte's observation that it is
easier to move bits than atoms (1995).

Examination of those points is particularly critical for gaining an understanding of some of the Web's spatial and temporal biases. They are at the "verge" that James Carey has written about in recent years, the moment at which convergence or divergence occurs. Carey noted that "journalism begins at a verge between the oral and printed traditions" (1989: 333). Borrowing from both Michael Oakeshott and Stuart Adam, Carey writes, "History is the whole of the real understood under the category of the past ... journalism is [the] whole of the real understood under the category of the present. Journalism, then, must be examined as the practices by which the real is made under the category of the present" (333).

The Internet, I believe, begins at the verge between the print and electronic traditions. The Web, particularly, is a technology that represents the development of electronic expression in a medium sufficiently removed from paper to render it apart from print. It is a medium of the screen and the link of text and connection. As a result, I believe that the Internet is the whole of the real understood under the category of the future. The Web exists in the present as a technology, but exists in the future as an infinite potentiality of connection, and it must be examined as such.

The bias of the Web is, at least for now, inextricably tied to that of the Internet. If one extends Innis's arguments concerning the biases of communication, the Web's bias in the final analysis is toward time and not space. The technology on which the Internet is based, namely, that of a "store-and-forward" mechanism, is inherently time-bound. If there is an appearance of the Internet's ability to have overcome space in some way, that appearance stems from the means by which the network itself articulates one point to the next, in a digital fashion, rather than in a linear, analog fashion. Space is not *overcome* so much as it is fragmented. Time, on the other hand, appears at the control of the user, who can choose to download data as desired. Time, though, is fragmented, divided into particular tasks (downloading images, text, files), is at the heart of bandwidth issues (since it is the time it takes to move data, and not in fact the space needed for that movement that is at stake—space exists in service of time as regards bandwidth), and its "saving" (an impossible feat) is the motivating factor behind increased use of the Web in business and education.

The activities of Web users (searching, finding, downloading) imply a future utility. What has happened is that the user has taken the place (or

at least shares the role) once held by journalists, whose task was to make *for tomorrow* the today, the *now*, that news once recorded. This is where the Web in practice makes real the category of the *future*. And, as Barnhurst (1998) points out, "the very mechanics of using the Web is best distilled in the verb await."

II.

In a letter to a friend in the U.S. Information Service, John Steinbeck wrote, "What can I say about journalism? It has the greatest virtue and the greatest evil.... It is the mother of literature and the perpetrator of crap. In many cases it is the only history we have ... over a long period of time and because it is the product of so many men, it is perhaps the purest thing we have" (quoted in Street and Wallsten, 1975: 526).

That "thing" has been swallowed whole by the current notion of "content." There are two meanings to *content* at present. One is traditional, that it is material intended to capture and hold the attention of an audience. The other meaning is less traditional, and has as its basis the oft-repeated phrase of those in Internet media industries that "content is king." That is not simply a reference to a content provider's interest in attracting audiences to a website by having "better" or more recent content; it is an acknowledgment that the Internet, and the Web, particularly, is deliberately used for purposes of information in a way that is different from the use of media before it.

Unlike other electronic media prior to the "verge" I mentioned earlier, the Web is *not* a background medium. One cannot choose to "tune in, turn on, drop out," to borrow from Timothy Leary. We go to the Web to get the Starr Report, or the Drudge Report, or to read Salon, re-creating the shift from learning of "breaking" news by word-of-mouth or special editions of newspapers to hearing it on radio and seeing it on TV. Yet we go to the Web less for "breaking" news and more for news of what is to come—the deeper, richer, more analytic news that cannot be readily attained through use of older media. It is notable that newspapers took twenty-four hours to print the Starr Report while it appeared on the Web instantaneously. Neither radio nor television could have delivered that report to the public; it was the first clear instance of the Web's identity as a news medium in its own right (one might cite Pierre Salinger's reports of government involvement in investigations into the crash of TWA flight

800 as the first actual instance). Converting President Clinton's video-taped testimony in the Starr report to streaming video occurred equally quickly. And it was delivered indexed: the Web has turned the connection between headline and lead and "the rest of the story" into a quite literal connection, one of the hyperlink. As Daniel Czitrom says, "very seldom did [newspapers of the colonial and early national period] seek out news.... The 'penny papers' ... brought back the element of timeliness and gave new life to the old notion that the most important news is

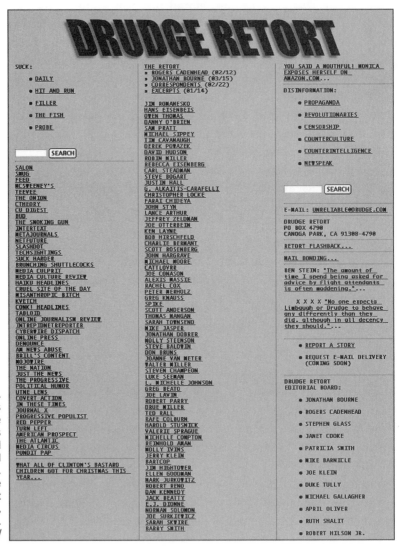

Fig. 9.1. The Web's bias in the final analysis is toward time and not space. The Drudge Report website, http://www.drudge.com/

what the public looks for" (1982: 14–15). The Web doesn't impart importance to the news; it makes news out of what the reader looks for.

Journalism on the Web is not journalism as we have known it thus far. It creates a different order of content. Speed is not so much the issue, as is the development of news that extrapolates and anticipates. It is not that the practice of journalism has changed: traditional news media are still involved in its practice in some cases, and in other cases they are not. Newsroom practice remains largely unchanged: journalism as a process is intact. The difference the Web makes to journalism is that it fully brings to bear the development of news as that which brings the future into the present. Journalism is no longer about space, about the bringing together of disparate places, peoples, and interests onto a page or screen. Nor is it any longer about time, about history and the merging of multiple pasts into a single present. As Carey wrote about the telegraph's impact on commodities trading and the futures market, the Web has had an impact on the commodification of journalism. Journalism trades in futures. It asks us less to attend to "the latest" and more to attend to what we find interesting; less to synthesize and understand a "who, what, when, where, how, and why" and more to attend to "what's next?"; less about a "them" and more about an "us" in view of its structuring to allow readers to interpolate their hopes and desires. The range of possibilities has widened: we are no longer certain of what is reported in the news, and we are much more likely to allow alternative explanations. And perhaps the widening of the range of possibilities leads to the destabilization of the present. It is not so much that we do not believe *what* we read, see, and hear in the news as it is that we are inclined to believe that there is *more than* what we read, see, and hear. As Marshall McLuhan put it, "'content' ... is always another medium. The content of the press is literary statement, as the content of the book is speech, and the content of the movie is the novel" (1964: 266). It is now more clear than ever that the content of the Web is news, though not necessarily journalism.

III.

What, then, is this form of news content? In what ways is it news? As Kevin Barnhurst and Diana Mutz point out in an article examining the decline of event-centered reporting, "Shit happens, but that is not necessarily news" (1997: 27). Tempting as it may be to say that the content of the Web is shit, it is more telling to note from their research that there

has been a fundamental shift from "the report of events and their novelty ... [that] have constituted the core meaning of denotation of news in the 20th century" toward de-emphasis of "events in favor of news analysis" (27). However, unlike the case with newspapers, the critical issue is not content, but commodity and potentiality. As Barnhurst and Mutz point out (and in line with Innis's observations concerning monopolies),

> The old journalism market had many newspapers competing for readers, whose purchases responded to particular stories hawked on the street corner. The writing needed a story line to carry the reader through to the end. The new long journalism developed as monopoly news markets became the rule in the U.S. Journalism then becomes a reference tool, and consumers use the paper not by reading entire narratives but by scanning and collecting bits of information. The transfixed and captivated reader changes into a captive but autonomous consumer, and the news event changes from a compelling story into one of a line of goods in a department store. The market thus produces news meant to be referred to, not read. (1997: 48)

What makes this observation particularly poignant is precisely the comment regarding referral. On the Web, referral is built-in via the hyperlink. As a result, news on the Web has less to do with creating a record of life (along the lines identified by the concept of the "newspaper of record") and more to do with anticipating what's next by accumulating information and making connections among stories, hearsay, gossip, disparate pieces of information that are sometimes coupled in the reader's imagination, and other times linked via hypertext markup language, or HTML. One can readily connect such a development to the creation of the index at the time of the print revolution by noting that the sum of connections makes a content greater than the sum of the parts (J. Burke, 1995).

It is important to note, too, that it is not only in the realm of print journalism in which these trends and issues exist. As Erik Barnouw has pointed out in his history of broadcasting, "Most sponsors did not want news programming" (1968: 17). And tensions between print media and the new medium of radio in the 1930s led the Associated Press to cease providing news to radio networks. In short order the United Press and the International News Service followed suit. Radio networks, in turn, cre-

ated their own news operations. When a compromise was reached between the news services and the networks, it rested on the premise that "[r]adio commentators were to confine themselves to 'generalization and background' and avoid spot news. This was later clarified: they were forbidden to use news less than twelve hours old" (Barnouw, 1968: 21). No such explicit compromises now exist among the print and broadcast media and the Web, but it is interesting to note that print media are at the forefront of Web news, while their broadcast counterparts are eager to join them (in some cases by buying them out or merging). Perhaps print media learned a lesson during the 1930s, when, after the afore-mentioned compromise with radio networks, "more and more newspapers applied for radio licenses or purchased existing stations (and joined) the enemy" (Barnouw, 1968: 22). Another parallel to the past: most news-paper-owned websites consider their Internet-based operation a value-added service, much as "early newspaper-owned (radio) stations were not conceived as news media but as devices to publicize the papers. The (news) 'bulletins' were largely teasers to stimulate readership" (Barnouw, 1966: 138). The practice of putting universal resource locators (URLs) at the end of short stories and bulletins in newspapers can be seen as serving a similar purpose.

Part of the reason I was reminded to reread Barnouw's three-volume history of broadcasting was simply that I noticed the second volume's title on my shelf: *The Golden Web*. During the period about which he writes (the 1930s to the postwar ascent of television), one of the most important social developments took place in the United States (and the rest of the world quickly followed), namely, the evolution of a mass audi-ence created by instantaneous mass communication. It was a time, as Barnouw puts it, when "transmitters in various parts of the country began broadcasting the same singer, the same speaker, the same comedian, the same drama" (1968: 3). Concomitantly, this was an important time of transformation for communication theory as well, as our conceptions of the audience (and to some extent our field) are still haunted by the num-bers: of people, of the vastness of the spaces they occupy, and of the increasingly short measurements of time it takes information to reach them. That emphasis on numbers allowed us to make meaningful obser-vations about an audience that is now, and was then, one of fragments and of individuals. Indeed, audience fragmentation is not in the least bit new; one can find it in the very history of journalism in the United States. As

Carey put it, "Everything can be found in American journalism, gener-
ally understood, but it is disconnected and incoherent.... The daily news
bulletins report this spectacle of change: victories, defeats, trends, fluc-
tuations, battles, controversies, threats. But beneath this change, the
structures of society—the distribution of income and poverty, the cleav-
ages of class and status, race and ethnicity, the gross inequalities of hard-
ships and life chances—remain remarkably persistent" (1989). We look
to technology to find what is persistent: community, communication,
understanding, friendship. We look to it to help us find *connection*, as is
the case not only with the Internet and hypertext but with new and inter-
esting developments in data mining and pattern recognition that find con-
nections, and in some cases create them, where they do not really exist.
We ask of it, as Dewey asked of the media, to "help create a 'great com-
munity'" (Czitrom, 1982: 103). It is therefore important for scholars to
ask questions not only about fragmentation but about connection. Though
audiences have become visibly fragmented, and the media of mass com-
munication seem less and less like they are—in fact, *mass*-oriented—it
may be that our logics are fragmented, or, to borrow from Joli Jensen and
John Pauly, it is how we "imagine the audience" that is at stake in our
attempts to understand the social consequences of these technologies.
Rather than holding fast to an understanding of mass communication
that guided research for decades—an understanding that has, somehow,
simultaneously encompassed and collapsed notions of consumption, pro-
duction, and distribution—we should be savvy to the differences not only
between those activities but within them as well.

One might go so far as to say that the phantom that is the mass audi-
ence for electronic media was born at the same time as the network. To
quote Barnouw again, "What is a network? In a way it is—strangely
enough—almost nothing, a phantom. It is mainly a tissue of contracts by
which a number of stations are linked in operation. The linkage has been
done largely through leased telephone cables which the entrepreneur—
the 'network'—does not own.... Thus networks as businesses would
seem to rest on the flimsiest foundations. Yet they have become a major
power center—having, in an age of American hegemony, world-wide
ramifications" (1968: 3). One could devise a number of ways with which
to make connections between Barnouw's observation and our concep-
tions of "audience." It was the development of a network that enabled
what Margaret Morse has noted in relation to cyberculture, namely the

"virtual" relation between sender and receiver, "the utterance in direct address of television subject to the viewer.... 'Interactivity' [as] ... a kind of 'suture' between ourselves and our machines." The result, she notes, is that "the news becomes the immediate or apparent cause rather than the report of events" (1998: 15–16).

To return to my earlier remark concerning the "transportation view" of communication, another reason I believe it is important for us to reconcile it with a "ritual view" is that the business of the media is predicated on transportation, on the delivery not of messages to audiences, but of audiences to messages. Attending to such movement provides us with another means by which not to focus strictly on content, and instead to return to some of Innis's remarks about the bias of communication, particularly in relation to newspapers. Innis noted how hard it can be to separate editorial and advertising content when "the front page sell(s) the newspaper," an observation that led him to highlight Ivy C. Lee's remark that "news is that which people are willing to pay to have brought to their attention; while advertising is that which the advertiser himself must pay to get to the people's attention" (Innis 1949: 23). To do so, newspapers sold space, trading on the attention people would pay to the spatial organization of the printed—mediated—word. Electronic broadcast media, in their turn, sold time, trading on the attention people would pay to the temporal organization of radio and TV. Internet media now sell attention, without regard to space or time, regarding only connection and linking.

IV.

In time we will be more aware of the nuanced ways in which attention is embedded in the topology of the Net. And the bias of the Web and of the Internet will be more clear, when the Net, via transfer control protocol/Internet protocol (TCP/IP), becomes a more ubiquitous phenomenon, running in portable devices, appliances, cars, and so on. News and information will then again be reshaped, as, for instance, they are being changed by the addition of Global Positioning Systems technologies in automobiles that provide directions and traffic information to drivers while positioning and localizing vehicles and their occupants. Technology will be designed to accommodate TCP/IP rather than retrofitted for it, and our electronic devices will in some sense all become information devices. Our institutions, too, will be designed to accommodate the Inter-

net, to the extent that distinctions between notions of *institution* and *communication* will blur, much as those between *community* and *communication* have already done.

We might then in some manner reconcile the division between what Carey has termed the "transmission" and "ritual" views of communication. A place to start is to note that ritual, too, involves movement and passage, though not only passage but a "passing on." Ritual entails the kind of shift Martin Buber notes—throughout his work—from *I* to *Thou*. It is important that we reconcile these views, because unless we do we will not account sufficiently for the political economy of network technologies on the one hand, and on the other we will not understand the affective dimensions of information's passage and movement. When one states, "I am moved" to refer to the emotional displacement and/or grounding knowledge and understanding can bring, one invokes both views of communication. Simply put for the purposes of this essay, transmission matters. What the software and hardware engineers, venture capitalists, hackers, and designers do *matters,* just as what audiences and journalists do matters. We should not turn away from studying the practices of these groups and their own understanding of practice as we pursue knowledge of the social and political consequences of Internet technologies. What purpose has journalism served the polity throughout its history but that of a means of passing on news and information by which we, and others, may mark passage? A journal is not merely an exercise in recordkeeping, but also an exercise in slowing time and capturing space. The Web is unlike any journal heretofore in existence. The history it shall reveal will not be read in the linear, sequential unfolding of events over time, nor in the structures of space it may develop, but in the relational movements of our interest and attention as we pay it heed.

NOTE

I greatly appreciate the suggestions and comments of Kevin Barnhurst, Associate Professor of Communication at the University of Illinois at Chicago, on an earlier draft of this chapter.

> FROM: THERESA M. SENFT
>
> SUBJECT: **Baud Girls and Cargo Cults**
> A Story about Celebrity, Community,
> and Profane Illumination on the Web
>
>
>
> How do you explain a radio to someone who has no
> concept of electricity? ... In a world crawling with the
> spirits of the dead, the answer was "magic."
> —Will Bourne, "The Gospel according to Prum"
>
> Whenever I design a chip, the first thing I want to do
> is look at it under a microscope—not because I think
> I can learn something new by looking at it but because
> I am always fascinated by how a pattern can create a
> reality.
> —W. D. Hillis, *The Pattern on the Stone*
>
>
>
> **INTRODUCTION**
> When asked why I study online community-making, my
> reply often winds up sounding like some combination
> of the two quotations above. The first is an American
> reporter's impression of natives living in Oceania—
> arguably one of the least techno-savvy locations on the
> planet. The second is from Danny Hillis, arguably the
> most gifted computer programmer living today. What
> strikes me most about these statements is their odd resem-
> blance to one another. Hillis argues that the flip side of
> believing in magic because one doesn't understand sci-
> ence is believing in magic because one *does*. After all, isn't
> a "pattern creating a reality" a fairly accurate description
> of what was called, in an older time, "magic"?[1]
> In this chapter, I'll be comparing patterns that create
> realities in two very different locales on the World Wide
> Web. The first is a now-defunct commercial site called
> Baud Behavior, where I worked for ten months. Baud
> Behavior was supposed to function as an engineered

community of sorts for neophytes on Prodigy Internet.[2] The other example is a ring of commercial and nonprofit sites devoted to supporting Louise Woodward, an English nanny accused of murdering a child in her charge in Massachusetts.[3] Certainly, the two types of sites have their obvious differences, but here I want to articulate their similarities, noting in particular the ways in which they both constructed, sexualized, and racialized discourses in order to facilitate the creation of community online. Though my interest in Baud Behavior is explicitly personal, and my fascination with the Woodward sites is predominately political, I have reason to believe that these two impulses will overlap during the course of my narration.

CARGO IS COMING!

For my theoretical lens, I'm going to use a metaphor that causes contention among postcolonial theorists, that of the "cargo cult." Simply understood, cargo cults are Oceanic island religious performances that began in 1860 and continue to this day. Island natives, seeing the economic disparity existing between themselves and white colonists, stage a series of performances in which they imitate the rituals of colonial military and commercial enterprises, in the hope that these rituals will one day summon cargo ships and planes of their own. In some instances, it is believed that the arrival of cargo will coincide with the reappearance of a prophet, like the mysterious "John Prum" discussed by Will Bourne (1995) in the first epigraph that opens this chapter. If the last century is any indication, witnessing a cargo cult in action offers up enough material to fill several books on mimicry, technology, desire, and performance.[4] Take, for instance, this account from a celebration of John Prum Day detailed on Vanuatu in 1995; as Bourne describes, "A double file of barefoot troops enter from beyond the village gate. They carry four-foot lengths of bamboo at the 'shoulder arms' position, the tops cut to a bayonet point and colored red to evoke fire. Across their bare chests 'U.S.A.' is lettered in red paint.... The scene is traversed here and there by bush dogs and the odd chicken ..." (Bourne, 1995: 3).

The reasons the cargo cults continue to fascinate lie in their strange refractory politics—they reflect different desires and fears, depending on one's position within the performance. For instance, in Melanesia today, national elites use the term *cargo cult* pejoratively in order to marginalize "savage" opposition to their rule. Similarly, enthographers have

been busy alternately redeeming and/or disavowing cargo cults altogether, dismissing their earlier ideas on the subject as too reductive. For most Western reporters, however, cargo cults are still often detailed as pure entertainment, full of authentic native characters: As Bourne details, "Tom Meles and Isaak Wan ... are the leaders of the John Prum Movement, and they despise each other. Stooped and tubercular, Isaak, fifty-five, sports a flashy chestful of medals. On closer inspection, I find that this resolves itself into an odd pastiche of symbols: an Air Force star, an 'Airborne' patch, a medal that reads 'Mississippi,' a 'People Power; patch with rainbow motif—all set off by a homemade sash trimmed in maroon nylon. Meles, eighty-two or thereabouts, is likewise adorned. He's crowned with a red Marine cap that fits his smallish head like a bucket; among his insignia are a pair of Northwest Airlines wings and a plastic medallion inset with a hologram of Shiva" (Bourne, 1995: 7).

Though varied in its rituals, the logic of any cargo cult might be summarized as "If we build it, they will come," a line that comes from the American film *Field of Dreams*, in which a man builds a baseball diamond in the middle of a cornfield in an attempt to summon the ghost of his father. Unfortunately for the Oceanic islanders, most cargo cults have thus far failed to secure goods from the gods. Today, the term mainly exists in popular slang as a retroactive naming of sorts—when something is built, and nothing comes of it, it is labeled a "cargo cult." In the past, the term has been applied to practices as varied as the "vaporware" phenomenon in the American software industry (Raymond, 1996) and the failed lending policies of the International Monetary Fund (Rathnam, 1997).

Because it serves double duty, describing both a colonial performance of mimicry and bogus business practices, the cargo cult metaphor has recently resurfaced, particularly in discussions of global telecommunications. In *Development and the Information Age* (Howkins et al., 1997), a book compiled by two United Nations-sponsored economists charged with forecasting possible futures of global telecommunications technologies, there is an entire section devoted to a chilling cargo cult scenario, in which "the dreams of the twentieth century, which had solidified into almost a religion, may fade away" (1997: 210). The dreams to which they refer is that access to computing technology will alleviate worldwide problems of poverty, education, and production. But when nations build supercomputing centers as a point of national pride rather than as

part of an economic development plan, the cargo cult scenario has been reached. In this vision, the computer becomes the postcolonial version of the painted stick passing as a gun, mimicking yet not achieving progress (1997: 221).

Of course, within even the most economically developed areas, there exist what Olu Oguibe (1996) calls "digital third worlds"—telecommunications-deprived bands, from Harlem to Ghana. There, too, community members and corporate and government angels extol the ways in which wiring up the world will alleviate class, race, and gender differences. David Porush calls this vision of cyberutopia a "primordial, and probably compulsory, form of cultural mysticism no different from cargo cults that erect towers of trash to summon the airplane gods, an expression of the enduring human compulsion to create a transcendental architecture, as if the right restructuring or reconfiguration of space, time, matter, and information will bring heaven down to earth" (1992: 3).

Notably, American business practices that appear to succeed aren't labeled cargo cults, even when their practices more or less resemble primitive ritual behaviors. For instance, I recently received a postcard in the mail from the group Silicon Alley Organization, inviting me to a business breakfast they are titling, "Pennies from Heaven: How Two Internet Companies Raised Millions in Today's Hot Marketplace": "When TheGlobe.com went public, its skyrocketing IPO [initial public offering] signaled the resurgence of the Internet stock phenomenon. How have these start-ups been able to raise so much money? ... These newsmaking Internet wizards share their secrets."

If we build it, they will come. Regardless of the players, whether domestic or homegrown, all cargo cults articulate the magic of mimesis, the desire to create something by way of imitation. In *Mimesis and Alterity*, Michael Taussig (1993) defines *mimesis* as "the faculty to copy, imitate, make models, explore difference, yield into and become Other" (1993: xiii). He links it to "sympathetic magic," a process by which a copy of something draws on the power of the original to the point where it assumes the character of the original. Put another way, cargo cults are mimetic gestures in which "we" engage in particular types of technologies in the hopes that "they" will arrive. Perhaps more significant, however, is our hope that when that magical meeting occurs, we'll find our own subjectivity somehow reanimated: we'll cure world poverty; we'll

escape the confines of our bodies; we'll re-create the wonder of old-time baseball in our own cornfield. This is what Taussig means when he calls mimesis the magical "nature that culture uses to create second nature" (1993: xiii).

Because they are performances in which mimesis, commodity, and desire for technological control are foregrounded, I believe cargo cults might offer some insightful ways of thinking about the magic of community building on the Web. I'd like to acknowledge in advance the potential danger of this project. As Homi K. Bhabha (1985) rightly points out, making universal metaphor out of location-specific particulars can be an act of discursive colonization par excellence. Painting one's chest with the letters U.S.A. means something different if one is American than if one is not; suspect international lending practices have different repercussions for indigenous peoples than multinational corporations; marketing vaporware is not equivalent to hoping that telecommunications will ease poverty. And, of course, the boast "we're all invisible," online or off, means something very different to those of us for whom visibility is precisely at issue.

For these reasons, Lamont Lindstrom (in Carrier, 1995: 36–37) argues that depending on one's position as observer/recorder, cargo cults actually can be theorized in at least four ways: as internal orientalism (a performance among natives, read between themselves); as sympathetic orientalism (a Western construction of Melanesian desire that permits a similarity between self and other); as pseudo-occidentalism (making a presumption about what the orient may be saying about the occident); and as assimilative cargoism (erasing boundaries so that stories of the oriental/cargo other explicitly transform into stories of oneself). The remainder of this chapter employs cargo cults to describe two very different attempts at community making on the Web. I suspect that my theorizing will most closely resemble Lindstrom's final definition of assimilative cargoism (turning stories of others into stories of myself). Ultimately, though, I hope to move beyond Lindstrom's categories of valuation and repudiation, and instead recast cargo cults as dialectical images with which to think about community online. In particular, I'm hoping that my particular stories of Web communities create a "transformative cargoism"—that is, a narrative that speaks not just "of the West," but rather, back to it.

BAUD GIRL IS COMING!

In February of 1997, after lengthy deliberations, Prodigy Services Corporation hired me to work as a Community Leader for their newest Web-based venture, Prodigy Internet. We agreed I would write a weekly column for their new website, host a weekly Internet Relay chat, and run a Usenet news group for Prodigy members. The community I pitched to them was called "Baud Behavior," designed to help new Prodigy users socialize online and figure out the Internet. I created an online persona for myself called "Baud Girl" and got to work.

It's no accident that the same month I was hired by Prodigy, the book *Net Gain: Expanding Markets through Virtual Communities* (Hagel and Armstrong, 1997) finally hit the stands. Published by the Harvard Business School and glowing with recommendations from industry gurus like Esther Dyson, *Net Gain* gave official sanction to a fervent hope among many CEO's that community would be the next "killer application" on the Web. Build the communities, *Net Gain* argued, and the advertising dollars will follow. As Quentin Jones (1997) has observed, like most of the business press of that year, *Net Gain* ignored the issue of whether group computer-mediated-communication discussions constituted "communities," focusing instead on creating a generic category that they opposed to "content" as a way to encourage people to invest in cyberspace locales for profit.

Ironically enough, the authors of *Net Gain*—investment counselors and self-admitted "newbies" to the Net themselves—noted in their preface that they got the idea to write their book by visiting the WELL, the famous San Francisco bulletin board system. Though they claimed to "salute the grassroots, anti-commercial momentum of the WELL," they nonetheless advocated building Web-based communities for profit based primarily on their experiences on what is a nongraphic, text-based bulletin board system, or BBS. Perhaps following *Net Gain*'s lead, it was important to my employers at Prodigy Internet that I was familiar with the politics of bulletin board communities, and I was. Since 1994, I had been working as a host at Echo, the New York City BBS often compared to the WELL. With my old-school pedigree in place, I appeared to be a natural leader for Prodigy Internet.

When originally presented with the idea of a Web community as a moneymaking enterprise, I was confused. How, I wondered, had John

Armstrong and Arthur Hagel—*Net Gain*'s authors— made the jump from the WELL (a notorious money-loser) to financial success via Web communities? From the image-based mechanics of the Web itself, they argued, which had finally become sophisticated enough to permit the process of "branding" (1997: 127–29). *Branding*, a term borrowed from television advertising, is a heavily studied yet barely understood phenomenon in which certain consumer goods become historical subjects by way of their "brand heritage," that is, their associations to particular users and markets.

Thus, when Macintosh computers are successfully branded as "computers for the rest of us," what is really being marketed is the history of Macintosh as a counterculture icon, which in turn spurs the consumer's belief that Macintosh machines have had subjective agency through the years, and have been in fact choosing to work for "the rest of us." Branding, in turn, enacts a sympathetic magic in which consumers loyal to a product are so entranced by its heritage that they supplant it with their own, self-identifying as "Macintosh people."[5]

Put in mimetic terms, branding is the magical nature by which consumption culture creates the "second nature" of the product-identified consumer. Certainly, branding is an example of what Karl Marx called "commodity fetishism," that "social delusion" coming from the attribution of spiritual qualities to goods (1906: 73). How else to describe the mystical transformation by which I identify with "my computer," marketed to me by Microsoft by that very naming? Marx, both a critic and a product of his time, called commodity fetishism the moment of the "savage-like" stare of the West, as we confront ourselves with objects endowed with more social power than our own labor.

How richly appropriate and ironic, then, that the first website credited by *Net Gain* with a strong brand recognition carries a legacy of "savagery" in its name: Amazon.com.[6] According to *Net Gain*, by allowing people to write uncensored book reviews at their site, Amazon gives the impression that their users are more important than anything, even selling books. Of course, *Net Gain*'s authors stress, this wound up a win/win scenario: as more people wrote reviews (for free) for Amazon, the site appeared busier, which in turn drew more viewers (Hagel and Armstrong, 1997: 30–32). As Amazon's name recognition rose, so did its attractiveness as a venue for advertising, and (perhaps most significant) its perceived worth on the stock market as a company worthy of investment.

Inspired by the success of sites like Amazon, and the promise of books like *Net Gain*, I believe Prodigy was counting on Web communities to be not just a big phenomenon, but a global one. Advocating a "Web community without national boundaries," Prodigy began negotiations with Mexico, South Africa, and China in 1997 to institute itself as the "international Internet service provider of choice" (Yamamoto, 1997). Ironically, while it reached around the world for customers, it chose to ignore the large number of pre-Web communities it had fostered earlier on its older service, now dubbed "Prodigy Classic." After attempting some relocation tactics to get Classic subscribers to move to Prodigy Internet (free accounts for the first month, and so on) Prodigy stopped servicing much of its Classic division altogether.

Like Melanesian cargo cult practitioners who burned their few possessions so as to encourage their ancestors to rain wealth upon them, executives probably saw sacrificing the Prodigy Classic members as a no-brainer. Sometimes you need to bulldoze a living field to get ready for a parking lot. Tempting though it is, however, I think interpreting Prodigy's actions as "cargo cult logic" misses the mark here. The sacrifices large American corporations make to grow richer—whether or not they are foolhardy sacrifices—are obviously not analogous to those made by the indigenous poor in Melanesia. The former emanates from a position of power, while the latter are located in cultural marginalization. Indeed, within the colonial politics of Prodigy, the sacrificial logic of the marginalized actually belonged to Classic members. To the irritation of the corporation, many Classic members refused to leave their older homesteading locale for the web-based version. Instead, they decided to stay where they believed that their original home in cyberspace might somehow survive what they must have known was to be its inevitable downsized demise.

Foregoing Classic members wasn't the only way Prodigy ignored the local for the lure of the global. Indeed, for all their talk of the connectivity of the Web, it felt to me that Prodigy forgot that the Net already exists as a "global village" unto itself. There was, for example, the company's mind-numbing insistence that all interactive functions (chat, for instance) be held behind a firewall that disallowed entrance by any non-Prodigy members. Because I couldn't bring in outside chatters, anyone arriving at my chat found a room with no more than two people, but no matter. The only people who came were seeking technical advice, usually about how

to get through the firewalls. Most of my time in chat was spent telling people that they couldn't send real-time messages to their non-Prodigy friends on the Internet using Prodigy software, but that America Online had an Instant Message software downloadable by anyone on the Net, which would work just fine anywhere in cyberspace.

Then there was the strange issue of my online persona. Noncommercial Net culture abounds with stories of users who are known more by their pseudonymic "handle" than by their given name. On the Web, this has led to the creation of "cyberlebrities" like the Motley Fools (Hagel and Armstrong, 1997: 18–19), speaking subjects who make branding possibilities by re-creating themselves as celebrity spokes-objects.[7] In his genealogy of the term, P. David Marshall emphasizes that the magic of "celebrity" lies in its ability to commingle the twin specters of modernity: democracy and consumerism (1997: 4). On the Web, "cyberlebrities" perform a similar function, helping to foreground the medium's self-proclaimed status as a locus of cutting-edge shopping and participatory experiences.

Clearly, Prodigy hoped that the cyberlebrity of Baud Girl would work in ways analogous to the star system in Hollywood. Indeed, negotiating the terms of Baud Girl's image constituted the most contact I had with Prodigy management. In the eleventh hour before my hire, there was a discussion about whether I had copyrighted the name "Baud Girl"—it was possible that the "community thing" might not work out, I was told, but perhaps I could appear as an advertising persona in mass mailings, advocating certain Prodigy services? At the time, I responded that I wasn't quite comfortable with that arrangement, but today I would reconsider.

Baud Girl was, of course, my pun on "bad girl." For my first Welcome column, I wrote, "Baud Behavior takes its title seriously. Baud refers to the speed at which data travels; likewise, we'll take for granted that the Net is a series of rapidly changing social spaces requiring skill and finesse to navigate.... More than anything, we'll discuss slipping in and out of online situations with grace, wonder, and a sense of humor. Rather than concentrating on being a good student of the Internet, we'll be the ones smoking in the bathrooms of cyberspace, asking you to skip school and join us." Like fantasies of bare-breasted women who lured men to the Pacific islands, geek pinup girls have long been a staple of commercial online services. The absence of any figure like Baud Girl on

Prodigy's designated "women's group" (called Avenue W) made it clear who my target market was to be—the men of Prodigy. However, unlike those racially "other" women of Melanesia, I was to follow in the mold of *Tomb Raider*'s Laura Croft and self-present as racially unmarked, which is to say white. In a sort of ultimate virtuality, I wound up being a pinup girl without a photograph—my predecessor had put her picture up on her site and it wound up being "too distracting," so I was told to leave mine off.

My predecessor at Prodigy's magazine Living Digital called herself CyberChick. CyberChick's columns consisted mainly of sexual innuendo, descriptions of her Stair Master, and admonishments to "be nice" online. Knowing only that Prodigy wanted someone more "real" than Cyber-Chick, I attempted to split my column writing between relatively serious Net reporting (encryption, stalking, how-to materials) and provocative forays into online dating, "technofetishism" and the like. Throughout my tenure, I received a number of ambiguous directives from my employer, including a request that I be "sexy but not always about sex," and (my personal favorite) "not too Freudian." Notably, these directives mirrored industry anxieties over government policing of the Web itself. For instance, to be "always about sex" might be in violation of the (then pending) Communications Decency Act.

I remained at Prodigy until November of 1997. Then, ten months into my tenure as "Baud Girl," I received a call letting me know that my services would no longer be needed. Like many Web operations, Prodigy was having difficulty providing a fiscal rationale for community building. I was told they were planning to trade their Web community's model for the newest promise of branding magic: the "portal," in which every website is made to mimic a search engine. Recently, Prodigy informed its members that it was merging with Excite! to "give members even more surfing options." A friend made the point that this is analogous to being invited to a party, only to be locked in a room with a phone book and told to have a good time.

Net Gain told companies like Prodigy that if they built communities on the Web, the money would follow, but it wasn't that simple or fast (to their credit, the authors point out that the process would take five to ten years— eons in today's new media climate). More to the point, the "they" Prodigy needed to "come"—advertisers and investors, trading on the "buzz" of Baud Behavior—never materialized. Certainly, in their insistence on the

global over the local, in their belief that users ought to be trapped in—rather than explore—the greater Internet, and in their slavish devotion to the "killer applications" of the moment, Prodigy provides many reasons for how a Web community can fail. But I believe part of the fault was my own. The fact is that while I was marginally successful as a cyberlebrity (my columns garnered large amounts of reader mail), my Web "community" never really gelled as a community at all.

In his exhaustive review of existing literature on the subject, Quentin Jones (1997) developed a four-point requirement system for what he calls "virtual settlements."[8] The most important conditions, Jones argues, are "a minimum level of interactivity marked by conversation" and "contact among two or more people." Though it's possible to say that the presence of Baud Girl caused some level of interactivity online, I was consistently unable to get people to gather and speak with one another, rather than just with me.

Steven Jones (1998) has quipped that we can no more "build" communities than we can "make" friends, but for all I know about bad virtual communities, I still can't explain what Taussig (1993) would describe as the "sensuous materiality" of "real" ones. Looking at his design for a microchip under a microscope, Danny Hillis (1998) writes of his fascination for the way a "pattern can create a reality." What kinds of patterns become the realities in "bona fide" Web communities like the WELL, gaming/fantasy settlements such as Ultima, or even consumption-based communities such as auction sites like Ebay? What kinds of magic occurs in those places to allow users to believe their transactions and participation are facts, and not fictions—in short, what makes them real?

Searching for the links between realness, magic, and mimesis, Taussig poses the question, "How much of a copy does a copy have to be to have an effect on what it is a copy of? How 'real' does the copy have to be?" (1993: 51). Examining the healing properties of Cuna medicine dolls (which barely look like the individuals they are designed to heal), Taussig concludes that "the magically effective copy is not, so to speak, much of a copy" (1993: 51). In fact, effective mimesis actually contains two intertwined facets: "imitation" (likeness) and the far more elusive "contact" (emanating from desire) (1993: 53). From this point of view, we see that hyping engineered Web communities nobody wants is as short-sighted as dismissing painted sticks because they aren't "really" guns. Both observations ignore the crucial magical power of contact, and the

fact that, as Yrjo Hirn writes, "Strong desire always creates for itself" (cited in Taussig, 1993: 52).

JUSTICE IS COMING!

In the fall of 1997, Massachusetts Superior Court Judge Hiller Zobel made history when he published his entire verdict for the notorious Louise Woodward "Nanny trial" over the World Wide Web. This was the first criminal court ruling to be so released. At exactly 10:00 AM on November 10, 1997, as the ruling, "manslaughter, with a commuted sentence" was given by the judge, Web surfers furiously typed and retyped the "official verdict URLs" provided by the media. Most saw only the message, "This site is currently busy. Please try back later." So much for instantaneous Internet coverage.

I went another route. Knowing it was mirrored in more than four other locations, I headed to The Official Louise Woodward Campaign for Justice website.[9] Yet I wasn't there simply to take in the latest news. In truth, I found myself drawn online nearly every day to watch the Web's fascination with its newest Baud Girl, Louise Woodward. As perverse as this sounds, I think I was jealous. A search for "Louise Woodward" on the search engine Hot Bot yielded more than two thousand separate entries. The very year I struggled to maintain three people in a chat room on Prodigy, a bona fide Web community had been forming online to support the " Killer Nanny."

It's ironic that while Prodigy was unable to follow *Net Gain*'s exhortation to build Web communities based on brand loyalty, the amateur Woodward sites managed this quite nicely. "Louise's personal pages" certainly had links to the major information sites like CNN and Britain's Sky News, but also provided goodies available nowhere else, such as a video diary of Louise's days as well as a QuickTime movie of Louise's parents thanking people for their support. There was even a Real Audio file of a song written by a fan moved by Louise's plight, and links to *Rent*, "Louise's favorite play." Why? What was it about Woodward that caused Web communities to spring up like mushrooms?[10]

To some degree, the proliferation of Woodward websites mimed the explosion of competing facts within Louise's trial itself. Woodward, a nineteen-year-old British au pair, was accused of murdering an eight-month-old American baby in her care, Matthew Eappen. The prosecution

charged that as a result of a furious shaking by Woodward, Matthew suffered a head wound from which he subsequently died. From the onset of the trial, however, it was clear the medical community disagreed over whether Woodward had caused Matthew's death via "shaken baby syndrome," or whether the child died as a result of brain injuries sustained earlier in his life. With all the conflicting evidence, and in the absence of a "smoking gun," the truth of the case (for the jury, at least) turned on Woodward's character and the credibility or her testimony during the trial.

The mechanics by which the Woodward trial was conducted were as ambiguous as the "facts" themselves. For a complex set of legal reasons, Woodward's lawyers designed their options so that a jury could only rule one of two ways: guilty of murder in the first degree, or not guilty. The judge specifically forbade a verdict of manslaughter (murder without premeditation) as an option. Thus, for the jury, the case was cast in black and white terms: either Woodward shook baby Matthew knowing it could kill him, or she was "not guilty"—at least as determined by the rules of the court.

Throughout the trial, many decried the horrific legal limits placed upon the jury, and anxiously awaited the ruling of Judge Zobel, who had the authority to overturn any decision as he saw fit. However, when the judge ultimately did change the jury's verdict of first degree murder to one of manslaughter, some people were outraged by the move, protesting that one individual with authority shouldn't be able to cancel the "will of the people" on a jury.

Because of the sensational nature of the trial and the questions it raised about power and democratic process in the United States, the case quickly became the stuff of nightly television, catapulting Woodward herself into that particular type of celebrity that James Monaco (1978) terms a "quasar." According to Monaco, a quasar is a celebrity who is involuntarily thrust into the spotlight and, as a result, exists mainly in and through media construction. Examining the public fascination with the many personas of Patti Hearst in the 1970s, P. David Marshall notes that with regard to quasars, "It is not what they are or what they do, but what we *think* they are that fascinates us" (1997: 14). Thus, the quasar is a speaking subject who, through little choice of her own, finds herself rendered as a consumable object.

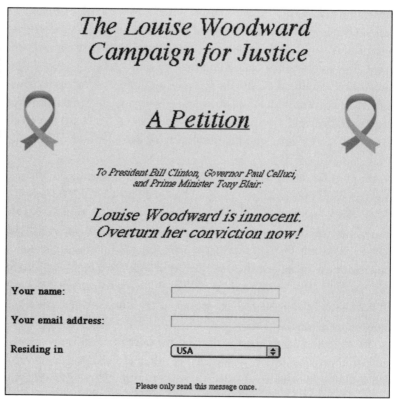

Fig. 10.1.
The dynamics of formulating and delivering ethical judgment upon the case was crucial to construction of the "reality" of both Woodward as consumable cyberlebrity as well as the community that consumed her image. The Louise Woodward Campaign for Justice website, http://www.the-net.co.uk/louise/petition.htm.

The notion of Louise as iconic quasar helps to explain why nearly every Woodward website during the trial's heyday began the same way: with a close-up shot of her pre-Raphaelite face. Marshall points out that poster images of Ché Guevara had iconic power "more vocal than the actions of the revolutionary [himself]" (1997: 14). Likewise, the presence of her head shot at the opening page of each website underscored the fact that Woodward the speaking subject had morphed into Louise the discursive object, an icon engendering debates "more vocal" than those articulated by Louise herself.

One of the most intriguing of the debates about Woodward had to do with the unreadability of affect in the modern world. To many, Woodward resembled a stereotypical old-world Madonna: round faced, doe eyed, soft spoken. Yet did she look placid, people wondered, because she was innocent, or because she was in reality a cold-blooded killer? In the English press, this confusion was cast as ethnocentrism: as long as

Americans confused "restraint" with "contempt," they argued, they would be unable to know the "real" (that is, English) Louise.[11] Yet Woodward was not just a criminal defendant— she was a celebrity defendant. Here, Richard Dyer's observation (1986) that celebrity creates a discourse of "realness" is especially apropos, for as Marshall observes, "We are aware that stars are appearances, yet the whole media construction of stars encourages us to think in terms of 'really.' What is Marilyn Monroe 'really' like? Is Paul Newman 'really' the same as he appears in films? These are the types of questions that the magazines and media as the stars create for us. Essentially, these questions point to the social function and position of the star in contemporary society" (1997: 17).

As if anticipating her fans desire to stop the stream of media coverage long enough to search for the "real" Louise, freeze-frame images from the Woodward trial were just a click away: Louise awaiting sentencing, Louise panicking during her verdict, Louise walking with her attorneys. While the actual jury was time-bound in their decision-making, on the Web, viewers were given all the time in cyberspace to render judgment. Once past the images, many Woodward sites offered multiple routes to interactivity and the formation of discourses on the trial. On some pages, visitors were polled to register their opinion as to whether the courts were doing right by Louise.[12] In still other locales, bulletin boards and chat rooms displayed a wide variety of opinions about the nature of the sentencing. I was surprised to find that over 30 percent of the visitors who posted comments on a "Support Louise" board I visited were in fact protesting the fact that Louise received such a light sentencing.[13]

The dynamics of formulating and delivering ethical judgment upon the case was crucial to construction of the "reality" of both Woodward as consumable cyberlebrity as well as the community that consumed her image. The centrality of such judgment to the constitution of virtual Web communities has been explored by John Sloop and Andrew Herman (1997), who argue that sometimes loose "courts of judgment" coalesce within virtual communities over the Web. Here's how they describe the way fans gathered in cyberspace to follow a copyright violation case being brought against the musical group Negativland: "It is not that any of this occurred as a result of a 'leader' gathering together opposition troops for battle. Instead, people were drawn together because of their access to the net, and once gathered, set up their own means of justice" (1997: 298).

Once gathered as a group on the Internet, fans began a sort of underground network to tape and distribute (for free) a Negativland single deemed illegal by the courts because of copyright violations. By setting up this "alternative means of justice," Negativland fans assumed an identity that Sloop and Herman have called "out-law"; that is, an identity that is technically legal, yet discursively subversive. This "out-law" identity is rearticulated on the Negativland home page, which features kitschy graphics from a 1950s diner (a visual staple of "alternative" music groups of the 1990s) and self-parodying slogans like "Copyright infringement is your best entertainment value!"[14]

Read as a magical phenomenon, the Negativland community used mimesis to brand themselves as "Negativland people." By their skillful use of kitsch and irony, they were able to cast mainstream corporate and legal systems as bogus, and thereby secure their own identity as "real" music fans. It is possible that they did so in part out of their concern for "justice." Yet it is probable that they also deeply desired for contact—not necessarily with Negativland itself, but with the ironic, hip image of Negativland they were able to create and consume by way of their communion with one another. Here, Yrjo Hirn's statement that "Strong desire always creates for itself" rings decidedly true.

Overall, both the Negativland site and the Woodward sites (considered as a whole) easily met Quentin Jones's requirements for a legitimate virtual settlement. Both relied on fan identification with their respective icons, and both were as interactive sites where people gathered to discuss justice. After this, the similarities end. Every Woodward website I visited was conducted with the utmost sincerity. Certainly, there were no slogans anywhere to the effect of "Murder trials are your best entertainment value!" Not a single Woodward page I viewed was self-consciously artistic. As if to underscore the seriousness of their concerns, all the Woodward sites I viewed took one of two graphical forms: simply laid out, amateurish home pages, or replications of corporate sites like CNN and Court TV Online.

As Sloop and Herman (1997) argue, "out-law" justice almost necessarily requires one to self-identify as marginalized. For Negativland fans, this was easily arranged: Negativland and its legal troubles are largely known outside of particular sections of the music industry and alternative press. For Woodward fans, the exact opposite was true. Thus, while Negativland fans created a "court of public opinion," contesting and

re-creating notions of sovereignty within cyberspace, Woodward's sites were engaged in a different process entirely. Not quite a court, but rather a "cult of public opinion," Woodward sites mimed the rituals of television culture, hoping to build a new psychic locale in which to situate Louise.

Take, for instance, the fact that many Woodward websites linked to Court TV Online as a main repository of legal documentation for the case.[15] Much the way *USA Today* has become the most-quoted paper in Congress by way of its easy-to-understand graphs, Court TV Online has become a hot website for the average person looking to grasp the mechanics of the American legal system. Of course, with its extremely narrow focus on celebrity trials, the show is hardly indicative of jurisprudence in America, but Court TV's producers understand that more Americans can recite the cast of the television drama *Ally McBeal* than can name all the judges currently sitting on the Supreme Court of the United States.

A trip to the special "Woodward section" of Court TV Online offered a series of predictable enough choices: records of court proceedings, transcripts of star witness testimony, and profiles of attorneys of the trial. Eerily, Court TV Online featured a downloadable QuickTime movie of O. J. Simpson on the Woodward page.[16] Because it had been mentioned repeatedly in the news, Simpson's iconic association with the Woodward trial was not a shock to me. Both shared the same celebrity attorney, Barry Scheck. Commercially, linking Simpson to the Woodward section made good sense for Court TV Online: their opening screen offered viewers a choice of "Famous Trials," ranking the "Killer Nanny" as number 1, and the "O. J. Simpson Case" as number 2.[17]

Here, to serve its own commercial interests, Court TV Online enacts a series of mimetic celebrity equivalencies in order to make random associations ("Oh, Scheck, yeah, he was connected to O. J., right?") with the "real" facts of the Woodward case. In odd turn, however, many amateur Woodward sites contained links not to O. J. Simpson, but the materials covering the death of Diana, Princess of Wales. Here, a desire to counter mainstream media's collective unconscious was striking, if confusing. Like Woodward, Diana was English, and young. Naturally, Woodward's supporters would like her associated with a love of children, as Diana was. But that's where the similarities seem to end. Recently, the public fascination with life and death of Diana has been likened to a cargo cult of its own, played out on television news magazines like *Entertainment Tonight* (B. Anderson, 1997). By posing one cult icon (Woodward) against

another (Diana), what kind of magic, I wondered, were Woodward fans trying to invoke?

Puzzling over the competing icons of Woodward, Diana, and Simpson, struggling with my own failure to incarnate myself successfully as a cyberlebrity worth remembering, I found myself struck by what Walter Benjamin (1978) has called "profane illumination." Benjamin, a Marxist inspired by magic, argued that there are times when modern technology (intentionally or not) backfires on us, replacing its presentation of "life as it is," with a more explicit version of "life as it is being shown to us." Because it is not properly science, or magic, but rather a revelation in which the magic of science is made clear, Benjamin argues that profane illumination is a moment both feared and craved within mass media, when our icons animate and stare back at us, demonstrating the ways in which they make and remake our subjectivity in the modern world.

A sort of inversion of the "savage" power of Marx's commodity fetish, profane illumination creates a shock of recognition within the consumer in which we see how (colonial progress myths to the contrary) we "enlightened" folks haven't left the gods at all. Rather, we've replaced "gods" with "goods"—both in the sense of consumer items and that marketable commodity of the information age, "reality." In our media-saturated time, trials are held, television coverage is broadcast, and websites are created. We do these things, we tell ourselves, in order to know what "really" happened the night Matthew Eappen died; what O. J. Simpson "really" did; what kind of person Princess Diana "really" was. We gather in communities, virtual or otherwise, where we can be "real." But realities are, as Danny Hillis would have it, patterns. And if the hyperlinking capacities of the Web demonstrates anything, it is that patterns always exceed the sum of their parts.

In its patterning, connections between Louise Woodward and Princess Diana became at least as comprehensible as the televised trial's malevolent haunting by the QuickTime ghost of O. J. Simpson. In a flash, I understood that viewed as pure icons, Diana and O. J. Simpson have a lot in common, although you'd never know it from mass media's construction of the two. Both had been heroes—she, a philanthropist; he a football player. Both had been stars—she at royal functions; he as a spokesperson and actor. And ultimately, both wound up quasars—she, led to an untimely death dodging paparazzi; he, an accused murderer of a white woman. Diana was revered by the mainstream press, and char-

acterized as a martyr to the public's obsession with royalty. And Simpson, though vilified by that same press, had nonetheless been adopted by a certain segment of the world's population as a martyr to unresolved race and class tensions within America. In a sense, they were opposite sides of the same coin: the idolized hypervisible white female and the vilified, predatory black male. Where the celebrity Diana was a mimetic creature par excellence, O. J. Simpson had become an icon to alterity—the "otherness" that allows the condition of "the same" to exist.

Staring at the refractions of these two icons, I saw new patterns emerging, creating (in my mind, at least) a new sense of the facts that transcended the celebrity lure of the "real" Louise Woodward. To boost ratings, Court TV Online worked to present Woodward as a "white O. J. Simpson," playing on unconscious racist fears of black men to interject additional drama into Woodward's case. Woodward fans retaliated by interjecting the image of Diana, not to claim an identical relationship between Woodward and the Princess (for no icon can top Diana's status as the palest ghost of white female privilege today) but because racism demands that it is better to be a "less white" Diana than a seemingly white (which is to say "passing") O. J. Simpson. While the former redeems Woodward and affirms the colonial power base securing her employment, the latter introduces the notion of alterity and violence back into the discussion. Court TV Online built one sort of pattern to meet their needs; Woodward fans countered with a different pattern, one that inverted yet strangely repeated the racist logic of the television. Here is the magic of mimesis at work, collapsing complex patterns like class relations, migrancy, and hybridity into an equivalency of consumable levels of whiteness.

I was reminded that throughout the trial, the quest to determine who a "real" caregiver truly was seemed to come down to a battle of white women: the "working mother" (Mrs. Eappen) and the woman "working as mother" (Louise). I remember thinking baby Matthew was awfully dark-skinned, only to find out later that Mr. Eappen (who is not white) was seldom on camera. It was then that I realized who wasn't visible in the very visible story of inscrutably white "Killer Nanny": the historical and current postcolonial bodies that currently comprise most of the domestic care force in the United States.

In her work on Asian identity on the Net, Lisa Nakamura has observed that the cry, "We're all invisible online," actually works mimetically,

making sure that some of us wind up (discursively, at least) far more visible than others in cyberspace (1998: 15). Unfortunately, Nakamura points out, racism and sexism are necessary components of the fantasy of invisibility, because in truth, invisibility is equivalent to whiteness and maleness. Just as the word "stereotype" began as a mechanical copying machine and morphed into a way to misread human bodies, today the mimetic mechanics of cyberspace produce "cybertypes"— communities defined as alternately "real" and "not real" within the political frame of virtuality. Thus the "invisible citizen of cyberspace" still demands that a *Newsweek* photo of O. J. Simpson be retouched, to look just a bit darker. Thus the Baud Girl still requires the "fact" of her gender to sell her cybertype on the Web market to that self-same invisible citizen.

Nakamura suggests that cybertypes may actually be more mutable than stereotypes, if only because their mechanics are more apparent to us, at least in our earliest stages of Web use. For instance, one of the cases branded on a Woodward site as being "important to Louise" was that of a Texas girl named Lacresha Murray, dubbed by the British press as the "Black Louise."[18] Of course, the passage of power is crucial here: Woodward fans didn't call Louise "the White Lacresha," and for good reason. As a black woman, Murray's case is virtually unknown in mainstream media. Racism works to insure that Lacresha is no more the "Black Louise" than Louise is the "White O. J. Simpson." But branding, when it works, can be magical, creating its own histories and making new realities. Does identifying with Lacresha Murray via Louise Woodward make any less sense than identifying with a Macintosh computer via a "think different" campaign? This desire to identify—and disidentify— is precisely how community is created, offline or on.

If we build it, they will come. One reason cargo cults persist—in Melanesia at least—is because sometimes cargo actually *does* arrive out of the sky. During the American occupation of South Pacific islands during World War II, cargo arrived by air for U.S. Marines, many of whom were black men. Significantly, the arrival of black Marines to Oceania began for many natives an education in the postcolonial distribution of wealth. Kyle Roderick describes how "*Life* magazines brought by the GIs contained photographic proof that in America Black people lived surrounded by refrigerators and cars in the kind of consumer paradise which the islanders had been striving so far unsuccessfully to obtain" (1997).

Dismissing the arrival of cargo as "not really" from the gods, but from General Douglas MacArthur, misses the point here. For this is a story about the magic of contact, specifically transnational contact brought about by the arrival of mass media. In this story, images in consumerist magazines like *Life* call into question the long-espoused notion (begun by white colonials) that blacks were less deserving of material goods by reason of their race. What's more, as Roderick puts it: "[Black Americans] could operate the radio transmitters which beckoned the falling cargo from the ancestors, and seemed to the oppressed islanders to be dealing with the white man confidently and on equal terms" (1997). The fact that black Americans could easily manipulate communications technology challenged earlier colonial notions of who could have powerful magic, and who could not. Nonetheless, the enabling similarities Melanesians saw between themselves and Americans came at a cost. As Andrew Lattas puts it: "They remember the law of America as the law of everything being free. They remember the black Afro-American soldiers who wore the same clothes as whites and ate European food. These old men tell of how they were treated as equals by American soldiers. The discipline and subordination to whites which were part of the war have been forgotten. What the old men selectively remember is the utopian dimension of their relations with Americans" (1996: 290). In Melanesian constructions of reality, Lattas explains, ethnographers often find themselves dealing with the "paradoxical situation of people needing to remember that they need to forget." And at the risk of being essentialist, I would argue that this "need to forget" alterity in order to establish similarity is a universal property of mimesis. Nevertheless, though all media has the power to deracialize and reracialize bodies, on the Web, that power can be traced, observed, and mapped. We can see the patterns that are creating realities. We can see the magic, not because we don't understand the science, but because we do understand it.

Though the kinds of Web communities fostered by the desires of those in a "cult of public opinion" might not be ones I'd like to participate in offline, online they have their uses. For instance, in real life, Americans are not only expected to deny their (racialized) fantasies, fears, and projections about the maternal—they are also expected to deny the racist trope of projection that buttresses this denial. Yet by connecting images of Woodward, O. J. Simpson, Princess Diana, and Lacresha Murray, a seemingly "safer" avenue is opened up in which to both have and defer

these fantasies, projections, and desires. In fact, the alterities summoned through the dialectical images of the Web might even provide some of us with a way to combat the current desire for online invisibility and sameness. For just as the fantasies of indigenous Melanesians are not analogous to those of American corporations, the complex of admittedly racist and sexist desires of Woodward Web-community members are not analogous to the invisible cyberspace residents and their textual geishas. All fantasies are not created, or played out, equally.

Perhaps I am overly optimistic, but I see every reason to hope that the future of the Web may provide an antidote to the current industry smugness about the way things "really" are, and really will be, online. For instance, Prodigy Internet has announced yet another internal corporate restructuring (Reuters, 1998). Though most industry analysts have dismissed the move as a lame attempt to jump on the IPO bandwagon, Jupiter Communications senior analyst Abhi Chaki disagrees. Chaki believes that Prodigy actually has the opportunity to meet a previously untapped consumer base—Latinos—primarily due to the fact that it is now 65 percent owned by the Mexican phone company Telefonos de Mexico (Telmex). As a subsidiary of Telmex, Prodigy may well find its own future dictated by the very global economy it wanted to dominate. Like cargo cults, sometimes things are built by people on the Web, commercial interests arrive, and changes do happen within the social fabric of the performance. Of course, with so many different players planning and dreaming, there is no telling whose story will actually come true, and which pattern will magically become a new reality.

NOTES

Jennifer Fink, Cathy Young, Chris Belanger, Jim Patrick, Michelle Tepper, Paul Wallich, and Michele D. Knaub read early drafts of this chapter and provided much-appreciated feedback. Thom Swiss, Andrew Herman, some anonymous readers at Routledge and participants at the Myth, Metaphor, and Magic Conference at Drake University posed crucial questions and encouraged me to resist easy answers throughout this project.

1. As will become evident, this essay has been greatly influenced throughout by the theoretical work and creative writing style of Michael Taussig. Even for the turn of phrase, "what was called, in an older time, 'magic,'" he deserves credit.

2. Baud Behavior has since been closed by Prodigy. However, I have mir-

rored the contents of the original site at http://www.echonyc.com/~jane-doe/baudbehavior/index.htm.

3. The Official Louise Woodward home page, which has since closed, was located at http://www.louisewoodward.com.

4. See Burridge (1960), Lawrence (1989), Lindstrom (1993), Trompf (1990), and Bourne (1995) for ethnographic accounts of Melanesian cargo cults.

5. For further discussions of branding, see Stobart (1994), Aaker and Biel (1993), L. Freeman (1998), Advertising Research Foundation (1994), Ogilvy (1985, 1988), and Mayer (1991).

6. Amazon's site is located at http://www.amazon.com.

7. The Motley Fool website is located at http://www. fool.com.

8. Jones's criteria for virtual settlements are as follows: first, a minimum level of interactivity marked by conversation—which would exclude one-way mailing lists; second, there should be a minimum of two communicators—which would eliminate simple databases; third, a settlement should contain one symbolically delineated virtual space—which would eliminate speaking of all of Usenet, or the Web as a settlement, but would allow for speaking of multiple sites as a settlement, provided the arrangement met the first two conditions; finally, Jones argued, a settlement ought to be able to display evidence of a sustained, long-term membership. Jones's criteria were developed from the conceptualizations of virtual communities of Weinreich (1997), A. R. Stone (1995a), Shenk (1997), Rheingold (1993), S. Jones (1995), Erickson (1997), and Hafner (1997).

9. The Official Louise Woodward Campaign for Justice site was located at http://www.louisewoodward.org.

10. The Woodward sites I examined included the following: Louise Woodward Campaign for Justice at http://www.louisewoodward.org; Force 9 Louise Woodward Campaign at http://homepages.force9.net/louise/htm Friends of Woodward-Boston at http://www.louisewoodwardboston.com; Louise Woodward: The Nanny Trial at http://www.densu.com/nanny; Cyberstorm: Louise Woodward at http://www.cyberstorm.demon.co.uk/louise; Free Louise Woodward at http://orphansoftware.com/Louise; Louise Woodward at http://www.geocities.com/Pipeline/5504/ louisepix. html; and VirginNet's Louise Site at http://www.virgin.net/ archive/louise98/background/campaign_sites.htm. Now that her trial has passed, most of the Woodward sites have shut down, and while collecting images for this essay, I've found that URLs that worked only two weeks earlier are broken, closed down, abandoned. As the days progress and the trial grows dimmer in public memory, a random Web search turns up more photos of the happy, glamorous Louise—hair bobbed,

smile bright. Some fans still keep pages going, to let us know that yes, Louise is now home with her Mum, and yes, she still likes the Elmo doll she got for Christmas. By and large, however, people have moved on. Perhaps this is only fitting. Celebrity community, like celebrity itself, is generally a short-lived phenomenon, Lady Diana notwithstanding.

11. Particularly at issue throughout the trial was Woodward's use of the phrase, "I popped Matthew on the bed." While American police read the expression as an indication of her disregard for the baby, the British press countered that the term was actually British slang, synonymous with the American "placed."

12. Some sample polls are (or were) at http://www.louisewoodward-boston.com/polls.htm and http://www.densu.com/nanny.

13. Sample bulletin boards are (or were) at http://dspace.dial.pipex.com/gshhome/louise.htm, http://www.louise.force9.co.uk/louise_home.htm, and http://www.louise.force9.co.uk/ricklox.htm.

14. Negativland's website is at http://www.negativland.com. The images discussed are on the main page and at http://www.negativland.com/riaa/index.html.

15. Court TV Online's site is located at http://www.courttv.com. Their Woodward section is located at http://www.courttv.com/trials/woodward.

16. The location of the O. J. Simpson QuickTime movie is http://www.courttv.com/trials/woodward/week2.html#oct17.

17. Court TV Online makes periodic changes to its "Famous Trial" lineup. Where once Louise Woodward and O. J. Simpson were ranked trial numbers 1 and 2, respectively, at the time of this writing Woodward had fallen to number 2, sandwiched between the Unabomber (number 1) and Marv Albert (number 3). See http://www.courttv.com/famous/

18. Lacresha Murray's website is at http://www.peopleoftheheart.org/home.htm. The other case branded as "important to Louise" was Scottish national Kevin Richey—presently on death row in Ohio.

> FROM: NANCY KAPLAN
>

> SUBJECT: **Literacy Beyond Books**
> Reading When All the World's a Web
>
>
>
>
>
>
>
>
> We are, as always, in the midst of a literacy crisis. Like
> business cycles and bear markets, one comes along at
> more or less frequent intervals, at least every ten or twenty
> years. The last major crisis that I can recall vividly an-
> nounced its arrival on the cover of *Newsweek* in the 1970s
> under the headline "Why Johnny Can't Write." Few ques-
> tioned the validity of the claim and few doubted the
> causes: the chief culprit, most pundits agreed, was tele-
> vision. As Rose Goldsen's (1977) sociological study *The
> Show and Tell Machine* argued, television is capable of
> teaching many things—especially the rituals of con-
> sumption. It fails, however, to teach literacy, even when
> literacy education figures prominently in a program's
> stated goals, as it does in most educational programming
> for children. In fact, in her analysis of *Sesame Street*, per-
> haps the world's most popular children's show, Goldsen
> argues not that its efforts to teach literacy are a failure but
> that the program's representational style and its content
> actively discourage reading. Each day one Muppet or
> another offers to sell young viewers an "O" and each day's
> program "is brought to you by" (that is, sponsored by) two
> or three letters and numbers. Under the guise of teaching
> letter-recognition and number concepts, each installment
> actually instructs children in the art of understanding
> television commercials.
> In the nineties version of the literacy crisis, pundits
> point to video games and computers in addition to (or

occasionally instead of) television (Postman, 1992), but the analysis Goldsen applied to *Sesame Street* still informs the general argument. The allure of the spectacle—realistic representation, catchy theme music and jingles, recognizable characters with whom players and viewers can identify—overwhelms the human sensorium, drawing children (and adults too) away from the more abstract, more intellectual, or more rigorous domain of the printed word. Television, video games, and personal computers using graphic user interfaces (GUIs), the argument goes, privilege emotion and empathy instead of reason and judgment (see Halio, 1990). Persuasive though it may seem on its surface, this argument is saturated with familiar anxieties, and the vague forebodings of loss that so frequently accompany technological change. The same sort of plaint rises every time a new technology for writing begins to permeate the cultural sphere. The most famous of these worried expressions is Plato's written record of a Socratic pronouncement: in Socrates' view, the technology of writing will rot the mind first by undermining mnemonic skills and then by making ideas "dumb"—literally speechless, unchanging, and incapable of intelligent response to questions.

As historical examples reveal, our fears and distrust blame newfangled technologies—materials, objects, and the techniques we need to use them—but the source of our disquiet actually arises from cultural disruptions. The technologies themselves become metaphors and synecdoches for shifts in power relations. The advent of the World Wide Web, which magnifies and amplifies the already implicit threat posed by earlier hypertext systems, has aroused deep distress among traditional humanists precisely because its ways threaten to unseat their own power and authority. Thus has it ever been.

APRÈS GUTENBERG, le DELUGE

In every literacy crisis, every level of social engineering and schooling plays its role. In elementary schools, the phonics and whole-language partisans battle to control literacy education at its most basic level, though neither side has ever advanced any sound empirical evidence in support of its case. In colleges and universities, the arena is even more vexed since it involves defending advanced literacy, always an imprecise and fungible concept. According to many professors of literature, the field claiming ownership of advanced literacy, hypertext—especially in the ubiquitous form of the World Wide Web—threatens to erode the

ability of young adults to read with acumen and insight. Ironically, perhaps, the text that seems to have initiated the debate about higher literacy and its demise in an electronic age is itself an erudite book written by the classicist Jay David Bolter. His book *Writing Space* (1991) begins with a quotation from a Balzac novel set in the fifteenth century, a period when literate practices had finally completed their triumph over oral traditions in the organization of social, political, and economic life (Clanchy, 1993). In the novel, the archdeacon of Notre Dame points to a printed book with one hand and the cathedral with the other, exclaiming "This will destroy that." Bolter uses Balzac's text as an analogic figure when he argues that hypertext, as the most general form of writing, will ultimately displace the printed book. For the past five hundred years, Bolter explains, the printed book has defined the organization and presentation of knowledge; in the future, he claims, hypertext will acquire these functions, relegating the printed book to the margins of literate culture just as the printed book had pushed stone monuments and iconic representations out of their didactic functions. Although he concedes that printed books will not absolutely disappear and that "the computer does not mean the end of literacy," he does argue that "the literacy of print" differs from the literacy of hypertext and that hypertext literacy will replace print literacy as the primary force that shapes what knowledge is and who the knowledgeable are (1991: 2).

Many academics as well as many men and women of letters—those who review books for the *New York Times* and other serious periodicals (see Kakutani, 1997; Miller, 1998)—have taken Bolter's statements as a challenge. In general, few have argued that print will in fact continue to govern the shape of knowledge; they have mostly conceded, either explicitly or implicitly, that computer-mediated texts will become important, perhaps dominant, in the organization of knowledge. The explosive growth of the World Wide Web as conveyor of news and as textual archive seems in some ways to have settled that issue: this (the Web's hypertext publishing system) is already displacing that (the more familiar print-based system). Rather than disputing Bolter's claim that hypertext (the Web) will displace print, critics have instead focused on whether it should define the organization and presentation of knowledge, or more accurately, what it will mean when print literacy loses its dominance in cultural, political, and economic affairs: what letting go of the book as the proper medium for serious intellectual work will do to civilization.

To craft their arguments, the defenders of print literacy necessarily seek to differentiate what happens when someone reads a printed text from what happens when that same person reads a hypertext. In the current literacy crisis, then, the threat to the core concept does not seem to arise from competing mediations—from graphics, film, video, or simulations. In this literacy debate, the threat to reading seems to originate in a form of mediation almost indistinguishable from the one that is threatened. In other words, critics of the Web fear that reading is at risk not because photographs or television or Hollywood films or computer games have seduced people away from verbal texts, but because a new and radically different form of verbal text may be taking over the cultural space that printed words have occupied.

In some ways, it is difficult to comprehend what all the shouting might be about: after all, words are words and in the value system of higher education, words trump all other means of encoding information and ideas. Yet the stakes are high. They include the power to define what it means for a person to be literate, what it means to teach others to be literate, and what it means to distinguish a literate culture from its implied opposite, an illiterate culture. Here I want to distinguish between two quite different projects and make my intentions in this chapter clear. The first project would offer real, true, or useful definitions of *literacy* so that experts could get on with the business of determining how to identify its cognitive, social, and economic effects and how best to teach it. This project, though worthy, is not my concern here. The second project seeks to tease out the meanings embedded in the term and the values attached to it. It focuses on the cultural functions the debates (or wars) play, and carefully examines the claims made in the name of literacy. This chapter aims to begin the work of the second project.

Our concepts of literacy generally encompass both the ability to read and the ability to write. In this chapter, however, I am focusing primarily on the reception of texts because the most serious and heated conversations about literacy in what Bolter has termed "the late age of print" seem to have arisen in disputes about what hypertexts in general and the Web in particular do to reading practices. These ongoing debates about reading practices help reveal the epistemologies, ideologies, and power relations driving the conservative (and sometimes openly hostile) response of the academy to challenges mounted by alternative reading modalities. Changes in tools for producing texts—for example, when the

personal computer and word processing software became widely available—did of course produce a certain amount of resistance, as had the typewriter and ballpoint pen in earlier eras. Some teachers and writers, for example, feared that these machines would undermine the quality of students' writing or might promote plagiarism. But these fears never reached apocalyptic levels. And despite early reservations, word processing became the dominant mode of producing all texts, including scholarship and research in all fields, in a relatively short period of time—not much longer than a decade.

Not so with hypertext systems. Hypertext's genealogy has been recounted often and in a number of accessible places so I won't rehearse it again here (see Barrett, 1988; Berk and Devlin, 1991; Landow, 1992). But a few facts about its origins and development are helpful in understanding the current controversies. Efforts to develop hypertext systems date back to the late 1960s, but the field was first organized in 1987, when computer scientists held the first conference devoted to it. A few years later, Tim Berners-Lee began to develop the authoring and publishing technologies we now call the World Wide Web. Ironically, Berners-Lee intended his work to solve intellectual and scholarly problems: Web technologies would provide intellectual communities with new tools for sharing information and ideas, a vital process in their collective effort to modify or improve their shared base of knowledge. Yet in the years since the Web became the dominant form for writing and reading hypertext, we have not seen the kind of gradual acceptance that greeted word processing and then e-mail. Instead we have seen increasing signs of hostility among humanists both inside and outside academic walls.

These concerns actually began to appear before the Web's genesis, as a reaction to experimental work with other hypertext systems, including Intermedia at Brown University; Hypercard from Apple; and Storyspace, produced by Eastgate Systems. Although the four systems I have mentioned here produce markedly different textual structures and support disparate publication and dissemination practices, critics of the textual experiments produced with these systems have been carelessly insensitive to the differences among their various interfaces and functions. Ignoring the manifold differences among particular hypertexts as well as among the authoring systems by which they were produced, they have gathered the similarities into an essence or set of essential features to postulate and then attack. Perhaps this procedure for demonizing a

shape-shifting opponent should not surprise us. After all, even more disinterested analysts of technological changes talk of hypertext as if it were always and everywhere the same. What should surprise us—but what seems to have gone unnoticed in the heat of debate—is the way discussions of literacy also essentialize print literacy, reducing its complexity and embeddedness in social and economic systems to a simple core of essential texts, practices, and readers. Before we can begin to sort out what literacy in the age of the World Wide Web and its progeny might become, we must sort out what literacy isn't and has never been.

READING LITERACY'S MEANINGS

One of the things literacy is *not* is independent from its material, social, and economic conditions. Failure to understand the relationships between reading practices and specific historical conditions leads to some of the oft-repeated and trivializing criticisms of computer-mediated reading: it's uncomfortable to read from screens; you can't read these texts in bed; paper provides important tactile or olfactory experiences without which some quality of the text is diminished or lost, so that computer-mediated texts cannot provide the same value that printed texts supply. These objections might bear scrutiny if we were to buy the underlying assumption that reading as we know it today has characterized all reading since the practice began in the ancient world. That assumption is, of course, false. Before most houses installed reliable artificial lighting, reading even a printed book, let alone a manuscript or papyrus scroll, could be physically uncomfortable. Before the kind of domestic architecture with which we are all familiar became the norm, probably few people read in bed: books were scarce, light was precious, bedrooms unheated (a factor in northern winters at least). In fact, there is some evidence that reading in private, let alone in one's own bedroom, has occasionally been considered dangerous or even transgressive, especially for girls, especially when they were reading novels (Darnton, 1985). How paper was manufactured and what it was made of; what sorts of inks were available or usable; book sizes; arrangements of public and private spaces; the design of houses; social status and wealth; gender and age; even transportation networks: all have played roles in the history of reading practices (Darnton, 1989). It should be no surprise then that more recent changes in the material aspects of texts should exert pressure on

where we read, and when. Changes in material containers and in material contexts have always mattered.

Other analyses of the differences between reading printed texts and reading hypertexts deserve closer scrutiny. In *Word Perfect*, Myron Tuman (1992) claims that hypertexts discourage deep reading and encourage reading surfaces, skimming, and frenetic motion. In Tuman's view, the essence of hypertext is the link. Links, he supposes, offer readers irresistible invitations to click mindlessly along, to avoid close attention, engagement, and contemplation. "Harried and information-driven readers . . . can find out the least they need to know more readily by clicking" or, as he elsewhere calls it, "zapping" their way through a large information space than by carefully scrutinizing some body of text. "'[R]eaders' in the future who will be fully acculturated into an electronic world . . . [and] who have no sustained experience of print" will not want to "attend [to a text] closely and over long periods of time" (69). In this view, linked texts may not absolutely prevent sustained, critical reading; instead, by privileging "information retrieval and report generation," they will decrease the likelihood that anyone will want to engage in that practice (74).

Nor is readerly inclination the whole of the problem. In building his case against electronic and hypertextual delivery systems, Tuman argues that future readers will not even know how to read a text closely over long periods of time. That ability, he claims, arises from "our broader experience of print culture and the inner consciousness that it both demanded and rewarded" (69). A printed text demands a certain "frame of mind," a receptivity hypertexts do not require and do not value. Indeed, hypertexts threaten "the primary notion of what it means to read" in print culture, "the ability (and willingness) of readers to . . . forego the demands of the present to live by some other, imaginary rules. A developmental model of literacy grounds reading . . . in our serious commitment to following a new set of rules" (75). Tuman's case boils down to this: hypertext constructs reading as successive bursts of seeking and finding, actions driven by the reader's immediate desires; print constructs reading as a continuous act of submission to the rules of the text, as deferral of those desires until the reader ceases to read that text.

Sven Birkerts's critique follows much the same line of reasoning, though with less rigor and cogency. In the chapter of *The Gutenberg*

Elegies called "The Woman in the Garden," Birkerts defines what he means by reading by describing a painting, one that he either remembers or has imagined. In this painting, a woman sitting in a garden holds an open book in one hand as she gazes pensively into some middle distance. The point of this portrait, Birkerts writes, is that "[t]he painting is ... about the book, or about the woman's reading of the book.... [S]he is planted in one reality, the garden setting, while adrift in the spell of another. That of the author's created reality.... [T]he painter has tried to find a visible expression for that which lies in the realm of the intangible. Isn't this the most elusive and private of all conditions, that of the self suspended in the medium of language, the particles of the identity wavering in the magnetic current of another's expression?" (1994: 77–78). In working out the implications of this starting point, Birkerts comes to insist absolutely that the act of reading has fundamental metaphysical implications, that "[r]eading is not on a continuum with the other bodily or cognitive acts. It instigates a shift, a change of state—a change analogous to, but not as totally affecting as, the change from wakefulness to sleep. Maybe the meditation state would be a better correlative" (80).

Having characterized reading as a mental state akin to meditation, Birkerts compares reading a book to reading a hypertext, first by insisting that words on a printed page differ absolutely, metaphysically, from words displayed on a screen and then by finding that in the presence of the word on the screen—the dematerialized word, the weightless word, the word that is no longer any thing but merely an idea of a thing—he is unable to make the shift, the change of state, that defines reading for him. "[T]he ever-present awareness of possibility and the need to either make or refuse choice was to preempt my creating any meditative state for myself.... I experienced constant interruption—the reading surface was fractured, rendered collagelike by the appearance of starred keywords and suddenly materialized menu boxes" (162). Like Tuman, Birkerts talks of a certain "receptivity" the reader desires in seeking out the book. In the system of values to which this discourse subscribes, the highest value resides in the reader's achievement of that receptive frame of mind.

This line of argument worries openly about the future not of reading per se—that is, not of reading defined as the elementary act of decoding verbal signs—but of "critical reading," the name often used for higher or more advanced literacy practices. Defining exactly what constitutes these

practices, however, poses significant difficulties. Unlike writing activities, reading episodes leave no visible traces behind them. Definitions of critical literacy lack rigor in part because we have no reliable gauges or measures of the events themselves. As Harvey Graff's definitive study of literacy's history demonstrates, the only measurable aspect of reading ability is also the most elementary, what Graff refers to as "basic or primary levels of reading and writing"—that is, the ability to decode linguistic marks and to inscribe them (1987: 3). Once the discussion moves beyond the limits of this definition, as Tuman's and Birkerts's discussions plainly do, it becomes increasingly difficult to define the central term with any precision. As a result, it tends to be subject to a good deal of semantic slippage.

READING AS AN IDEOLOGICAL AGENDA

Despite the differences in their analyses of causes and culprits, the critiques of hypertexts mounted by Tuman, Birkerts, and others share a central rhetorical move with Goldsen's critique of television. This maneuver involves a collocation of terms or a progressive set of substitutions during the course of which the meaning of the central term, *literacy*, shifts dramatically. For all these writers, literacy is always synonymous with reading books. The elision of terms emerges in an interesting way from Goldsen's straightforward assertion that "the 'Sesame Street' curriculum ... has nothing to do with ... reading" (1977: 250–51). Her claim is obviously inaccurate if we take reading to mean decoding marks to form words and meanings. Even a glance at a single episode will demonstrate that lots of characters, both Muppets and humans, read some things: street signs, words on products and doors, and so on. To be sure, these reading activities are pretty elementary, as we might expect on a show aimed at preschool children whose most immediate literacy goals are likely to include this sort of basic transaction. Other moments depicting reading activities may be somewhat rarer, but they do occur. Adult characters are at least occasionally seen reading newspapers or magazines, even a sort of "video-enhanced" storybook to children. But it isn't hard to believe Goldsen's observation that "the daily dramas on the street have never featured anyone absorbed in a book, laughing or crying over a book, or so gripped by a book that he cannot bring himself to set it aside." As she succinctly puts it, "the incessant 'commercials' sing the praises of the

letters and numbers, but never of books and reading" (1977: 251). The title of her chapter about Sesame Street says it all: "Literacy without Books." In her view, real reading is embodied only in the bound volume.

The shift from "reading" to the more specific "reading books" is easy to see in *Word Perfect* and *The Gutenberg Elegies*: like Goldsen, Tuman and Birkerts make the equation specific. Thus, in the first paragraph of his preface, Tuman declares that his most immediate concern is "charting the enormous impact computers are having on ... how we define literacy...." The first sentence of the second paragraph glosses his meaning: his theme is a "grand narrative recounting the transition from ... a modern age ... committed to the reading and writing of books to a postmodern age ... committed to reading and writing with computers" (1992: x). In a curious development, Tuman's formulation reinforces the first semantic shift by bolstering it with a second one, from reading an object or writing to produce that object to reading or writing by means of a technology—from product to process. Reading in the modern age, he seems to say, derived its value chiefly from the value of the thing that was read; in a postmodern age, it seems, reading cannot have much value because it has no constant object with value to impart. In his introduction, Birkerts takes as his subject the modification of "the printed book, and the ways of the book—of writing and reading" by electronic communications (1994: 6). More forthright than Tuman, Birkerts simply declares that "the bound book is the ideal vehicle for the written word" (1994: 6). Although these authors continually gesture toward wider and more capacious notions of literacy, they continually return to the book as its apotheosis.

It would no doubt be easy to demonstrate that only a small portion of all the texts ever distributed have been produced as bound volumes, even if we include only texts produced after the introduction of the printing press in the second half of the fifteenth century. But it would also be tedious and unnecessary. The text that these and so many authors of news articles and book reviews invoke is not just any text—a pamplet or grocery list or business memo. Nor does the term "book" include every instance in the class of all bound volumes—cookbooks, travel guides, self-help manuals, encyclopedias, textbooks—but rather only a much smaller group of bound volumes. Instrumental texts of all types are automatically excluded; mere pulp also need not apply. In this usage, the book means only a small set of all the bound volumes ever produced: only those whose contents can plausibly make a bid for a permanent or

enduring place in the written record.

Once the operative definition of literacy has shifted from reading in general to reading *important* books, that formulation also undergoes a metamorphosis: reading important books rapidly becomes synonymous with reading literature, a term whose semantic shifts in the late eighteenth century prove instructive. In *The Death of Literature*, Alvin Kernan (1990) argues that in the heyday of neoclassicism the term *literature* generally meant "'all serious writing' or ... 'anything written' or even 'the ability to read.'" Terms like "polite letters" or "poetry" were used to designate the smaller subset of serious writing formed by poems, plays, and works of prose fiction. By the end of the eighteenth century, as neoclassicism gave way to romanticism, "literature" meant only that smaller subset, "the best *imaginative* writing, regardless of genre—lyric, epic, dramatic—prose as well as verse. The philosopher and historian David Hume's intention, expressed in his autobiography, printed in 1777, ... 'to regard every object as contemptible, except the improvement of my talents in literature,' uses the word in its older sense, though with something of the newer romantic intensity. Judging from the context, Wordsworth pretty clearly intends the newer modern sense when he argues in 1800 in the preface to the second edition of *Lyrical Ballads* that science, not prose, is the true opposite of poetry, and speaks of 'revolutions not of literature alone, but likewise of society'"(1990; 12–13). A term like *literacy*, once used to mean all reading and writing practices from the most rudimentary to the most learned, has drifted in the same direction so that it often applies only to a small subset of reading and writing activities: those involving literary works.

Tuman and Birkerts in general employ the term *literature* in the Wordsworthian sense: to mean *imaginative* literature rather than other sorts of serious writing represented by most works of history, philosophy, or, most especially, science. Wordsworth's sense of literature is what Birkerts means when he speaks first of "the stable hierarchies of the printed page" and then of "literary practice, mainly reading" and finally of "the experience of literature" as synonyms for the book that the dreamy fellow to whom he refers at the end of his introduction holds open in his lap (1994: 7).

Tuman's account of literacy is somewhat more nuanced and less explicit about the semantic drift. People may seek out a wide range of texts, Tuman acknowledges, but those without "aesthetic" or "literary"

qualities are merely devices for storing information. Their structures hold little interest and are of little consequence: he is content to let such texts reside in what he calls "lifeless databases" or elsewhere "a shapeless database" (1992: 73, 59). Although in one section of *Word Perfect* Tuman appears to speak broadly and inclusively of texts as "the embodiment of history, philosophy, literature, science" (43), he finally asserts that the central and defining experience of print literacy is the study of imaginative literature. His clearest expression of this position comes in a response to my own hypertextual discussion of electronic literacy published on the World Wide Web:

> [T]he highest practice of literacy has meant ... the sustained engagement of readers via abstract (essentially nongraphical) written language, with the imagined world of writers.... What we have tended to find most valuable about literacy [is] the richly imagined, and seemingly fully constructed possible worlds that accomplished writers ... are capable of realizing." (Kaplan, 1995–9: tuman_responds.html)[1]

These elisions—gradually defining reading as reading books then as reading literature—commonly occur in more popular discussions of electronic texts as well. In a recent news article about two new "electronic books" soon to be available, one reporter discusses the latest bids to replace printed books with some kind of computer-mediated text (Stroh, 1998). Although his article occasionally confuses the physical object with its contents, using the term book to refer to both (and thus enabling one electronic book to hold and display the texts of many books), he's clear enough when it comes to what kinds of texts he means when he talks about books: "the complete works of great writers," also known as "literary classics" (Stroh, 1998: C1). Even Stephen Johnson, whose book *Interface Culture* celebrates the coming of a hypertextual world, takes the same journey. His favorite synecdoche for the whole chain of terms, in fact, is not just the literary work but the novel, particularly the Victorian novel. *Bleak House* seems to top his list. Perhaps it is not quite coincidental that Birkerts's woman in a garden is dressed in Victorian clothing or that Tuman's discussion of hypertext reading focuses on George Landow's course on Victorian fiction and the works of Charles Dickens. Tuman's final word on electronic literacy invokes *Jane Eyre*,

perhaps the most frequently read English novel:

> [A] global hypertext system like the World Wide Web will enable students to amass a great deal of information about *Jane Eyre* and its author, Charlotte Brönte, but not necessarily have the wherewithal (dare I say 'patience') to dwell contentedly in Jane Eyre's imaginative world of deeply felt, closely realized anticipations and desires. (Kaplan, 1995–1999: tuman_responds.html)

Having shifted from a capacious concept of advanced or critical literacy to a narrower focus on the book and then to the even more specialized category of the novel, the declension finally comes to rest on a narrow set of novels: the realist novel of the Victorian period.

The story of reading I have been retelling here suggests some troubling questions. For example, the claims made for critical literacy require us to ask why certain genres and periods of imaginative literature so often figure in these stories. Does the account of reading practices these authors privilege—the meditative, receptive, transfixed, deep study of imaginative literary works—accurately describe real practices: the practices of literature professors (where it is most likely to be plausible), the practices of other intellectuals, the practices of more numerous and more ordinary readers? And what work does this definition of higher literacy do? If the concept of literacy these critics provide offers only an idealized condition, one constantly sought but rarely attained, we might want to know whose interests are served by this concept (and whose are suppressed).

But even if we conclude that the stories Tuman and others tell offer a powerful understanding of a certain kind of critical literacy—the kind germane to verbal works of the literary imagination—we must still account for the literacy used to engage other sorts of texts, for surely the division of the world of texts into two kinds—the literary text and the reference work—seriously misstates the case. What does it tell us about reading history, philosophy, sociology, music theory, anthropology, not to mention astronomy, biology, or zoology? About legal briefs and judicial rulings? About newspapers or serious public discussions in other kinds of publications? And then there are the vast reaches of texts crudely grouped as popular culture and the reading practices of the hoi polloi. As these questions imply, when we see this story of literacy in its native ide-

ological costume, we recognize the sort of cultural capital its proponents command.

READING AS A COGNITIVE PROCESS

Still, those of us proposing alternative narratives are obligated to move past simple ideological critiques. Exposing the power interests motivating the story does not excuse us from articulating our own account of literacy, one that addresses both its socioeconomic functions and its cognitive dimensions. For the sake of argument, then, we can accept the underlying assumption that the most important or highest form of literacy manifests itself as a sustained, critical engagement with ideas expressed verbally and presented in visible language (rather than as audible language) in order to determine whether print per se creates the necessary conditions and hypertexts per se do not. From the perspective Tuman and Birkerts occupy, the crucial difference between works in print and works in hypertext derives primarily from the nature of hypertextual links, the operational elements that provide connections among the collection of nodes. It is the seduction (or interference) links offer, their promise to gratify readers' desires instantly or to prevent readers from becoming receptive, that appears to differentiate reading words on paper from reading words on screens. In their account, links create three related problems: they disrupt cognitive processes by calling attention to the text's visible elements (its surface rather than its meaning); they destroy the possibility of coherence by offering more than a single sequence of pages; and they undermine the possibility of meaningful interpretation by preventing readers from completing the work of reading.

There is no doubt that to qualify as a hypertext, a work must make use of one or more kinds of links. Isolating the link from other constituent elements of hypertexts, however, distorts the view of reading and literacy a more inclusive understanding might yield. To arrive at a different narrative of reading, we have to expose the inadequacy of this standard, but reductive, definition of hypertext as an arrangement by which the collection of nodes constitutes the real work while the links merely connect nodes to each other. Using this definition, hypertexts published through the World Wide Web—for example, Michael Joyce's "Twelve Blue" (1997) or my own critical essay "E-literacies: Politexts, Hypertexts, and Other Cultural Formations in the Late Age of Print" (1995–1999)— consist of their nodes (where the words are) and their links (to transport

the reader from one node to the another). If texts like these presented only one exit point (link) out of each node and that exit point took the reader to only one entrance point for one other node, we'd call this activity "turning the page." We know how to do this with books but we also know that in a book the page boundary is an arbitrary edge, an accident produced by other decisions: about the size of the book, the layout of its pages, its typeface, and so on. Only in rare circumstances would the author of a story or essay be involved in the decisions that determine where page boundaries will fall in relation to the words of the work. Thus, a prose work produced for a print environment demands only that the author arrange the words. For the most part, the other arrangements that collectively constitute the book lie outside the work.

In any hypertext worthy of the designation, there are several ways to leave each node and several ways (or directions from which) to arrive at each node; each node offers readers several links. Links have to exist because each node's boundaries are shaped by the author. Thus, in hypertexts published via the World Wide Web, the node's edges aren't arbitrary: the author or designer of the text has devised each node as a unit.[2] Like a poet's decisions about the length of any given line of free verse, the hypertext author's decision about the scope of a node constitutes an occasion for invention, a decision driven by aesthetic or rhetorical considerations. Rather than lying outside the work and therefore providing a container for the work's content, the decisions that determine the page boundaries not only affect how a story or an essay looks; they also form constituent parts of the work's design. As a practical, authorial matter, it is impossible to compose hypertexts without considering the relationship between the boundaries of each node and the multitude of links leading into and out of each one.

The deliberately crafted separation between nodes and the provision of multiple points of entry and exit for each node require readers to make choices: the words each node offers come to an end. There is no necessary "next" node in a preordained sequence. Hence the reader must choose among the offered links in order to keep reading. By her reading activities, she assembles the sequence of nodes. And it is these facts for which our story of reading must account, for in all other respects, the reader is simply reading one word after another: whether she is deeply engaged by the verbal arrangements and receptive to the unfolding story only the reader and her own tastes can say. But in the practices we can

observe, we see an activity largely indistinguishable from reading printed pages, except for this matter of turning or moving—choosing one sequence from among the set offered.

What then is the relationship between the activity of turning pages or moving from one node to another and the cognitive activity we call literacy? How might this novel feature affect reading practices? For Tuman and Birkerts, links create the problems they see because links do not fade into out-of-awareness practices the way page boundaries in print do. So links intrude into and disrupt the cognitive activity of reading by forcing a reader's attention away from the work. To continue reading a hypertext, the reader has to attend to features of its container; otherwise she can't find her way to another segment of the work. As pure description of the process, Tuman and Birkerts have it right. Links force readers out of one mode of coginitive activity and into another, at least for a time. But we could look at the effects of this process in a much more useful way if we resist drawing the line between what is in the work and what merely delivers the work to the reader—if we avoid using a conceptual framework that is consistent with the world of print but inappropriate to the world of electronic writing spaces.

What, exactly, is a link? Strictly speaking, a link is simply a little snippet of executable code that instructs a software program to respond to a user's actions in a particular way. The same sort of code causes an icon on a screen to be highlighted when a user selects it by clicking the mouse button when the cursor or pointer falls inside the icon's boundaries. In hypertext markup language (HTML), a link's code looks like this:

```
<A HREF="http://raven.ubalt.edu/staff/kaplan/nak_home.html">
```

Unless the reader of the hypertext goes looking for it, however, she never sees the link itself: she merely causes the program to issue a request to display the file specified in the code. It is worth noting here that in other hypertext authoring systems, a reader will *never* see the link proper even if she happens to obtain the source code for the program. The link is inscribed into the file she is writing but it is invisible to her in the same way that the codes a word processing application uses to "mark" some text as bold or italic are invisible; the only reader of such inscriptions is the application that writes them. Because the authoring system for the World Wide Web is a scripting language rather than a programming lan-

guage, the author of the hypertext typically writes the link's script. The reader of the hypertext, however, simply sets in motion the browser's request for a file by clicking on something. Unlike the link proper, what the reader points to and clicks on must be a visible element: something she can see. These visible elements are sometimes called "hot words" or "hot links" or, in Michael Joyce's evocative phrase, "words which yield" (1990). A better term for them might be "link cues."

A link cue, as its name suggests, prompts or invites the reader to activate the link whose visible sign it constitutes. For reasons I will discuss below, it ought not to be mistaken for or conflated with the link itself. Exactly what these cues look like depends entirely on the hypertext authoring system's interface. Differences between interface conventions from one hypertext to another can matter a great deal. Some hypertext authoring programs give authors a great deal of control over the way their link cues look; some allow authors to suppress visual features that would otherwise identify a link cue. Some systems—Storyspace is one—offer alternatives to explicit cuing so that the reader might need to learn a secret way to detect which elements in a node are operating as link cues. The interface convention for the World Wide Web typically distinguishes link cues from the other words in a node by underlining them and displaying them in a special color.

The system for cuing the reader powerfully affects the reader's experience with the text and the reading strategies she brings to it. For example, Michael Joyce's first work of hypertext fiction, *Afternoon*, does not differentiate visually between words functioning as link cues and other words in each node, even though some words activate specific links and others do not. In the reader's experience of the work, however, *every* word may seem to be a link cue because any clicked word brings a new node into view. In this work, any word not affiliated with a specific link activates the default link, that is, turns the page. This feature makes it possible, though not necessarily desirable, to read the work just as if it were delivered on printed pages. Instead of absent-mindedly moistening a forefinger as she prepares to isolate the top leaf of her book from all the others waiting to be read, however, the reader simply learns to tap the return key in the same absent-minded way.

In contrast, an author using Web technologies will find it very difficult to conceal link cues from readers. Browser interfaces give their users a number of mechanisms for specifying the display of elements—the

ability to suppress the font and color choices the author has encoded, for example. Moreover, browser interfaces provide multiple and overlapping sources of information, both about the locations of cues and about the destinations of the links. The appearance of the cursor may change as it moves over the cue. Alphanumeric information may appear in the "status bar" at the bottom of the window when the cursor encounters a cue. These interface elements are meaningful signs operating within a rule set enabling their users to decode and understand what the screen says. Like other languages, the visual language of a good interface is overdetermined in the sense that it deploys multiple signs whose overlapping and converging meanings increase the chances that the reader will detect and interpret them in useful and meaningful ways.

How the hypertext reader interacts with the hypertext depends on how these features of the interface are constructed and deployed. For that reason, it makes little sense to generalize about all hypertexts, or even about all those sharing a single literary or rhetorical genre. Only those hypertexts sharing interface conventions will offer approximately the same reading conditions.

CUES FOR READING

However link cues are displayed, each one operates as an offering, a place from which the reader can exit the current node and enter a subsequent one. Each node offers many cues. Although Birkerts does not recognize the distinction between link cues and links, links themselves do not interrupt or fragment the reading surface. It is the cues, not the links, to which Birkerts so strenuously objects. By calling attention to themselves, the words comprising cues distract him. But properly read—that is, read in two registers—these special words offer much deeper engagements with the text. Insofar as a cue belongs syntactically and semantically to a passage of prose or poetry, it belongs to the ordinary decoding and interpreting activities reading always requires. Insofar as a cue is a gesture inviting the reader to engage its link as the transition to another node in the hypertext, it belongs to the set of structures that defines the scope and the possibilities of the text being read. In other words, a cue contributes to meaning both locally (within the node) and globally (within the larger hypertext). Through their double action, link cues blur the distinction between the work and the interface, between content and container.

Because they are not verbal signs, iconic cues (graphic buttons, for

example) may operate somewhat differently. But whenever a link cue is comprised of a word or set of words visually differentiated from but embedded in the verbal stream of a node, the cue does double duty. It is read twice, or at least in two distinct registers: the word or words of the cue mean one sort of thing when read as a portion of a syntactically ordinary phrase or sentence and another sort of thing when read as a meta-textual pointer. In the first role, any part of speech occupying any syntactical function permitted by linguistic rules can become a link cue. In that second role, however, the cue's semantic and syntactic functions resemble those for which we use a specific set of linguistic devices, the special words used to create coherence among sentences and paragraphs: transitions, conjunctions, demonstrative pronouns, and the like. For example, in "E-Literacies," I ask readers to "take chances with their choices," an ordinary enough sentence exhorting readers to be daring. When the word "chances" or the word "choices" also operates as a cue, it implies a second meaning: at the other end of the link cued by the word "choices" lies a node whose relation to the current one is conditioned, perhaps in some sense defined, by the cue's resonance or power to persuade the reader to travel its way.

READING FOR CUES

Although there is much we do not yet know about how people make use of hypertexts, there are a few well-known and oft-demonstrated facts: whether the hypertext in question is an aesthetic, imaginative one or one designed for the most quotidian and instrumental purposes, its success depends on its readers' ability to locate and to make sense of cues. The readers of a medical encyclopedia and the readers of "Hegirascope" (Moulthrop, 1995) will be equally frustrated if they cannot find the link cues or if, having located them, these readers cannot tease meaning out of the cues. Locating is a matter of specific interfaces in specific authoring software: there is no "generic" form for a link cue. Making sense, on the other hand, applies broadly: it means gaining a degree of confidence that the link (or articulation) whose availability the cue signals participates in a design whose purpose can be understood, or perhaps interpreted in a satisfying way. In a purely instrumental text—a website offering information about used cars or a set of commentaries on the works of Charles Darwin—that system and its shape may need to be transparent: cues should accurately forecast each link's results. In his

Fig. 11.1.
The work of
the author is
everywhere in
evidence—
in the design
of the hyper-
textual space,
in the design
of the inter-
face, as well
as in the
design of the
prose style.
The author's
website,
http://raven.
ubal.edu/
staff/kaplan/
lit/One_
Beginning_
417.html

E–LITERACIES

Way In-Way Out

In this hypertextual essay, I offer some brief definitions and descriptions of electronic textual formations and argue that the proclivities of electronic texts -- at least to the extent that we can determine what they are -- manifest themselves only as fully as human beings and their institutions allow, that they are in fact sites of struggle among competing interests and ideological forces.

Or, to put the matter another way, social, political, and economic elites try to shape the technologies we have so as to preserve, insofar as possible, their own social, political, and economic status. They try to suppress or seek to control those elements of electronic technologies uncongenial to that purpose. The degree to which they are successful in controlling the development and use of electronic texts will define the nature and the problems of literacy in the future.

work on hypertext, George Landow calls this aspect of the hypertext its "rhetoric of arrivals and departures" (1987). In narrative and imaginative or literary texts, of course, such transparency is unlikely. Presumably, readers of poetry and fiction expect a kind of verbal play, a language game whose rules would not obtain in a more workaday world.

The process of making sense out of the set of link cues and the results of links activated need not ask us to depart radically from the standard explanations of reading's cognitive dimensions. Having weighed alternative offerings, however briefly, the reader chooses; she activates the link whose cue has beckoned and sets off down someone's garden path. When the system is working well, the journey to the other end of the link takes only a fraction of a second and yet everything depends on it, on the reader's ability and willingness to attend to the potential meanings of each traversal, to read as it were the shape the reading is tracing. All readers construct forecasts and expectations as they read verbal texts; they create provisional and anticipatory understandings, modifying them as they progress through the text and encounter information either confirming earlier forecasts or causing them to be revised. In the same way, readers consider the options that the link cues offer. From those cues, from their past experience with how things have turned out before—how a link cue provides information about the node at the other end of its link—readers of hypertexts develop a contingent sense of the hypertext they are reading and continually modify their expectations and forecasts as the reading progresses. Weighing link cues constitutes part of the cog-

nitive activity of meaning making that we think of as reading. Making these choices may well be the most intellectually taxing problem readers of hypertexts face, for the choices readers make along the way enact their expectations. The selections aggregate into a kind of contingent interpretation of the text at hand.

Although Birkerts complains about the fractured reading surface and the disrupted trance, the moments during which readers recognize and consider the offered link cues should be understood in quite a different way, as moments of especially deep engagement with meanings. Comprehending a link's cue both as an element in the locally sequenced flow of words and as a signal about the nature of the underlying link leads to understanding each link chosen as a successive act of development. In other words, the repeated acts of choosing links by succumbing to each one's cue creates a contingent order, a linearity perceived in tension against the possibility of other lines. It is the reader's activity that Michael Joyce describes as "the emerging surface of the constructive text as it is shaped by its reading" (1995: 239). If, as Joyce writes, a hypertext is "a structure for what does not yet exist," each reading is a (contingent) bringing into being of some facet of the hypertext's structured potential (1995: 42). The link cue offers a potential for meaningful reading; the link itself provides the transition from one element of the text's emerging meanings to another. Readers choose each link as a connection from one part of a structure to another.

In the story of hypertext that Tuman, Birkerts, and others tell, a link is a purely local object: each link disintegrates and falls out of any meaningful relationship to the real text (the words in the nodes) once it has been used. In this view, a link is merely a stepping stone, a way soon traversed and forgotten, offering no meaning of its own and contributing nothing to what they define as the work. To understand the link in this way, however, is to make the classic page-turning error. Turning a book's pages indeed adds nothing to signification: the end of a page is an arbitrary boundary imposed by an intransigent material world. Taking a link from here to somewhere is not the same thing at all, for in the aggregate the set of chosen links and each link's place in the set play off against all the sets passed over. That doubleness—the links taken and those passed by—brings a particular reading into being (Harpold, 1991b; Joyce, 1995; Kaplan and Moulthrop, 1994).

The act of choosing this link rather than that one brings the reader

and her reading into relation with what was in this reading but also what was not encountered in this particular journey through the system of nodes and links: that undiscovered country marked by the paths not chosen and the sequence of nodes left behind in the space of mere potential. First through the visible face each one offers—the beckoning of its cue—and then through their aggregated actions, links carve what Mark Bernstein, Michael Joyce, and David Levine (1992) call the "contour of the reading" as against the "negative ground" or space of what is deferred. Each reader's way includes some nodes and some set of the connections among those nodes, but it never includes all the nodes and all their potential connections. Thus, the deferred space forms a background, as it were; all the possibilities of nodes and routes that were not a part of this reading become the white space against which the visited nodes and routes this reading did encounter form a pattern, design, or figure.

What is deferred in any hypertext reading includes both those nodes a specific reading never reaches and, that more complicated and challenging problem, the sequencings foreclosed. This story of reading, then, understands a link not simply as a local occurrence (or annoyance) but as a requisite part of a larger structural pattern, a pattern visible only as it emerges through each reader's successive acts of choosing. Whatever else we might observe about the process, it's certain that there's no automatic pilot for reading a hypertext. And that remains true even for "Hegirascope" (1997), Stuart Moulthrop's Web fiction that ironically or parodically pretends to read itself (or at least turn its own virtual pages). For even there, an apparently passive reader must stubbornly, willfully choose not to choose: the reader must choose to pass over each link cue as it is offered, each invitation to intervene in the flickerings of the text as each node appears for its brief bow and then hurries off to be replaced, programmatically, by the next one.

READING FOR ORDER, SEQUENCE, AND DESIGN

For all the focus on links and the local disturbances they cause, however, the more pressing but less frequently confronted trouble for hypertext's critics is the fact of multiple sequences. At the center of their understanding of a well-formed text lies an invariant order, the one best way. Those who misunderstand these texts conclude that because hypertexts necessarily offer multiple ways, hypertexts cannot offer any good way: each sequence of nodes must surely be as good as any other; and

under those conditions why bother to choose? Yet the singular and invariant sequence on which this story of literacy relies actually belongs to printed texts themselves, rather than to the quality or quantity of attention readers bring to their practices. The behavior of readers signals that this is so: when asked, many people confess that they do not always read in the prescribed sequence; they cheat by glancing ahead or by backing up to reread. Rarely if ever do readers demonstrate a "serious commitment to following a new set of rules" precisely as laid down by the fixed sequence of the words on the printed page. But even if each word is read only in its appointed place, reading is not "a single process, something like the scanning of a printed book from the first to the last word, with information passing into cognition in a sequence dictated by an author." No reader ever "'has in mind' precisely what an author 'put there' and in the *order* that the author 'put it there.' [Rather, readers build up] a pattern of overall meaning which can modify—or else, be modified by—subsequent text items (words, sentences, paragraphs, and so on)" (McHoul and Roe, 1996).

Although fixed order is represented as if it were necessary to control the reading sequence, it is really a device for designing a set of patterns in the prose. What distinguishes the best writers from the pack, in the view of Tuman and Birkerts, is not and cannot be their absolute control over readers, but their absolute control over the work's design—the structure of the sequence of words, sentences, paragraphs, and chapters. Authors of print fiction typically provide no alternatives because to do so would be to renounce control over the design, conceived of as a larger pattern of imagery, character development, or unfolding of plot. The value attached to these patterns may have little or no effect on what readers actually do when they read the text.

Hypertext fictions may in fact loosen the threads in some of these fabrics, but they do so in the interests of other large patterns, other elements of design. Even a sequence of nodes generated from a database on the fly participates in an underlying design, the rules of engagement as it were. When the text has been entirely scripted, as "Twelve Blue" and "E-literacies" and "Hegirascope" have been, the work of the author is everywhere in evidence—in the design of the hypertextual space, in the design of the interface, as well as in the design of the prose style. Craft and artistry emerge in the design of this space, sculpted from the decisions writers make about the boundaries of nodes, the suggestive-

ness of link cues, and the patterns of links. Just as the negative space of graphic design and page layouts provides the ground for the work's figure, here gaps and fissures allow aspects of the author's invention to be perceived: they define the work of shaping. The interpretive challenge for readers includes this new level of complexity, the semantic space surrounding the nodes, the space each link traverses (Kaplan and Moulthrop, 1994). It is not enough to see only the nodes and the links connecting them, not enough to understand reading as merely a sequencing activity. Adding to the language codes we already know, hypertexts occur within and help construct their own semantic codes. Their rules may differ from those formulated by texts in print, but hypertexts also ask readers to dwell within some imaginary rules for a time.

READING AS CONSUMPTION

Yet, how long a time? The critic no doubt wonders. The last "fact" about hypertext works is the fact that they appear to leave the reader with a high level of uncertainty about her own adequacy as a reader. Tuman confronts this issue when he writes that

> responding to your hypertextual rendering of 'E-Literacies' is an especially daunting, even an exhausting task—although one that confirms some of my worst suspicions concerning hypertext: that it is ideally suited for the storing and accessing [of] diverse information, not for sustained, critical analysis. It takes considerable energy—and anxiety—to reach the point of feeling that one has finished reading the essay, or enough of it to feel as if one can fairly comment on it." (Kaplan, 1995–1999: tuman_responds.html)

Printed works are in some sense "complete"—or a reader's current reading of one is completed—when all the words on the last page have been consumed. The reader exhausts the text rather than the other way around. No such tidy moment occurs with hypertexts. The World Wide Web differs from many other hypertext systems in that its interface conventions let the reader know whether or not she has visited all the nodes at least once, although even this certainty can be snatched from the poor reader by a canny author. But even if the author retains the standard visual cue to signal readers that they have visited every node, no reader exhausts the text simply by getting to each place once. Because these texts have a

spatial dimension and multiple patterns of circulation, there may be an almost infinite number of possible readings for any hypertext, especially if a reading may include multiple encounters with one or more nodes. These repetitions, Bernstein, Joyce, and Levine (1992) have argued, are features, not bugs: they constitute design elements that readers learn to understand in much the same way that movie audiences learned how to understand the visual vocabulary and syntax of various cuts, dissolves, and fades. Readers complete their readings when the sequences they are constructing through their decisions about link cues and links cease to yield compelling or new encounters with the design of the hypertextual space—the space, if you will, of the story and its unfoldings.

Ironically, empirical evidence suggests that readers control their encounters with printed texts in exactly the same way, shutting the book in which they no longer have an interest, staying up all night to finish one they obviously can't put down, returning to some many times only to wonder, at last, what they ever saw in it, and so on. Readers of scientific articles regularly read out of order: it is in their interests to do so. To admit these things, however, is not to say that no one will be able to establish a standard of readerly competence, with hypertexts or with any other sort of text. That task is no harder than it ever was; it has always been a matter of power relations, of who is empowered to define such things. In some theories, interpretive communities do this work. In others, power relations loom large. In college classrooms, readers of literature are deemed more or less competent depending on the degree to which they conform to the prevailing standards of the elites who make the rules. That is to say, a good reader of *Jane Eyre* is one who interprets the work almost as well as the professor of literature does. As the history of scholarship on the subject shows, good readings (that is, interpretive strategies) come and go (see Graff, 1987).

READING AS SOCIAL PRACTICE

In the final analysis, though, it is important to remember that our understanding of reading will always be seriously distorted if we confine its application to the literary texts the critics of hypertext prefer. The recent role of the Web in disseminating the infamous Starr Report suggests that plenty of other important texts also demand (as best they can) careful readerly attention. It's been instructive to see just how that text has been structured for use and just how people have in fact read it. On some web-

sites, the text appears in a single scrolling node: no hypertext here. On others, it has been chunked and linked to facilitate multiple traversals. On one ambitious website, the work of a company promoting its own hypertext authoring system for Web publications, the text has been elaborately "hypertexted" and the designers of the site have added interface cues to aid readers in their movements through the text, essentially permitting readers to sequence their encounters to suit their immediate needs for information or their investigative and interpretive strategies. The strategy permits moving from any node to any other node in the set. Presumably such a system could be expanded to include easy access between the text of the referral and the thousands of pages of grand jury testimony relevant to it.

Is there anything useful we can say about what readers do when they read this and its supporting texts in some printed version in contrast to what people do when they read these texts as hypertexts on the Web? Are there detectable differences, and if so, do those differences make a difference? To be sure, the Starr Report was not originally designed as a hypertext and its transformation into one might well have been shaped by the print culture that has no doubt shaped those who did the transforming. We are not clairvoyant, and probably cannot adequately imagine the sorts of reading and writing practices people who do not grow up in a print culture may yet develop. But social practices, and reading surely is one, have a kind of dynamic we already know well enough. And part of that dynamic involves wandering off, leaving the guided tour, walking on the grass even when the posted signs try to prohibit such activity. Sure, we can read the signs. But that rarely stops us.

Michel de Certeau (1984) divides literacy into two equally primary acts: deciphering marks and connecting dots. The deciphering act is necessary, to be sure, but it alone is not a sufficient condition for the entire act of literacy. What we're after is not what de Certeau calls the lexical act; we're more concerned with the interpretive act, "scriptural" in his parlance—the connecting and making readers must do to get anything out of or from what they read. His choice of terms is intriguing. While readers do not literally write anything anywhere and leave no traces that we know of, not even (as far as we can tell) in their own brains, they do in a sense provide their own scriptures, their own rules, in light of which they are sometimes content to dwell within that other set of rules, imag-

inary or not, that the texts they are reading supply. Acts of critical literacy depend on the doubleness: the two sets of rules, one supplied by the reader and the other by the text. De Certeau is certain that reading isn't passive, that the scriptural act belongs to the reader, not to the text or to the text's author(s). This pronouncement is not news now and wasn't news even when he wrote *The Practice of Everyday Life*. Of course, of course—readers bring baggage to the text; they carry their life experiences with them even though only a few of those experiences are ever relevant to understanding the story; they attach erroneous meanings to words that would probably be startled at the surprising ideas some (ignorant) readers suppose they signify.

De Certeau and other cultural theorists understand reading as a type of practice: the very model of all social practices. And if I have read any of these theorists right, everyday practices are idiosyncratic and deviant, elusive and subversive, and in the most obvious way not what was meant at all by the devisors of the system or code within which practices are supposed to occur. Mostly, practices escape their maps and algorithms; mostly we plain folk act contrary-wise.

For Sven Birkerts, reading is best understood as a story about a painting that may exist or that may be merely a visualized metaphor, some corsetted woman sitting on a bench in a garden, a book held open in her lap while she gazes in reverie at something/nothing. Birkerts imagines this woman imagining the world the unknown author of the book she holds has imagined and scripted for her. Whether Birkerts has seen an actual painting of this sort or has only conjured one up for his own purposes, he has read it wrong. The woman of his dreams, no bag lady or welfare queen, sits enthralled to his vision? Nonsense. Like the rest of us, she's nomadic, the painter having arrested her at a moment of absence. She's off task. She's daydreaming. She's doing the practice thing. Which is to say, she's wandered off down the street we cannot see because it resides behind the wall of the English garden so if the painter painted it he also covered it up. Perhaps she's going someone's wrong way. But even if she goes with the flow, she goes at her own pace and in the presence of a multitude of earthly voices, each one singing an entire anthology of other stories all at once like a Buddhist monk who can, after years of arduous training, sing his own harmony. A multitude of one.

NOTES

1. The date reflects the fact that the source continues to evolve; because there are no page numbers for nodes in the hypertext, I have used the file name instead.

2. Not all hypertext systems define nodes and their boundaries in the same way. Guide (an early type of "smooth" hypertext), for example, used a strategy more like "unfolding" and "overlaying" texts than like "jumping." The unfolding (or stretching) effect meant that when the reader chose a link that expanded the text, the added "node" would not displace the current one entirely but would insert itself into the current one. The resulting "new node" would contain both the text of the node before the link was activated and the text of the new material in a seamless, scrolling field.

> FROM: JODY BERLAND
>
> SUBJECT: **Cultural Technologies and the "Evolution"**
> **of Technological Cultures**
>
>
> If evolution cannot rationally be viewed as a way to get
> from ape-like creatures to man, then cannot the use of
> evolutionism as an ideological belief system get us
> from man to an ape-like creature? Such a capability
> would be of enormous value in politics.
> —Sir Peter Medawar, "The Future of Man"
>
> Virtuality without ethics is a primal scene of social sui-
> cide.
> —Arthur Kroker, "Virtual Capitalism"
>
>
>
> As the new millennium approaches, we are becoming
> inundated with pronouncements and speculations about
> our brilliant technologically enhanced future. This excite-
> ment crosses all the usual disciplinary and logistical
> boundaries of knowledge production. The association
> between new technology and progress, coupled with an
> excitable disregard for the banalities of the present, uni-
> fies otherwise disparate voices: business and feature writ-
> ers in the daily press; government and the broader arena
> of public policy; postmodernist and cyberfeminist mani-
> festoes; television and science documentaries; and the
> more overtly spectacular entertainments offered up by sci-
> ence fiction, children's television, and the military.
> Their consensus is that new digital and networking
> technologies have the capacity to reorder every domain
> of social and personal life, transforming gender and the
> body politic, work and knowledge forms, health and
> science, domestic life and entertainment, national
> economies and international relations, democracy and the
> distribution of power. If teleology has indeed vacated the

discourses of history, religion, perhaps even science; if utopia has expired in the cultural imaginary, as many critics now believe, this is only so that it may gather and condense in the narrative of techno-evolution, which seems to draw us irresistibly toward the holographic world of technological futures.[1]

The premises of techno-evolutionism dominate the newspapers, magazines and TV documentaries, workplaces and various institutions of contemporary public discourse. Like many publications, the *Toronto Star* entitles its weekly technology section, "Fast Forward." There is no time to wait, the title says—jump ahead of where you are, or you will be flattened beneath the headlights of progress. In both mainstream press and enthusiast subcultures, digital communication is celebrated as a self-evolving system whose rapid change poses a challenge to government, industry, and individual consumers. It is no accident that techno-evolutionism's hyperbolic temporality points us back to the aesthetic movements of the early twentieth century. With the emergence of the artistic avant-garde, Antoine Compagnon notes in *The Five Paradoxes of Modernity*, the term *avant-garde* shifts from a spatial to a temporal meaning. "Art desperately clings to the future, no longer seeking to adhere to the present but to get a jump on it in order to inscribe itself in the future.... Art is irrevocably linked to an evolutionary model" (Compagnon, 1994: 37). With this shift, "[t]he avant-garde, substituting the pathos of the future for acceptance of the present, doubtless activates one of the latent paradoxes of modernity: its claim to self-sufficiency and self-affirmation inexorably leads it to self-destruction and self-negation" (Compagnon, 1994: 32). The same paradox defines the logic of techno-evolutionism now dominating technological discourse in contemporary North American society.

Evolutionism and cybertopianism are readily perceived as part of postmodern culture because of their collapsing of boundaries between human/machine; human genders; global geographies; and past, future, and present experience. I see them rather as naive and yet powerful modernist anachronisms, not only because they remain stubbornly teleological and faithful to modernism's progressive ideals, but because of their vestigial commitment to the autonomy and power of the techno-evolutionary process. In the techno-evolutionist account, digital technologies propel our evolution into a postnational, postspatial, postembodied, perhaps posthuman community because of tactics and innovations generated

by these same information technologies, regardless of larger contexts involving power, money, security, or social life. The Net is represented as "a collective cyborg system of individuals and machines, ruled by strict evolutionary laws" (Terranova, 1996: 71). Commitment to this perspective situates techno-evolutionists as modernists who, like the earlier artistic avant-garde, project themselves into a future where the achievement of their objectives brings about their own obsolescence. Today, though, it is their species, rather than their art or "ism," that is imagined into obsolescence.

My purpose here is to explore the identification between biological, technological, and social evolution that dominates public discourse on technological achievement and technological change, and thus shapes our attitudes and practices in relation to the Web. Is this identification an historical hypothesis? A metaphor? A scientific claim? A performative gesture? The technology-biology-evolution connection has become so pervasive that its metaphorical nature has become quite invisible, and evolutionary accounts are repeatedly offered as objective, scientific representations of history, of technological change, and of the necessary trajectory of human nature itself. Many ostensibly critical discussions are shaped by this trope, so that participants in the discourse begin to perceive evolution solipsistically as both author and product, cause and effect of technological change. This raises interesting challenges from a methodological point of view. Within this tautology, the question of whether "evolution" is a metaphor, model, or scientific description cannot and need not be answered. The current interdisciplinary ascendancy of metaphorical thought reveals itself here as both cause and effect of the new digital media, with their celebrated capacity for what Marshall McLuhan prophetically called "a new tribal encyclopaedia of auditory incantation" (1996: 92).[2] Put two or three concepts from different knowledge paradigms next to each other, and it's magic! They become one.

Whether the connection between evolutionary biology and human artifact is understood as metaphor, model, or scientific truth, the powerful influence of this idea is attributable to a social climate that is both ambivalent about and preoccupied with time. Evolutionism gives shape to a disjointed temporal imagination oscillating between an uncomfortable present and a future that can legitimate and transcend this present. If our predecessors invested their evolutionary faith in the diverse realms

of economy and art, contemporary depictions of digital and network-based technologies promise to reconcile these realms, and our own psychic fragmentation, in a new world of sublime transcendence. By functioning simultaneously as scientific claim and invisible metaphor, the techno-evolutionary motif evokes a confidence in science that manages to evade much of the disquiet about technology and science now permeating North American culture. By avoiding the disparate realities of social life on this side of the screen, this narrative narrows the horizon for Progress but thereby keeps its hold on the future.

Techno-evolutionism relies on an assumed analogy between biological and technological evolution whose underlying premises we need to examine. On the surface, there are important regions of consensus between techno-evolutionism and critical cultural theory. The claims of increased reflexivity put forward by techno-evolutionists invite comparison with the notion of "cultural technologies" introduced by Foucauldian theorists to describe the orchestrated production of self-conscious social subjects under capitalist modernity. We find ourselves at an important intersection between two modes of analysis that in other respects display fundamental theoretical and political differences in their approach to human and technological history. My purpose is to orchestrate an encounter between the discursive tropes of technological evolution and cultural technologies, and to explore them critically in relation to one another. We need to analyze these technologies as distinct but related instruments of power that act in complex ways upon human bodies and subjects.

In the following pages I explore the discourse of techno-evolutionism circulating through contemporary culture. I survey several influential texts connecting biological and technological evolution, and question the evolutionary and social assumptions on which their theories are based. I suggest that differences in the evolutionary model produce differences in how the future of technologies like the Web are conceived. Such differences also carry implications for how the future of human life is conceived. My object is to consider how the techno-evolutionary discourse is itself a "cultural technology"; that is, in conjunction with the digital technologies of the Web itself, capable of producing tangible effects in how we think about, socially produce, technologically mediate, and viscerally experience our bodies.

FUTURE CONDITIONAL

Hyperbolic promises for the technological future have played an important role in bringing technologies into use throughout the twentieth century. Just a few years ago, to cite one account: "[t]he smashing of the atom would release cheap energy in abundance; the Pill would limit population growth; computers and automation would do all dirty, dangerous and heavy work in factories and on the land; television would bring education into every home; and telecommunications would link all people on the globe. And once people were freed from dull, stultifying, and dangerous work they would become enlightened and considerate of one another. A new and better age would dawn, hallmarked by humanism, solidarity, and well-being for everyone" (Laszlo, 1994: 8).

Experts predicted that the so-called Information Revolution would give rise to a leisure society; between 1973 and 1994, leisure time declined 37 percent (Castells, 1996: 367). They predicted that the emergence of the home-based electronic cottage would alleviate urban transportation problems; subsequent evidence points to the opposite effect (395–96). Many commentators have claimed that virtual communication would revolutionize gender roles, but the simulated persona roaming the Web replicate the most "stereotypically spectacular" gender stereotypes of the predigital age (Clark, 1995: 125; cf. Millar, 1998). Advocates of the "Wired City, Wired Nation" predict that computer-mediated communications (CMC) will enable citizens to cast off the hierarchical distortions of the mass media and develop a more genuine alternative democracy. How far this alternative can revive democratic politics or whether it can affect more than a small part of the world's population is much in dispute today. Cyberspace designers claim that new technologies will "make the body obsolete, destroy subjectivity, create new worlds and universes, change the economic and political future of humanity, and even lead to a posthuman order" (Escobar, 1996: 118). Whether we find this an inviting or even plausible prospect, there is no escaping the grandiose speculation in technological and social engineering that continues to inform such claims.

These pundits seem oblivious to the irony of their situation. The more rapidly scientific and technical knowledge is accumulated, the more fragile is popular faith in its ability to ensure social well-being. The social construction of technological systems and practices comes to embody

this apparently paradoxical situation, a point well illustrated by the Web. Anxiety about the indifferent powers of technology and/or its embed- dedness in corporate systems stimulates a desire for human connected- ness, which is in turn deliberately aroused by the design and promotion of technological services and commodities that can offer a sense of place and community in the new wired "spaces" of the Web. "Webness," assures Derrick de Kerckhove (1998), is "connectedness." Indeed most home-based nonwork Web use is dedicated to electronic mail—to main- taining personal networks through the new medium. How ironic, then, that personal depression increases in direct proportion to Web time! In a recent industry-sponsored study, Internet use made family members isolated and depressed, and actually decreased the size of their social networks (Kraut et al., 1998). "We were surprised to find that what is a social technology has such anti-social consequences," say the research- ers. People are communicating more, just as the McLuhanites claim, yet feeling less "in touch" than ever. These findings have had little impact on the Internet's mythic powers in media culture and educational policy, however. The actual effects of actual technologies in the world are kept secondary to the mythic power evoked on each one's behalf. Neither past nor present appears to blemish new predictions. Famine and homeless- ness, ecological destruction, urban chaos, spreading unemployment, unimaginable growth in corporate and biotechnological power, now increasingly visible in our own milieu, the university—all these magi- cally disappear from the utopias of millennial techno-evolutionism.

In order to maintain its evolutionary logic, techno-evolutionism must continuously separate itself from the echoes of its history. Because the cracks between social and technological progress are obscured, the *idea* of evolution remains a powerful and magical instrument. Drawing on the evolutionary paradigm permits commentators to privilege mythic meta- narrative over empirical analysis—and thus, the contagion of corporate discovery over public research and debate. This promotional magic obtains for us what Arthur Kroker terms a "Techno Topia," a promised cornucopia that makes no space for ethics, critique, or the actuality of experience (Kroker, 1996). The contrast between the anxious depiction of a globe in crisis, and the ubiquitous promise of technological trans- formation that will simultaneously subvert and redefine that world, grows ever more pronounced.

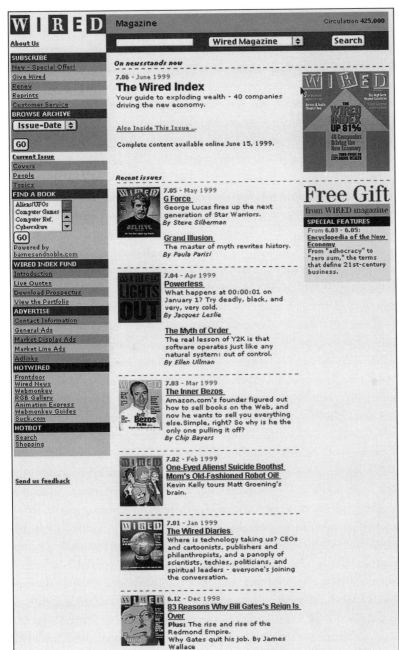

Fig. 12.1.
The technological narrative blooms in the fertile ground of amnesia, in our reluctance to remember the actualities of the past or the present. The *Wired* magazine website, http://www.wired.com.

The conflation of human and technological evolution works not only to envision electrifying futures but also to displace alternate strategies for imagining our futures. Techno-evolutionism displaces alternate imaginings by positing the technological imperative as coming from outside ourselves, outside of human culture, through a self-generating evolutionary progression rather than from the culpable logics of our own social system. The logic of autonomous technological change, so carefully disassembled by Langdon Winner (1977), now possesses a largely unchallenged authority in political discourse, commerce, science, and the far-flung narrative imaginings of culture and myth. As a result, technology, like previous known religions, enables people to live toward an imaginary future while disciplining the hopes and expectations of the present. "A mechanized world," McLuhan observed, "is always in the process of getting ready to live" (McLuhan, 1964: 254). George Grant echoes this thought in his observation that in modern science and philosophy, "the possible is exalted above what is." Paul Virilio adds that the "technologies of real time ... kill 'present' time by isolating it from its presence *here and now* for the sake of another commutative space that is no longer composed of our 'concrete presence' in the world, but of a 'discrete telepresence' whose enigma remains forever intact" (1993: 4). One could not ask for a better description of the experience of surfing the Web, which involves, as so many have commented, a growing obliviousness of time, one's body, and one's physical surroundings. Enthralled by the sense of "aheadedness," Sam Mallin adds, the pursuit of the future as the "pure image of the cognitive" unveils a present that "thrusts forward inhesitantly and with full faith and confidence, [but] has all about it the most astonishing wreckage and waste" (Mallin, 1996: 328) The technotopian discourse displays a deep ambivalence toward presence and embodiment that permits the most striking anomalies of perception. While technology is the agent that will inevitably bring about the transformations we long for in the future, it has, by contrast, nothing to do with the present, whose dissatisfactions are severed from last year's promises of utopic transformation. The technological narrative blooms in the fertile ground of amnesia, in our reluctance to remember the actualities of the past or the present.

Most commentators on the digital future fit this portrait all too well. They "forget" that the current collapse of economic and social security has been precipitated, at least in part, by the deployment of new tech-

nologies that were the direct predecessors of those very technologies that they propose will rescue us from our current difficulties. This is a convenient oversight, particularly for dealing with a populace that is becoming skeptical about progress, for this realization might provoke the idea that more than technological change is necessary for a truly transformed future, that different kinds of change might produce different kinds of evolution. It might provoke the realization that just as human evolution is not primarily genetic, so social evolution may not be primarily technological, that some evolution involves aspects of human behavior and commitment that have nothing to do with technology. Contemporary techno-evolutionism wants nothing to do with these ideas, and has gone some distance toward displacing them from our understanding of evolution. Just as images of the future have imperialized the present as we live it, so the discourse of technological evolutionism has imperialized the future as we imagine it. This discourse, like the technologies it promotes, forfeits collective memory for a phantasmagoric future.

Here the dream of human unfolding is simultaneously evoked and projected onto technology, whose space becomes the space of the future. It is not us who unfold, or rather, if we do unfold, it is forward into a specifically technological space that, ever evolving, draws us in to meet our more hopeful, more convivial, more evolved selves. What is evolving here though is really technique.[3] No one seems to ask whether the techno-evolutionary trajectory might play a role in the *de*volution of human freedom and capacities. Cheered on by the apparent consensus of mainstream and marginal voices, techno-evolutionism relies on the assumption that human culture, democracy, freedom, and intelligence must and will progress along with our technology. And surely this is the secret of the technological utopic: technology both signifies and guarantees that change can only go forward, never backward, and so human intentionality is magically confirmed as both causality and effect of a technologically evolved future that is in any case inevitable.

So mythic thinking has not relinquished its hold on the marketplace of contemporary thought. This is both an ontological and a political challenge. Supposedly we are on the brink of unprecedented and fundamental transformation. But who is changing what? Hasn't technology changed the nature of evolution itself? If so, does this change give us greater or less control over our futures?

TECHNOLOGY AND EVOLUTION

Whether working in business and finance, culture and entertainment, information technologies, or science and medicine, most journalists and many academics view technology and progress as interchangeable terms. If this conviction seems questionable in the wake of post-Enlightenment thought, its exponents justify their claim in the name of science. They rely on evolution to explain the progressive nature of technological change, and technological change in turn demonstrates the progressive nature of historical change. The evolutionary trope is not seen as metaphorical or even transdisciplinary. Because technological change has become so rapid and dramatic, it does not seem inappropriate to collapse thousands of years of geological and genetic change into a generation. The evolutionary rhetoric may depend on an explanatory structure of metaphor, model, analogue, or replication, but its use negotiates a wide range of paradigms and problematics, offering an apparently neutral and incontestable alibi for an otherwise questionable claim to progressive change.

"It seems hardly open to dispute," writes Joel Mokyr in his book on technology and economic progress, "that what has happened to people's ability to manipulate the laws of nature in the service of economic ends is unidirectional and deserves the word progress" (1990: 15).[4] Mokyr justifies his dismissal of countering evidence—which might lead us to question, among other things, whether the "laws of nature" are as passive and obedient as his account suggests—by means of the evolutionary paradigm. The dynamic of this unidirectional progress, he explains, needs to be understood in relation to evolution as "a specific dynamic model governed by mutation and selection." For Mokyr, the concept of natural selection is helpful for understanding technological progress because "techniques—in the narrow sense of the word, namely, the knowledge of how to produce a good or service in a specific way—are analogues to species and changes in them have an evolutionary character.... Some cultural, scientific, or technological ideas catch on because in some way they suit the needs of society [note that 'society' has, or is, a single interest—] in much the same way as some mutations are retained by natural selection for perpetuation. In its simplest form, the selection process works because the best adapted phenotypes are also the ones that multiply the fastest" (1990: 275–76).

In other words, technological innovation is perfectly analogous with the laws of nature, rendered here as competitive adaptation and the survival of the fittest, whose universal truth is thereby corroborated. Because natural law accounts for the process whereby some technological prototypes succeed on the marketplace while others do not, there is no need to seek other kinds of explanation.[5] Another influential historian of technology, James Beniger, situates this techno-evolutionary drive within the larger drive for control manifested across the various domains of biology and genetics, information and communication, intelligence and cybernetics. Technology takes on the function of order and control in societies that are too complex to be guided by primitive sociality or the reciprocal altruism of more evolved societies. Crucially, evolution is redefined here in relation to a cybernetic model. Because cybernetic systems are adaptable, or capable of "learning," the development of computer programs approximates our definition of evolution, and the two processes become interchangeable. Progress or mutation in information processing becomes a metonym for progress in intelligence, which in turn stands in for progress in human evolution. This series of replacements allows commentators to describe "evolutionary" changes in virtual creatures inhabiting simulated environments as though this process were interchangeable with organic evolution.

"All that is required for evolution to occur," Beniger explains, "are the static and dynamic aspects of its essential control function: replication of programming and its differential selection relative to other programs. It is the emergence of precisely this capability, in the earliest ancestors of DNA that marked the origin of life on earth, that is the beginning of evolution through natural selection" (1986: 118). Having established prehistoric identity between laws of nature and laws of history, Beniger can now account for the history of industrialization, the intensification of processing speed, and the ensuing crisis of control in industrial society. It's evolutionary.

Not surprisingly, the enthusiastic merger of natural, cybernetic, and economic histories finds wider application in the resurgence of social Darwinism in social and economic thought. Here technology is represented as the instrument of progress in response to which culture, economy, social space, and the human body must continuously reorganize themselves. Technology, or rather the imperative of technological change, takes the place of the natural environment to which humans adapt.

Specific technologies might be man-made but the underlying logic of technological change replicates the laws of nature. This means not only that we must learn to view human evolution as coextensive with technological evolution, but that technological evolution must be understood with reference to bioevolutionary principles of adaptation and the survival of the fittest (Mazlich, 1993: 80). The depiction of technology as self-evolving link between natural law and progressive change serves to communicate the idea that individual struggle, nomadic mobility, and rapid obsolescence are at one and the same time laws of the environment, and components of adaptation required to survive environmental change. Building on this foundation, social Darwinism simultaneously narrows the definition of evolution, and broadens its applicability: all aspects of human endeavor are improved by competitive struggle and adaptation to laws of change. If this results in unpleasant activities in the social realm, these are valorized by the notion that evolution is ultimately progressive. Mary Midgley terms this the "irresistible escalator" of Lamarckian evolutionary thought, which assumes that evolutionary change inevitably draws us upwards and onwards (1985: 30–35). As diverse commentators have observed, this assumption "has lent the organic process a highly moral coloring that Darwin himself was eager to avoid;" for Darwin, notes Andrew Ross, "nature had no teleology, apart from the better adaptation of species to their environment" (1994: 260–61). Indeed, Darwin resisted the term *evolution* precisely for that reason; he wished to portray natural selection not as a theory of progress, but merely as a description of local adaptation to changing environments. As Steven Jay Gould has argued, Darwin's own theory of natural selection proposes "no perfecting principles, no guarantee of general improvement; in short, no reason for general approbation in a political climate favoring innate progress in nature." Adaptive changes that enable animals to survive in local environments "do not mark intrinsic trends to higher states" (Gould, 1977: 45).

Yet the Victorian emphasis on progress has dominated the public understanding of evolution and forms the lasting bridge between its scientific and nonscientific meanings. In representing natural and social laws as parallel and interchangeable, both are endowed with immutable principles to which "we are asked to subordinate our actions and thoughts" (Ross, 1994: 261). If violence and suffering result from "progressive" technological change, this is because nature legislates that change be driven by adaptation and survival of the fittest. Nature is rep-

resented as a constellation of fixed laws from which principles of cooperation, community, altruism, and stability have been evicted (Keller, 1992). Given the dominance of this paradigm in media and corporate narratives, part of the critical task of redefining technological evolution is to restore these evicted principles of cooperation and solidarity to the interlocked domains of society and nature as these are understood and enacted in the public sphere.

For many, this is precisely the mission of the Web. In a countering evolutionary narrative, the World Wide Web enables us to transcend social hierarchy, personal isolation, and disempowerment produced by earlier technologies, drawing us into a more evolved, perhaps "posthuman" collectivity in which human alienation, social injustice, and the quandaries of embodiment have all been transcended and made obsolete. While evolutionism—or social Darwinist thought—dominates the mass media, the evolutionary discourse is equally privileged by critics and theorists writing about cybernetics, web communities, digital subcultures, and the technologically oriented fine arts. Like the "wired" communities of cybernetic subcultures, these groups deploy evolutionary motifs to evoke a more technologically advanced future dominated by smart machines (Terranova, 1996).

However current technocritics define technology—as a particular tool, an historical force, or the discursive work of a political or cultural formation—they share the tendency to situate technological development within the narrative of evolutionary law. Positing a link between technological and human evolution bridges the knowledge domains of genetic biology, the history of technology, and social and cultural history. Bioengineering plays a special role, here; founded on the remapping of the human body as digital information, it transforms and cements the relationship between human and technological developments, which now replicate one another in more explicit ways. The distinctions among social, biological, and genetic evolution appear to diminish, and technological change appears as "an inevitable evolutionary process mapped on the anatomy and physiology of the [human] body" (Woodward, 1994: 50). The evocation of the human body as subject/object both locates and naturalizes the evolutionary process. The rhetoric of these communities produces a powerful animation of the machine world, accompanied by "an extraordinary proliferation of images of, and narratives about, the obsolescent body" (Terranova, 1996: 73).

EVOLUTIONARY BODIES

If the body is obsolescent, it must be "left behind" by something better, an emergent species more adaptive within the more "evolved" environment. This more evolved species can move effortlessly through simulated three-dimensional space (virtual reality, the Web): it is a new form of posthuman intelligence inhabiting an alternative spatial universe whose spatialized utopian qualities are tautologically derived from this same scenario. Researchers and science fiction writers have explored the idea that protein-based life forms are moving toward obsolescence, to be replaced by silicon-based life forms that can be downloaded and reproduced via computer.[6] This narrative displaces the social and biological complexity of human life in favor of a reified form of human intelligence that is reducible to digitally replicable information. It focuses therefore on the evolution of technical forms (3-D information processing, digital environments, robotics), rather than on the interaction between technical and human agents. The human role is limited to the organization and extension of the "technical ensemble," in order to pass it on to the next generation.

In this scenario, as Langdon Winner observes, "The mortality of human beings matters little, for technology is itself the immortal and, therefore, the more significant part of the process. Specific varieties of technics can be compared to biological species that live on even though individual members of the species perish. Mankind serves a function similar to that of natural selection in Darwinian theory. Existing structures in nature and the technical ensemble are the equivalent of the gene pool of a biological species. Human beings act not so much as participants as a selective environment which combines and recombines these structures to produce new mutations, which are then adapted to a particular niche in that environment" (1977: 58). In other words, individual humans do not create or shape the evolutionary process; they merely enable and respond to it. It is technologies, not people, that evolve into new species or taxonomies. By developing its technologies and tools, the human body learns to multiply its strength (so the story goes—they mean, of course, the strength of human instruments and prostheses). These prosthetic technologies serve to extend human capacities in space and time, an advance that, as the influential archaeologist and historian V. Gordon Childe argued, is quantifiable and constitutes "tangible proof of human

progress."[7] What characterizes technology as progressive is its ability to accomplish new tasks, to aid in the growth of human populations, and to extend human capabilities in time and space. These changes are not unidirectional, of course; each of them produces a plethora of paradoxical effects. We are concerned here with the last of these accomplishments, the extension of the human body across the "electronic frontier" of time and space.

The more that technology comes to function as a prosthesis of the human body, as many critics have observed, the more the body itself becomes immaterial. One presumes they use this term metaphorically, to mean extraneous, afunctional, devalued; note that the idea of the immaterial is itself dematerialized. "Communication media of the future will accentuate the extensions of our nervous systems," McLuhan explained, "which can be disembodied and made totally collective." This prediction (which reminds us of McLuhan's status as "patron saint" of *Wired* magazine) anticipates customary descriptions of the Web as a new form of disembodied collectivity, and virtual space as a new posthuman environment. McLuhan's comment also anticipates the conception (if this is the right word) of artificial life, whose researcher-advocates rely on "the feasible separation of the 'informational' from its material substrate" (Penny, 1996: 61).

There is a seductive paradox in this narrative, as Kathleen Woodward has pointed out, for the collaboration between technical development and human evolution coexists with a progressive vanishing of the human body, which gradually disappears into the "hypervisualisations" of cyberspace. "Over hundreds of thousands of years," Woodward summarizes, the body, "with the aid of various tools and technologies, has multiplied its strength and increased its capacities to extend itself in space and over time. According to this logic, the process culminates in the very immateriality of the body itself. In this view technology serves fundamentally as a prosthesis of the human body, one that ultimately displaces the material body, transmitting instead its image around the globe and preserving that image over time" (Woodward, 1994: 50).

Because this logic permeates discourse on and about the Web, it is important to examine it closely. Of course bodies are not literally displaced, however much their nervous systems are modified or extended; it is the "information" transmitted through the act of communication that is dematerialized, not the human body. But the disconnection between

the two is apprehended in terms of a hypermobile functionalism that reverses them: through new technologies of communication, information is animated with life and movement, and the human body is left behind, conceptually displaced into air by the more significant movement of information. "In this electric age," writes McLuhan in *Understanding Media*, "We see ourselves being translated more and more into the form of information, moving toward the technological extension of consciousness. That is what is meant when we say that we daily know more and more about man [sic]. We mean that we can translate more and more of ourselves into other forms of expression that exceed ourselves" (McLuhan, 1964: 64). In this account, the collectivization of consciousness and intelligence (de Kerkhove's "Webness") occurs in direct proportion to—and can only be realized by—the disembodiment of subjectivity.

This particular equation of communication and disembodiment stems from a century-old description of the impact of electronic media's ability to commune instantaneously with others without physical proximity to them. The body evoked in techno-evolutionist writing is defined by the same discourse. The physical body remaining behind, in front of the telephone or computer, is erased, not simply (or rather apparently) by the technology but more insidiously by the written account of it, which continuously affirms the idea that the body has been supplanted by (not only in) the act of communication itself. The common rhetoric of bodily displacement associated with the Web thus makes a double move that displaces its own rhetorical effects.

Of course, this reification is not merely rhetorical. Cyberspace is designed precisely to create the sensation of leaving one environment and entering another, three-dimensional, virtual space. I'm going to put that issue aside for now, however, and take the argument on its own terms. If communication displaces the person, if simulation nullifies the original, what actually happens to the body? This question points us toward but beyond the subject of postmodern simulation. Is the absent body merely a function of representation? When we nullify the body, do we not make ourselves obsolete as a species? What are the origins of this metaphysical assassination, this revenge against the "meat" (in William Gibson's oft-quoted phrase) of organic life? Why does this theme so dominate our fantasies? Are we imagining a more evolved human nature, or are we willing ourselves, like the chatty homicidal virologist in Terry Gilliam's *12 Monkeys*, into obsolescence?

If it is the latter (the film suggests), evolution can be measured and/or stopped by self-critical recognition of our own ethical maladies. Gilliam's virologist wants to condemn the human species to death because of the damage we inflict upon the universe, which therefore in one form or another—if necessary, through him—must rise to defend itself. His desire is consciously paradoxical, since it is the new scientific power of humans to destroy their own species that makes their destruction ethically imaginable. He imagines a cosmic universe in action, and places himself—aided by manufactured viruses and airplanes—as its representative. Here the will to obsolescence declares its altruistic motivations; the human species must disappear not because we are godlike in our creative capacities but because we have believed ourselves to be so. Robert Romanyshyn evokes this idea when he writes, in *Technology as Symptom and Dream*: "One can still imagine technology as *vocation*, as the earth's call to become its agent and instrument of awakening. But in the shadows, the imagination falters and technology seems less the earth's way of coming to know itself and more the earth's way of coming to cleanse itself of us" (1989: 3). [8]

This dystopian narrative commonly shows evolution leading to the supplanting of human cultures by other, more "advanced" moral and technological systems. In this way our only-human irrationality is simultaneously justified and defeated by the accomplishments of our science. In one popular motif in contemporary science fiction (*Terminator 2, Millennium*, Gene Roddenbery's *Earth: The Final Conflict, 12 Monkeys*, and so on), technologically enhanced futures create cyborgian angels who can travel backward in time to rescue us from catastrophe, thereby simultaneously exposing and redeeming our collective Frankensteinian pathologies. Echoing Darwin's own understanding of evolution, this trajectory displaces human society from the center of the cosmos. But Hollywood rescues us just as earth takes its revenge against our hubris through apocalyptic natural and other catastrophes.

EVOLUTIONARY TECHNOLOGIES

The literature of evolutionary biology records a series of challenges to those post-Darwinian versions of evolution that define adaptation purely in terms of self-interest, and self-interest purely in terms of competition and struggle. Yet, as Evelyn Fox Keller observes in her study of this literature (1992), theorists who seek to elaborate general theories proceed

as if these challenges were without foundation or had never occurred. If the scientific community has tended to foreclose this discussion, how much more easily these tensions disappear by the time evolutionary theory has wandered into and lost itself in the nonscientific world, where it keeps enough scientific credibility to maintain the mythic imperative of technological progress. This myth creates a mimetic equivalence between biological and technological evolution that serves to justify and to shape technological innovation within a regressive economic and political climate. The evolutionist ideology also produces definite effects in the production of technologies themselves, which work to shape our perceptions of social, cultural, and physiological possibility. These technologies may not change us at a genetic level, unless they are genetic technologies; but they do shape and direct the fabric of the social, and thus the values and conditions of possibility for our lives as embodied social beings. Such changes are part of human evolution; social and economic relations, ethics and justice, aesthetics and symbolic culture, and evolutionary narratives themselves are thus all part of the evolutionary process.

For McLuhan, changes in the media of communication—the "extensions of man"—produce neurological and sensory changes that significantly affect our perceptions and actions. "Every new technology," he claims, "gradually creates a totally new human environment. Environments are not passive wrappings but active processes" (1964: viii). Like Michel Foucault, McLuhan emphasizes the constructivist and disciplinary characteristics of modern culture; both theorists demonstrate the extent to which modern culture has focused on the self-conscious formation of the individual subject. Drawing on the work of Walter Ong, McLuhan traces this emphasis to the birth of print and its facilitating of a separation of inner and outer space, as well as speech from text. For McLuhan (who arguably manifests his technological determinism most strongly on this very point), print thereby produces the hyperrationalized, alienated, and aggressive ego of modern civilization. Paul Virilio develops this insight while freeing it of its reductionist excesses, noting, "Individuality or individualism was thus not so much the fact of a liberation of social practice as the product of the evolution of techniques of the development of public or private space" (1993: 5). For Virilio, the hyperindividualism that protoscientific culture ascribes to the genetic code of human nature is a historical and socio-spatial product, a lived consequence of the cultural technologies of modern power.

The same understanding can be brought to bear on the rhetoric of disembodiment now surrounding cyberspace and the Web. Most critics trace this theme to the cyberpunk fiction of William Gibson, whose 1984 *Neuromancer* popularized the image of the body as 'meat' to be shed as quickly as consciousness can be uploaded onto a computer. Obviously the opposition between body and intellect has far older roots; but the idea of a machine as a three-dimensional environment to be explored and lost in is more usefully traced to 1968, when Douglas Engelbart's invention of the mouse transformed the computer screen into a new three-dimensional "informationscape." That innovation, argues Steven Johnson, changed not only how we use machines but how we imagine them: "The bitmapped datasphere he unleashed on the world in 1968 was the first major break from the machine-as-prosthesis worldview. For the first time, a machine was imagined not as an attachment to our bodies, but as an environment, a space to be explored" (1997: 23–24).

Note that this is precisely the argument McLuhan was making about the media environment. Engelbart's move to "endow that data with spatial attributes" (Johnson, 1997: 20) occurred within the context of a popular and scientific culture in which a spatialized, technologically enhanced intelligence was both comprehensible and desirable. The term "interface" arose at the same time, when a flight simulator developer merged the real-time imaging capabilities of the digital computer with mechanical flight simulators to help train military pilots. By the 1970s, techniques for rendering objects and spaces with an apparent three-dimensionality were being perfected, "laying the foundations for lifelike computer animation, and for the illusion of immersion in the image field" (Clark, 1995: 119). This virtual space creates the sense of "an open world where your mind is the only limitation" (Adam, 1998: 171); as Alison Adam cogently argues, the disavowal of limits accompanying the representation of the virtual community eliminates ethics from the virtual field. Gradually the interface between self and virtual "space" has become transparent, enabling users to deny the socially mediated nature of digital technology (Wise, 1998). Like the notion of evolution with which this illusory "space" has been so closely linked, the idea of an alternative, three-dimensional, purely informational "environment" open to exploration by an appropriately disembodied intelligence has subsequently been thoroughly naturalized.

As a discourse working across the domains of science, technology,

commerce, journalism, and culture, techno-evolutionism functions as a cultural technology that privileges individuation, mobility and the continuous conquering/abolition of space, and disembodiment. The Web is an ideal manifestation of these principles. In that sense it is a logical extension of what Raymond Williams termed "mobile privatization," enabling human beings to inhabit an increasingly everywhere/nowhere space of hypertechnological mediation. But techno-evolutionism also offers a countering narrative, in which the Net enables us to transcend the hierarchy, isolation, and disempowerment produced by earlier technologies, and to evolve toward a new postcapitalist, postnationalist, truly interactive collectivity. The history and practice of this idea has also contributed to the evolution of the Web, first through the influence of communitarian values among designers in the 1960s and subsequently through the influential ideals and practices of first-wave Web practitioners. Murray Turoff wrote, in 1976, "I think the ultimate possibility of computerized conferencing is to provide a way for human groups to exercise a 'collective intelligence' capability. The computer as a device to allow a human group to exhibit collective intelligence is a rather new concept. In principle, a group, if successful, would exhibit an intelligence higher than any member. Over the next decades, attempts to design computerized conferencing structures that allow a group to treat a particular complex problem with a single collective brain may well promise more benefit for mankind than all the artificial intelligence work to date" (Rheingold, 1993: 113).

But what "complex problems" were addressed? Early users were primarily affluent, employed, unmarried men (Castells, 1996: 359–60), who commonly subjected themselves to punishing programming schedules and "deaestheticized" the body by ignoring its needs and appearance (Clark, 1995: 118). If our coevolution with CMC technologies is producing greater "collective intelligence," its designers commonly dissociate intelligence from the organic and social situatedness of human life, preferring its machinically adaptive "higher"—that is, disembodied—form. As Katherine Hayles writes, "The body's dematerialization depends in complex and highly specific ways on the *embodied* circumstances that an ideology of dematerialization would obscure" (1999: 193).

The emphasis on the Web as a constellation of "virtual communities" also obscures its importance as a site of control technologies. As Dale Bradley emphasizes, "Cyberspace is more usefully understood as an

active strategy through which various forms of control are enacted ... than a static space 'in' which individuals and information are somehow digitally (re)produced.... The importance of the presumed 'split' between the physical and the virtual (whether in terms of space or the body) cannot be overstated because it is only by positing a profound separation between the physical world of society and the virtual world of cyberspace that the utopian claims made with regard to cyberspace can be deployed. If there is no separation, then cyberspace's utopian possibilities dissolve as one is forced to consider its historical production *within* and *by*, rather than *beside* or *beyond*, social power relations" (1998: 33, 101).

EVOLUTIONARY TRAJECTORIES

The discourse of evolutionism functions as an alibi for social Darwinism in the public sphere, and for corporate expansion and innovation unimpeded by collective democratic participation. The rendering of technological change as a law of nature works to defend economic and technological relations from social debate and critique, and thus from the production of communal rather than competitive spaces. The widespread representation of technological innovation as following systemic, autonomous, progressive laws—ostensibly synonymous with evolutionary principles—provides a context and alibi for the anxious desire to "make something of oneself" so central to modern Western culture. At the same time it tempers the seductive anxiety of self-formation with the cool neutralities of technological imperative and scientific law. Thus it reiterates the managerial imperative of constant technological updating.

The techno-evolutionist discourse has a utopian side, which continues to play an important role in technological innovation and diffusion. As Michelle Kendrick has observed:

> It is ... no surprise to read so many manifestos of "cyberliberation" by those involved in promoting the sale and dissemination of computer technologies. Cyberspace fictions regularly channel anxieties regarding technology into romanticized notions of a reconfigured subjectivity that represents the triumph of the algorithmic mind over a physical body that refuses to be fully computed. Shifting the focus from the constructed nature of subjectivity to the "need" for technological enhancement, such fictions create a desire to be connected, a desire not to be left behind on the information superhighway. To escape the

anxieties of being violated by an "inhuman" technology, therefore, becomes (paradoxically) a process of producing the desire to desire more technological intervention in order to become more fully human." (1996: 145–46)

This process creates a growing market demand for technologies that satisfy these social and subjective desires. Rheingold notes, "When people who have become fascinated by BBSs or networks start spreading the idea that such networks are inherently democratic ... they run the danger of becoming unwitting agents of commodification.... [T]he hopes of technophiles have often been used to sell technology for commercial gain" (Rheingold, 1993: 286).

These hopes are not only part of market strategy; in complex and even paradoxical ways, they become incorporated in the design of the technologies themselves. Discourse and technology join in the practice of virtual space. Like heaven, cyburbia's inverted spatiality encourages us to believe that a postembodied life will enable us to dispense with gender troubles, distance and loneliness, illness, disability, even death, and all other barriers to total freedom and communication. A deeply rooted cultural symptomology thus gives form, through complex technological mediation, to the horizon and limit of conceivable futures.

This posited alternative "space" re-creates the perception that the only thing standing between us and the constantly receding phantasmagoric future of technotopia is our bodies. This edginess toward the human body contains an important if unacknowledged truth. The human body is not reducible to pure information. It is therefore threatened by irreversible damage from petrochemical industries, plutonium, pesticides, chemical additives, nuclear testing, global warming, the hole in the ozone, and the escalating toxicities of speed. Our imperfect abilities to withstand these stresses do threaten to impede the highway to progress. We are not ready to transport ourselves to Jupiter or Mars—Hollywood notwithstanding—and cyberspace seems the next best place to hide. Our immune and reproductive systems are the roadkill of the information highway. Without bodies, there are no obstacles to the evolution of Technotopia. With bodies, we confront divergent evolutionary paths: digital rapture and metal body parts for the privileged few, or extinction, or a more habitable planet.

If we want other kinds of futures (some say, any future at all), we need

better ways to imagine and connect with the physical world. The emergence of collective intelligence should be available and useful for all, not just those in search of the technological sublime. We need to learn to reconcile the dream of renewed community with the everyday life of our own bodies, however perplexing their relationships with the technologies that shape and extend us may be. Only by doing so can we intervene usefully in the process of technological change, and hope to reconcile its imperatives with the dreams of renewed connection and fraternity that have for so long kept these imperatives alive and well in the cultural imaginary.

NOTES

I would like to thank Bernie Lightman, Joan Steigerwald, David McKie, Bruce Willems-Braun and the editors of this volume for critical comments that helped me to sort out the arguments in this chapter.

1. On utopias or lack thereof in contemporary culture, see Levitas (1993) and Jameson (1996).
2. The problem of metaphor in interdisciplinary thought is addressed in J. Berland and Sarah Kember (1996). Exchanges among cybernetics, literature, biology, information theory, communications, and evolutionary history are creating a "discursive melee," we argue, in which "biology is now programmed, evolution is cybernetic, communication is evolutionary, and the economy, unlike the human body, partakes of the laws of nature. Knowledge in general seems to be growing simultaneously more technocratic and more metaphorical. Its ability to slip sideways across once impervious epistemological boundaries exceeds all the expectations of a generation of critical intellectuals who once critiqued disciplinary knowledge as a privileged mode of social control" (Berland and Kember, 1996: v).
3. "This is the flip side of the technical realization of human intent," notes David Rothenberg (1993:110). "[I]ntentions are themselves renovated through the success of techniques. The entire array of desires is transformed as we are seduced into analogy by the things we have built and constructed." I understand *technique* more or less as Jacques Ellul (1964: 5) defines it: "Technique ... constructs the kind of world the machine needs and introduces order where the incoherent banging of machinery heaped up ruins. It clarifies, arranges and rationalizes; it does in the domain of the abstract what the machine did in the domain of labor." Similarly, Marx writes: "The appropriation of these powers is itself nothing more than the development of the individual capacities corresponding to the material instruments of production. The appropri-

ation of a totality of instruments of production, is for this very reason, the development of a totality of capacities in the individuals themselves" (cited in Winner, 1977: 37).

4. "Of course," Mokyr adds, "if technological change eventually leads to the physical destruction of our planet, survivors may no longer wish to use the word progress in their descriptions of technological history. Until then, however, I feel justified in using the term, not in the teleological sense of leading to a clearly defined goal, but in the more limited sense of direction" (1990: 15).

5. An alternative historical approach to the relationship between scientific research, technological invention, and the marketplace can be found in Brian Winston (1986).

6. For critical explorations of this theme see Romanyshyn (1989), Hayles (1999), N. Clark (1995), V. Sobchack (1995), and Terranova (1996). The theme of a cybernetic intelligence downloaded from intelligent humans, creating a being with unique abilities to save the planet, is explored in many recent science fiction novels, including David Brin's *Earth* and John Barnes's *Mother of Storms*.

7. For Childe, research on prehistoric archaeology demonstrates beyond doubt "the continuous improvement made by humanity since its initial appearance on earth, [and] suggest[s] that what the historian called *progress* was known to the zoologist as *evolution*" (quoted in G. Basalla 1988: 213).

8. This reiterates the concept of Gaia; for James Lovelock (1988), Gaia is "stern and tough, always keeping the world warm and comfortable for those who obey the rules, but ruthless in the destruction of those who transgress. Her unconscious goal is a planet fit for life. If humans stand in the way of this, we shall be eliminated with as little pity as would be shown by the micro-brain of an intercontinental nuclear missile to its target" (1988: 212).

> **FROM:** STUART MOULTHROP
>
> **SUBJECT:** **Error 404**
> Doubting the Web
>
>
>
>
>
>
> ### 1: NOT FOUND
>
> If I say, "the Web"—casual shorthand for "the World
> Wide Web," itself a dubiously loose way of talking about
> certain things possible within Hypertext Transport
> (HTTP) and Internet Protocol (IP)—you will probably
> form some immediate set of impressions. These may
> involve vast, trackless information spaces (the abstract or
> topological Web), or more likely, particular features in this
> indeterminate expanse ("pages," "sites," "channels,"
> "portals"). Clearly the first alternative will not suffice. To
> speak of the World Wide Web as pure abstraction confers
> no more understanding than thinking about "the tele-
> phone" or "radio" or even "network television" in such
> imprecise terms. The many objects and interests caught
> up in the *technologique* of WWW/HTTP/IP can hardly be
> glossed so simply. They constitute something that is more
> event than object, more subjectivity than subject, more a
> network of bewildering particulars than a system of gen-
> eralized content.
>
> Yet the alternative strategy—veering into the particu-
> lar, as Joan Didion might say—seems no more useful.
> What instance of Web production can serve as metaphor,
> or even metonymy? Microsoft's vision of the Web fused
> into the Windows desktop might seem a logical candidate
> based on its audacity, if not its actual universality. To sym-
> bolize the Web in this way would identify the phenomenon
> mainly as a tool of productivity, the nonstick surface or
> myelin sheath for Bill Gates's "friction-free economy." But

even as its capital base expands to surreal proportions, the information economy has yet to demonstrate solid and reliable gains in efficiency or production (see Landauer, 1996). There is in fact good reason to suspect that digital networks promote substantially different models of commerce and even of value (see Kelly, 1998). Where else can we go today?

Perhaps to the city of Melbourne, where I used to see regularly a tram poster that said, in large letters, STOP PLAYING WITH YOURSELF. Aimed at a certain kind of eternally adolescent male, the banner touted an Internet provider who offered access to multiplayer, online games like *Doom* and *Ultima II*. The pitch seems revealing in both its obvious senses. The Internet and Web are often condemned as a great market of pornography (a function they inherited from earlier media like pulp printing and 8-millimeter film), and even when not about playing with oneself, the Web often panders to activities not permitted on company time. Maybe the Web and related technologies have less to do with business than pleasure—or with entertainment, that always-profitable combination of the two.

On the other hand, surely the World Wide Web has more to offer than fleshpots and gunsights. Reading the Web as an entertainment medium obscures its role as forum and font of potentially important information. Consider on the one hand the millions of "home pages" featuring everything from vacation snaps to political philosophy, and on the other, the infamous Drudge Report, the website whose scandal-mongering touched off one of the most significant political controversies in recent U.S. history. Each type of publication represents a watershed or possible turning point in the latter-day evolution of mass media, and in both one might see a turn away from centralized authority and rigid control of media markets. Consequences of these developments may be good (an end to passive consumerism) as well as evil (misrule by fanatical elites); but in either case, some applications of the Web clearly go beyond mere amusement.

In fact, the Web's implications may be very large indeed. If it lives up to its currently dubious "World Wide" status, we might expect the Web at least to complicate the effects of cultural imperialism and nation-state identity in the New World Order. Thought experiment: choose ten webpages that represent what you consider the most important developments in this medium at the moment. How many of those pages use a language other than English? What is to be said about websites that English-only speakers cannot read, or can only barely comprehend? Or to take the

inquiry beyond language to cultural practice, what about Web publications that do not carry corporate advertising, or are not indexed by search engines and linked from "portal" sites?

To ask these questions is to raise issues of accessibility and access, which are always crucial in cases of technological innovation. Access can be mediated by language and culture, but material factors also come into play. To whom is the Web visible, after all? Or to turn this question the other way, even for those who have ready access to the Internet, how much of the Web is visible from moment to moment? What about the pages that are very hard to find—or impossible to find at all? Perhaps this, after all, is the most representative aspect of anyone's Web experience:

> Error 404:
> The object you requested
> could not be found on this server.

In fact, I have begun to think this error message may be the most profound thing one can say about the World Wide Web—the best representative for all its shifting multiplicity. This notion leads to a serious question: What if the Web as we think we know it does not really exist?

2: DETOUR

Though wise to the dangers of Cartesian thinking, I have to ask indulgence at this point for something that might look like an attempted cogito. I can cheerfully enough deny existence of "the Web" in general, but I have a harder time calling into question one of the Web's fundamental features: hypertextuality. This is partly because I have spent more than fifteen years thinking about and tinkering with that concept. While I would not go so far as to say "I link, *donc je suis*," I do come back to hypertext as something not altogether dubious. What follows is a short and somewhat personal digression meant to explain how it is possible to maintain an interest in the Web even as one doubts or even denies its proper existence.

Two major influences helped solidify my emerging interest in hypertext long before anyone had heard of the Web. The first was Michael

Joyce's work of experimental fiction *afternoon*, which convinced me both that hypertexts can be deeply frustrating and that this frustration, properly understood, yields a fresh approach to reading (see Moulthrop, 1989). Working through *afternoon*, I realized that the text was like the proverbial iceberg, or as I described it at the time, a miniature railroad controlled by some remote automaton. Both metaphors are meant to emphasize the importance of the unseen to any understanding of the text that is encountered. In the case of hypertext, what you see is only a small part of what you conceptually get. The text is not all *there* in a literal sense, and yet what is not visible or present matters very much.

The second early influence on my thinking came from a series of essays by Terry Harpold in which he argued on poststructuralist grounds that hypertext is a fundamentally perverse practice, a space of illusions and "detours" (1991a, 1991b). Like many people beginning to think about hypertext in those days, Harpold had read George Landow's eminently practical rhetoric of "arrivals and departures" (1987), then headed in a different direction, as Landow himself would soon do. Instead of considering a link as a necessary joining of preordained parts, Harpold insisted that no link ever runs true. Even when operating as intended, every link is phenomenologically a "detour," taking us someplace we did not anticipate. Building on Harpold's insight, Nancy Kaplan and I argued that links traverse a space of possibility that must be considered as much a part of the text as the visible expression itself (Kaplan and Moulthrop, 1994). Hypertext is always both seen and unseen, real and hypothetical.

When we came to the Web, or it came upon us, this notion of detours across semantic space gained new significance. Considering the things we began to see on the Web, it seemed that the space traversed by the link had material, social, and even economic implications that meant something important to a growing number of people, and not necessarily just the venture capitalists. It was at this point, around the end of 1994, that I began to see the importance of "not finding," or the deeper significance of Error 404. It was also then, mediated by my emerging understanding of hypertextual detours, that I started to wonder what we meant by "the World Wide Web"; but this was only the beginning of uncertainty.

3: ASK NOT WHAT THE WEB MEANS TO YOU

I doubt anyone knows what he means by "the Web"—but this unanswered question leads inevitably to others. To fully understand our situation we

must turn the question the other way: What do we mean *to* the Web? It is important to recognize that as a community of scholars we—especially those of us trained from the 1960s through the 1980s—belong to a communications regime that differs fundamentally from what may be emerging on the Internet. We were brought up on print and mass culture; and while I admit that these are broad generalizations whose meaning is even less precise than the phrase the Web, it still seems true that for most people the discursive universe falls into two broad categories. At the center of this domain we find the stable and generally monologic productions of the "serious" intellectual disciplines (science, the law, and their aspiring ephebe, academic humanism). On the fringes of our attention, though perhaps far more present than we care to admit, come the ephemeral and rigidly traditional products of the entertainment industry, those overnight sensations that Pat Cadigan so usefully labels "porn":

> Valjean had a screen for every porn channel, jammed together in the wall so that food porn overlapped med porn overlapped war porn overlapped sex porn overlapped news porn overlapped disaster porn overlapped tech-fantasy porn overlapped porn she had no idea how to identify. Maybe nobody did, maybe it just bypassed the stage where it would have been anything other than porn. Meta-porn, porn porn?
>
> *I don't know what it is, but it makes me horny, and that's all that matters.* (1991: 140; emphasis in the original)

Porn: to paraphrase the recent talk in Washington, it's not about sex, or not just about sex anymore. Something important has happened in the outer reaches of the sign system, a curious alignment of the spheres into more numerous and tightly defined microcultural orbits. The contents of the media wasteland seem less like fragments shored against our ruins than like self-organizing structures. It may be that this perturbation of the system will send comets tumbling into the academic inner orbits, strange lights that cross our skies with portents of change. Maybe this time it really is the end of the world as we have known it.

Given such a cataclysmic outlook, perhaps a print-based academic can say nothing useful about the Web. Maybe we should consign its strange productions to the cultural Oort cloud along with pop songs, TV

shows, comic books, professional sports, and other excremental spectacles. Maybe the smartest strategy is to step from skepticism to denial. Word: *What* Web? Is there anything out there that really matters? What if the whole thing is just more Rupert Murdoch and Ted Turner, pure Silicon Alley and Hollywood hype? "Hypertext," after all, begins with that same nasty four-letter word. Nor are other formulations more convincing. William Gibson's original gloss on *cyberspace* may be tiresomely familiar but it remains accurate. He called the technology a "consensual hallucination"—illusion, mirage, mass-mediated phantasm (1984: 51). This definition is worth remembering. Any denial can be carried too far, and I would be the last to defend a purely reactionary retreat to print; but at the same time I think we must approach the Web with an attitude of disbelief.

This is not to say, however, that all varieties of disbelief are equal. Some must clearly be excluded as trivial or tautological, such as the assertion that the Web, as precursor to the grand vision of cyberspace, somehow falls outside our temporal jurisdiction, vested in a future evermore about to be. The head of a prominent university press once told me, with evident bitterness, that the prospect of electronic publishing made her glad she would soon be retiring. While it is nice not to have to worry about the future, this sort of skepticism is no longer defensible with respect to the Internet. "Cyberspace" may still be science fiction, but the World Wide Web is not—and anyway, as Bruce Sterling has famously said, we live in a science-fictional world (1988: xi). It is increasingly hard to separate fiction from reality these days. Cyberspace may be hallucinatory (or hallucinogenic), but "consensual" it certainly is not, especially if we understand that word not in Gibson's unusual sense of sensory input but with its more familiar sense of community or polity. Taken this way, the unreal image of the Web seems a shadow or projection of very real social and economic concerns. Things may matter even though—or as—they do not exist.

So the Web does not exist; but it fails or refuses to exist in a particular way of which we must take note. If we must give up the pleasure of historical nihilism, we should probably also forego any easy antiessentialism or reflex affirmation that *the* Web, monologic singular, cannot exist because webspace is of course a multicosm, a heterogeneous network of complex and dynamic regimes. The truth of this statement equals its banality. Heterogeneity matters, as we said in beginning, but that is a

given. What things in life are not complex and dynamic? These are fundamental qualities of most, if not all social activity, at least insofar as that activity is reflected in discourse. True, the infamous 404 error often indicates mutability and instability, and the Web is indeed a strange and shifty set of appearances; but these qualities must be the beginning, not the end of doubt.

We should know, or at least suspect, that reflex antiessentialism can lead to more serious abuse. Dr. Johnson knew what he was doing when he attacked Berkeley's idealism by kicking the nearest rock. The gesture had an Archimedean meaning. To kick the essence out of something demands leverage. One must plant the other foot securely somewhere. Where do I stand when I point my toe at the Web? What can we say about postprint technologies from the standpoint of the classically industrial, mass-communication regime? From what venue do we issue our announcements that the Web is hallucinatory, chimerical, not quite there? Look in the library, the bookstore, or these days out along the Interstate, in those remainder shops that populate the outlet malls. The Web may leave us in uncertainty, but we know where we are with print.

4: MONSTER

Enter the devil's advocate, or superskeptic. Perhaps we can know where we are in relation to the Web as well—and perhaps, as I suggested earlier, that position will not seem tenable. What if the Web is not just hallucination, but pernicious delusion? Let us assume not simply that the Web does not exist, but that surely nothing like it ever *could* exist. Consider the World Wide Web as (in every sense of the term) a monster. No one will be admitted to the theater during the terrifying death-of-reading scene.

You may have heard that the Web is inherently hypertextual (Haraway, 1997: 125), even though many chief exponents of that more general technology, from Ted Nelson to Michael Joyce, deeply resist the claim. Authorities may differ about their nature and function, but hypertext links do provide a foundation for Web discourse. Links bring with them an important element of intertextual relatedness, and even a kind of hypertextuality, so it seems safe to assert that hypertext and the Web have something important in common.

But here is a problem. To anyone brought up in an ideology of textual mastery—which is, after all, what many of us were taught in graduate

school—hypertext is apt to inspire horror. Not only does this sort of writing expand the scope of the textual universe by allowing links from one body of signs to others, it also invites users to complicate and exfoliate their textual productions. There is more and more text all the time and more discursive volume within the component texts. The burden on critics and editors, to say nothing of ordinary readers, expands exponentially. As a literary or literate practice—viewed from the comfortable parameters of the print regime—hypertext does not seem to fit into our world of discourse. On practical if not intellectual grounds, then, we might wonder how there could ever be a World Wide Web, at least in the sense of an enterprise we mean to take seriously. The devil's advocate rests.

However, this cannot be the end of our skepticism. Michel Foucault defined the *author function,* our practice of delimiting bodies of literary work under proper names, as the "thrifty" principle that prevents signification from proliferating out of control (1979: 158–59). The economic metaphor was well chosen, for there seems to be a deep connection between textual and material economies. This is quite evident today. Now that we have undone the limits on text, the old rules of business practice seem also to have disappeared. We have entered a period of explosion, if not inflation, in finance as well as texts. A recent article in the corporate journal *InfoWorld* observes that the seven most prominent "all-Internet" businesses, companies like Netscape, Excite, Infoseek, and Amazon.com, have registered roughly a billion dollars in losses after two to three years in operation (Reed, 1998). Most are still losing money and have no clear plan to generate profits except by dominating some inestimable market. Yet at the time of this report these unprofitable companies had capitalizations ranging from $1 billion to $17 billion, figures equal to or greater than those of old-line concerns like American Airlines and Sears-Roebuck.

While the vast, silent majority of info-business startups have already failed, and though massive retrenchment may always be just around the corner, there has been as yet no sustained retreat from Internet or Web commerce. The boom continues to defy logic. The gamble on information technologies continues to prove irresistible—witness the notorious case of Microsoft, which may have been undone, in a judicial if not an economic sense, by its desire to rule the Internet. And yet the economics of the Web, even in a fundamentally sound business like Amazon.com

(of which we will discuss more later), seem to make little sense. Amazon.com may be profitable, but it seems unlikely to succeed at the titanic levels expected. Surely the Web cannot sustain itself as a business proposition, if by such we imply anything beyond pure symbolism.

Having turned to the economics of the sign, however, we may find that our skepticism expands in unsettling directions. Perhaps it is neither the Internet nor the Web that is untenable, but the entire social order from which these technological boondoggles arise. For the same bizarrely self-contradictory pattern that seems to obtain in textual production and Internet business plans—a mad expansion that threatens to outrun the capacity of any underlying market—can be seen at the most general level of social relations. Technologies like the Web seem to promise a general devolution, at least in discursive or symbolic production. Every computer-equipped, reasonably wired person can be a publisher or "content provider." Let a million startups bloom! Yet even as this vision unfolds, the logic of mergers and acquisitions consolidates ultimate control of communications channels, to say nothing of finance and industrial production, in the hands of a vanishingly few: the Gateses, the Murdochs, the Turners, the equity holders of Time-Warner, Bertelsmann, Wolters-Klüwer. Are we living through an expansion or a huge contraction—the apotheosis of free markets or their final implosion? How can the answer be both at once?

Surely no society such as this can really exist. By reading the Web as illusion, we may have discovered that it is a creature of fantasy, a very scary monster indeed. Yet the creature is no stalker of the Hollywood night, but rather the Red King from *Through the Looking-Glass*, which would make us the tenuous people of his dreaming.

5: WHAT USE?

Maybe the reverie of postindustrial capitalism will not last much longer; sleepers eventually awaken. If the Web does not exist, it may be because it is, like the society that engenders it, an artifact of transition, a blur in the slow-motion film of history, or to try a less anachronistic metaphor, a file that can no longer be found: 404 indeed. Perhaps the world is truly about to end, or change utterly. As Marshall McLuhan claimed, one may identify certain social formations or identities with evolutions in technology (1964: 68–69). He argued that "the public," the body of rational individuals inculcated by the Enlightenment, could be traced in large

measure to the influences of print, while "the mass," the next social identity to evolve, owed its emergence largely to broadcast media. If the Web and other forms of Internet communication represent nascent forms of something yet to be fully defined, will they usher in a third form of humanity? Who or what succeeds the mass?

At this point we might think about tempering somewhat our sustained skepticism. If space may produce new worlds and cyberspace brave new people, then maybe there is something to look forward to after all. Maybe the Red King can remain in his dream state a good while longer; long enough, at least, to consider a more constructive set of questions. Why *should* the Web exist? Assuming the manifold contradictions of information culture could be worked through, what would be its likely social effects? Or at the risk of a certain banality, What is the World Wide Web good for?

One canonical answer, perhaps the standard Enlightenment answer, looks to augmentation or prosthesis. The Internet is the distributed human nervous system, the översoul, noösphere, or as Don DeLillo once wickedly named a computerized consciousness, "Space Brain" (DeLillo, 1977: 45). So who are these Web people, even now climbing out of their learning pods and Skinner boxes, ready to reinvent the digital economy, or at least start processing all that hypertext? Whoever they are, I suspect they are the millennial equivalent of F. Scott Fitzgerald's rich—not the same as you and me. They are, one hopes, smarter.

The dream of augmenting or "bootstrapping" human intelligence can be a good thing, less perhaps in the self-serving rhetoric of Bill Gates or Nicholas Negroponte than in the visionary thinking of Douglas Engelbart, the great designer who invented many fundamental technologies on which our current dreams are based (Engelbart, 1996). Still, there is always a gap between vision and reality. Writing about a particularly bizarre piece of fiction from William Burroughs, the critic Charles Newman called it "an aesthetic experience recommended for a species which has yet to appear on earth" (1985: 93). Generalizing from literature to culture more broadly, we might find in Newman's critique an important corrective. Biologists differ about the speed at which speciation occurs, but there can be little doubt that it takes longer than the release cycle of most Internet software—a fact that may explain much.

The true children of the Internet may be already among us, or they may be much longer in coming. It is probably impossible to character-

ize their arrival except in retrospect. In any event, the apocalyptic notion of a technological Great Awakening or Childhood's End seems to have little bearing on the present status, or not-quite entity, of the World Wide Web.

Hopelessly addicted to the McLuhan Channel, I have always preferred another crackpot explanation for our current predicament. Admittedly, this thinking probably works better as myth or fiction than cultural analysis, but I offer it nonetheless. McLuhan noted that technologies "reverse" as they approach some limit of development or expression (1964: 35). Carried to its extreme in the twentieth century, industrial mass communication reversed from the linear and perspectival medium of print into the "cool" immediacy of broadcasting. Scaling up this rationale, we can derive the origin of the Internet and its curious illusion, the Web, from the reversal of that supreme signifier, the thermonuclear bomb (as Susan Sontag quipped, "cogito ergo boom"). Having produced doomsday weapons, we turned from technologies that reduce discursive potential to one (I win) or zero (everyone loses) to technologies that ramify discourse beyond any dream of control, as Kevin Kelly (1998) points out. This was the creative leap of technoculture, the grand postmodern swerve from the path of mutual assured destruction. In the words of Harold Bloom, "Discontinuity is freedom" (1997: 39). Or in this case, survival.

Though not intended as legitimate historical analysis, this account at least registers (though it cannot explain) the irrationality of our current condition. To continue in a Bloomian vein, as we fell out of the modern nightmare we swerved, and now we lie in a postmodern hell improved by our own making. Welcome to the Information Age. But before I suggest that the end of the cold war was engineered by the Trilateral Commission in order to spur commercial development of the Internet, let me confess that the World Wide Web makes no more sense as a bridge across the gulf of Apocalypse than as an agency of bootstrapping or *Steigerrung*.

Neither scenario helps explain the fundamental problem with which we began: though everywhere in evidence, the existence of the Web cannot be accounted for in any satisfactory way. For *what*, after all, would the Web exist? (Note that the answer to this question must be framed in terms of practice, not theory.) Thomas Landauer, system designer and former research chief at Bellcore, puts this question most effectively in his trenchant study of information technology and its business culture (1996: 13–14). After noting that the massive computerization of the 1980s and

1990s yielded no appreciable gain in productivity, and that business would on the whole have done better to put its technology dollars into the bond market, Landauer raises a crucial and uncomfortable question. He asks of information technology, *What's the use?*

This question is significantly hard to address (though Landauer's answers are well worth considering); but even in confronting the question we might begin to reach a better understanding of the deeply dubious Web. If the Web does not yet exist as a fully formed communications regime, or indeed as an economic proposition, perhaps it is because we have not yet understood, recognized, or even formulated the uses to which it should be put. We have yet to understand the parameters of our fallen state. It may be that the World Wide Web requires a thorough rethinking of what we mean by *use*. Much of that process is still before us. We may wish, following Kevin Kelly and Sherry Turkle, to think of the Web as an "emergent" phenomenon whose nature will be revealed as it unfolds. Taking this line in a pragmatic direction, we may search with Jay David Bolter for a process of "remediation" in which the ecology of media settles itself into new arrangements, self-motivated, autopoetic, and deeply recursive (Bolter and Grusin, 1999: 4–5). Though Bolter recognizes remediation as something of a sideshow trick that demands critical inspection, there is a palpable change here from his earlier line, which began by arguing that "this [hypertext] will destroy that [print]" (1991: 1). Perhaps Bolter is on to something. Is there remediation (if not remedy) for our doubts? Might it be possible to stop worrying and love the Web?

6: CREDO

So the Web is all in your head, pure illusion, not so much consensual hallucination as special digital effect. That doesn't mean you can't learn to appreciate the thing, or perhaps even cherish it, especially if you happen to hold a chair in a humanities department somewhere in the wired world. Bolter's new pragmatism—and it is mine as well, since I come from a working-class college balanced on the ax-edge of budget cuts—can have strong appeal, considering the career prospects of majors in literature and the fine arts. Could the Web be the great salvation of the humanities at century's end, a decent fallback option for talented people left wanting by feeble academic job markets? If so, the Web could be the most important development for the humanities since the interlibrary loan.

But what if one still refuses, perversely and adamantly, to accept this miracle? Some people cannot bring themselves to embrace this sort of unbridled (and perhaps unprincipled) pragmatism. They are not necessarily wrong. Cautious engagement seems the best course, a position that neither dismisses the possibilities for emergence nor takes as read what is not yet written. There is undeniably a danger in the Web mirage—perhaps especially, to strike closer to home, in the conceit of *Web design* as a cure-all for a moribund academic culture still yoked to the printing press. Palliatives may conceal symptoms of more serious disease. If we choose to believe pragmatically in the Web, we should remember that it may be a diversion meant to hold the attention of intelligent people while the masters of capital lock down the gates of oligopoly control.

What, after all, do Web designers design? To adapt Thomas Landauer's line, what is the use of textual production on the Web? There may of course be valid answers to these questions. Perhaps there are things for weavers of Webs to do besides creating user interfaces for PC banking software, corporate intranets, or banner ads for the latest Hollywood disaster epic. If we can lift our eyes from the print-derived metaphor of Web "pages," if we imagine that working on the Web might mean something other than creating discrete, marketable commodities, then we might be able to open some space for change. Even now the "hacktivists" are among us (Dominguez et al., 1999). Their program may offer firmer ground for action, and thus for belief.

At the same time, there may also be possibilities for improvement within the oligopolized space of late late capitalism. Consider this story about a funny thing that happened on my way to the virtual cash register. Seeking a course text for my class in hypermedia production, I paid a visit to Amazon.com and carried out name searches for several authors whose books I had used with satisfaction in the past. One of these searches turned up a book whose title contained the phrase *communication design*. Among other positive indications, this phrase closely resembles the name of my academic program, so I was ready to add the book to my virtual shopping cart, with thoughts about making it a course requirement; but these thoughts vanished as I read farther on the webpage.

The descriptions of books at Amazon.com prominently display brief, unsolicited reviews by readers. The very first comment I encountered for the text in question (which in fairness should remain unnamed) advised

Fig. 13.1.
Amazon's hallucinatory business model, in which it holds only a nominal inventory and can afford to unsell the books that line its virtual shelves, represents a very interesting revision of commodity capitalism.

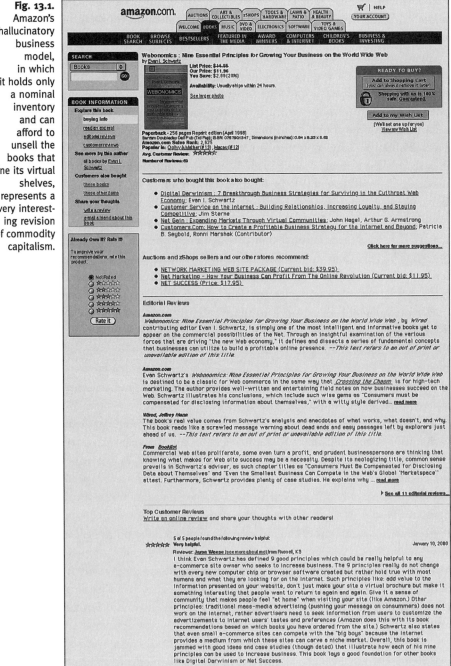

that this book, billed as a collaboration between a respected senior writer and a relative unknown, was actually written almost entirely by the unknown. The comment concluded with the simple prescription: "Avoid." After looking at the negative review in more detail and remembering problems with similar books in the past, I followed the reviewer's advice. There was no sale.

My tale from the cybermall may say something important about the reforming potential of the World Wide Web. It has been some time since I walked into a bookstore and picked a title from the shelves only to be talked out of the purchase—although this did happen more than once, in another place and time, when I was dealing not with multinational chains but with a dedicated independent bookseller. I wonder if this bookseller is still in the business; things are different now. I do not recall ever choosing a book at my local Borders, Barnes and Noble, or B. Dalton, only to find stuck to the cover a warning, "Avoid." This sort of thing does not and cannot happen in a regime dominated by inventory costs, hyper-competition, and the demand for ever higher profits.

Yet the value of books transcends their commodity status—a reason we still have lending libraries and (for the moment) first-use rights. Amazon's hallucinatory business model, in which it holds only a nominal inventory and can afford to unsell the books that line its virtual shelves, represents a very interesting revision of commodity capitalism, albeit in a limited, local instance. Perhaps it merely corrects a perverse mistreatment of books, which were never meant to be sold like hamburgers; and perhaps the Amazon.com effect will not transfer or, in that most ominous requirement of e-business, "scale." But it does seem possible that Amazon's approach indicates fundamental and eligible changes in the way vendors define their relation to consumers—changes in which Web designers as well as Internet radicals might find common ground.

If this seems an extravagant suggestion, consider that the notable success of Amazon.com as a retailer of books—and lately music, videos, and toys—may represent only the first stage in the development of a new market for textual goods. Amazon.com has successfully separated its trade from traditional channels of inventory and distribution, but this transformation can be taken further. Since the value of a book, music CD, or videotape inheres mainly in its content and not in the material substrate, why not eliminate the object altogether? Why print books? Relatively cheap and lightweight display devices now on the market can

store hundreds of titles. Price and performance of these e-books seem likely to improve markedly over the next few years. Amazon.com could easily deliver texts for these devices as bitstreams transmitted through the Internet, as several vendors of electronic books are doing already. For those who still cherish the physical object, local service outlets could return to the ancient practice of booksellers and print and bind on demand. Even physical bookstores might survive this change. Redefined as marketing and browsing places, they might come to resemble lounges and cafes even more than they do now.

Would these differences make a difference in the larger scheme of things? Much depends, of course, on unpredictable social and political articulations. In concept, however, sale by download could allow providers of textual goods to bypass the large industrial concerns that now control production and distribution. Amazon.com depends entirely on News Corp., Time/Warner, Macmillan, and a few other major corporations that provide its stock in trade. But this might not always be the case. If publishing no longer meant expensive production and delivery of physical objects, content providers might find new outlets for their work.

There would of course be further complications. The choke point in publishing might shift from production to evaluation and publicity, with capital interests arguing, as they already do in Web publications like *Salon* and *Slate*, that they are the only proper arbiters of textual value. The capitalists might then shift their arguments for heavy investment and high profit margins to the demands of taste-making, or advertising. However, these functions depend on tight control of product lines. It is relatively easy to shape the public's desire for movies at the cineplex or paperbacks at the airport, where consumer options are limited to a handful of products only briefly available. Would the same reasoning apply to a market where the shelves or marquee are replaced by a hypertextual catalog, and where no title ever goes out of print?

While this logic has yet to penetrate the relatively backward book trade, there has been movement in this direction in the popular music market, spurred by the advent of MPEG-3 recorders and the rapid growth of music download sites on the Web. Television programmers may be waking up as well. Thomas Rosenstiel, director of the Project for Excellence in Journalism, recently said, "Our mass media depends on an audience that no longer exists—a mass audience which is now fragmented" (quoted in Barringer, 1999: C1). Might we reach a point at which the

monolithic mass market, for some commodities at least, becomes as chimerical as the Web seems today?

Probably not, if the current owners of the media have any say in the matter. It is worth noting that even as MPEG-3 and e-books make their appearance, the U.S. Patent Office has begun to award alarmingly broad protections for basic business practices—a development that apparently spurred Microsoft to apply for a patent on sale of electronic magazines by subscription over the World Wide Web. That such an application would even be considered seems instructive. Oligopoly capital continues to call the tune, in this country at least, and will continue to do so as long as political campaigns are paid for by corporate subvention. Any major shift in markets is bound to arouse opposition.

As usual, those who would enter this contest on the side of change must subsist largely on illusions—radical economic models, faith in individual enterprise, and anachronistic notions of a public good. To this list of illusions we might now add the World Wide Web and some of the possibilities it may hold for electronic commerce. To be sure, it would be foolish to place in these imaginings anything but the most conditional belief. Like all technologies, the Web and the Internet in themselves make little difference. Visions do not change the world, except as they inform real work. And work without vision leads nowhere.

BIBLIOGRAPHY

Aaker, D. A., and A. L. Biel. (1993). *Brand Equity and Advertising: Advertising's Role in Building Strong Brands.* Hillsdale, NJ: Lawrence Erlbaum.

Adam, A. (1998). *Artificial Knowing: Gender and the Thinking Machine.* London: Routledge.

———. (1977). "Letters to Walter Benjamin, 18 March 1936." In Ernst Bloch, et al., *Aesthetics and Politics.* London: New Left Books.

———. (1994). "The Stars Down to Earth: The *Los Angeles Times* Astrology Column." In *The Stars Down to Earth and Other Essays on the Irrational in Culture*, ed. Stephen Cook. London: Routledge.

Advertising Research Foundation. (1994). "Building Brand Equity, the Lead Role of Research in Managing the Power of Brands." New York: Advertising Research Foundation.

"All Together Now." (1997). *Electronic Media*, December 15, p. 14.

Anderson, B. (1997). "Many People Feel That They No Longer Understand Their Countrymen." *Spectator*, September 13, p. 8.

Anderson, T. (1995). 'Thou Shall Not Steal Television: Signal Theft in the Age of Information." *Velvet Light Trap* 36: 69–78.

Angelia. (1998). "The Numerology of Your Dwelling: How to Judge a House by Its Number." *NumberQuest*, http://www.numberquest.com/numerology/articles/dwelling.html

"AOL Tops Website Ratings." (1998). *Broadcasting & Cable*, June 22, p. 63.

Argyle, K. (1996). "Is There a Body in the Net?" In R. Shields, ed., *Cultures of Internet: Virtual Spaces, Real Histories, Living Bodies.* London: Sage.

Attali, J. (1985). *Noise: The Political Economy of Music.* Minneapolis: University of Minnesota Press.

Bakhtin, M. M. (1981). *The Dialogical Imagination.* Austin: University of Texas Press.

———. (1986). *Speech Genres and Other Late Essays.* Austin: University of Texas Press.

Bank, D. (1999). "Microsoft May Face Battle Over 'Content.'" *Wall Street Journal*, February 13, B6.

Bank, D., and L. Cauley. (1998). "Microsoft, Compaq Make Net-Access Bet." *Wall Street Journal*, June 16, A3.

Barber, J. (1996). "Polishing the Big Apple." *The Globe and Mail*, June 1, p. 2.

Barlow, J. (1996). "A Declaration of the Independence of Cyberspace." http://www.eff.org/pub/Censorship/Internet_censorship_bills/barlow_0296.declaration.

Barnhurst, K. (1998). Personal communication with the author.

Barnhurst, K., and D. Mutz. (1997). "American Journalism and the Decline in Event-Centered Reporting." *Journal of Communication* 47 (4): 27–53.

Barnouw, Erik. (1966). *The Golden Web: A History of Broadcasting in the United States*, Vol. 1. New York: Oxford University Press.

———. (1968). *A Tower in Babel: A History of Broadcasting in the United States*, Vol. 2. New York: Oxford University Press.

Barrett, E. (1988). "Introduction: A New Paradigm for Writing *with* and *for* the Computer." In Edward Barrett, ed., *In Text, ConText, and HyperText*. Cambridge, MA: MIT Press.

Barringer, F. (1999). "In Washington, Is There News After Scandal?" *New York Times*, February 15, C1, C6.

Barron, J. (1998) "Disney Can Use Park Meadow Closed to Public." *New York Times*, March 28, B1.

Barron, K. (1998). "Bill Gates Wants Our Business." *Forbes*, April 6, pp. 46–47.

Barthes, R. (1975). *The Pleasures of the Text*. New York: Hill and Wang.

Basalla, G. (1988). *The Evolution of Technology*. Cambridge: Cambridge University Press.

Baty, P. (1995). *American Monroe: The Making of a Body Politic*. Berkeley: University of California Press.

Baudrillard, J. (1975). *The Mirror of Production*. St Louis: Telos Press.

———. (1990). *The Precession of Simulcra*. New York: Semiotexte.

———. (1996). *The Perfect Crime*. New York: Verso.

Bender, T. (1987). *New York Intellect*. New York: Knopf.

Benedikt, M., ed. (1992). *Cyberspace: First Steps*. Cambridge, MA: MIT Press.

Beniger, J. R. (1986). *The Control Revolution: Technological and Economic Origins of the Information Society*. Cambridge, MA: Harvard University Press.

Benjamin, W. (1978). "Surrealism: The Last Snapshot of the European Intelligentsia." In *Reflections : Essays, Aphorisms, Autobiographical Writings*, ed., P. Demetz, New York: Harcourt Brace Jovanovich.

Berk, E., and J. Devlin. (1991). "A Hypertext Timeline." In E. Berk and J. Devlin, eds., *Hypertext/Hypermedia Handbook*. New York: McGraw-Hill.

Berland, J. (1993). "Sound, Image and Social Space: Music Video and Media Reconstruction." In S. Frith, A. Goodwin, and L. Grossberg, eds., *Sound and Vision: The Music Video Reader*. New York: Routledge.

Berland, J., and S. Kember. (1996). "Editorial: Technoscience." *New Formations* 29: v–vii.

Bernstein, M., M. Joyce, and D. Levine. (1992). "Contours of Constructive Hypertexts." In J. Nanard and M. Nanard, eds., *Proceedings of the ACM Conference on Hypertext*. Milan: Association for Computing Machinery.

Bhabha, H. K. (1985). "Signs Taken for Wonders: Questions of Ambivalence and Authority under a Tree in Outside Delhi, May 1817." *Critical Inquiry* 13(3): 144–64.

Birger, J. (1996). "N.Y.C. Is Weighing Ending Debt Power of Business Districts." *Bond Buyer*, September 6, p. 1.

Birkerts, S. (1994). *The Gutenberg Elegies: The Fate of Reading in an Electronic Age*. Boston: Faber and Faber.

Bloom, H. (1997). *The Anxiety of Influence: A Theory of Poetry*. New York: Oxford University Press.

Bolter, J. D. (1991). *Writing Space: The Computer, Hypertext, and the History of Writing*. Hillsdale, NJ: Lawrence Erlbaum.

Bolter, J. D., and R. Grusin. (1999). *Remediation: Understanding New Media*. Cambridge, MA: MIT Press.

Bordo, S. (1993). *Unbearable Weight: Feminism, Western Culture, and the Body*. Berkeley: University of California Press.

Bourne, W. (1995). "The Gospel according to Prum." *Harper's*, vol. 289, num. 1736, pp. 60–70.

Boyd, K. G. (1995). "Cyborgs in Utopia: The Problem of Radical Difference in *Star Trek: The Next Generation*." In T. Harrison, S. Projansky, K. A. Ono, and E. Helford, eds., *Enterprise Zones: Critical Positions on* Star Trek. Boulder, CO: Westview Press.

Bradley, D. (1998). *Unfolding a Strategic Space: A Discursive Analysis of Cyberspace's Power Relations*. Ph.D. Dissertation, York University, 1998.

"Brands Bite Back." (1998). *Economist*, March 21, p. 78.

Breskin, I. (1997). "Times Square's Dykstra." *Investor's Business Daily*, May 27, A1.

Brooker, K. (1998). "Papers Lose Tweedy Tude, Find Black Ink." *Fortune*, June 8, pp. 36–37.

Brown, J. (1998). "MSNBC on the Net Ready to Play Ball." *Electronic Media*, January 19, p. 96.

Brown, L. (1998). "Market Forces Killed the Media Dream." *Television Business International*, April, p. 10.

Buchstein, H. (1997). "Bytes That Bite: The Internet and Deliberative Democracy." *Constellations* 4 (2): 248–63.

Bulkeley, W. (1998a). "Radio Stations Make Waves on the Web." *Wall Street Journal*, July 23, B1, B5.

———. (1998b). "Sound Off." *Wall Street Journal*, June 15, R24.

Burke, J. (1995). *Connections*. Boston: Little, Brown.

Burke, K. (1945). *A Grammar of Motives*. New York: Prentice-Hall.

Burridge, K. O. L. M. (1960). *A Melanesian Millennium*. London: Methuen.

Cadigan, P. (1991). *Synners*. New York: Bantam.

Cairncross, F. (1997). *The Death of Distance*. Boston: Harvard Business School Press.

Calley, L. (1998). "Sony Plans to Purchase a 5 percent Stake in NextLevel." *Wall Street Journal*, January 5, A3.

Campion, N. (1994). *The Great Year: Astrology, Millenarianism and History in the Western Tradition*. Harmondsworth, U.K.: Penguin.

Cardenal, E. (1992). "Los Yaruros." In R. Salmon, ed., *Los ovnis de oro: Poemas indios/ Golden UFOs: The Indian Poems*. Bloomington: Indiana University Press.

Cardona, M. (1997). "Media Industry Grows Faster Than GDP: Veronis." *Advertising Age*, November 3, p. 16.

Carey, J. (1989). *Communication as Culture*. Boston: Unwin-Hyman.

Carrier, J. G. (1995). *Occidentalism: Images of the West*. Oxford: Clarendon Press.

Caruso, D. (1998). "If It Embraces Everything from CD's to Films, It Must Be the New Synergy." *New York Times*, July 20, C3.

Castells, M. (1996). *The Rise of the Network Society*. Oxford: Basil Blackwell.

Castells, M., and P. Hall. (1994). *Technopoles of the World*. London: Routledge.

Castells, M., and J. Henderson. (1987). "Techno-economic Restructuring, Socio-political Processes and Spatial Transformation: A Global Perspective." In J. Henderson and M. Castells, eds., *Global Restructuring and Territorial Development*. Beverly Hills: Sage.

Chambers, I. (1994). *Migrancy, Culture, and Identity*. New York: Routledge.

Charbeneau, T. (1995). "Dangerous Assumptions." *Toward Freedom* 43 (7): 28–29.

Chen, D. W. (1997a). "New York Bound Bookshop Is Closing at End of Summer." *New York Times*, June 24, B7.

———. (1997b). "New-Media Industry Becoming Juggernaut." *New York Times*, October 23, B12.

Chervokas, J. (1998). "Internet CD Copying Tests Music Industry." *New York Times*, April 6, C3.

Chesher, C. (1997). "The Ontology of Digital Domains." In D. Holmes, ed., *Virtual Politics: Identity and Community in Cyberspace*. Newbury Park, CA: Sage.

Chomsky, N. (1998). "Hordes of Vigilantes." *Z Magazine*, July/August, 51–54.

Chomsky, T. (1994). *World Orders Old and New*. New York: Columbia University Press.

Christiano, T. (1996). *The Rule of the Many*. Boulder, CO: Westview Press.

"Citizenship," 1989. *Oxford English Dictionary*, 3. Oxford: Clarendon.

Clanchy, M. (1993). *From Memory to Written Record, England 1066–1307*. Oxford: Basil Blackwell.

Clark, N. (1995). "The Recursive Generation of the Cyberbody." In M. Featherstone and R. Burrows, eds., *Cyberspace Cyberbodies Cyberpunk: Cultures of Technological Embodiment*. London: Sage.

Coile, Z. (1997). "Looking for a Fight: With New Entries Expected by Microsoft and CNET, the Search Engine Industry Readies for a Battle." *San Francisco Examiner*, August 17, B5.

Coleman, P. (1998). "Malone Proposes In-tier-net." *Broadcasting and Cable*, June 15, p. 53.

Colonna, J. (1998). "For Internet Stocks, the Fall of Overvalued Companies Can Hurt Strong Companies as Well." *New York Times*, June 1, C5.

Compagnon, A. (1994). *The Five Paradoxes of Modernity*. New York: Columbia University Press.

Connolly, W. (2000). "The Will, Capital Punishment, and Cultural War." In J. Dean, ed., *Political Theory: The Cultural Turn*. Ithaca, NY: Cornell University Press.

Coopers & Lybrand. (1996). *The New York New Media Industry Survey*. New York: Coopers & Lybrand.

———. (1997). *The Coopers and Lybrand Money Tree*. New York: Coopers & Lybrand.

Cordingly, D. (1995). *Under the Black Flag*. San Diego: Harcourt Brace.

Crockett, R., G. McWilliams, S. Jackson, and P. Elstrom. (1998). "Warp Speed Ahead." *Business Week*, February 16, 80–83.

Cubitt, S. (1998). "Powers of the Air: Simon Biggs' 'Halo, A Memorable Fancy.'" In *Halo*, catalog, London: Film Video Umbrella.

Czitrom, D. (1982). *Media and the American Mind*. Chapel Hill: University of North Carolina Press.

Dahl, R. (1989). *Democracy and Its Critics*. New Haven, CT: Yale University Press.

Darnton, R. (1985). *The Great Cat Massacre and Other Episodes in French Cultural History*. New York: Vintage Books.

———. (1989). "What Is the History of Books?" In C. Davidson, ed., *In Reading in America: Literature and Social History*. Baltimore: Johns Hopkins University Press.

Davies, P. (1987). *The Cosmic Blueprint: Order and Complexity at the Edge of Chaos*. Harmondsworth, U.K.: Penguin.

Davis, D. B., ed. (1971). *The Fear of Conspiracy*. Ithaca, NY: Cornell University Press.

Dawkins, R. (1989). *The Selfish Gene*. Oxford: Oxford University Press.

De Certeau, M. (1984). *The Practice of Everyday Life*. Berkeley and Los Angeles: University of California Press.

De Kerckhove, D. (1997). *Connected Intelligence: The Arrival of the Web Society*. Toronto: Somerville House.

De Ste. Croix, G. E. M. (1981). *The Class Struggle in the Ancient Greek World*. London: Duckworth.

Dean, J. (1998). *Aliens in America: Conspiracy Culture from Outerspace to Cyberspace*. Ithaca, NY: Cornell University Press.

———. (2000). "Declarations of Independence." In J. Dean, ed., *Political Theory: The Cultural Turn*. Ithaca, NY: Cornell University Press.

Deibert, R. J. (1997). *Parchment, Printing, and Hypermedia: Communication in World Order Transformation*. New York: Columbia University Press.

Deleuze, G. (1983). *Cinema I*. London: Athlone.

Deleuze, G., and F. Guattari. (1988). *Thousand Plateaus, Capitalism and Schizophrenia*, Vol. 2. London: Athlone.

DeLillo, D. (1977). *Ratner's Star*. New York: Vintage.

Dennett, D. (1991). *Consciousness Explained*. Hammondsworth, U.K.: Penguin.

Denton, N. (1998a). "Mainstream.com." *Financial Times*, January 3–4, p. 6.

———. (1998b). "Online Media Face Heavy Job Losses." *Financial Times*, March 12, p. 6.

Derrida, J. (1994). *Specters of Marx*. New York: Routledge.

———. (1996). *Archive Fever: A Freudian Impression*. Chicago: University of Chicago Press.

Dery, M. (1996). *Escape Velocity: Cyberculture at the End of the Century*. New York: Grove Press.

Deutsch, D. (1997). *The Fabric of Reality: The Science of Parallel Universes and Its Implications*. New York: Penguin.

Dominguez, R., C. Karasic, B. Stalbaum, and S. Wray. (1999). "Zapatista Floodnet Public Version Release. http://www.fornits.com/renegade/articles/2231.htm.

Douglas, K. (1971). *Religion and the Decline of Magic: Studies in Popular Beliefs in Sixteenth and Seventeenth Century England*. London: Weidenfeld and Nicholson.

Dugan, J. (1998). "New-Media Meltdown." *Business Week*, March 23, pp. 70–71.

Dyer, R. (1986). *Heavenly Bodies : Film Stars and Society*. New York: St. Martin's Press.

Dyson, E. (1997). *Release 2.0: A Design for Living in the Digital Age*. New York: Viking.

———. (1998). "The End of the Official Story." *Brill's Content*, July/August, 50–51.

Elliott, S. (1998). "A Big World Wide Web Site by Time Inc. New Media Is Devoted to the 1998 Soccer World Cup." *New York Times*, June 4, C12.

Ellul, J. (1964). *The Technological Society*. New York: Vintage Books.

Elmer, G. (1997). "Spaces of Surveillance: Indexicality and Solicitation on the Internet." *Critical Studies in Mass Communication*, 14 (2): 182–91.

———. (1998). "Diagrams, Maps and Markets: The Technological Matrix of Geographical Information Systems." *Space and Culture* 3: 49–65.

Engelbart, D. (1996). "Boosting Collective IQ, and an Open Hyperdocument System." http://www.cel.sfsu.edu/msp/Lectureseries/engelbart3.html

Engler, A. (1995). *Apostles of Greed: Capitalism and the Myth of the Individual in the Market*. London: Pluto Press.

Eno, J. (1997). "Piracy Crackdown Brings in Big Bucks." *Wired News*, Oct. 10, http://www.wired.com/news/news/business/story/7610.html.

Erickson, T. (1997). "Social Interaction on the Net: Virtual Community as Participatory Genre." *Proceedings of the Thirtieth Hawaii International Conference on Systems Science*, Vol. 6. Los Alamitos, CA: IEEE Computer Society Press.

Escobar, A. (1996). "Welcome to Cyberia: Notes on the Anthropology of Cyberculture." In Z. Sardar and J. Ravetz, eds., *Cyberfutures: Culture and Politics on the Information Superhighway*. New York: New York University Press.

Featherstone, M., and R. Burrows, eds. (1995). *Cyberspace Cyberbodies Cyberpunk: Cultures of Technological Embodiment*. London: Sage.

Feldman, T. (1997). *An Introduction to Digital Media*. London: Routledge.

Fineman, H. (1997). "Who Needs Washington?" *Newsweek*, January 27, p. 52.

Fish, S. (1980). *Is There a Text in This Class: The Authority of Interpretive Communities*. Cambridge, MA: Harvard University Press.

Fitch, R. (1993). *The Assassination of New York*. London: Verso.

Flaherty, N. (1997). "Diving In at the Deep End." *Cable and Satellite Europe*, March, pp. 61, 63.

Foucault, M. (1979). "What Is an Author?" In J. Harari, ed., *Textual Strategies: Perspectives in Post-Structuralist Criticism*. Ithaca, NY: Cornell University Press.

Frauenfelder, M. (1998). "The Net's Chop Shops." *Yahoo Internet Life*, October, http://www.zdnet.com/yil/content/mag/9810/chop2.html.

Freeman, L. (1998). "Led by Warner, Animation Leads Syndicators to Web." *Advertising Age*, January 19, s10.

Friedman, M. (1962). *Capitalism and Freedom*. Chicago: University of Chicago Press.

Fryer, B. (1995). "The Software Police." *Wired*, May, http://www.wired.com/wired/archive/3.05/police_pr.html.

Galetto, M. (1997). "CNN Spots Online Gold and Starts Speaking Swedish." *Electronic Media*, March 17, p. 28.

Gandy, O. (1993). *The Panopticon Sort: A Political Economy of Personal Information*. Boulder, CO: Westview Press.

Gates, B. (1996). *The Road Ahead*. New York: Penguin.

Gellatly, A. (1998). "Online Crowd-Pleasers." *Financial Times*, June 10, p. 24.

Gibson, W. (1984). *Neuromancer*. New York: Ace.

———. (1987). *Count Zero*. London: Graton.

Gilder, G. (1994). *Life after Television*. New York: W. W. Norton.

Gilpin, K. (1998). "Thinking Rationally as the Web Goes Wild." *New York Times*, July 12, p. 7.

Ginzburg, C. (1980). *The Cheese and the Worms: The Cosmos of a Sixteenth Century Miller*. London: Routledge.

Gleick, E. (1997). "With an Exit Sign from Heaven." *Time*, April 7, 28–36.

Gleick, J. (1987). *Chaos: Making a New Science*. London: Penguin.

———. (1998). "Control Freaks." *New York Times Magazine*, July 19, p. 18.

Goldberger, P. (1996a). "The New Times Square: Magic That Surprised the Magicians." *New York Times*, October 15, C11.

———. (1996b). "A Small Park Proves That Size Isn't Everything." *New York Times*, November 24, H46.

Goldblatt, H. (1998). "AT&T's Costly Game of Catch-Up." *Fortune*, July 20, pp. 25–26.

Goldsen, R. (1977). *The Show and Tell Machine: How Television Works and Works You Over*. New York: Dial Press.

Goldsmith, C. (1998). "PolyGram Establishes Panel to Focus on Internet Effects, Posts Profit Growth." *Wall Street Journal*, February 12, B6.

Gonzalez, D. (1997). "News Vendors Face Prospect of Last Stand." *New York Times*, May 17, p. 21.

———. (1998). "Hard Times for Art in Realm of the Coin." *New York Times*, July 15, B1.

Gould, S. J. (1977). *Ever Since Darwin: Reflections in Natural History*. New York: Penguin Books.

Graff, G. (1987). *Professing Literature: An Institutional History*. Chicago: University of Chicago Press.

Graff, H. (1987). *The Legacies of Literacy: Continuities and Contradictions in Western Culture and Society*. Bloomington: Indiana University Press.

Green, H., R. Hof, and P. Judge. (1998). "Vying to Be More Than a Site for More Eyes." *Business Week*, May 18, p. 162.

Green, H., A. Cortese, P. Judge, and R. Hof. (1998a). "The 'Click Here' Economy." *Business Week*, June 22, p. 124.

———. (1998b). "Click Here for Wacky Valuations." *Business Week*, July 20, pp. 32–34.

Greenhouse, S. (1997). "Unions Woo Business District Workers." *New York Times*, February 20, B4.

Greenwald, J. (1997). "Think Big." *Wired*, August, 95–104, 145.

Griffith, V. (1998). "Get Them While They're Young." *Financial Times*, January 5, p. 19.

Grossman, W. (1997). *Net.wars*. New York: New York University Press.

"Growing Up." (1998). *Economist*, May 2, pp. 56–58.

Grover, R. (1998). "Online Sports: Cyber Fans Are Roaring." *Business Week*, June 1, p. 155.

Gunkel, D., and A. H. Gunkel. (1997). "Virtual Geographies: The New Worlds of Cyberspace." *Critical Studies in Mass Communication* 14: 123–37.

Gunther, M. (1998). "The Internet Is Mr. Case's Neighborhood." *Fortune*, March 30, pp. 69–80.

Gurley, J. (1998). "The Soaring Cost of E-Commerce." *Fortune*, August 3, p. 226.

Habermas, J. (1989). *The Structural Transformation of the Public Sphere*. Cambridge, MA: MIT Press.

Hafner, K. (1997). "The Epic Saga of The WELL." *Wired*, May, 98–142.

Hafner, K., and M. Lyon. (1996). *Where Wizards Stay Up Late: The Origins of the Internet*. New York: Simon and Schuster.

Hagel, J., and A. Armstrong. (1997). *Net Gain: Expanding Markets through Virtual Communities*. Boston: Harvard Business School Press.

Halio, M. (1990). "Student Writing: Can the Machine Maim the Message?" *Academic Computing*, January, 16–19, 45.

Hall, L. (1998). "Web Ads Changing Online Business." *Electronic Media*, March 23, p. 16.

Hamm, S., A. Cortese, and S. Garland. (1998). "Microsoft's Future." *Business Week*, January 19, 58–68.

Hansell, S. (1998a). "Disney Will Invest in a Web Gateway." *New York Times*, June 2, C3.

———. (1998b). "NBC Buying a Portal to the Internet." *New York Times*, June 10, C1, C8.

———. (1998c). "Hooking Up the Nation." *New York Times*, June 25, C5.

———. (1998d). "The Battle for Internet Supremacy Is Shifting to the Companies That Sell Connections to Users." *New York Times*, June 29, C4.

Haraway, D. (1985). "A Manifesto for Cyborgs: Science, Technology, and Socialist Feminism in the Last Quarter." *Socialist Review* 80: 65–107.

———. (1997). *Modest_Witness@Second_Millennium. FemaleMan©_ Meets_OncoMouse™: Feminism and Technoscience*. New York: Routledge.

Harmon, A. (1997). "NASA Flew to Mars for Rocks? Sure." *New York Times*, July 20, 4E.

———. (1998). "Technology to Let Engineers Filter the Web and Judge Content." *New York Times*, January 19, C1, C4.

Harpold, T. (1991a). "Threnody: Psychoanalytic Digressions on the Subject of Hypertexts." In P. Delany and G. Landow, eds., *Hypermedia and Literary Studies*. Cambridge, MA: MIT Press.

———. (1991b). "The Contingencies of the Hypertext Link." *Writing on the Edge* 2 (2): 126–38.

Harvey, D. (1996). *Justice, Nature, and the Geography of Difference*. Cambridge, MA: Blackwell.

Hayles, K. (1999). *How We Became Posthuman: Virtual Bodies in Cybernetics, Literature and Informatics*. Chicago: University of Chicago Press.

Healy, D. (1997). "Cyberspace and Place: The Internet as Middle Landscape on the Electronic Frontier." In David Porter, ed., *Internet Culture*. London: Routledge.

Heidegger, M. (1977). "The Question concerning Technology." In *The Question concerning Technology and Other Essays*. New York: Harper.

Herman, E., and R. McChesney. (1997). *The Global Media: The New Missionaries of Corporate Capitalism*. London: Cassell.

Hiassen, C. (1998). *Team Rodent*. New York: Ballantine.

Higgins, J. (1998). "IP Telephony: Does AT&T Have Its Number?" *Broadcasting & Cable*, July 8, pp. 36–38.

Hill, C. (1972). *The World Turned Upside Down*. London.

Hillis, W. D. (1998). *The Pattern on the Stone: The Simple Ideas That Make Computers Work*. New York: Basic Books.

Hof, R. (1998). "How Sweet It Is (Again) for Chairman Bill." *Business Week*, July 6, p. 31.

Hofstadter, R. (1952). *The Paranoid Style in American Politics and Other Essays*. Cambridge, MA: Harvard University Press.

Hollinger, P. (1998). "Internet Shopping Set to Soar in Next Four Years." *Financial Times*, January 27, p. 5.

Holmes, D., ed. (1997). *Virtual Politics: Identity and Community in Cyberspace*. London: Sage.

Howkins, J., R. L. Valantin, International Development Research Centre (Canada), and United Nations Commission on Science and Technology for Development. (1997). *Development and the Information Age: Four Global Scenarios for the Future of Information and Communication Technology*. Ottawa: The Centre.

Ingersoll, B. (1998). "Internet Spurs U.S. Growth, Cuts Inflation." *Wall Street Journal*, April 16, A3.

Innis, H. (1949). *The Press*. New York: AMS Press.

———. (1972). *Empire and Communication*. Toronto: University of Toronto Press.

———. (1995). *Staples, Markets, and Cultural Change*. Montreal: McGill-Queen's University Press.

Iser, W. (1978). *The Act of Reading: A Theory of Aesthetic Response*. Baltimore: Johns Hopkins University Press.

Jackson, M. (1997). "Assessing the Structure of Communication on the World Wide Web." *Journal of Computer-Mediated Communication*, 3 (1), http://www.ascusc.org/jcmc/vol3/issue1/jackson.html

Jakobsen, L. (1997). "CNN Interactive in Swedish." *Cable & Satellite Express*, March 20, p. 8.

Jameson, F. (1996). *The Seeds of Time*. New York: Columbia University Press.

Jensen, J. (1998). "Columbia Tristar Teen TV Show Adds Interactive." *Advertising Age*, July 13, 27.

Johnson, F. (1996). "Cyberpunks in the White House." In Jon Dovy, ed., *Fractal Dreams: New Media in Social Context*. London: Lawrence and Wishart.

Johnson, K. (1997). "The Place for the Aspiring Dot Com: Internet Industry's Most Popular Address Is Manhattan." *New York Times*, September 30, B1.

Johnson, S. (1997). *Interface Culture: How the New Technology Transforms the Way We Create and Communicate*. San Francisco: HarperEdge.

Jones, Q. (1997). "Virtual-Communities, Virtual Settlements & Cyber-Archaeology: A Theoretical Outline." *Journal of Computer-Mediated Communication*, 3 (3), http://www.ascusc.org/jcmc/vol3/issue3/jones.html

Jones, S. (1995). *CyberSociety: Computer-Mediated Communication and Community*. Thousand Oaks, CA: Sage.

———. (1997). *Virtual Culture*. London: Sage.

———. (1998). Introduction. In S. G. Jones, ed., *Cybersociety 2.0: Revisiting Computer-Mediated Communications and Community* (14). Thousand Oaks, CA: Sage.

Joyce, M. (1990). *Afternoon: A Story*. Cambridge, MA: Eastgate.

———. (1995). *Of Two Minds: Hypertext Pedagogy and Poetics*. Ann Arbor: University of Michigan Press.

———. (1997). "Twelve Blue." *Postmodern Culture*, 7 (3), http://www.eastgate.com/TwelveBlue/Welcome.html.

Kakutani, M. (1997). "Never-Ending Saga." *New York Times Magazine*, September 28, pp. 40–41.

Kaplan, N. (1995–1999). "E-Literacies: Politexts, Hypertexts, and Other Cultural Formations in the Late Age of Print," http://raven.ubalt.edu/staff/kaplan/lit.

Kaplan, N., and S. Moulthrop. (1994). "Where No Mind Has Gone Before: Ontological Design for Virtual Spaces." *Proceedings of the ACM Hypertext Conference*. Edinburgh: Association for Computing Machinery.

Karlgaard, R. (1998). "The Web Is Recession-Proof." *Wall Street Journal*, July 14, A18.

Karon, P. (1998). "Online Entertainment Crashes." *Variety*, May 4–10, p. 3.

Katz, J. (1997). "Deaths in the Family." *Hotwired*, March 31, http://www. hotwired.com/netizen/97/13/index0a.html.

Kehoe, L. (1998a). "Internet Plumber Needed." *Financial Times*, June 17, p. 12.

———. (1998b). "The End of the Free Ride." *Financial Times*, July 1, p. 14.

Kehoe, L., and R. Wolfe. (1998). "System on Line: Ruling Clears Microsoft's Way to Market." *Financial Times*, June 25, p. 4.

Keller, E. F. (1992). *Secrets of Life, Secrets of Death: Essays on Language, Gender and Science*. New York: Routledge.

Kelly, K. (1994). *Out of Control: The Rise of Neo-Biological Civilization*. Cambridge, MA: Addison Wesley.

———. (1998). *New Rules for the New Economy: Ten Radical Strategies for a Connected World*. New York: Viking.

Kelly, K., and G. Wolf. (1997). "Push: Kiss Your Browser Goodbye." *Wired*, March, 69–81.

Kendrick, M. (1996). "Cyberspace and the Technological Real." In R. Markley, ed., *Virtual Realities and Their Discontents*. Baltimore: Johns Hopkins University Press.

Kern, S. (1983). *The Culture of Time and Space, 1880–1918*. Cambridge, MA: Harvard University Press.

Kernan, A. (1990). *The Death of Literature*. New Haven, CT: Yale University Press.

King, A. D., ed. (1996). *Re-presenting the City: Ethnicity, Capital, and Culture in the Twenty-First-Century Metropolis*. New York: New York University Press.

Koranteng, J. (1998). "Time Inc. New Media Explores Outside U.S." *Ad Age International*, June 29, p. 20.

Kraut, R., V. Lundmark, M. Patterson, S. Kiesler, T. Mukopadhyay, and W. Scherlis. (1998). "Internet Paradox: A Social Technology That Reduces Social Involvement and Psychological Well-Being?" *Communications of the ACM*, 41(12): 21–22, and http://homenet.andrew.cmu.edu/progress/ acmlet.html.

Kroker, A. (1996). "Virtual Capitalism." In S. Aronowitz and B. Martinsons, eds., *TechnoScience and Cybercultures*. New York: Routledge.

Kunii, I., S. Brull, P. Burrows, and E. Baig. (1998). "The Games Sony Plays." *Business Week*, June 15, pp. 128–30.

Kuttner, R. (1997). *Everything for Sale: The Virtues and Limits of Markets*. New York: Alfred A. Knopf.

Landauer, T. (1996). *The Trouble with Computers: Usefulness, Usability, and Productivity*. Cambridge, MA: MIT Press.

Landler, M. (1998). "From Gurus to Sitting Ducks." *New York Times*, January 11, sec. 3, pp. 1, 9.

Landow, G. (1987). "Relationally Encoded Links and the Rhetoric of Hypertext." *Proceedings of the ACM Conference on Hypertext*. Baltimore: Association for Computing Machinery.

———. (1992). *Hypertext: The Convergence of Contemporary Critical Theory and Technology*. Baltimore: Johns Hopkins University Press.

Laprad, D. (1998). "Digital Anarchy: An Analysis of Software Piracy." *Adrenaline Vault*, March, http://www.avault.com/articles/warez1_1.asp; http://www.avault.com/articles/warez2_1.asp.

Laszlo, E. (1994). *The Choice: Evolution or Extinction? A Thinking Person's Guide to Global Issues*. New York: Putnam Books.

Lattas, A. (1996). "Memory, Forgetting and the New Tribes Mission in West New Britain." *Oceania*, 66 (4): 286–305.

Lawrence, P. (1989). *Road Belong Cargo: A Study of the Cargo Movement in the Southern Madang District, New Guinea*. Prospect Heights, IL: Waveland Press.

Lefebvre, H. (1991). *The Production of Space*. Cambridge, MA: Blackwell.

Lehman, S. (1996). "Divining Arthur C. Clarke." http://222.iti.qc.ca/iti/users/sean/bunny/b02/ess/s1-clarke.html

Levinas, E. (1981). *Otherwise than Being or Beyond Essence*. The Hague: Martinus Nijhoff.

Levitas, R. (1993). "The Future of Thinking about the Future." In J. Bird, et al., eds., *Mapping the Future: Local Cultures, Global Change*. London: Routledge.

Levy, S. (1992). *Artificial Life: The Quest for a New Creation*. Harmondsworth, U.K.: Penguin.

Lewis, W., R. Waters, and L. Kehoe. (1998). "AOL Shares Leap as Group Rebuffs AT&T." *Financial Times*, June 18, p. 20.

Lewontin, R. C. (1991). *The Doctrine of DNA: Biology as Ideology*. Harmondsworth, U.K.: Penguin.

Li, J. H. (1996). "Is This Man Dangerous?" *New York Times*, September 1, A13.

Lindstrom, L. (1993). *Cargo Cult: Strange Stories of Desire from Melanesia and Beyond*. Honolulu: University of Hawaii Press.

Littleton, C. (1998). "Channel Scrollers Become High Rollers." *Variety*, July 20–26, p. 21.

Lohr, S. (1998a). "Microsoft Will Soon Offer Peek at New-Media Strategy." *New York Times*, February 2, C5.

———. (1998b). "Media Convergence." *New York Times*, June 29, A11.

Lord, J. (1995). "Gilles Deleuze: Levinas." *CTHEORY*, October 20, http://www.ctheory.com/deleuzelord.html.

Lovelock, J. (1979). *Gaia: A New Look at Life on Earth*. Oxford: Oxford University Press.

———. (1988). *The Ages of Gaia: A Biography of Our Living Earth*. New York: W. W. Norton.

Lyon, D. (1994). *The Electronic Eye: The Rise of Surveillance Society*. Minneapolis: University of Minnesota Press.

Lyotard, J. (1984). *The Postmodern Condition: A Report on Knowledge*. Manchester: Manchester University Press.

———. (1991). *The Inhuman: Reflections on Time*. Stanford, CA: Stanford University Press.

"Ma Bell Convenience Store." (1998). *Economist*, June 27, pp. 61–62.

Maddox, K. (1998a). "Forrester Study Says Users Ready for E-Commerce." *Advertising Age*, March 23, p. 34.

———. (1998b). "Rapid Growth Online." *Electronic Media*, April 6, p. 10.

————. (1998c). "Warner Bros. Develops New Web Content Model." *Advertising Age*, June 22, p. 8.

Maffesoli, M. (1996). *The Time of the Tribes*. London: Sage.

Mallin, S. (1996). *Art Line Thought*. Dordrecht, Netherlands: Kluwer Academic Publishers.

Mand, A. (1998a). "Beyond Hits and Clicks." *Mediaweek*, March 30, pp. 48, 52.

————. (1998b). "P&G to Hold Marketer Confab about Online Ads." *Mediaweek*, May 11, p. 41.

Markham, A. (1998). *Life Online: Researching Real Experience in Virtual Space*. London: Altamira.

Marshall, P. D. (1997). *Celebrity and Power: Fame in Contemporary Culture*. Minneapolis: University of Minnesota Press.

Marshall, T. H. (1964). *Class, Citizenship, and Social Development*. Garden City, NY: Doubleday.

Martin, P. (1998). "The Merger Police." *Financial Times*, March 12, p. 10.

Marx, K. (1906). *Capital*. Vol. 1. New York: Modern Library.

————. (1973). *Grundrisse*. New York: Random House.

Marx, L. (1964). *The Machine in the Garden: Technology and the Pastoral Ideal in America*. New York: Oxford University Press.

Mason, P. (1990). *Deconstructing America. Representations of the Other*. London: Routledge.

Massey, D. (1992). "Politics and Space/Time." *New Left Review* 196: 65–84.

Mayer, M. (1991). *Whatever Happened to Madison Avenue? Advertising in the 90s*. Boston: Little, Brown.

Mazlich, B. (1993). *The Fourth Discontinuity: The Co-Evolution of Humans and Machines*. New Haven, CT: Yale University Press.

McCandless, D. (1997). "Warez Wars." *Wired*, April, http://www.wired.com/wired/archive/5.04/ff_warez_pr.html.

McChesney, R. (1999). *Rich Media, Poor Democracy: Communication Politics, History, and Scholarship in Dubious Times*. Urbana: University of Illinois Press.

McConville, J. (1998). "New Nick Web Site Not Just for Kids." *Electronic Media*, March 16, 18.

McHoul, A., and P. Roe. (1996). "Hypertext and Reading Cognition." Paper presented at Virtual Informational Digital Workshop, Murdoch University, Perth, Australia, October 10, http://kali.murdoch.edu.au/~cntinuum/VID/cognition.html.

McHugh, J. (1997). "Politics for the Really Cool." *Forbes*, September 8, pp. 172–92.

McLuhan, M. (1964). *Understanding Media, The Extensions of Man*. New York: Penguin.

McLuhan, M., Q. Fiore, and J. Agel. (1996). *The Medium Is the Message: An Inventory of Effects*. San Francisco: Hardwired.

McManus, Joy. (1997). "Putting a Value on Web Site Awards." *Washington Post*, July 7, F14.

Medawar. (1956). *The Future of Man*. London: Faber and Faber.

Mehta, S. (1998). "US West Is Set to Offer TV Programming and Internet Access over Phone Lines." *Wall Street Journal*, April 20, B6.

Mermigas, D. (1997). "Strong Media Forecast for '98." *Electronic Media*, November 3, p. 31.

———. (1998a). "TCI Goes Digital with Microsoft." *Electronic Media*, January 19, pp. 3, 119.

———. (1998b). "New Media Takes on the Old." *Electronic Media*, May 11, pp. 28–29.

———. (1998c). "Avoiding the Web's Pitfalls." *Electronic Media*, May 18, p. 18.

———. (1998d). "Analysts Adding Up AT&T–TCI Deal." *Electronic Media*, July 6, pp. 3, 25.

"Microsoft to Feature 250 Content Channels in New Web Browser." (1997). *Wall Street Journal*, July 15, B3.

Midgley, M. (1985). *Evolution as Religion: Strange Hopes and Stranger Fears.* London: Methuen.

Millar, M. S. (1998*). Cracking the Gender Code: Who Rules the Wired World?* Toronto: Second Story Press.

Miller, L. (1998). "WWW.Claptrap.com." *New York Times Book Review*, March 15, p. 43.

Mokyr, J. (1990). *The Lever of Riches: Technological Creativity and Economic Progress.* New York: Oxford University Press.

Mollenkopf, J., and M. Castells, eds. (1991). *Dual City: Restructuring New York.* New York: Russell Sage Foundation.

Monaco, J. (1978). *Celebrity: The Media as Image Makers.* New York: Dell.

Moravec, H. (1988). *Mind Children: The Future of Robot and Human Intelligences.* Cambridge, MA: Harvard University Press.

Morse, M. (1998). *Virtualities.* Bloomington: Indiana University Press.

Moser, M. A., ed. (1996*). Immersed in Technology: Art and Virtual Environments.* Cambridge, MA: MIT Press.

Moulthrop, S. (1989). "Hypertext and 'the Hyperreal.'" *Proceedings of the ACM Hypertext Conference.* Pittsburgh: Association for Computing Machinery.

———. (1997). "Hegirascope 2." *New River* 3, http://raven.ubalt.edu/staff/moulthrop/hypertexts/hgs

"MTV Emphasizes Online Synergy." (1998). *Broadcasting and Cable*, June 22, p. 59.

Multimedia Development Corporation. (1997a). *Investing in Malaysia's Multimedia Supercorridor: Policies, Incentives, and Facilities.* Kuala Lumpur: Multimedia Development Corporation.

———. (1997b). *Seven Flagship Applications.* Kuala Lumpur: Multimedia Development Corporation.

Munson, E., and C. Warren, eds. (1997). *James Carey: A Critical Reader.* Minneapolis: University of Minnesota Press.

Nagel, E., and J. Newman. (1959). *Gödel's Proof.* London: Routledge and Kegan Paul.

Nakamura, L. (1998). "After/Images of Identity: Gender, Technology, and Identity." Unpublished manuscript from speech given at "Disciplining Deviance" Conference, Duke University, October 4.

Negroponte, N. (1995). *Being Digital.* New York: Alfred A. Knopf.

Nelson, S. (1995). "Broadway and the Beast: Disney Comes to Times Square." *The Drama Review* 39 (2): 71–85.

Neumann, A. (1995). "Information Wants to Be Free—But This Is Ridiculous." *Wired*, October, *www.wired.com/wired/archive/3.10/privacy.html.*

Newman, C. (1985). *The Post-modern Aura: The Act of Fiction in an Age of Inflation*, Evanston, IL: Northwestern University Press.

Ng, F. (1997). "Silicon Corridor Set up in the North to Complement MSC." *New Straits Times*, April 23, p. 23.

Nix, J. (1998). "Bertelsmann to Sell Books on the Internet." *Variety*, March 2–8, p. 7.

Nunes, M. (1997). "What Space Is Cyberspace?" In D. Holmes, ed., *Virtual Politics: Identity and Community in Cyberspace*. London: Sage, 1997.

Nye, D. (1994). *American Technological Sublime*. Cambridge, MA: MIT Press.

O'Brien, R. (1992). *Global Financial Integration and the End of Geography*. New York: Council on Foreign Relations Press.

O'Connell, V. (1998). "Soap and Diaper Makers Pitch to Masses of Web Women." *Wall Street Journal*, July 20, B1, B6.

Ogilvy, D. (1985). *Ogilvy on Advertising*. New York: Vintage Books.

———. (1988). *Confessions of an Advertising Man*. New York: Atheneum.

Oguibe, O. (1996). "Forsaken Geographies: Cyberspace and the New World 'Other.'" Paper originally delivered at the 5th International Cyberspace Conference, Madrid, June, http://eng.hss.cmu.edu/internet/oguibe.

Oldfield, A. (1990). *Citizenship and Community: Civic Republicanism and the Modern World*. London: Routledge.

Orwall, B. (1997a). "On-Line Service by Disney's ABC Unit Will Be Promoted by AOL, Netscape." *Wall Street Journal*, April 4, A5.

———. (1997b). "Disney Blitzes Cyberspace with 'Daily Blast' Service." *Wall Street Journal*, July 28, B4.

Osborne, L. (1998). "The Pirate's Progress." *Lingua Franca*, March, 35–42.

Pareles, J. (1998). "Records and CD's? How Quaint." *New York Times*, July 16, B1, B6.

Parkes, C. (1997). "The Birth of Enclave Man." *Financial Times*, September 20–21, p. 7.

Parkes, C., and L. Kehoe. (1998). "Mickey Wants Us All Online." *Financial Times*, June 20–21, p. 7.

Passavant, P. (2000). "The Governmentality of Discussion." In J. Dean, ed., *Political Theory: The Cultural Turn*. Ithaca, NY: Cornell University Press.

Passell, P. (1997). "A Financial Capital? Yes. A Model Economy? No." *New York Times*, October 19.

Penny, S. (1996). "The Darwin Machine: Artificial Life and Interactive Art." *New Formations* 29: 59–68.

Penrose, R. (1995). *Shadows of the Mind: A Search for the Missing Science of Consciousness*. London: Vintage.

Perez-Peña, R. (1997). "Study Shows New York Has Greatest Income Gap." *New York Times*, December 17, A1.

Pierce, C. S. (1955). *Collected Papers*. Cambridge, MA: Harvard University Press.

Pile, S., and N. Thrift. (1996). *Mapping the Subject*. London: Routledge.

Pipes, D. (1997). *Conspiracy*. New York: The Free Press.

Plant, S. (1997). *Zeros and Ones: Digital Women + The New Technoculture*. London: Fourth Estate.

Plantec, P. (1998). "Bootleg Bounty." *AV Video Multimedia Producer*, October, 29, p. 192.

Pogrebin, R. (1998). "For $19.95, Slate Sees Who Its Friends Are." *New York Times*, March 30, C1, C7.

Pogue, D. (1997). "Some Warez Over the Rainbow." *MacWorld*, October, http://macworld.zdnet.com/pages/october.97/Column.3919.html.
———. (1997). "High Definition TV Is Dealt a Setback." *Wall Street Journal*, August 13, B5.
Pope, K. (1998). "Telecom World Is Wondering: 'Who's Next?'" *Wall Street Journal*, June 25, B1.
Porush, D. (1992). "Transcendence at the Interface: The Architecture of Cyborg Utopia, or Cyberspace Utopoids as Postmodern Cargo Cult." In R. B. Miller and M. T. Wolf, eds., *Thinking Robots, an Aware Internet, and Cyberpunk Librarians: The 1992 Lita President's Program*. Chicago: Library and Information Technology Association.
Poster, M. (1990). *The Mode of Information: Poststructuralism and Context*. Chicago: University of Chicago Press.
———. (1995). *The Second Media Age*. Malden, MA: Polity Press.
Postman, N. (1992). *Technopoly: The Surrender of Culture to Technology*. New York: Knopf.
Poundstone, W. (1985). *The Recursive Universe: Cosmic Complexity and the Limits of Scientific Knowledge*. Oxford: Oxford University Press.
Poynder, R. (1998). "Internet Small Fry on the Road to Oblivion." *Financial Times*, April 29, p. 12.
Prigogine, I., and I. Stenghers. (1984). *Order Out of Chaos: Man's New Dialogue with Nature*. London: Flamingo.
Quick, R. (1997). "The Crusaders." *Wall Street Journal*, December 8, R6.
———. (1998a). "Internet Contains a Racial Divide on Access and Use, Study Shows." *Wall Street Journal*, April 27, B6.
———. (1998b). "On-Line Groups Are Offering Up Privacy Plans." *Wall Street Journal*, June 22, B3.
Quittner, J. (1977). "Life and Death on the Web." *Time*, April 7, p. 47.
Rathnam, L. (1997). "On the Contrary Cargo Cult." *Global Investor*, September, 16.
Ravo, N. (1998). "Silicon Alley Seeing More Deals and Cash." *New York Times*, February 12, B9.
Rawsthorn, A. (1998a). "Digital Music On-Line for Cable TV Customers." *Financial Times*, January 20, p. 2.
———. (1998b). "Discord over On-Line Music Royalties." *Financial Times*, January 21, p. 8.
———. (1998c). "Internet Sales Could Become Key to the Music Industry." *Financial Times*, June 2, p. 18.
Raymond, E. S. (1996). *The New Hacker's Dictionary*. Cambridge, MA: MIT Press.
Reed, S. (1998). "Internet Companies Are Rewriting the Accepted Rules of the 'Old' Economy." *InfoWorld*, November 2, p. 67.
Reilly, P. (1998). "Web Publishers Wage War for Music Scoops." *Wall Street Journal*, April 15, B1.
Reuters News Service. (1998). "Pre-IPO Prodigy Eyes New Markets." *CNET News.com*, September 28, http://www.news.com/News/Item/0,4,26862,00.html?st.cn.nws.rl.ne.
Rheingold, H. (1993). *The Virtual Community: Homesteading on the Electronic Frontier*. New York: HarperCollins.
Richards, I. A. (1929). *Practical Criticism: A Study of Literary Judgment*. New York: Harcourt, Brace.

Richtel, M. (1998). "Survey Finds TV Is Major Casualty of New Surfing." *New York Times*, July 16, D3.

Riedman, P. (1997). "ParentTime 1st Channel for PointCast." *Advertising Age*, August 18, p. 19.

———. (1998a). "P&G Plans Pivotal Ad Forum about Net." *Advertising Age*, May 11, 4.

———. (1998b). "Cyber Brands Spread the Word with Off-Line Ads." *Advertising Age*, July 6, p. 18.

Riesenberg, P. (1992). *Citizenship and the Western Tradition: Plato to Rousseau*. Chapel Hill: The University of North Carolina Press.

Rizal Razali, M. (1997). "Cyberjaya to Pave the Way for Technological Excellence." *New Strait Times*, April 21, p. 30.

Robbins, B., ed. (1993). *The Phantom Public Sphere*. Minneapolis: University of Minnesota Press.

Robbins, K. (1995). "Cyberspace and the World We Live In." In M. Featherstone, ed., *Cyberspace/Cyberbodies/Cyberpunk*. Newbury Park, CA: Sage.

Roche, E. M. (1997). "'Cyberpolis': The Cybernetic City Faces the Global Economy." In M. E. Crahan and A. Vourvoulias-Bush, eds., *The City and the World: New York's Global Future*. New York: Council on Foreign Relations Press.

Roderick, K. (1997). "Cargo Cult." *You Magazine and Amok Journal, Sensurround Edition*, http://www.youmag.com/u2/cc/start.html.

Rodger, W. (1997). "Don't Copy That Floppy." *Inter@active Week Online*, November 14, http://www.zdnet.com/intweek/daily/971114g.html.

Rodowick, D. N. (1990). "Reading the Figural." *Camera Obscura* 24: 10–45.

Rogin, M. (1987). *Ronald Reagan, The Movie*. Berkeley: University of California Press.

Romanyshyn, R. (1989). *Technology as Symptom and Dream*. London: Routledge.

Rose, F. (1996). "Can Disney Tame 42nd Street?" *Fortune*, June 24, pp. 94–104.

Rosenberg, S. (1997). "A Giant Sucking Sound." *Salon Magazine*, November 13, http://www.salonmagazine.com/twenty-first/feature/1997/11/cov_13feature.html

Rosenberg, T. (1998). "Helping Them Make It through the Night." *New York Times*, July 12, p. 16.

Ross, A. (1994). *The Chicago Gangster's Theory of Life: Nature's Debt to Society*. New York: Verso.

Ross, C. (1998a). "Broadband Kicks Open Internet Door for Cable." *Advertising Age*, April 13, s6, s23.

———. (1998b). "NBC Opens On-Line Revenue Stream." *Advertising Age*, June 1, p. 2.

———. (1998c). "Hachette Looks for On-Line Profits with Outside Help." *Advertising Age*, June 29, p. 50.

Rothenberg, D. (1993). *Hand's End: Technology and the Limits of Nature*. Berkeley, CA: University of California Press.

Rothstein, M. (1998). "Offices Plugged in and Ready to Go." *New York Times*, February 4, B6.

Rucker, R. (1987). *Mind Tools: The Mathematics of Information*. Harmondsworth, U.K.: Penguin.

Rucker, R., R. U. Sirius, and Q. Mu., eds., (1993). *Mondo 2000: A User's Guide to the New Edge*. London: Thames and Hudson.

Sacharow, A. (1997). "Star Power." *Adweek*, May 5, p. 48.

———. (1998a). "Disney-B&N Deal Signals Shift in Online Sales Business." *Mediaweek*, February 2, p. 22.

———. (1998b). "Wolf at the Portal?" *Mediaweek*, February 9, p. 47.

———. (1998c). "After Divorce, Online Newspapers Regroup." *Mediaweek*, March 16, p. 31.

———. (1998d). "Rhapsody in BMG: Music Service Expands Online." *Mediaweek*, April 13, p. 34.

———. (1998e). "NBC Opens Door to Its Portal Strategy with CNET's Snap." *Mediaweek*, June 15, p. 33.

Sachs, S. (1998) "Giuliani's Goal of Civil City Runs into First Amendment." *New York Times*, July 6, B1.

Sandberg, J. (1998). "It Isn't Entertainment That Makes the Web Shine; It's Dull Data." *Wall Street Journal*, July 20, A1, A6.

Sanger, D. E. (1997). "The Overfed Tiger Economies." *New York Times*, August 3, E3.

Santoro, G. (1994). "The Internet: An Overview." *Communication Education*, 43, 73–86.

Sassen, S. (1991). *The Global City: New York, London, Tokyo*. Princeton, NJ: Princeton University Press.

Saxenian, A. (1994). *Regional Advantage: Culture and Competition in Silicon Valley and Route 128*. Cambridge, MA: Harvard University Press.

Schiesel, S. (1998a). "Venture Promises Far Faster Speeds for Internet Data." *New York Times*, January 20, A1, C7.

Schiesel, S. (1998b). "F.C.C. May Act to Aid Home Internet Access." *New York Times*, July 17, C1, C3.

Schonfeld, E. (1998). "The Network in Your House." *Fortune*, August 3, pp. 125–28.

Scism, L., and K. Swisher. (1998). "Internet Firms Heat Up on News of Interest by Media Companies." *Wall Street Journal*, June 19, C1, C2.

Screen Collective. (1996–1997). *Lines of Flight*. Exhibition. Ottawa: Gallery 101.

"Sex on Display." (1998). *New York Times Magazine*, June 28, p. 8.

Shapin, S. (1994). *A Social History of Truth: Civility and Science in Seventeenth-Century England*. Chicago: The University of Chicago Press.

Sharkey, B. (1997). "Warner's Web." *IQ*, August 18, pp. 10–14.

Shaw, Russell. (1997). "CNN/SI Challenges ESPN Site." *Electronic Media*, July 21, pp. 20, 32.

Shenk, D. (1997). *Data Smog: Surviving the Information Glut*. San Francisco: Harper Edge.

Shields, R. (1991a). *Places on the Margin: Alternative Geographies of Modernity*. London: Routledge.

———. (1991b). "Introduction to the Ethic of Aesthetics." *Theory Culture and Society* 8 (1): 1–6.

———. (1992). "A Truant Proximity: Presence and Absence in the Space of Modernity." *Environment and Planning D: Society and Space* 10 (2): 181–98.

———, ed. (1996a). *Cultures of Internet: Virtual Spaces, Real Histories, Living Bodies* London: Sage.

———. (1996b). "Meeting or Mismeeting: The Dialogical Challenge to *Verstehen*." *British Journal of Sociology*, 47 (2): 275–94.

———. (1999). *Lefebvre, Love and Struggle: Spatial Dialectics*. London: Routledge.

Siklos, R. (1998). "Can Record Labels Get Back Their Rhythm?" *Business Week*, July 27, pp. 52–53.

Silberman, S. (1997). "Don't Blame the Bits." *Hotwired*, March 28–30, http://www.hotwired.com/netizen/97/12/index4a.html.

Singh, S. (1997). *Fermat's Last Theorem*. London: Fourth Estate.

Sloop, J., and A. Herman. (1997). "Negativland, Out-law Judgments, and the Politics of Cyberspace." In T. Swiss, J. M. Sloop, and A. Herman, eds., *Mapping the Beat: Popular Music and Contemporary Theory*. Malden, MA: Basil Blackwell.

Smolin, L. (1997). *The Life of the Cosmos*. New York: Oxford University Press.

Snoddy, R. (1997a). "Programmer Turned Publisher." *Financial Times*, June 9, p. 7.

———. (1997b). "Chronicle of a Death Foretold." *Financial Times*, August 18, p. 7.

Snyder, B. (1998a). "Web Publishers Morph into On-Line Retailers." *Advertising Age*, February 9, p. 30.

———. (1998b). "AOL's Partners Put Up Millions, Wait for Payoff." *Advertising Age*, April 20, p. 30.

———. (1998c). "Sport Web Sites Rely on Strength of TV Networks." *Advertising Age*, May 11, pp. 46, 50.

———. (1998d). "AT&T Inks $120 Mil Package at Disney." *Advertising Age*, June 29, pp. 1, 52.

Sobchack, V. (1995). "Beating the Meat/Surviving the Text, or How to Get Out of This Country Alive." In M. Featherstone, ed., *Cyberspace/Cyberbodies/Cyberpunk*. Newbury Park, CA: Sage.

Solomon, N. (1998). "Motherhood, Apple Pie, Computers." *Eugene Register-Guard*, June 12, A2.

Springer, C. (1996). *Electronic Eros: Bodies and Desire in the Postindustrial Age*. Austin: University of Texas Press.

Stephenson, N. (1992). *Snow Crash*. New York: Bantam Spectra.

Sterling, B. (1988). *Mirrorshades: The Cyberpunk Anthology*, New York: Ace.

Stewart, I. (1987). *The Problems of Mathematics*. Oxford: Oxford University Press.

———. (1995). *Nature's Numbers: The Unseen Reality of Mathematics*. New York: Basic Books.

Stobart, P. (1994). *Brand Power*. New York: New York University Press.

Stone, A. R. (1995a*). The War of Desire and Technology at the Close of the Mechanical Age*. Cambridge, MA: MIT Press.

———. (1995b). "Split Subjects, Not Atoms; or, How I Fell in Love with My Prosthesis." In Chris Gray, ed., *The Cyborg Handbook*. New York: Routledge.

Street, E., and R. Wallsten. (1975). *Steinbeck: A Life in Letters*. New York: Viking Press.

Stroh, M. (1998). "The Electronic Book." *Baltimore Sun*, October 5, 1C, 4C.

Studemann, F. (1997). "Online and on Top." *Financial Times*, November 18, Germany section, p. 9.

Surkan, M. (1998). "Piracy on the Digital Seas." *PC Week Online*, June 8, http://www.zdnet.com/pcweek/opinion/0608/08worth.html.

Sweezy, P. M. (1981). *Four Lectures on Marxism*. New York: Monthly Review Press.

Swisher, K. (1998). "Microsoft Readies New Home Page for the Internet." *Wall Street Journal*, February 3, B5.

Takahashi, D., and S. Mehta. (1998). "Bells Push a Modem Standard to Rival Cable's." *Wall Street Journal*, January 21, B6.

Taussig, M. T. (1993). *Mimesis and Alterity: A Particular History of the Senses*. New York: Routledge.

Taylor, P. (1997). "Publishers to Charge Web Users." *Financial Times*, December 29, p. 11.

———. (1998). "Big Shake-Up for Telecom Suppliers." *Financial Times*, May 6, IT supplement, p. 1.

Tedesco, R. (1998a). "NFL Keeps ESPN Game Plan." *Broadcasting and Cable*, June 1, p. 37.

———. (1998b). "Disney Stakes Big 'Net Claim with Infoseek." *Broadcasting and Cable*, June 15, p. 15.

———. (1998c). "N2K Links with Disney, ABC Radio." *Broadcasting and Cable*, July 8, p. 46.

Terranova, T. (1996). "Digital Darwin: Nature, Evolution and Control in the Rhetoric of Electronic Communication." *New Formations* 29: 69–83.

"The Press in Spin Cycle." (1998). *Economist*, June 20, p. 35.

"The State of New York City's Parks." (1998). *New York Times*, January 27, A18.

"The Warez Ethic." Hotline server news postings archive (no longer online).

Tierra. (1998). Welcome to the Tierra Homepage," http://www.hip.atr.co.jp/~ray/tierra/tierra.html

"Times Web Site Ends Fee for Foreign Users." (1998). *New York Times*, July 15, C6.

Todorov, T. (1984). *The Conquest of America*. New York: Harper.

Toulouse, C., and T. Luke, eds. (1998). *The Politics of Cyberspace*. New York: Routledge.

"Tribune Company." (1998). *Goldman Sachs Investment Research*, May 14, p. 27.

Trompf, G. W. (1990). *Cargo Cults and Millenarian Movements: Transoceanic Comparisons of New Religious Movements*. New York: Mouton de Gruyter.

Tuman, M. (1992). *Word Perfect: Literacy in the Computer Age*. Pittsburgh: University of Pittsburgh Press.

Turkle, S. (1984). *The Second Self: Computers and the Human Spirit*. London: Granada.

———. (1996). *Life on the Screen: Identity in the Age of the Internet*. Cambridge, MA: MIT Press.

Turner, V. (1974). *Dramas, Fields, Metaphors*. Ithaca, NY: Cornell University Press.

Turow, J. (1997). *Breaking Up America*. Chicago: University Of Chicago Press.

Van Bolhuis, H., and V. Colom. (1995). *Cyberspace Reflections*. Brussels: VUB Press.

Virilio, P. (1991). *The Aesthetics of Disappearance*. New York: Semiotext(e).

———. (1993). "The Third Interval: A Critical Transition." In V. Conley, ed., *Rethinking Technologies*. Minneapolis: University of Minnesota Press.

Waldrop, M. (1992). *Complexity: The Emerging Science at the Edge of Order and Chaos*. Harmondsworth, U.K.: Penguin.

Walkerdine, V. (1988). *The Mastery of Reason: Cognitive Development and the Production of Rationality*. London: Routledge.

Warner, B. (1998). "Online Sprawl." *IQ*, May 25, p. 21.

Warner. C. (1998). "Dialing for ISP Dollars." *Mediaweek*, June 1, pp. 30, 32.

Waters, R. (1998a). "Sprint Leap Needs Firm Landing." *Financial Times*, June 3, p. 18.

———. (1998b). "Sprint Remodels Network to Adapt to Internet Age." *Financial Times*, June 3, p. 15.

Wayne, L. (1998). "Inside Beltway, Microsoft Sheds Its Image as Outsider." *New York Times*, May 20, C4.

"Web Becomes a Viable Channel." (1997). *Advertising Age*, December 22, 21.

Webber, T. (1998). "Who, What, Where: Putting the Internet in Perspective." *Wall Street Journal*, April 16, B12.

Weinreich, F. (1997). "Establishing a Point of View towards Virtual Communities." *Computer-Mediated Communication*, 3 (2), http://www.december.com/cmc/mag/1997/feb/wein.html

Wheelwright, G. (1998a). "Upheavals for the Broadcasting World." *Financial Times*, May 6, IT section, p. 5.

———. (1998b). "Tap into the Sound of the Superhighway." *Financial Times*, June 2, p. 11.

Wilkie, T. (1993). *Perilous Knowledge: The Human Genome Project and Its Implications*. London: Faber.

Williams, R. (1989). *Resources of Hope*. London: Verso.

Winner, L. (1977). *Autonomous Technology: Technics-out-of-Control as a Theme in Political Thought*. Cambridge, MA: MIT Press.

Winston, B. (1986). *Misunderstanding Media*. Cambridge, MA: Harvard University Press.

Wise, J. M. (1998). "Intelligent Agency." *Cultural Studies* 12 (3): 410–28.

Wittgenstein, L. (1979). *Notebooks 1914–1916*. Oxford: Basil Blackwell.

Wolff, M. (1998). "Burn Rate." *Advertising Age*, June 8, pp. 1, 16, 18.

Woodward, K. (1994). "From Virtual Cyborgs to Biological Time Bombs: Technocriticism and the Material Body." In G. Bender and T. Druckrey, eds., *Culture on the Brink: Ideologies of Technology*. Seattle: Bay Press.

Wray, S. (1998). "Paris Salon or Boston Tea Party? Recasting Electronic Democracy, a View from Amsterdam." http://www.thing.net/~rdom/ecd/teaparty/ html.

Wysocki, B. (1997). "Malaysia Is Gambling on a Costly Plunge into a Cyber Future." *Wall Street Journal*, June 10, A1, A10.

Yamamoto, M. (1997). "Prodigy Going Global." *CNET News.com*, May 2, http://www.news.com/SpecialFeatures/0,5,10296,00.html?st.cn.nws.rl.ne.

Yang, C. (1998). "How the Internet Works: All You Need to Know." *Business Week*, July 20, pp. 58–60.

Zukin, S. (1995). *The Cultures of Cities*. Cambridge, MA: Basil Blackwell.

CONTRIBUTORS

Jody Berland is coeditor of *Theory Rules: Art as Theory / Theory and Art* and the forthcoming *Capital Culture: Modernist Legacies, State Institutions and the Value(s) of Art* (McGill-Queen's University Press). She is author of a forthcoming volume on *Cultural Technologies and the Production of Space* and editor of the journal *Topia: Canadian Journal of Cultural Studies*. Berland is Associate Professor in the Graduate Program in Social and Political Thought at York University, Canada.

Sean Cubitt is Reader in Video and Media Studies and head of Screen Studies at Liverpool John Moores University. He is author of *Timeshift: On Video Culture* (Routledge), *Videography: Video Media as Art and Culture* (Macmillan), and *Digital Aesthetics* (Sage). Chair of the Foundation for Art and Creative Technology, he has published widely on contemporary arts and media.

Jodi Dean is an Assistant Professor of Political Theory at Hobart and William Smith Colleges in Geneva, NY. Her most recent book is *Aliens in America: Conspiracy Cultures from Outerspace to Cyberspace* (Cornell University Press). She has edited symposia on networked communications and new technologies for *Constellations* and *Signs*. Currently, she is editing a collection on Political Theory and Cultural Studies for Cornell University Press and writing a book on the links between conspiracy and the Internet.

Greg Elmer is Visiting Assistant Professor in the Department of Communication at the University of Pittsbugh. He completed his dissertation on the discriminatory aspects of computer profiling in the Department of Communication, University of Massachusetts, Amherst. His articles have appeared in *Space and Culture*, *Critical Studies in Mass Communication*, and *Continuum*. He is currently editing a special issue of *Space and*

Culture on the topic of archives. He is also writing a book on the social implications of computer profiling.

Andrew Herman is Associate Professor of Sociology and Cultural Studies at Drake University. He is the author of *The "Better Angels" of Capitalism: Rhetoric, Narrative and Moral Identity among Men of the American Upper Class* (Westview, 1998) and the forthcoming book, *The "Goods" Life: Consumer Culture and Moral Identity in Contemporary America* (Basil Blackwell). He is coeditor of and contributor to *Mapping the Beat: Contemporary Theory and Popular Music* (Basil Blackwell).

Steven Jones, Professor and Head of Communication at the University of Illinois-Chicago, is the author or editor of five books, including *Cyber-Society 2.0: Computer-Mediated Communication and Community*, *Virtual Culture: Identity and Community in Cyberspace*, and *Doing Internet Research* (all published by Sage).

Nancy Kaplan is Associate Professor in the School of Communications Design at the University of Baltimore. She has been a developer of award-winning software for writing instruction, director of a writing program, and a long-time student of electronic communication practices. She has published many articles exploring electronic literacies, gender and communication styles, verbal and visual representations, and interface issues.

Robert McChesney is Research Associate Professor in the Institute of Communications Research and the Graduate School of Library and Information Science at the University of Illinois at Urbana-Champaign. He has written or edited six books. His most recent book is *Rich Media, Poor Democracy: Communication Politics in Dubious Times* (University of Illinois Press). He is currently working on a critique of neoliberalism in economics, politics, and communication.

Vincent Mosco is Professor of Communication at Carleton University in Ottawa. He is the author of four books and editor or coeditor of seven on media, communication, and new technologies. His most recent book, *The Political Economy of Communication* (Sage), draws on current work in sociology, geography, and cultural studies to rethink this approach to media studies. He is currently working on a four-nation study of communication and culture in post-industrial cities.

Stuart Moulthrop is Associate Professor of Communications Design at the University of Baltimore. He has published numerous articles on hypermedia and information culture, as well as a number of widely discussed hypertext fictions, including *Victory Garden* and "Hegirascope." He served from 1995 to 1999 as coeditor of *Postmodern Culture*, a major postprint scholarly journal in the humanities.

Theresa M. Senft is completing her Ph.D in the Department of Performance Studies at New York University. She coedited *Sexuality and Cyberspace: Performing the Digital Body* (Women and Performance Press). From 1997 to 1998, she wrote a weekly column for Prodigy Internet's online community, entitled "Baud Behavior."

Rob Shields is editor of *Space and Culture* and author of *Places on the Margin: Alternative Geographies of Modernity* and *Lefebvre: Love and Struggle—Spatial Dialectics*. He has edited several books, including *Lifestyle Shopping: The Subject of Consumption*, *Cultures of Internet*, and *Social Engineering*. He is Acting Director of the Institute of Interdisciplinary Studies, and Associate Professor in Sociology and Anthropology at Carleton University, Ottawa.

John H. Sloop, Assistant Professor at Vanderbilt University, is author of *The Cultural Prison* (University of Alabama Press), and coeditor of *Mapping The Beat* (Basil Blackwell) and *Judgment Calls* (Westview). His work generally focuses on metacritical issues in rhetorical criticism and cultural criticism of public representations.

Thomas Swiss is Center for the Humanities Professor of English and Director of the Web-Assisted Curriculum at Drake University. He is the author of two collections of poems: *Rough Cut* (University of Illinois Press) and *Measure* (University of Alabama Press). He is the coeditor of *Mapping the Beat: Popular Music and Contemporary Theory* and *Key Terms for Popular Music and Culture* (both published by Basil Blackwell).

David Tetzlaff teaches new media theory and production at Connecticut College in Oakland, California. He also makes documentary films for public television, and writes on the politics of popular culture.

INDEX